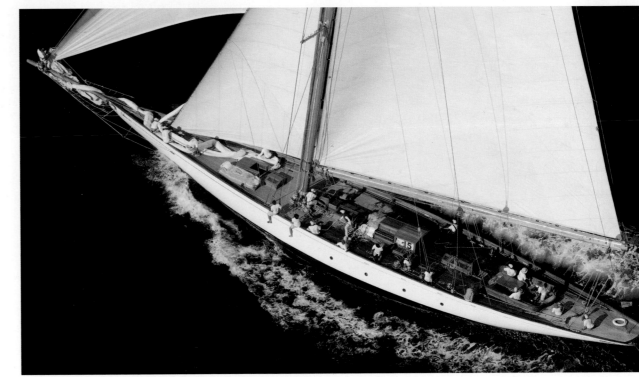

Classic Yachts

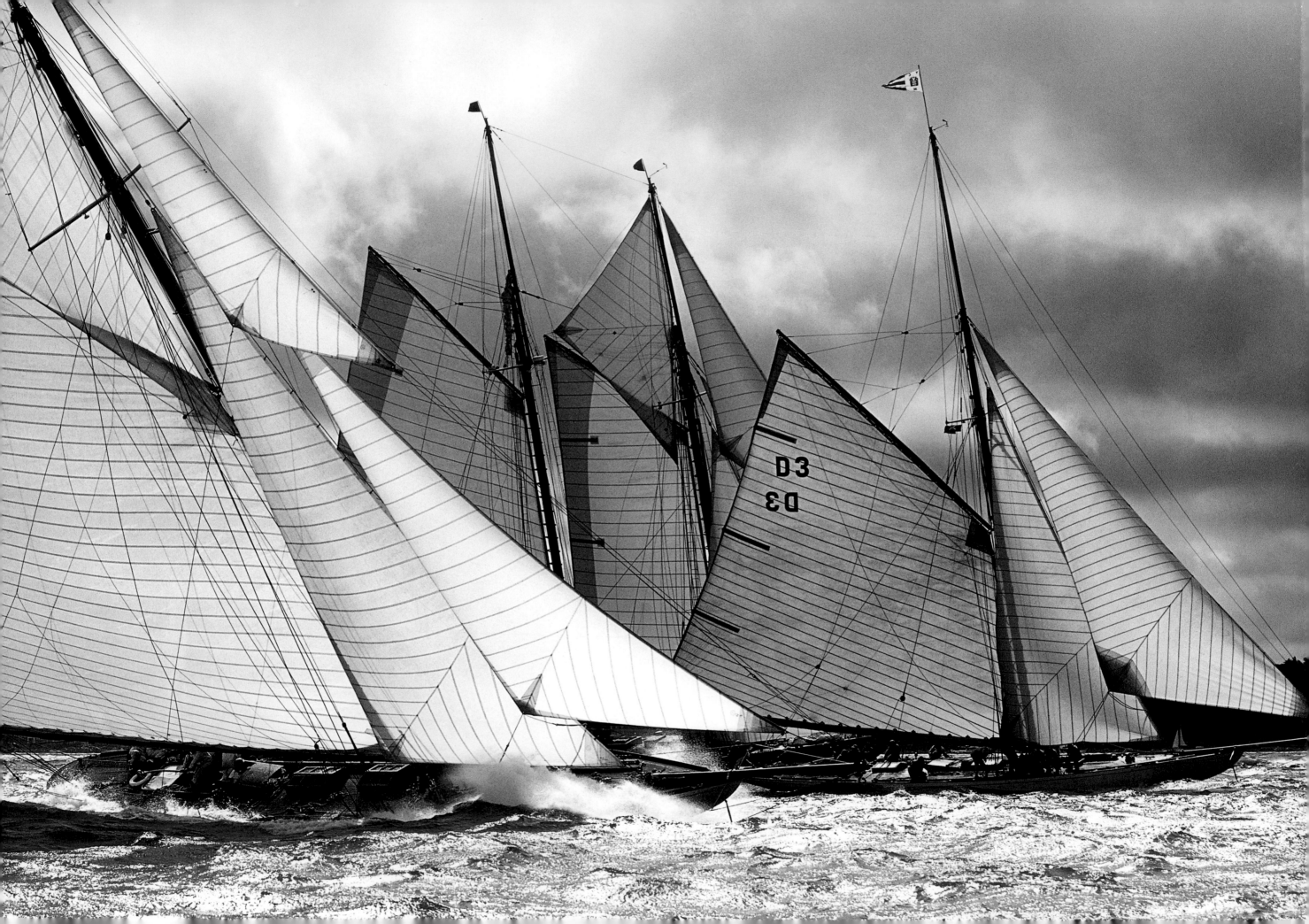

Classic Yachts

TEXT & DRAWINGS BY FRANÇOIS CHEVALIER

PHOTOGRAPHY BY GILLES MARTIN-RAGET

FOREWORD BY GARY JOBSON

CAPTIONS BY FRANÇOIS CHEVALIER & GARY JOBSON

Abbeville Press Publishers New York London

FOREWORD

BY GARY JOBSON

It was the first day of our cruise in Maine aboard the rebuilt J-class *Endeavour*. The mist was clearing and the prevailing southwesterly breeze started to fill. Time to get underway. As I came up on deck, I was asked the greatest question ever heard in the sport of sailing, "Would you like to take the helm?" Every sailor will always respond positively to that wonderful query. So with my hands on the wheel and my feet planted firmly on deck, I waited as the immense sails were hoisted. The anticipation of the upcoming sail made the moment special. We live for these days. Soon the yacht started to heel over in fifteen-knot winds, and we were underway.

Looking aloft, I spied a bird flying above the mast. Perhaps the graceful creature identified with the shape of our sails, which resembled its wings. At that moment it seemed, to me, that the sky, the bird, the sails, my body, the boat, and the water existed as one complete entity.

There is no greater moment than when a boat begins to move under her own power. The crew feels the freedom of leaving land. The sensation is the same on every yacht, and in particular the classics featured in this beautiful book. On page after page, these yachts leap into our affections. You can truly feel what it is like to be on board these fourteen recently restored classics.

I love studying the intensity of the crews in this book's photographs. These are teams just like you find in any sport, and their uniforms show the importance of each day on the water. Each member is assigned a different job, with everyone working together to set and trim sails, steer, call tactics, grind the winches, haul on halyards, and handle the endless miles of lines. The environment at sea is dynamic—in order to gain an edge over the competition, crews must continually focus to stay in tune with the winds and waves. Well-disciplined crews keep their eyes on the task at hand, but no one can resist looking across the water to judge how their yacht is performing, and when gains are made, the crew feels a communal sense of satisfaction.

When I sail aboard a classic yacht, I make a point to spend time on every part of the vessel. Your feelings change dramatically from different vantage points. The helm, of course, is my favorite because you can feel the power of the boat in your hands. Notice in many of the pictures that the helmsmen lean forward in an effort to make the yacht sail faster. Another great spot is on the leeward rail near the shrouds. The water rushing by the rail is loud. The hull seems to glide through the waves with authority. There is little conversation here because you fall into a kind of trance.

The bow is reserved for a unique fraternity of sailors. The bowman, in charge of setting new sails, is often the first to go aloft for any reason and is the lookout during close quarter situations with other boats. These people have a big responsibility to perform to perfection.

Going aloft in a bosun's chair is not for the faint of heart. The deck looks very small when you are one hundred feet above it. The boat's movement is amplified aloft. It is no accident that the early mariners had a rule, "one hand for yourself, and one hand for the ship." Seasoned sailors are comfortable working on a yacht, while the novice can only marvel at the routine. However, once you get a taste for sailing, you are hooked by its rewards for a lifetime.

The boats featured in *Classic Yachts* connect generations. Friendships formed aboard are the common denominator that bonds every crew. Two shipmates might be separated for years, but a conversation about a race long past will never be forgotten. It is no accident that an owner would rather hang a picture of his yacht than of any other possession. She will always bring back pleasant memories.

Intrinsically at home in her surroundings, whether her backdrop be a seaport town, competitor, or just the water, a classic yacht makes one clean statement. From a distance she looks stately. As she gets closer, she comes alive with the living community of crew working on deck. To paraphrase an old quote from baseball legend Yogi Berra, "classic yachts are even better looking than they look."

Classic yachts reflect the passion of their owners and designers. Every detail must be worked out in advance of construction. The master craftsman must take the dream, the drawings, and the materials to create these magnificent yachts. Many thousands of hours of loving labor go into building a yacht, and, once launched, great care must be taken to maintain her grandeur as well as her functionality. Every classic in this volume is well maintained. The teak decks are bright, the brass is always polished, the varnished wood glistens with the spray flashing past. And the crews, in their uniforms, look like they belong.

Flags, burgees, and pennants fly with purpose. You can tell that these signals all have great importance in reflecting the home yacht club, country, or owner's private signal. There is always a reason for any flag to be displayed. Amateur vexillologists ensure that the proper flag is flown according to a strict protocol.

I love the way the shapes of sails form in shadows on the water in these photographs. The action of the waves accentuates the movement of the yacht. Every ripple adds to the majesty of the image. The symmetry of sails working together is artwork. In a strong breeze they are the lifeblood of yachts, as each one's speed is derived from her sails. Getting just the right shape can make all the difference. Trimming is an endless experimentation. Crews measure progress against other boats, and when everything is trimmed to perfection, many yachts can sail themselves. As a boat achieves balance, the helmsman can guide the yacht with only small adjustments to the rudder. At other times, such as in a big seaway, the yacht must be strictly controlled. At this point, the helmsman will work hard to keep her on a steady course, and sail trimmers will make adjustments for maximum gain. You can hear the clipped orders being shouted around the deck.

The great yacht designer Olin Stephens once said at a lecture at the New York Yacht Club that his priority for designing yachts was the comfort of the crew. When you are comfortable on a boat, you are able to work with confidence. This is quite an important statement coming from a man whose yachts have won the America's Cup eight times, and the Newport to Bermuda Race fourteen times.

On April 13, 2008, Stephens celebrated his hundredth birthday. No doubt he has seen many changes in yacht design over his century of life. Classic yachts only seem to get better looking with age. Technological marvels of their day, these yachts are now even better to sail and easier to handle thanks to modern equipment like efficiently geared winches, synthetic ropes, advanced electronics, and light, but strong, perfectly shaped sails. *Classic Yachts* documents these technological advances and includes line drawings of the hull, keel, deck, and spaces down below. Future designers will no doubt study these drawings to understand why these classics endure decade after decade.

The owners of the classic yachts in this book deserve our appreciation for keeping them alive. And now, happily, *Classic Yachts* offers strikingly illustrated documentation of these enduring, legendary vessels. The sailors of today, as well as of tomorrow, are all grateful that these treasures live on. This is a book that you will return to often, and through it, your time on the water will come to life in moments of reflection.

CONTENTS

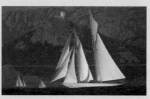
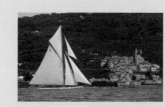
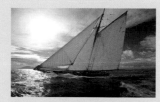
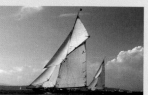
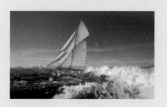

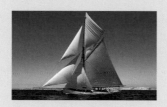
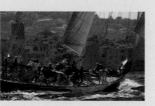

Altaïr

Although the schooner *Altaïr* regularly occupies a place of honor in any list of classic yachts, she was never designed for racing. She was commissioned for deep-sea cruising in the southern seas, and nothing more. Designed by William Fife III, who was then seventy-three years old, she launched from the William Fife & Son boatyard at Fairlie, Scotland, in early May 1931. Since her restoration in 1987, *Altaïr* has taken part in more regattas than ever before and traveled far more nautical miles than she did in her original state.

The restoration was so exemplary, the yacht's racing achievements so decisive, and the admiration she has inspired so contagious that *Altaïr* is considered the standard for classic yachts.

With *Ataïr* sailing full out, I'm intrigued by how the crew is adding more sail to gain even more speed. Notice the extra sails on the deck ready for the next sail change. The crew, holding on to the headstay, is using hand signals to indicate when it is time to pull the new sail aloft.

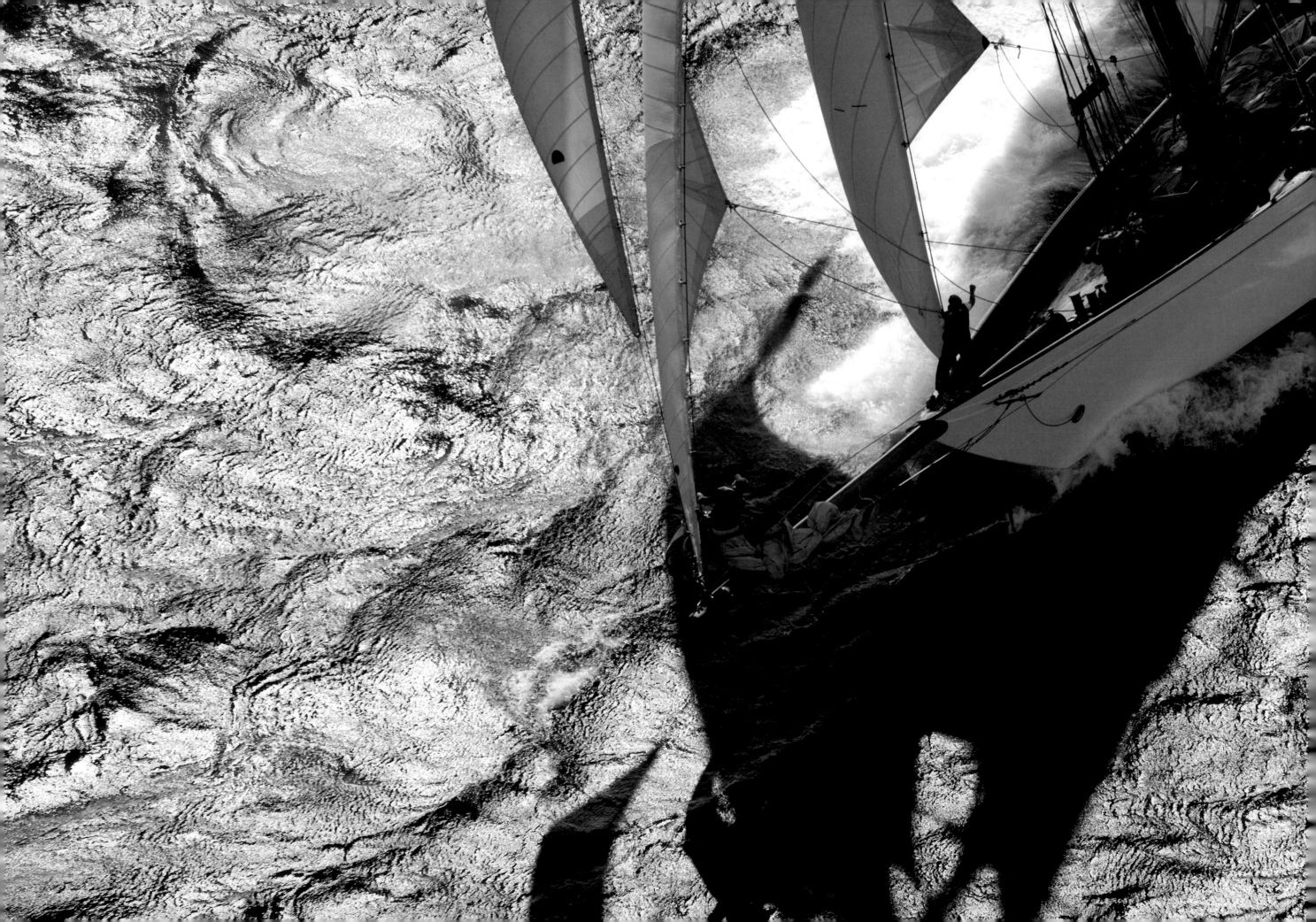

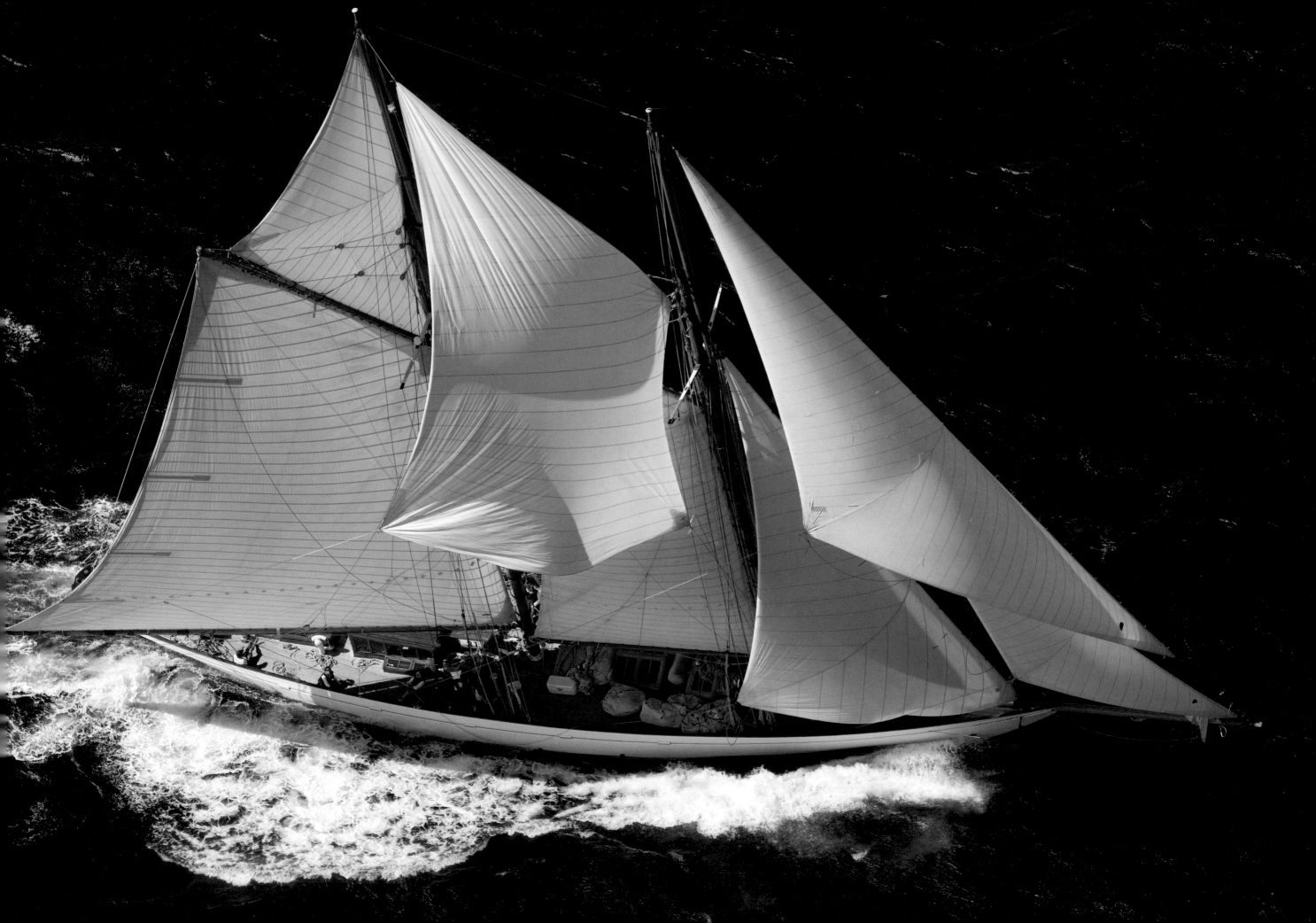

I n the race now known as Les Voiles de Saint-Tropez in October 2006, *Altaïr*, 107 feet 7 inches (32.80 m) wide at the bridge, whose overall length is 131 feet 3 inches (just short of 40 m), placed second in the general division. She defeated regatta yachts with glorious pasts such as the nineteen-meter *Mariquita*, the fifteen-meter *Tuiga*, the gaff-rigged Big Class *Lulworth*, and even *Eleonora*, a replica of the famous American schooner *Westward* that sailed on the Solent just off Southampton, England, in the early twentieth century.

When *Altaïr* made her first appearance at the Saint-Tropez Nioulargue, she started an entire movement. The Mediterranean arrival of this masterful restoration raised expectations to a new level of perfection. Seeing *Altaïr* gave several wealthy people the aim not only of owning a yacht of this type but of restoring her in the best spirit of the tradition, and a trend was started. *Altaïr* gives a person the desire to sail the seas on a yacht at least as majestic, if only to be in her company.

Photographer Gilles Martin-Raget often recounts an incident that particularly impressed him. A few years ago, he was on board a launch with a few other newspaper photographers, all of them enthralled by the fascinating spectacle of a major international yacht race. Every photographer was jockeying to capture the picture of the century—the foaming waves, the long white hull, the superb sails gilded by the Mediterranean sun, the crews lined up on deck in their immaculate dress. Shutters were clicking away. Suddenly, a hush fell on the scene. Everyone stopped to admire the collective grandeur of the fine yachts, the sight was just too magnificent.

A Difficult Beginning

Altaïr was the last great yacht designed by William Fife III (1857–1944). Captain Guy H. MacCaw wanted a powerful, sturdy sailing ship, inspired by the pilotships that guided the great ships into port, with little mast rake and capable of facing any type of weather condition at sea. Discussions with his architect began in 1929, with Fife trying to persuade MacCaw that speed also had safety concerns. Eventually, MacCaw was delighted with the lines of his schooner and her elegant raking. Both men were convinced that the gaff rigging, with its simpler maneuvering, would be perfectly suited to the sailing course, even though all the yachtsmen of the time were opting for ketches or Bermudan yawls. The order for the yacht, placed in December 1929, was particularly welcome in Fife's boatyard on the Clyde, as demand for racing yachts of the metric class—the six-, eight-, and twelve-meter J-class yachts— was at its lowest point in 1930. Only two six-meter yachts left the boatyard in 1931, although there had been five in 1929, as well as six eight-meter yachts. While she had a draft of only thirteen feet (4 m), *Altaïr* still had to be launched from the floating dock. Then to Fife's great consternation, the ship did not hit the water on the level; the bow was too low. Archibald McMillan Sr., head of the rigging team, came on board and determined the quantity of ballast needed to correct the seat, but errors multiplied. At the very moment

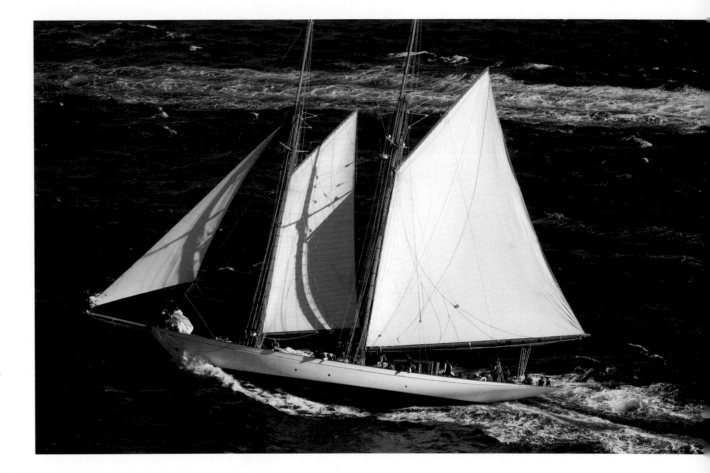

that the topmast was being placed on the mainmast, it became apparent that the base was too thick to fit into the yoke, the metal support at the base of the topmast. McMillan and his son quickly planed down the foot of the mast so that it could finally be inserted.

Fife, according to his great-niece May Fife McCallum in her book on the history of the Fife family and boatyard, was utterly horrified, shouting, "This will ruin me!" The yard was his whole life. When speaking of his occupation, Fife was the first to admit that for him it was more of a game than a job. He lived with his sisters and practically adopted his nephew Robert Balderston Fife when he was old enough to be apprenticed, setting him to work as a draftsman. Robert, however, did not inherit his uncle's genius and subsequently became a specialist ship's chandler, selling the boatyard upon Fife's death in 1944.

After a few outings on the Solent and a cruise down to Saint-Jean-de-Luz in the south of France, MacCaw parted with *Altaïr* in 1933. He sold her to Walter, First Viscount Runciman of Doxford, owner of *Sunshine*'s sister ship, *Asthore*, another schooner built by Fife in 1902. He and his father, Lord Walter Runciman, a major shipowner, co-owned *Sunbeam*, a three-master with an auxiliary motor. At the time, he also had the second ship of that name, *Sunbeam II*, an even bigger vessel, nearly 200 feet (59.50 m) long. *Altaïr* sailed along the west coast of Scotland to the Hebrides and took part in

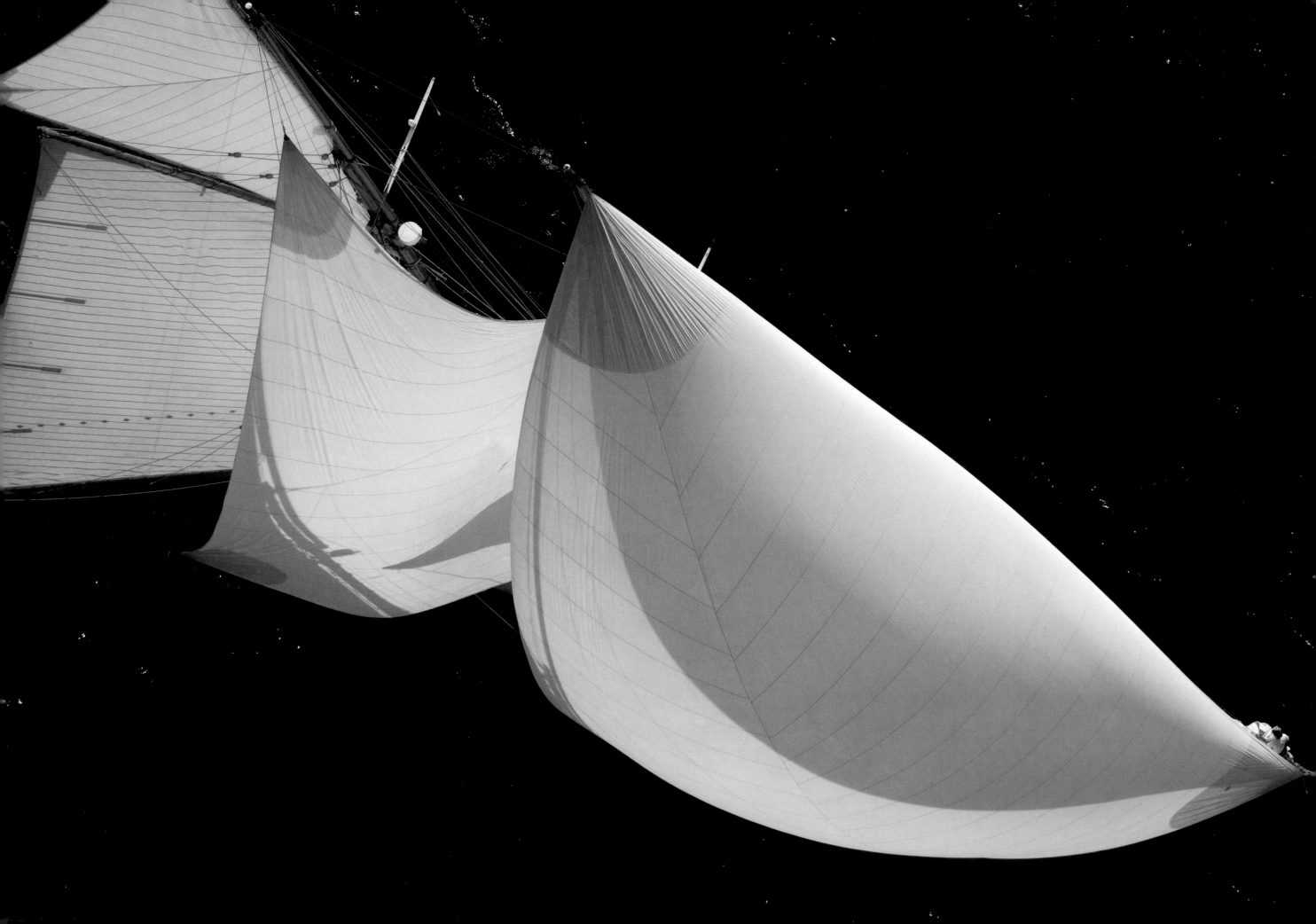

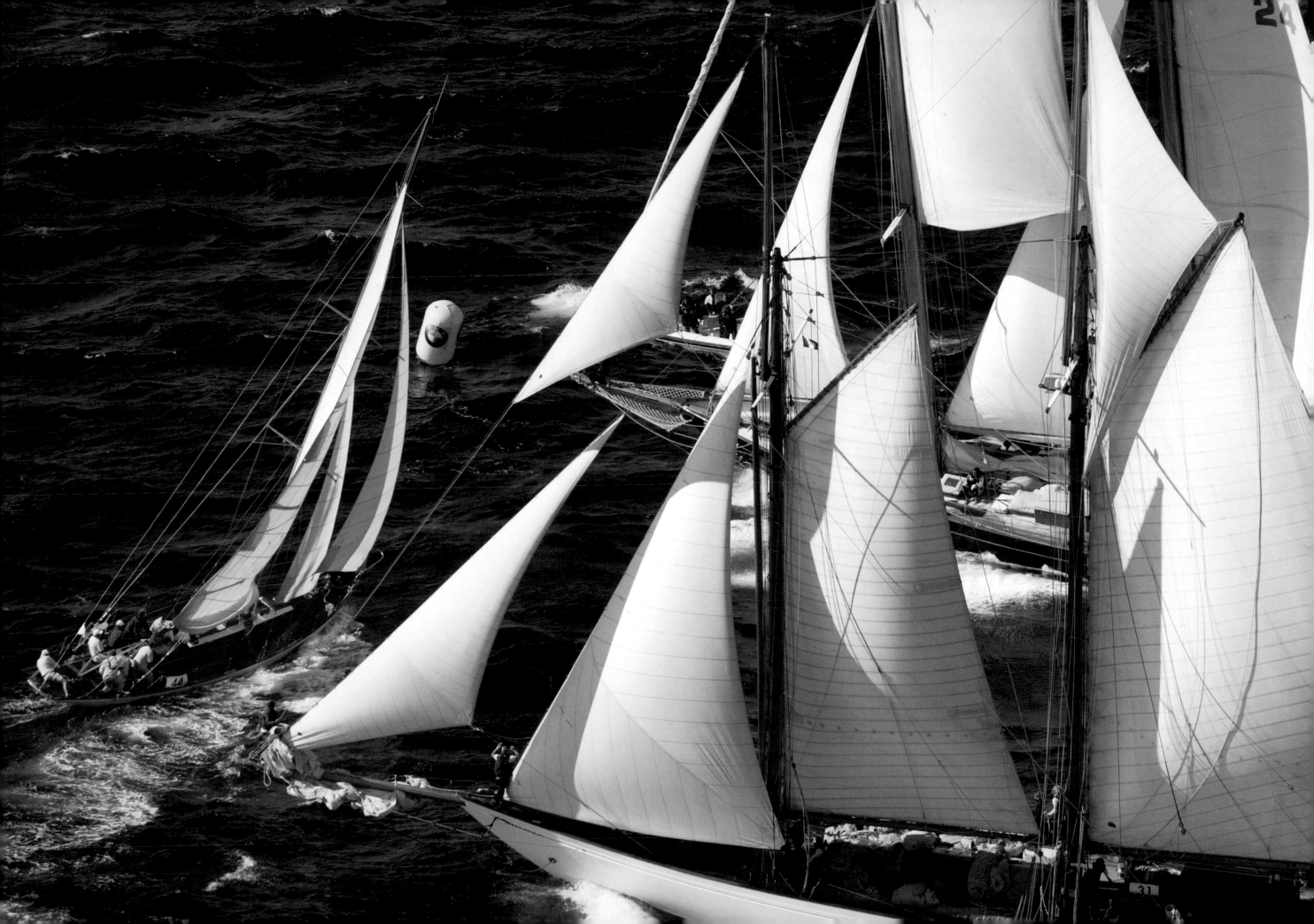

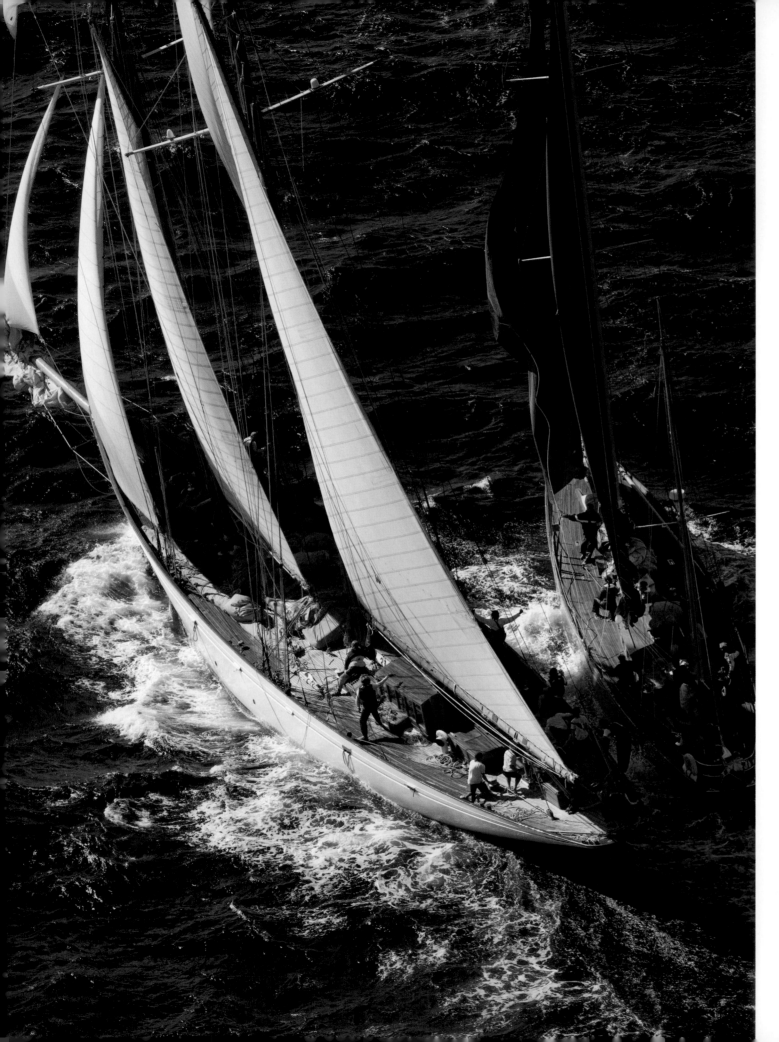

several regattas on the Solent until 1938. Her next owner, Sir William Verdon-Smith, renewed her plumbing and kept her for two years. In 1940, the British Admiralty requisitioned her, as it did most ships. After a general overhaul in Southampton in 1948, Verdon-Smith sold the schooner to José Augusto Mendoça e Vasconcelos. *Altaïr* was given a new General Motors six-cylinder engine and for two years sailed from Lisbon under the Portuguese flag. She was then acquired by a husband and wife from Barcelona, Miguel and Maria Esther Sans Acevedo. At first, *Altaïr* moved to Barcelona. Miguel was an enthusiastic sailor: in 1952, the yacht happened to be passing the Stromboli volcano when it erupted, and she took part in such Mediterranean regattas as the Giraglia, from Saint-Tropez to Corsica. In the early 1960s, *Altaïr*'s homeport moved to Monte Carlo, where the Inatra International Navigation Company managed her. Sans Acevedo kept the schooner for thirty-six years, until 1985, when the Swiss collector, Albert Obrist, took her under his wing on the advice of *Altaïr*'s Australian skipper, Paul Goss.

An Exemplary Restoration

Under the auspices of the Blue Wave company in the boatyard of Southampton Yacht Services on the Itchen River, *Altaïr* received a complete restoration. Obrist, passionate about beautiful objects and having the means to pursue them, once said, "I love beautiful things and take pleasure in preserving them." For instance, he once owned a collection of sixty-five Ferraris, all of which had been restored until they were like new. Skipper Goss was in charge of the renovation project with Duncan Walker as his deputy. With the help of Ian McAllister, who had documented the history the Fife family, a whole paper trail for the yacht and her construction was compiled, right down to invoices for crew's uniforms and letters written by Fife to Ratsey, the master sailmaker.

They placed *Altaïr* in dry dock, berthed on a cradle. Next they built a hangar over her so she could be worked on under cover. They dismantled the schooner piece by piece, starting with the superstructure, i.e., the roofing, skylights, deck paneling, and all of the fittings. Each item was labeled and stored on shelves, just as if an inventory was being made for an ancient wreck. After the deck panels, they removed the bulkheads, furniture, and walnut paneling, followed by the technical equipment, electrical circuitry, and plumbing as well as the tanks and engine room equipment. Each item was then analyzed and repaired or replaced.

Once the hull was empty, the structure was easily accessible. They found the Burmese teak bottom plank, more than two inches (5 cm) thick, in good condition. The advantage of the Burmese wood, which has a particularly close and regular grain, is that it cannot be attacked by marine worms. The work of the ship's carpenters at the William Fife & Son boatyard had been exemplary, and the seams between each teak plank had remained sound even over the years. On the other hand, the iron flooring linking the ribs in the ship's bottom was partly corroded and needed to be changed. All of the damaged oak ribs had to be repaired, though they preserved the healthy parts by

Left
An anxious moment aboard *Altaïr* and *Agneta*. You can hear the yelling between the two yachts even in this aerial photograph. Luckily, *Agneta* stays clear.

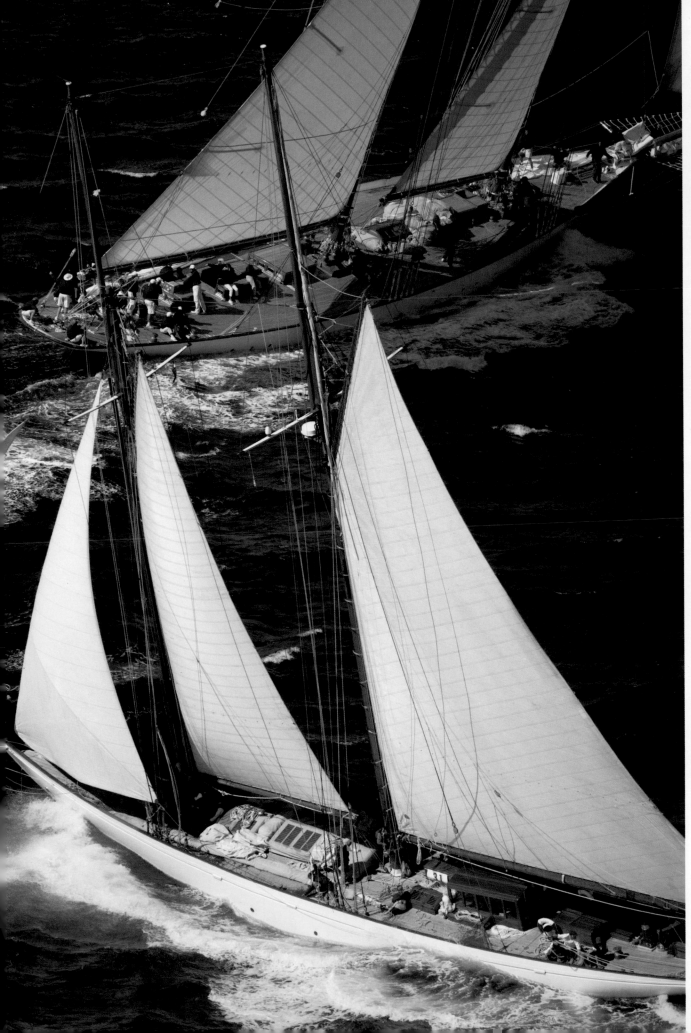

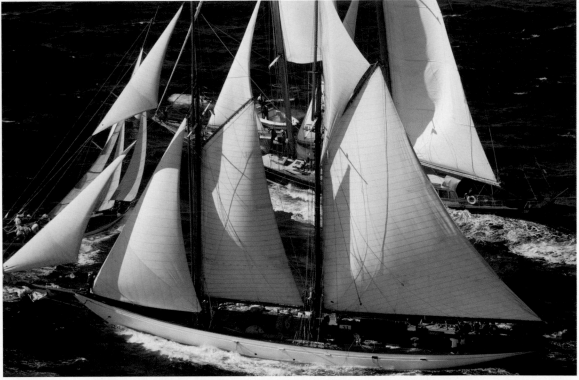

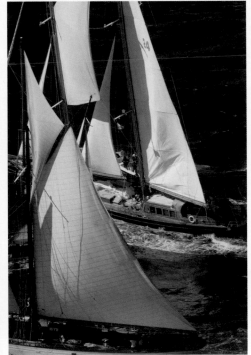

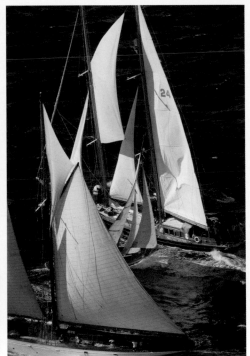

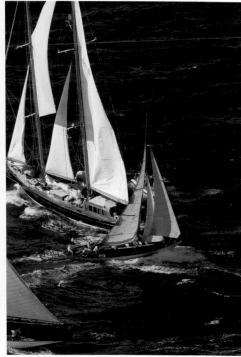

The tiny cutter *Isis* sails between two massive yachts. The black schooner is *Ashanti IV*. Every crew member breathes a sigh of relief when the potential disaster is avoided.

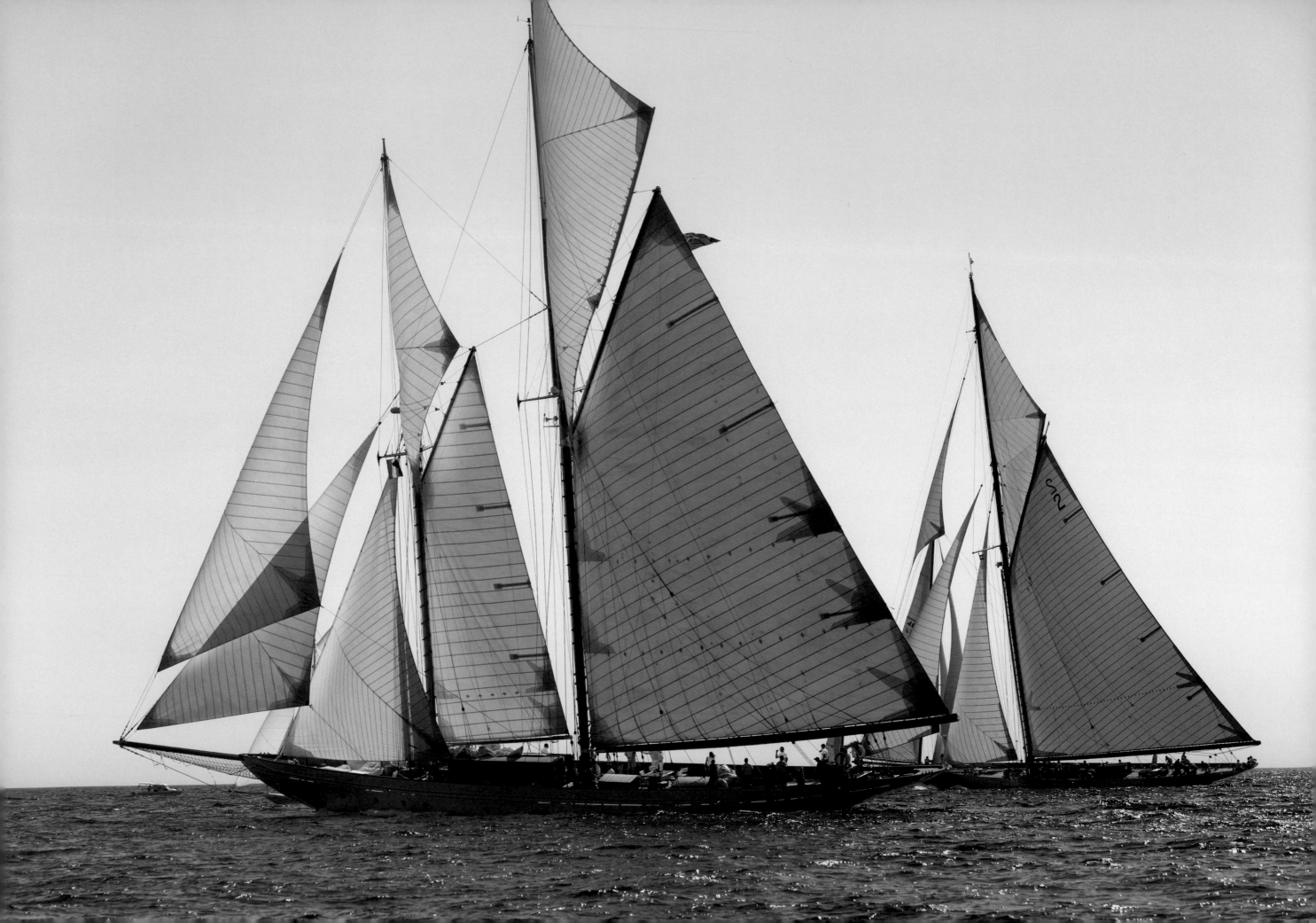

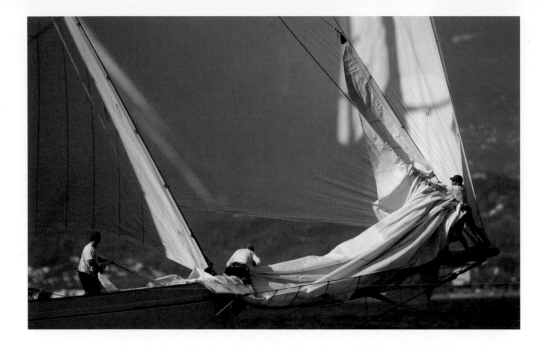

Opposite
Altaïr, in the foreground, and *Lulworth* (#2) to windward demonstrate that classic yachts are businesslike, sleek, purposeful, and magnificent.

Above
It is hard work hooking the jib to the forestay. This crew is very excited that their labor is about to be rewarded when the new sail is set.

Right
Compare the differences in shape between the spinnakers of the small sloop on the right and the older classic on the left. Sail design has come a long way in the past hundred years.

level-cutting and gluing them in place. In these so-called composite structures, in which iron is combined with oak, rust eventually attacks deep into the wood. If condensation or rainwater gets in through a deck that is not completely watertight and has no egress, it will penetrate the timbers and start to blacken them.

In the Spirit of Fife

As has been mentioned, *Altaïr* was not entirely seaworthy when she launched in 1931. McMillan had to place lead kentledges (ingots) in the bottom of the stern to keep the ship upright. After studying the original plans and taking into account the modern equipment that would be installed in the schooner, the restorers cast a new 62-ton ballast from lead taken from the old keel. The freshwater and fuel tanks were cleaned out and proved to be completely reusable, so they were put back in place. A new 200 hp engine, a six-cylinder Gardner, replaced the 1950s General Motors engine. Ceilings and furnishings, electrical wiring, and plumbing were installed. They designated a special place beneath the galley to hold modern conveniences such as a desalination plant, washing machines, and freezers. The original pine deck was replaced by a teak deck installed on marine plywood, but everything was done to ensure that Fife's masterpiece should remain as close as possible to the way he designed her. Specialist Harry Spencer provided the rigging, checking each detail and making the spars from Oregon pine and spruce. The metal for the mast was mainly original, and was later used as the model for the renovation of *Tuiga*, a 1909 Fife design. For the sails, Obrist preferred the Egyptian cotton used before the war, although Goss advised using a synthetic fabric. Eventually, Ratsey & Lapthorn, the sailmakers, opted for Terylene dyed a pale ocher in strips of the same width as seen in contemporary photographs. This solution would also be adopted for other restorations so that at gatherings of these classic yachts the pale beige hue of the sails increases its historical impression.

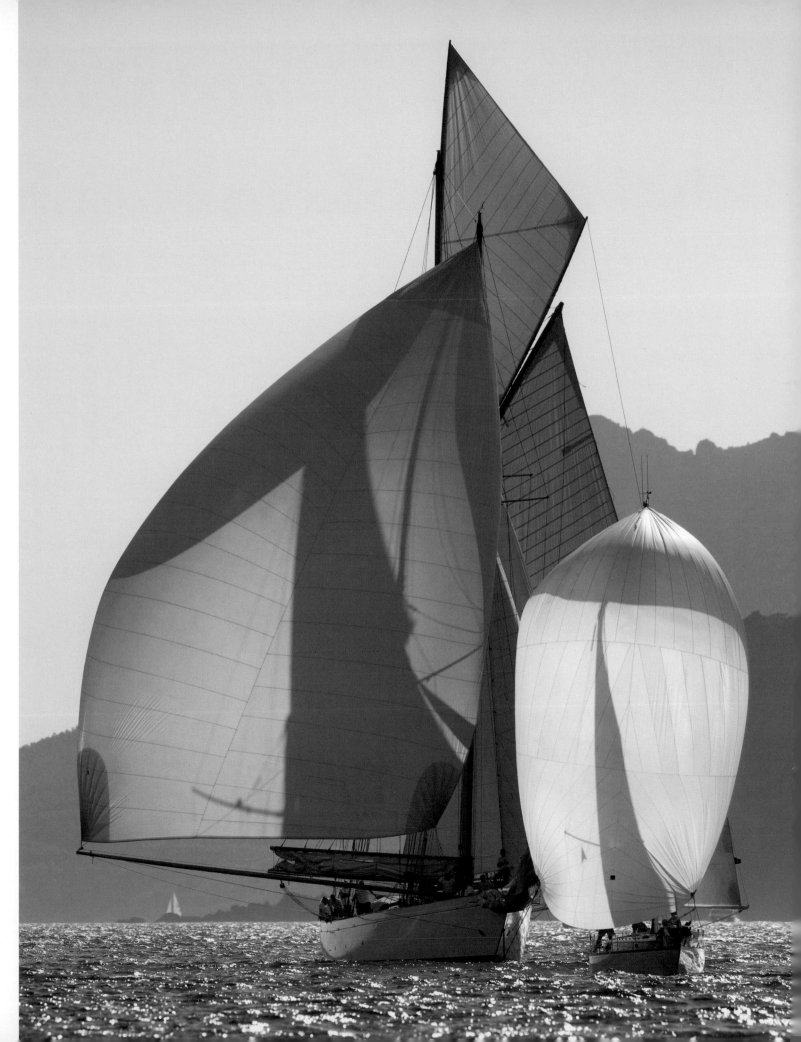

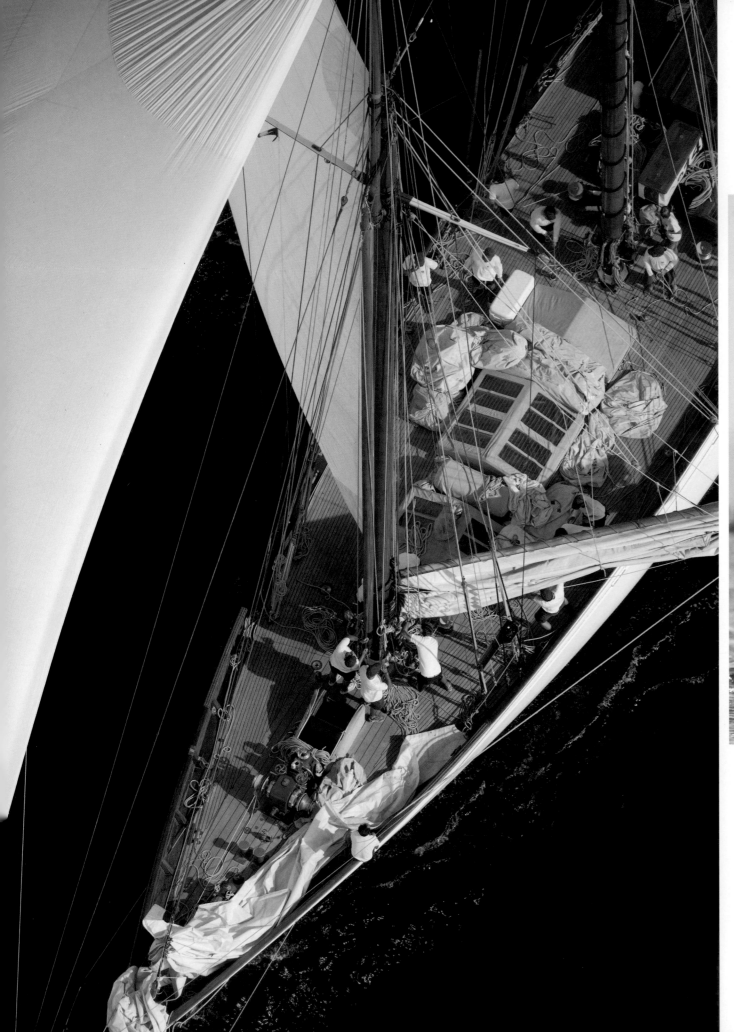

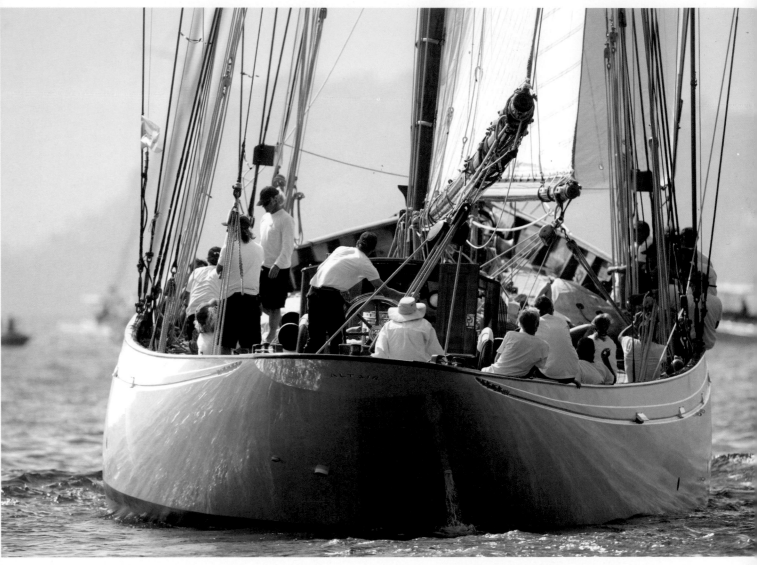

Left
The great fun of sailing
a schooner is experi-
menting with the many
combinations of sail. This
crew has an entire sail
loft at the ready for any
eventuality.

Above
The helmsman's posture
makes him look as if he
is physically pushing his
yacht faster. Every mem-
ber of the crew seems to
be cheering him on. They
would all like to see
a stronger wind.

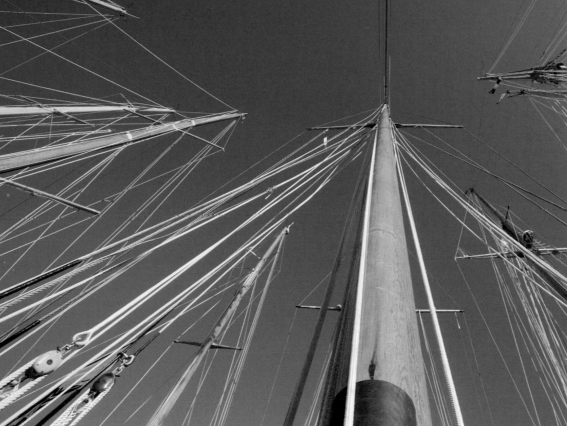

The Impact of a Renovation

As for the rest of *Altaïr*'s remodeling, the layout of the cabins remained the same, consisting of three guest staterooms connected to the two owner's staterooms. A bathroom and two heads opened into the gangway leading to a huge saloon. Fabric replaced the original pale blue morocco leather, and each step—varnishing, painting, and carpeting—was finished with special care. In particular, the eggshell blue oil paint used on the ceilings was exactly the same as the original. On deck, a few winches with bronze warping ends were discreetly incorporated into the rest of the fittings. After eighteen months of intensive work, on July 7, 1987, *Altaïr* finally launched to great acclaim. After a few sorties on the Solent to add the finishing touches, the schooner was ready for her inaugural cruise to the South Seas, the route for which she had been built.

The restoration story does not end here, however; the collector in Obrist still had a taste for more. Because the long months searching for perfection had been pure pleasure for him, he financed the research and restoration of other Fife designs and entrusted the talented Duncan Walker with leading the adventure. In September 1989, the Fairlie Restorations yard opened its doors to renovate *Tuiga*, which Obrist had discovered in Cyprus. It was then *Tuiga*'s sister ship, *Mariquita*'s, turn. While Obrist paid the boatyard's costs, these two projects also set the yard on its way to becoming self-supporting. Fairlie continues to operate independently, with restoration and new traditional constructions in its order books, all of them inspired by Fife.

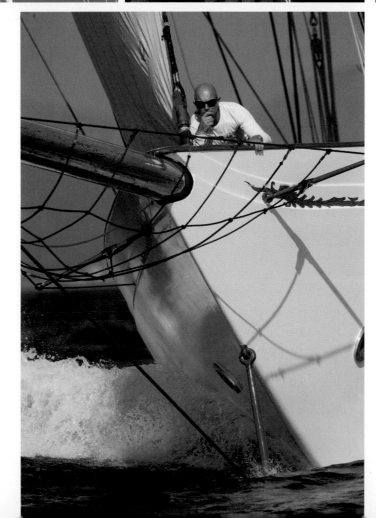

The restoration and maintenance of *Altaïr* over the years is exemplary of its type. Everything is polished to perfection.

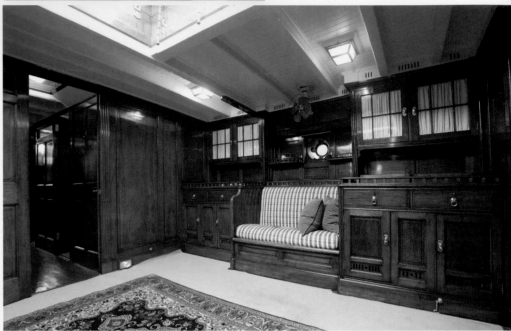

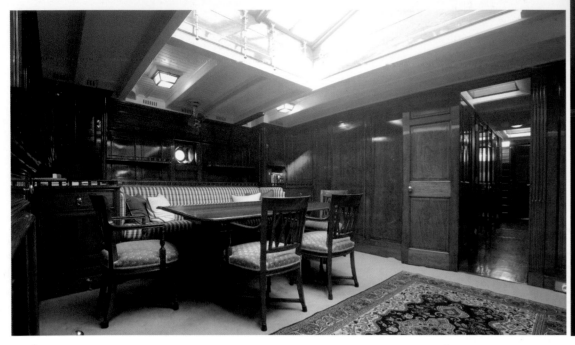

While speed always imposes new aesthetics, beauty can also be a factor of speed, as *Altaïr* proves every season. Yet there is another, less easily definable, element that radiates from the schooner. It is something that could be called the aura of a sailing ship. It is both invisible and incarnate, because on the surface nothing seems to change from one day to the next—everything on board is impeccable, regardless of the weather conditions, time of day, or location. Nothing is in the wrong place. Aboard it is as if time has stood still, as if the yacht was waiting for a special, particularly important visit. Or it might be felt in a maneuver, an arrival in port: nothing disturbs the smoothness, each movement performed in silence, among connoisseurs. Of course, some classic yachts like to linger for a week at Les Voiles de Saint-Tropez or the Royal Regattas in Cannes, but few are as capable as *Altaïr* of maintaining this air of perfection over time.

The rules that govern these gatherings of classic yachts in the Mediterranean naturally take into account the authenticity of the ships, and *Altaïr*'s achievements in regattas are the result of these years of rigor and care. The schooner is regularly overhauled every season, keeping her equipment in perfect working order and looking magnificent any time of year.

The saloon, gangway, period instruments in the wheel-house, and flag lockers are just a few of the details that are carefully studied and frequently copied in neoclassical yacht-building and in reconstructions of antique yachts.

Each stateroom washbasin and head bathtub is in period style.

· FEATURES ·

Name: ALTAIR
Architect: William Fife III
Builder: William Fife & Son, Fairlie
Rigging: gaff schooner
Type: cruiser
Launched: 1931
First owner: Guy H. MacCaw
Restoration: 1987
Boatyard (restoration): Southampton Yacht Services
Construction: composite, teak-edged
on steel ribs

Overall length: 131 feet 8 inches [39.52 m]
Deck length: 109 feet 4 inches [32.80 m]
Length at waterline: 79 feet [23.71 m]
Maximum beam: 20 feet 8 inches [6.20 m]
Draft: 14 feet [4.20 m]
Ballast: 62 tons
Displacement: 161 tons
Approximate sail area: 6,824 square feet [634 m²]
Engine: Gardner 200 CV

· DECK PLAN ·

PORT

ENGINE ACCESS DOGHOUSE MAINMAST MIZZENMAST BOWSPRIT

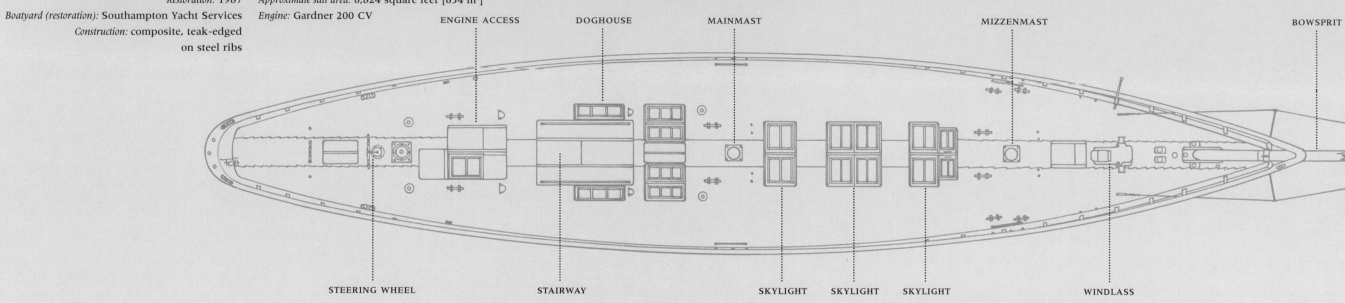

STEERING WHEEL STAIRWAY SKYLIGHT SKYLIGHT SKYLIGHT WINDLASS

STARBOARD

· LAYOUT ·

MACHINE ROOM STATEROOM HEAD STATEROOM SALOON GALLEY

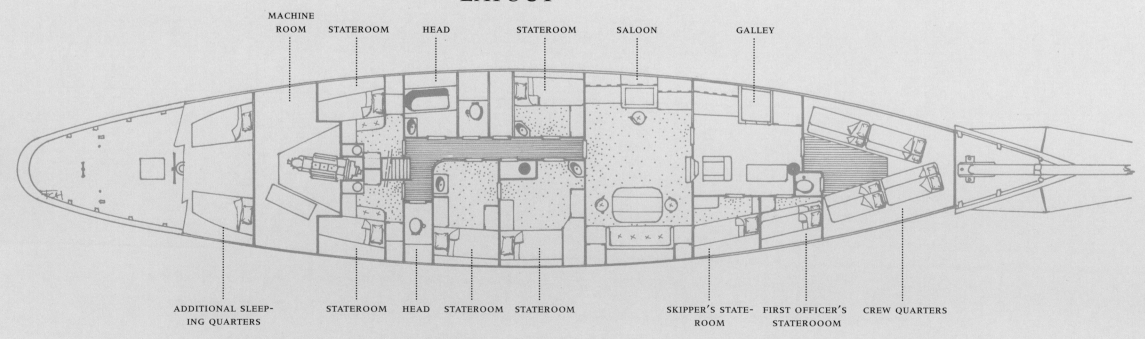

ADDITIONAL SLEEP-ING QUARTERS STATEROOM HEAD STATEROOM STATEROOM SKIPPER'S STATE-ROOM FIRST OFFICER'S STATEROOOM CREW QUARTERS

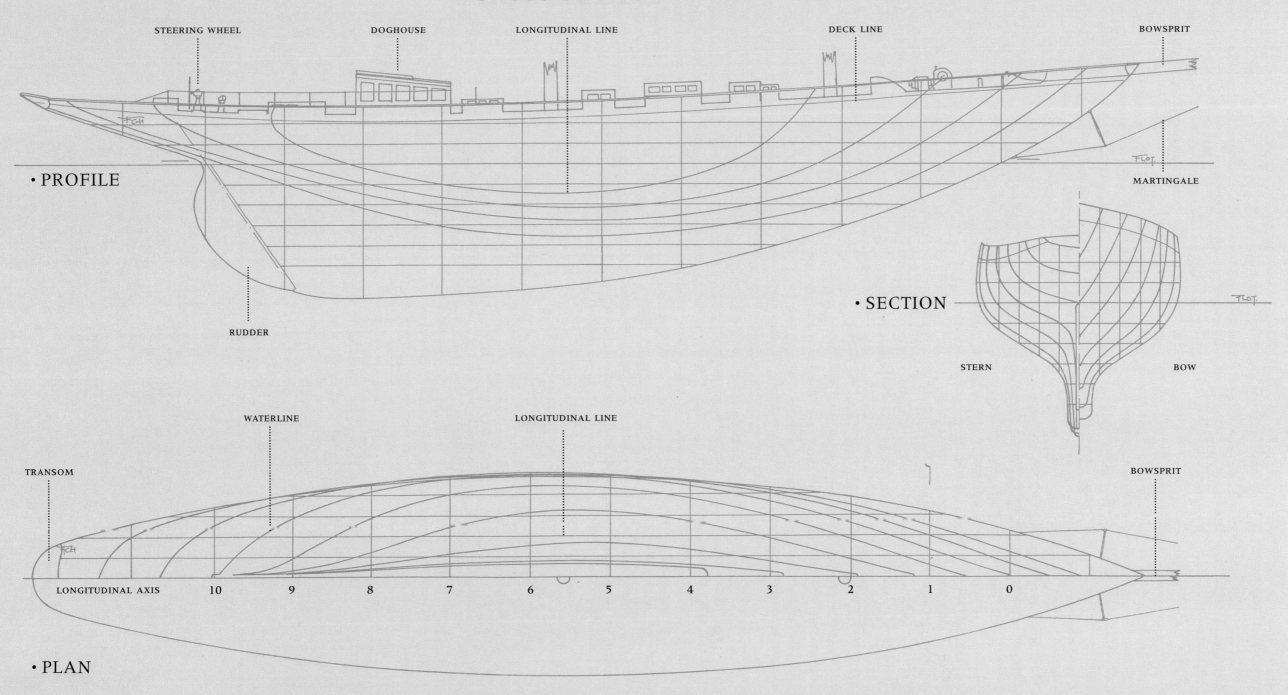

·CROSS SECTION

STEERING WHEEL DOGHOUSE LONGITUDINAL LINE DECK LINE BOWSPRIT

·PROFILE

MARTINGALE

RUDDER

·SECTION

STERN BOW

WATERLINE LONGITUDINAL LINE

TRANSOM BOWSPRIT

LONGITUDINAL AXIS 10 9 8 7 6 5 4 3 2 1 0

·PLAN

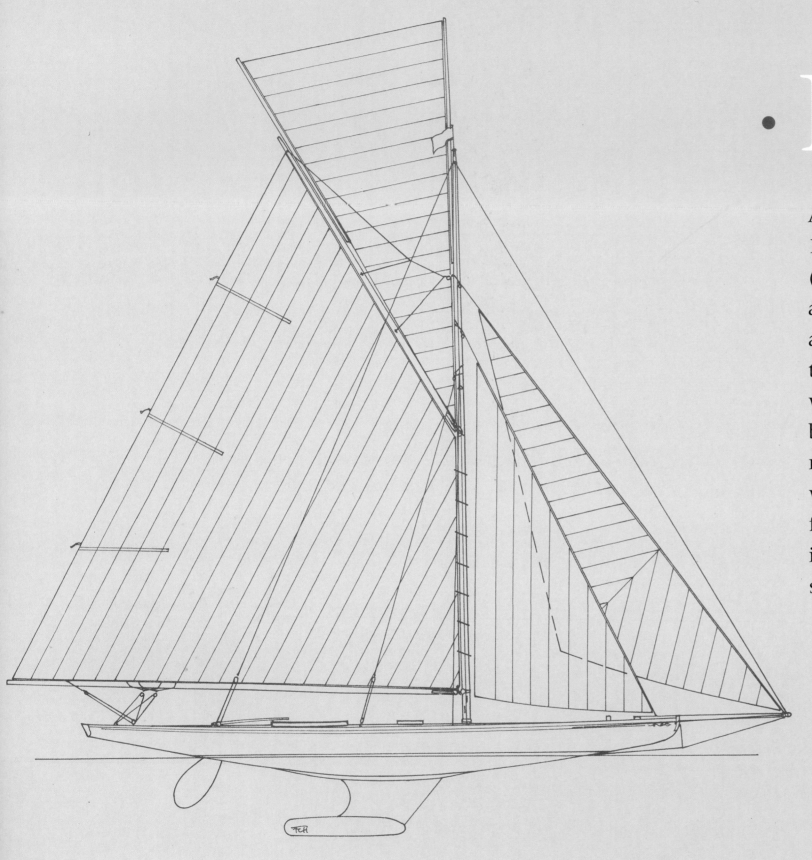

· Bona Fide ·

As the only gold medalist still afloat from the 1900 Olympic Games sailing event, this 45-foot (13.60-m) cutter, built in 1899, is evidence of an age in which creativity and audacity in naval architecture were the order of the day. She is also the last representative of the 1892 French Rule, with her flat sections, suspended rudder, and bulb keel, a magnificent example of light displacement. *Bona Fide* carved past classic yachts as if she were a tornado, and created a sensation when she first appeared on the circuit in 2003. The centenarian *Bona Fide* remains in fine form, and has the same feel afloat as a modern keelboat.

An image from the nineteenth or twentieth century? Nothing has changed. With her bulb keel underwater and streamline shape, this cutter has all the attributes of a modern yacht.

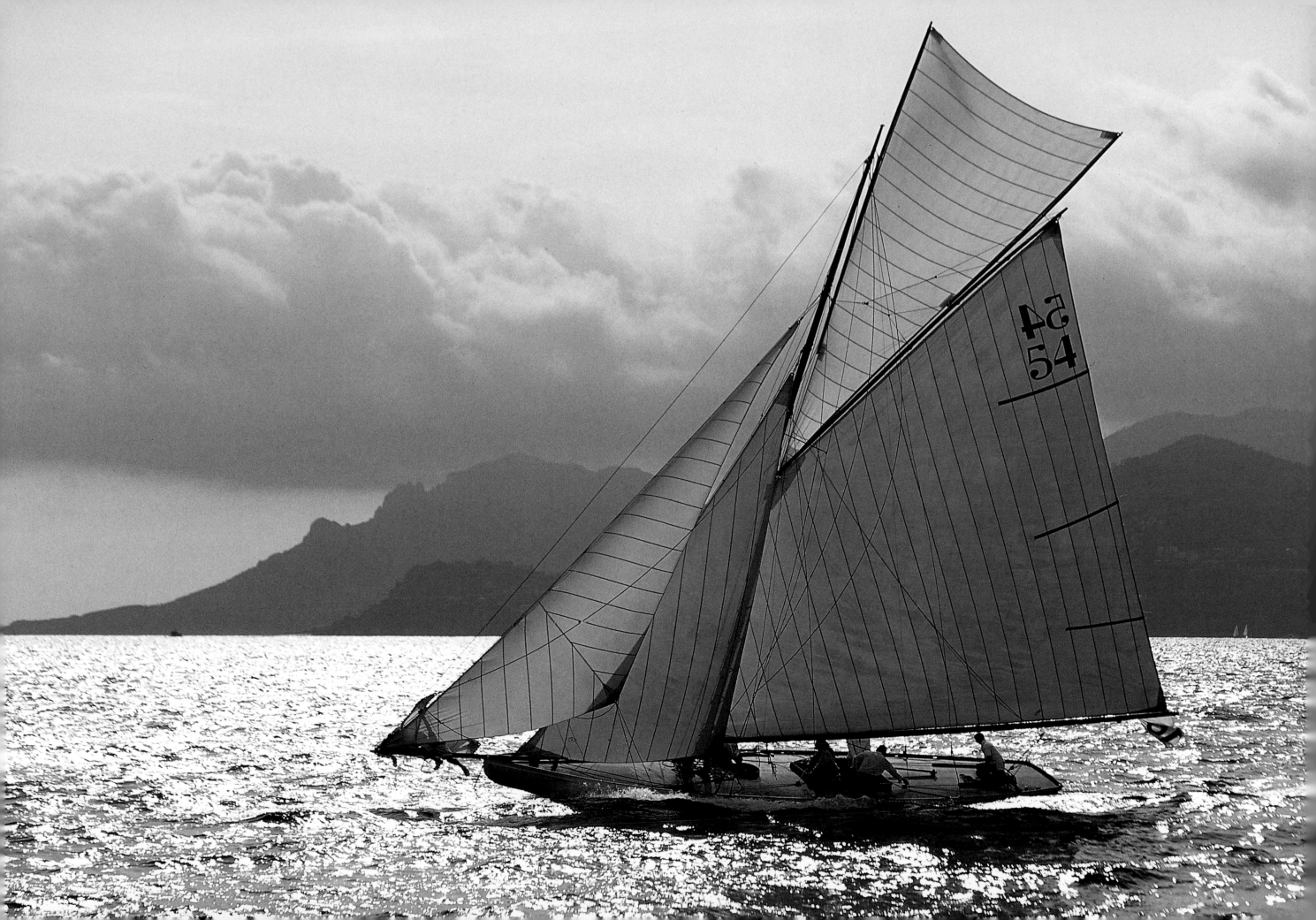

Amid the glistening varnish and gleaming brass of modern yachts, austere *Bona Fide* is quite hard to pick out of the quayside assembly. She was discovered not far from Milan by American architect Doug Peterson, who is responsible for building several America's class yachts, including two winners. At that time *Bona Fide* was owned by Giuseppe Giordano who had her restored by the famous naval boatyard at Argentario, Italy.

In September 1899, English yachtsman J. Howard Taylor commissioned architect and boatbuilder Charles Sibbick, based in Cowes, Isle of Wight, to build a five-ton, 45.33-foot (13-m) vessel of a design based on the 1892 French Rule known as "Godinet." He wanted to spend the next season sailing in the Mediterranean and on the Seine in Meulan, France, where regattas were being held to mark the Paris Exposition Universelle and, for the first time, the Olympic Games were holding sailing events. Construction was completed in late November 1899, and the cutter was sent by ship to Honfleur, Normandy, then loaded on a truck for dispatch to Nice.

She was a fairly small craft and named *Bona Fide* (1899), a Latin expression meaning "sincerely," or "in good faith," and a sort of diminutive that her owner gave her to distinguish her from the large cutter *Bona* (1897, plan by George L. Watson) he had acquired in early 1899 from Prince Louis of Savoy.

The Architect Who Liked Small Boats

At this time, Sibbick was a specialist in small racing yachts. Born in 1842, he started his career as a building contractor, spending his leisure time sailing on ships that he himself designed. His success in regattas made him consider switching to naval architecture and naval construction, and in 1888, he purchased the Albert Boatyards in Cowes.

Sibbick focused on small craft with light displacement, becoming a rival to Watson, Fife, J. M. Soper, Linton Hope, and A. E. Payne. He clearly achieved a measure of success, because in 1895 the future King George V commissioned the famous One-Rater *White Rose* from him on the tightest schedule imaginable: the vessel was designed and built in seven days! The French magazine *Le Yacht* explained at the time that, "Monsieur Sibbick has all of his lasts and woods ready in advance, his hulls are pre-cut, his spars are cut to approximately the right length, etc." His finest achievement is certainly *Norman* (1895), captained by J. Orr Ewing of Oxford, England, who, in a single season of fifty-six races, came in first fifty-one times and second twice. Ewing was an unconditional fan of Sibbick and owned two other Sibbick-designed yachts, *Prawn* (1895) and *Anglia* (1896).

With an architect of this caliber, it is hardly surprising that *Bona Fide* fully met Taylor's expectations.

However, the 1906 International Rule was the death knell for light racing yachts. Albert Boatyards tried to change its output to cruising yachts, but its last project, *Thalassa*, was completed by Fay in Southampton. During his twenty-four years as a professional boatbuilder, Sibbick produced three hundred vessels, from little Half-Raters to the 60-ton yawl *Ruth* (1902).

In January 1912, Sibbick disappeared while sailing off the coast of Cowes. The craft was soon found, but his body did not wash ashore until several days later.

A Gold Medal in the 1900 Olympic Games

In mid-February of 1900, in Toulon, France, *Bona Fide* inaugurated the Mediterranean season with a magnificent victory. She beat 20-ton *Esterel* (1897, plan by C. M. Chevreux) and the 18-ton *Laurea* (1899, plan by A. E. Payne) in real time. On the following day, she did the same in a strong mistral and overtook her direct competitor, *Emerald*, owned by H. W. Jefferson (1896, plan by A. E. Payne). *Bona Fide* raced constantly off Cannes, Monaco, and Nice from February 17 through April 21. Out of thirty-one starts, she only abandoned two races due to lack of wind or squalls and stormy seas. In the spring of 1900, she won fifteen victories and six second prizes.

To complete her program, the English vessel needed to compete in the Meulan regattas of the 1900 Olympic Games organized by the Cercle de la Voile de Paris (CVP) from May 20 to 27. She was transported by railroad, but got stuck at Bercy Station. Taylor did not get to the games until the second and last regatta, on May 25, 1900.

In a light breeze, *Bona Fide* scored a brilliant victory over eleven competitors including Frenchman Maurice Gufflet and his *Gitana* (1896, plan by J. Guédon) and American H. MacHenry and *Frimousse* (1894, plan by William Fife III).

R. William Martin, owner of *Pirouette* (1890, plan by E. H. Hamilton) that had been classed seventh, challenged the win, but the bid was rejected by the committee. True, the English had only competed in a single regatta, but their "good faith" was evident. The Olympic gold medal for the three-to-ten ton class was awarded to *Bona Fide*.

The Godinet Rule

Bona Fide was the last representative of the 1892 French Rule, the so-called Godinet Rule. This system of classification was supported and promoted by the French Yachting Union, and validated for seven years until 1900. It was the third largest French national formula adopted by numerous yacht clubs, in particular by the Swiss Société Nautique de Genève, and coincided with the development of fin-keels and bulb keels.

A proposal by Auguste Godinet (1853–1936), a naval architect from Lyon, France, resulted in a formula that consisted for the first time in the history of yachting of three fundamental elements: flotation length, the speed element; sail area, the motor that would produce speed; and the perimeter, the weight component, i.e., the brake, calculated by encircling the boat with a rope at the widest part. The Godinet Rule is then calculated by multiplying the perimeter by the square root of the sail area, and by the difference between

Opposite
Bona Fide (#54) and her crew appear determined to keep the larger *Lulworth* from passing. *Bona Fide's* crew's weight is in the middle of the boat to help reduce pitching. The young sailors on the bow of *Lulworth* are focused on the course ahead and are clearly enjoying the ride.

Page 26
Ever since *Bona Fide* was restored, it has been a challenge to calculate her handicap time for regattas.

Page 27
The yacht, crew, and sails all seem to be at rest as *Bona Fide* slips quietly downwind.

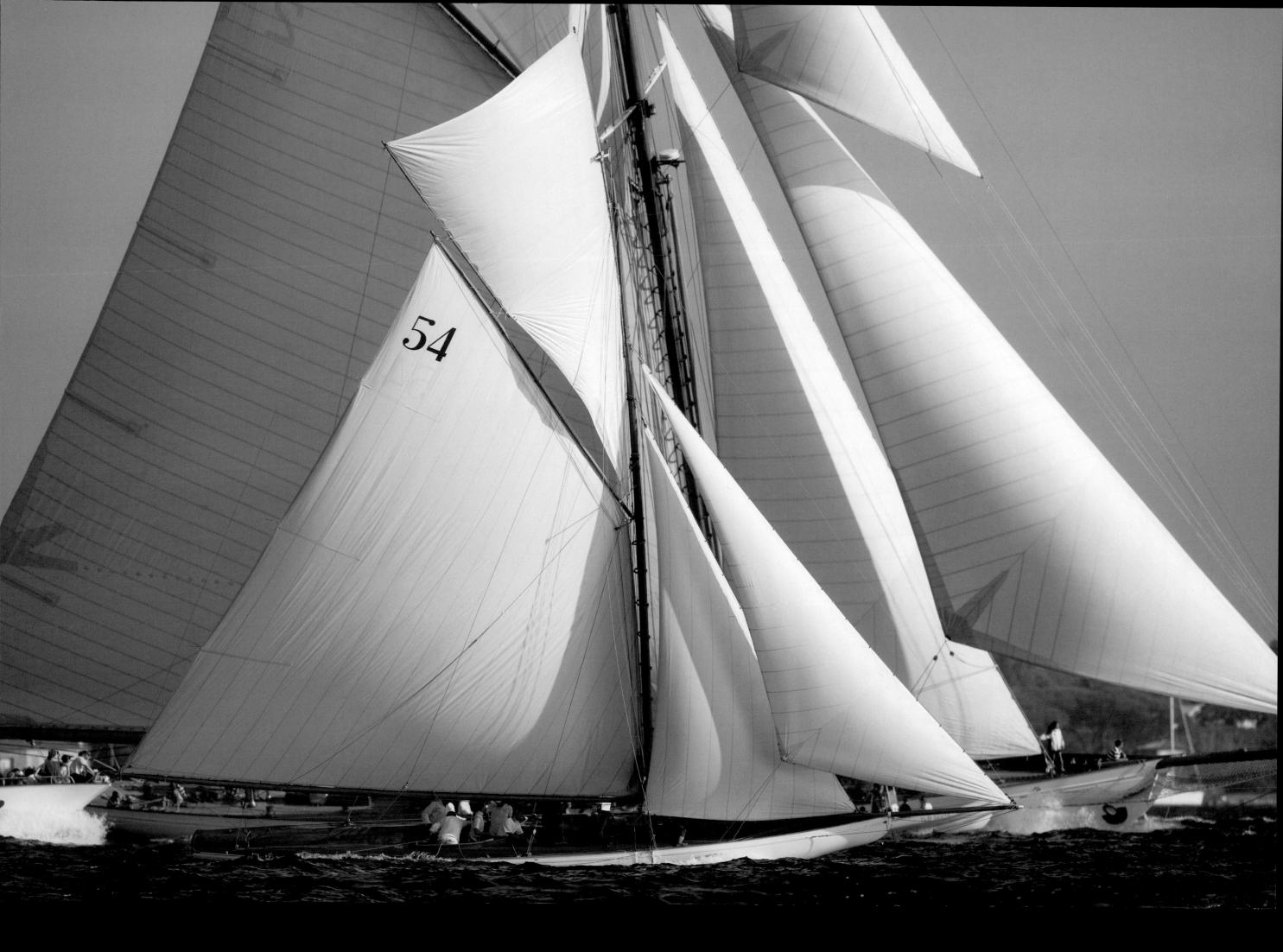

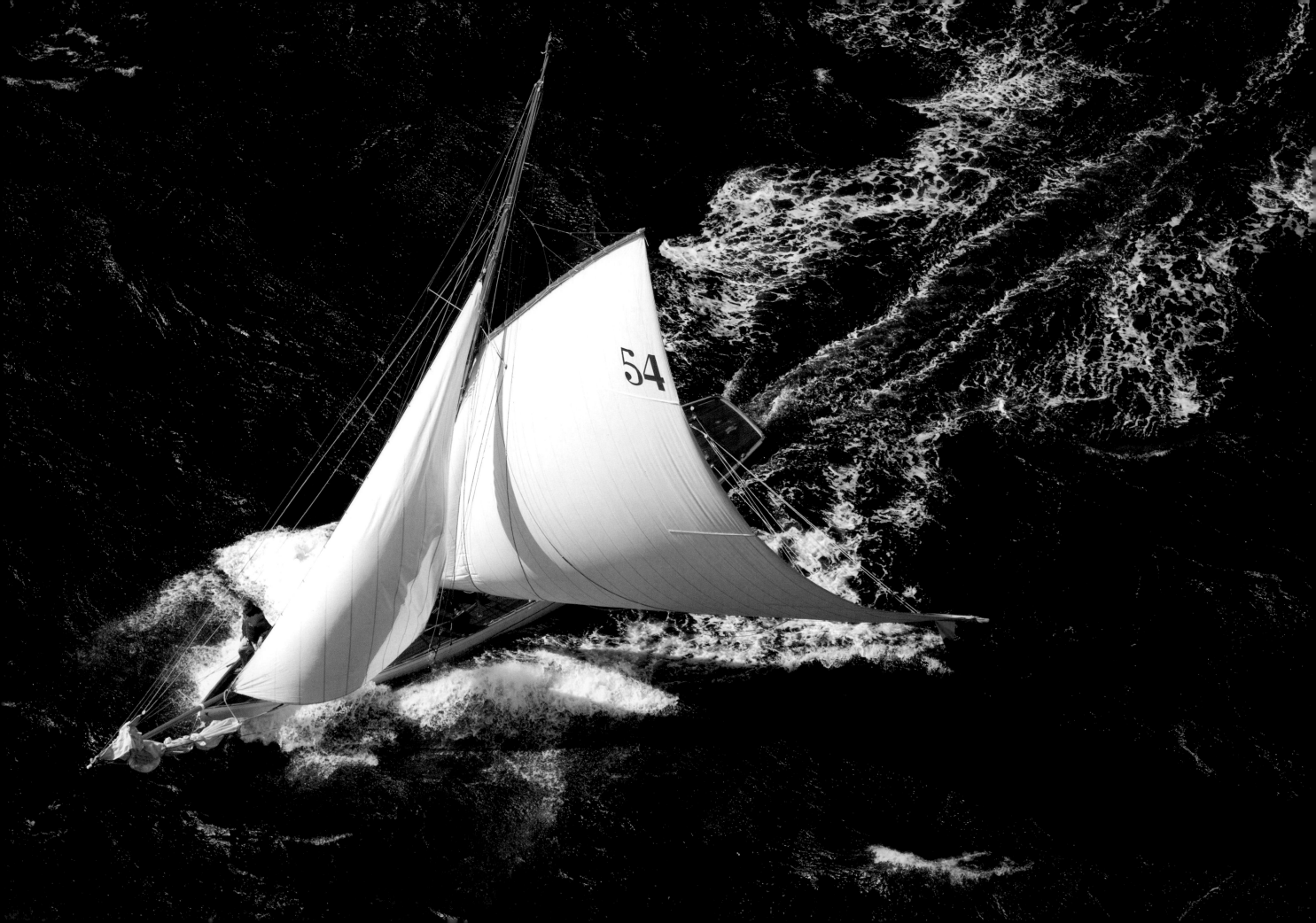

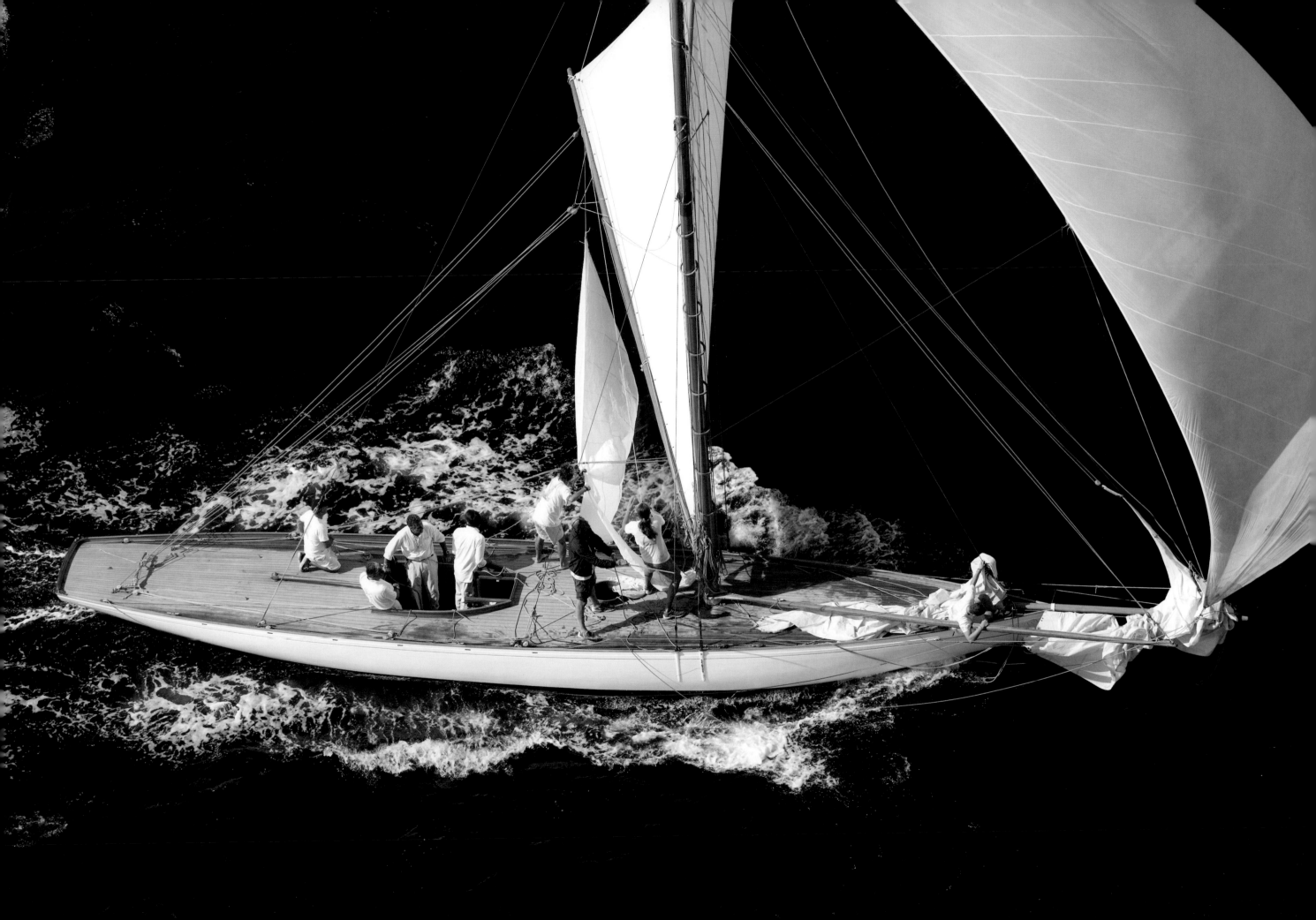

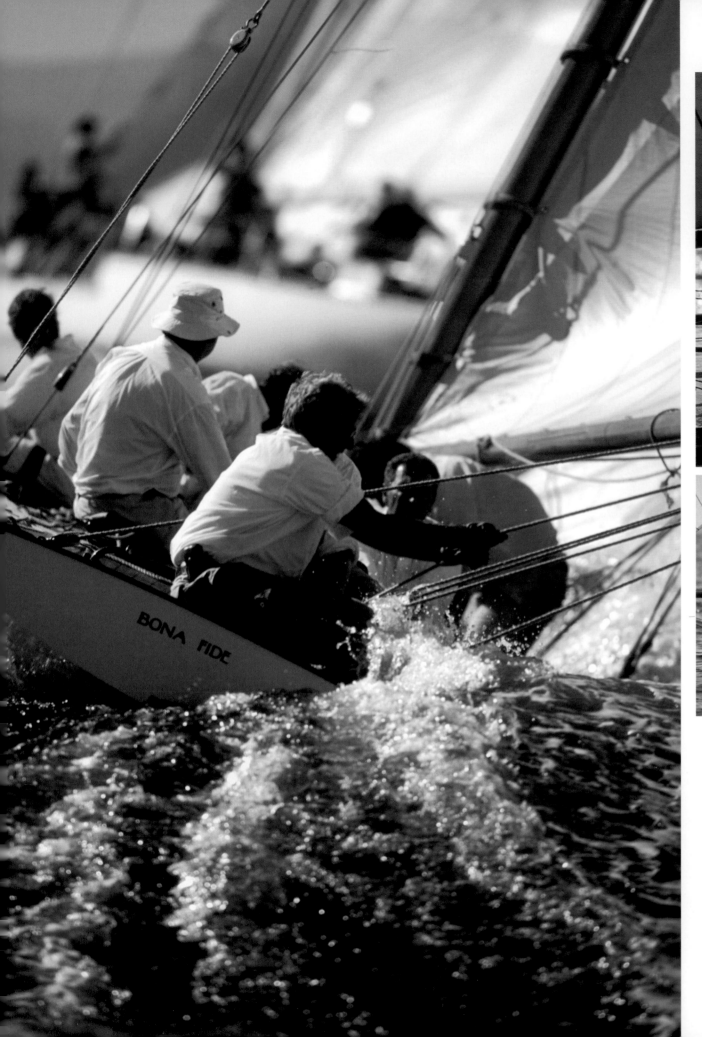

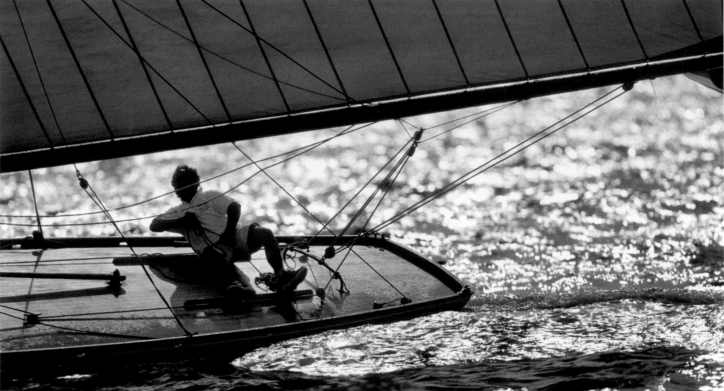

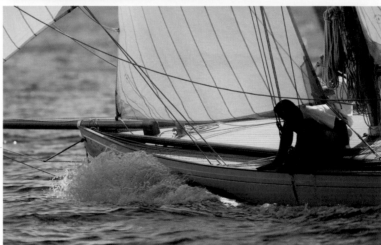

Bona Fide was built in 1899 and designed by Charles Sibbick. The sails are a handful for her burly crew in a stiff breeze.

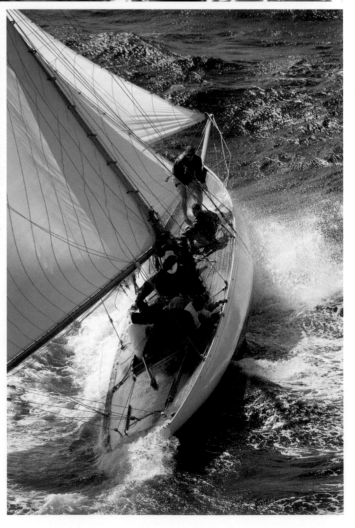

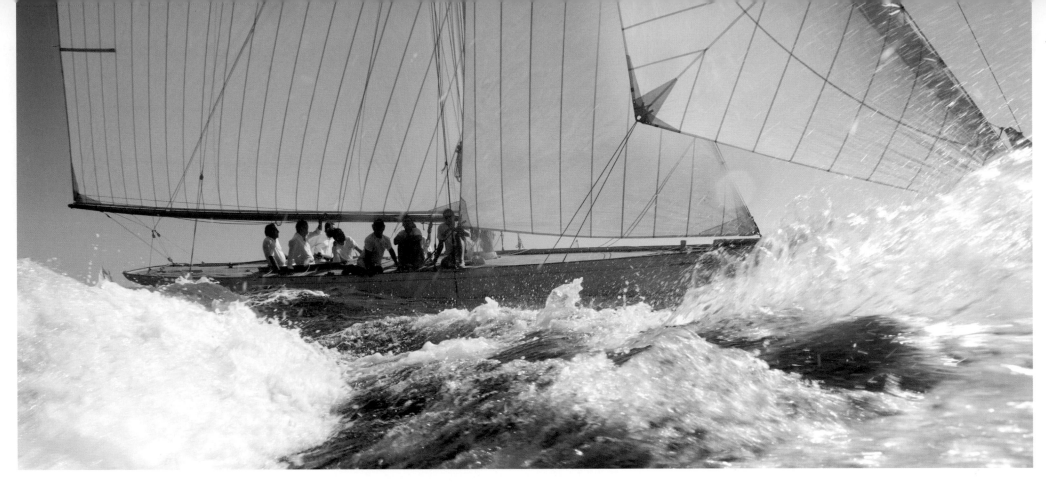

Ever since 1900, the year in which she won fifteen races on the Côte d'Azur, *Bona Fide* has been at home in the salt spray of the Mediterranean. A hundred years later, she still loves it.

the flotation length and a quarter of the perimeter, and then dividing everything by 130. The result is expressed in tons. If the sum of the forward and aft rakes is more than half the flotation length, the excess is added to the length in the calculation. This proportion gives the outline a very special look and explains the snub-nosed appearance of *Bona Fide* and her wide transom. The yachts are divided into eight series, ranging from less than half a ton to more than 40 tons.

On All Waters

Thanks to his success, Taylor had no difficulty selling *Bona Fide* at the end of the 1900 season to Italian Giuseppe Brambilla, member of the Regio Yacht Club Italiano and resident of the Villa Sucota on Lake Como. *Bona Fide* joined *Spindrift*, a dinghy built by Hope in 1895. Brambilla planned to spend the following year racing in the Mediterranean, and to improve his chances, he sent the yacht to the boatyard to reduce the balance by four inches (10 cm) and increase the area of sail by extending the boom. However, these modifications penalized the yacht in compensated time, and she did not win the expected number of trophies.

Brambilla sailed for around fifteen years mainly on Lake Como. His nephew, Giovanni Lanza di Mazzarino, took over during the interwar period. In 1937, *Bona Fide* was sent to the Taroni boatyard beside Lake Maggiore, from which she did not emerge until 1962, when the Pellegrini brothers brought her back to Lake Como where she was Marconi-rigged with a large triangular sail. Three years later, *Bona Fide* was sold to Gianluigi Gini.

In 1993, the yacht was abandoned in the Dàlo boatyard, near Como, and it is here that Peterson came across her in 1999 while he was working on the plans for the last *Prada* for the America's Cup to be held Auckland, New Zealand. When what was left of *Bona Fide* reached the Argentario naval ship-

yard, manager Federico Nardi wondered whether it might simply be easier to rebuild her. But from ethical considerations, and especially because the plans no longer existed, the choice was made to restore her instead. They suspended her hull on the beams of the framework and, with the help of weights, bent the whole structure back into its original shape. Boatyard architect Dafne Vecchi then more or less restored the hull to its original form. In order to design the deck plan, they had to enlarge contemporary photographs, since little of the original deck remained, just a few cleats and eyebolt. Fortunately, the Como boatyard had kept the original rudder, although it was particularly badly rusted.

Almost all of the mahogany clapboard needed replacing, as did 192 of her 200 ribs. They replaced the crossbeams and deck entirely and covered this in bent pitch pine around 3 inches (7 cm) wide and 1 inch (2.3 cm) thick. The deck had a cockpit for the helmsman and running tackle that governs the reel width, and there was a manhole behind the mast from which a crew member could adjust the jib. A new bronze tiller was made and spruce rigging was installed. Beppe Zaoli, the master sailmaker in San Remo, Italy, finally cut a superb set of Dacron sails, measuring nearly 1,550 square feet (144 m^2) when one adds up a mainsail, fore-topmast staysail, jib, flying jib, and large topsail, for a displacement of 11.4 tons. After she had been worked over for eight months, the yacht finally launched on June 19, 2003.

Ninety-five-year-old Olin J. Stephens, who had designed more America's Cup winners than anyone else, commented at the Royal Regattas in Cannes, France, that year: "I steered *Bona Fide* when she was launched in June. She responds to the slightest breath of air, and she gets off to a flying start. One can feel her accelerations." Clearly, she is a fine yacht.

· FEATURES ·

Name: Bona Fide
Architect: Charles Sibbick
Builder: C. Sibbick & Co., Cowes, England
Rigging: gaff cutter
Type: five-tonner
Launched: November 1899
First owner: J. Howard Taylor
Restoration: 2003
Boatyard (restoration): Argentario naval boatyard
Construction: mahogany planking on curved pitch-pine ribs

Overall length: 53 feet 9 inches [16.12 m]
Deck length: 45 feet 4 inches [13.60 m]
Length at waterline: 29 feet 2 inches [8.90 m]
Maximum beam: 8 feet 5 inches [2.53 m]
Draft: 6 feet 2 inches [1.86 m]
Ballast: 2.35 tons
Displacement: 11.4 tons
Approximate sail area: 1,550 square feet [144 m²]

· DECK PLAN

PORT

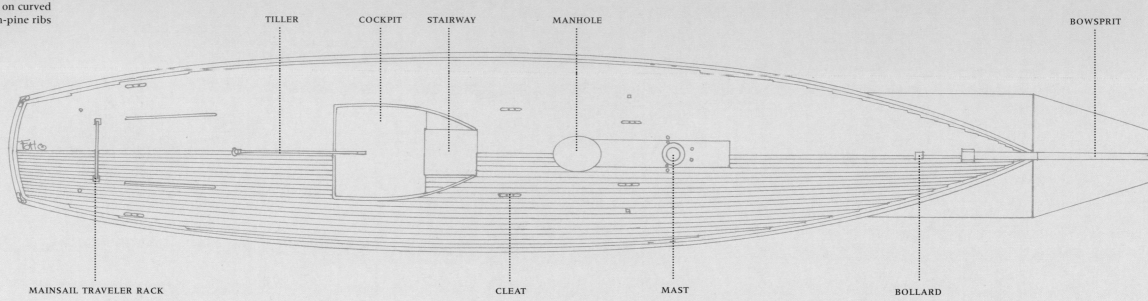

TILLER COCKPIT STAIRWAY MANHOLE BOWSPRIT

MAINSAIL TRAVELER RACK CLEAT MAST BOLLARD

STARBOARD

· LAYOUT

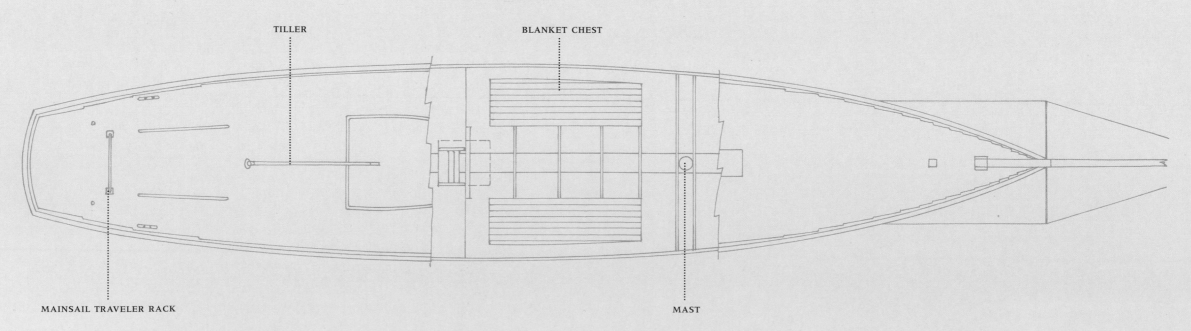

TILLER BLANKET CHEST

MAINSAIL TRAVELER RACK MAST

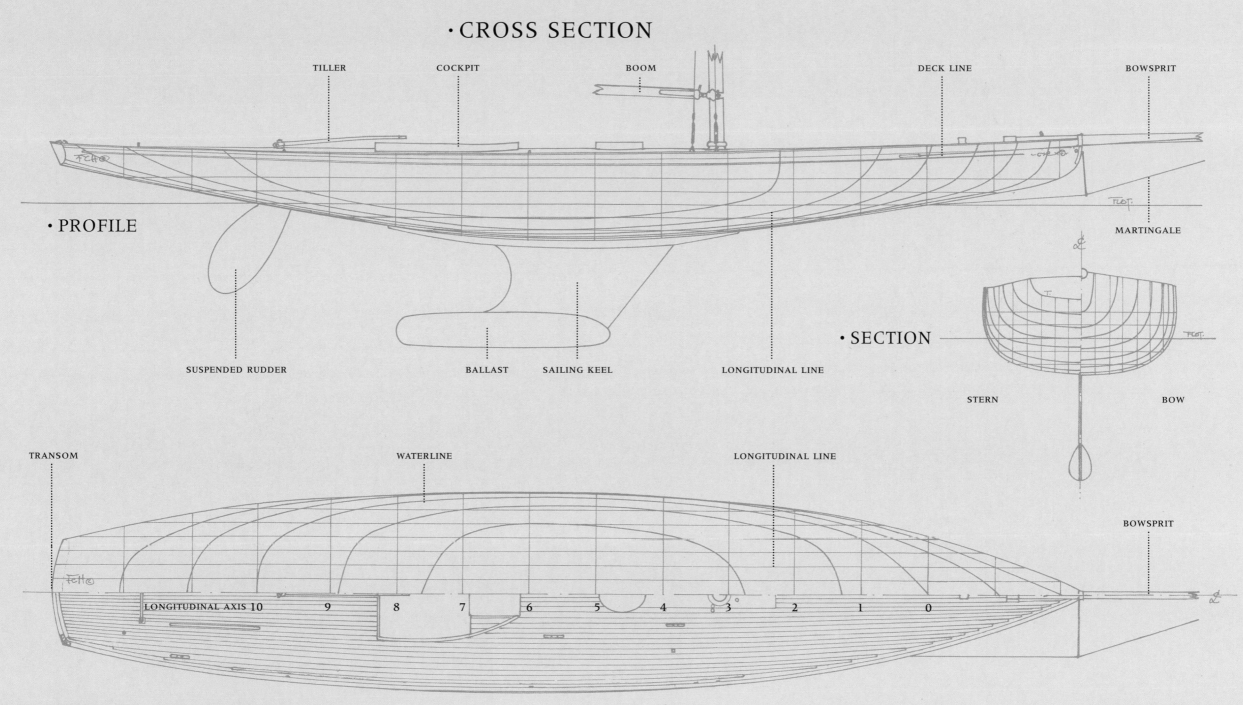

·CROSS SECTION

TILLER COCKPIT BOOM DECK LINE BOWSPRIT

· PROFILE

MARTINGALE

SUSPENDED RUDDER BALLAST SAILING KEEL LONGITUDINAL LINE

·SECTION

STERN BOW

TRANSOM WATERLINE LONGITUDINAL LINE

BOWSPRIT

LONGITUDINAL AXIS 10 9 8 7 6 5 4 3 2 1 0

· PLAN

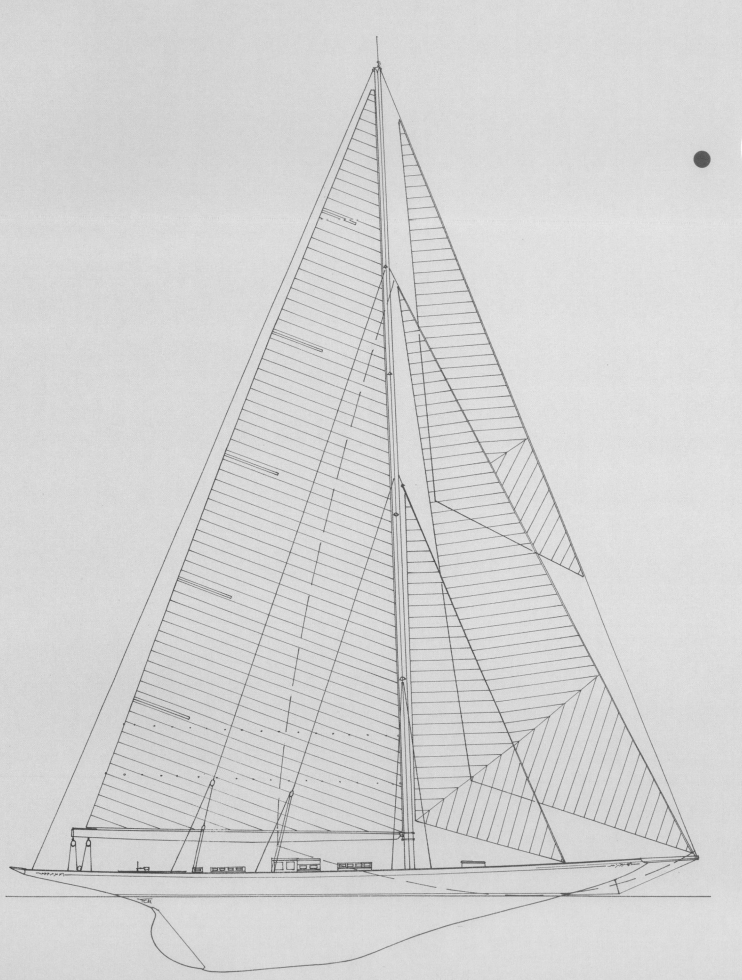

• Cambria •

There is good reason that Fife yachts are so sought after. It is not the gilded twisting dragon, so coveted by yachtsmen, that sparks the demand but it is the superb lines of these vessels. The elegance of *Cambria*, the 23-meter yacht built by Fife in 1928, is beyond a doubt. Yet she has not had as many victories as her owners had hoped. Maybe this is proof that it is not always enough to be the most beautiful.

The 23-meter *Cambria* has sailed with the J-class during her modern era. Notice the wet mid decks indicating that water is splashing over the rail on both tacks. The stern and foredeck are dry. Every crew member spread out along the deck has an assignment.

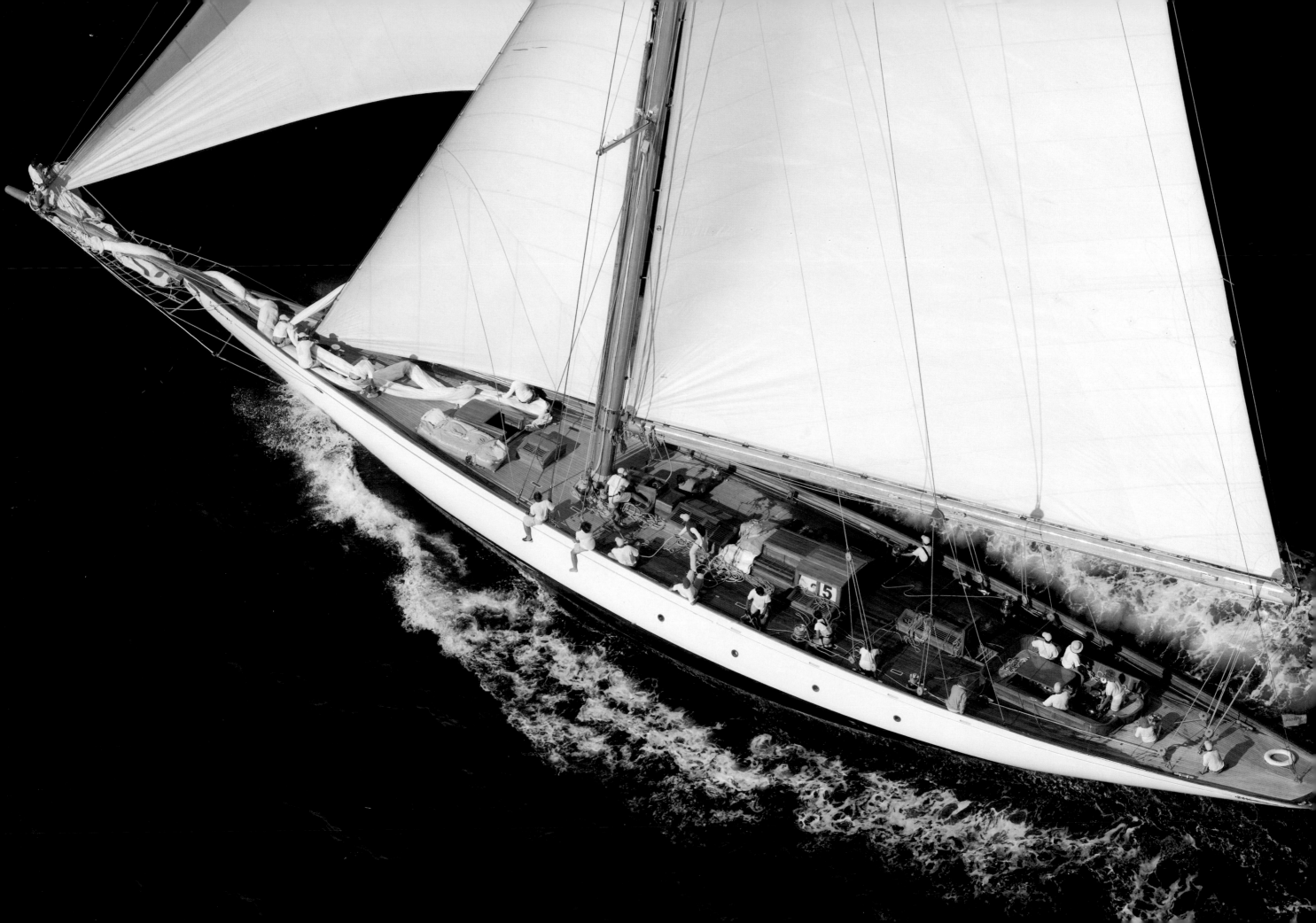

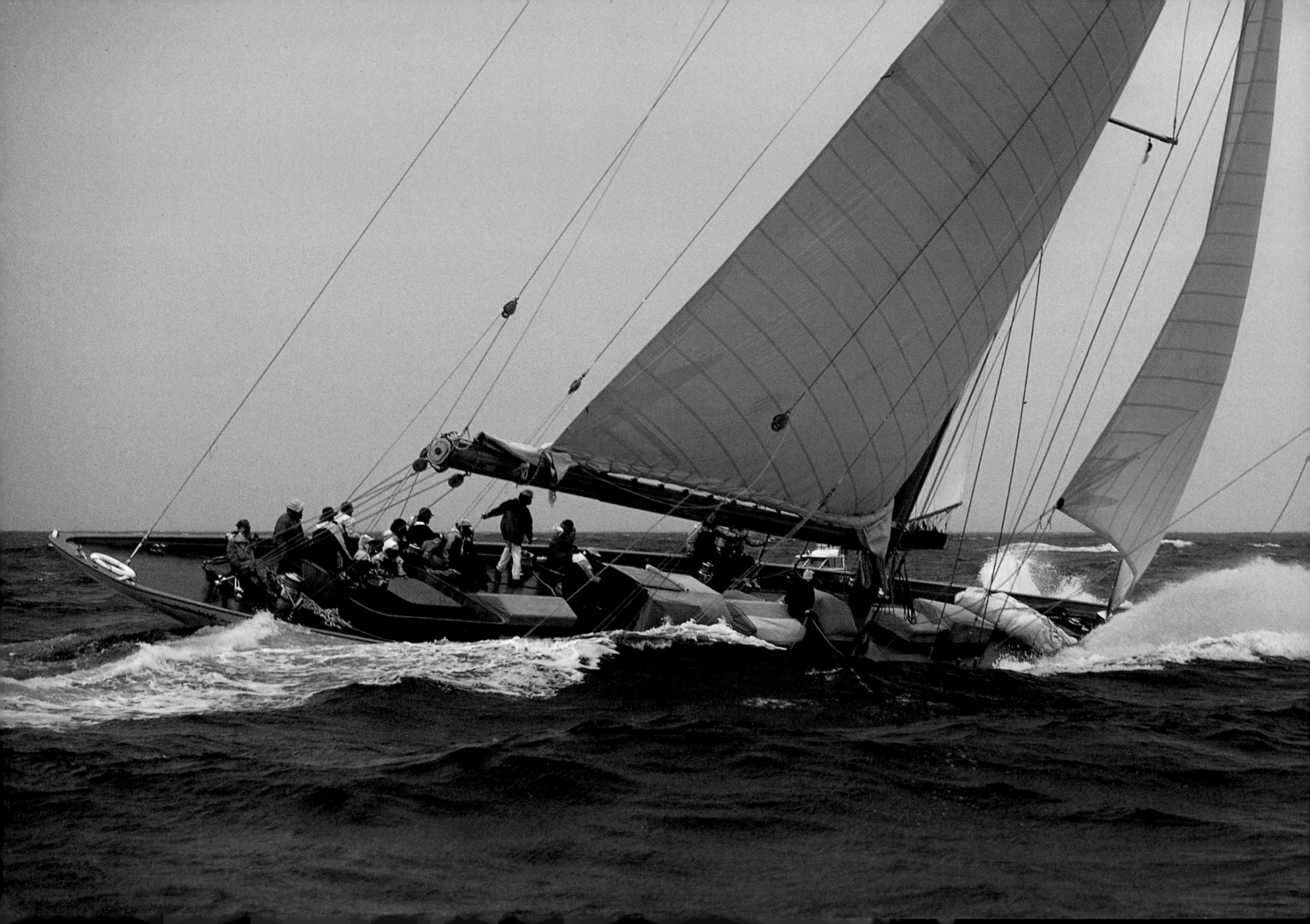

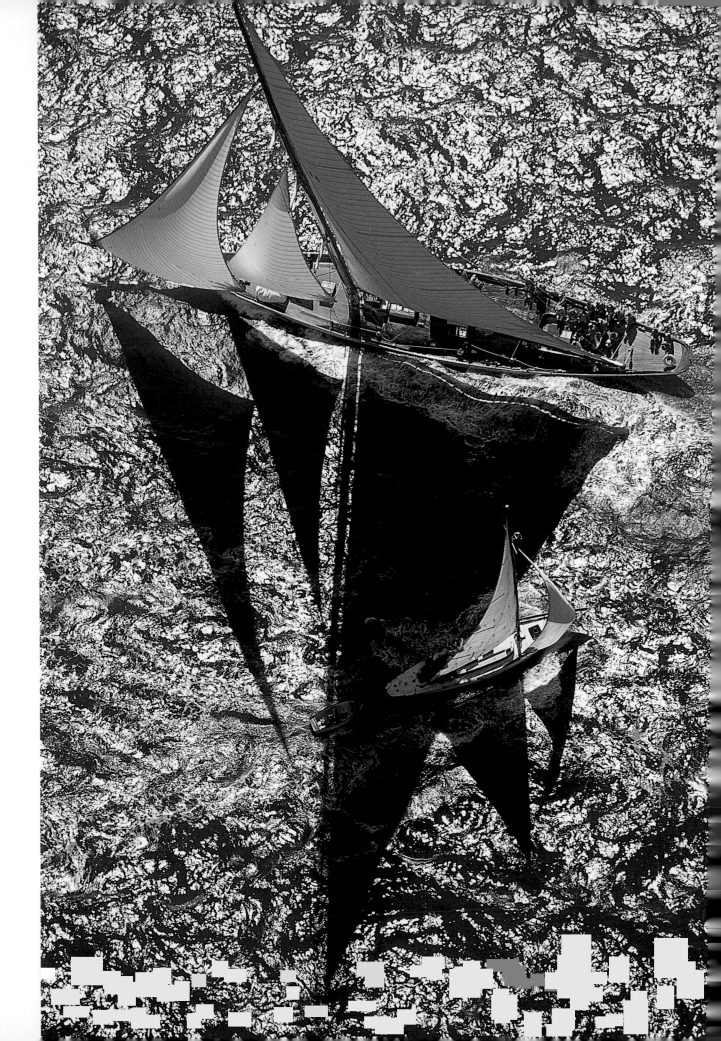

*C*ambria was originally commissioned by Sir William Ewart Berry (1879–1954), a British press baron who made his fortune during World War I with the magazine *The War Illustrated*. He also owned *Yachting World*, whose editor in chief was none other than the famous Major Brooke Heckstall-Smith. The articles written by Heckstall-Smith, a chronicler and author of reference works who was nicknamed "Bookstall" by his friends, influenced Berry's decision to build this yacht. Berry even allowed Heckstall-Smith to steer her during her first regatta, the Royal Harwich, when he had heard that *Katoura*, the first J-class recently built in the United States and the same size as the English class *Cambria* but with a hull length of 120 feet (36 m), was going to be racing in Europe for the season.

For Berry, 1928 was decisive. He acquired *The Daily Telegraph* newspaper as well as the very new and modern *Cambria*. He even secretly envisioned preparing a challenge for the America's Cup, but in 1928 and 1929, out of respect for Sir Thomas Lipton, the big name in Big Class yachting, he tabled the project. Later, when airplane designer Tom Sopwith embarked on a bid for the Cup in 1934, Berry, who gained the title of Lord Camrose in 1929, announced that he was ready to enter a competitor as well.

The Big Boats of 1928

In yachting, however, it is not enough to own a great yacht—talent, perseverance, and luck are just as important. Heckstall-Smith was convinced that the class had a great future, and his views were reinforced by the advent of two more 23-meter class yachts: *Astra*, owned by Sir Mortimer Singer (1863–1929)—son of the inventor of the sewing machine and himself an aviation pioneer—and designed by Charles E. Nicholson and launched at Gosport, England, on April 21, 1928; and *Cambria*, a William Fife III and Robert Balderston Fife design, launched at Fairlie, Scotland, only ten days later. These two great yachts made 1928 a really exciting season—it had been a long time since so many tall ships competed against one another.

Of course, there was *Britannia*, the cutter owned by King George V, built in 1893 by D. and W. Henderson on the Clyde for Edward, Prince of Wales, the future Edward VII, and designed by George L. Watson. To reduce construction costs, the boatyard worked on the unsuccessful America's Cup challenger, *Valkyrie II*, owned by Lord Dunraven, at the same time. In 1926, Fife modified *Britannia*'s rigging and sail plan once again, having already been revamped in 1900, 1910, and 1920. Like the large cutters in the United States that had been modified after 1899, *Britannia* was fitted out with a Marconi rig. In Marconi and Bermuda rigging, the topmast is enclosed within the mainmast, and the boom is shortened, creating a taller, narrower sail profile. *Britannia* was a powerful racer and won 187 first places and sixteen prizes in her lifetime, including eight wins out of twenty-four races during the 1927 season.

Westward, the famous steel-hulled schooner designed in 1910 by Nathanael Herreshoff, is known the world round. She was owned at one stage by Thomas B. Davis, a shipping magnate originally from South Africa. He had

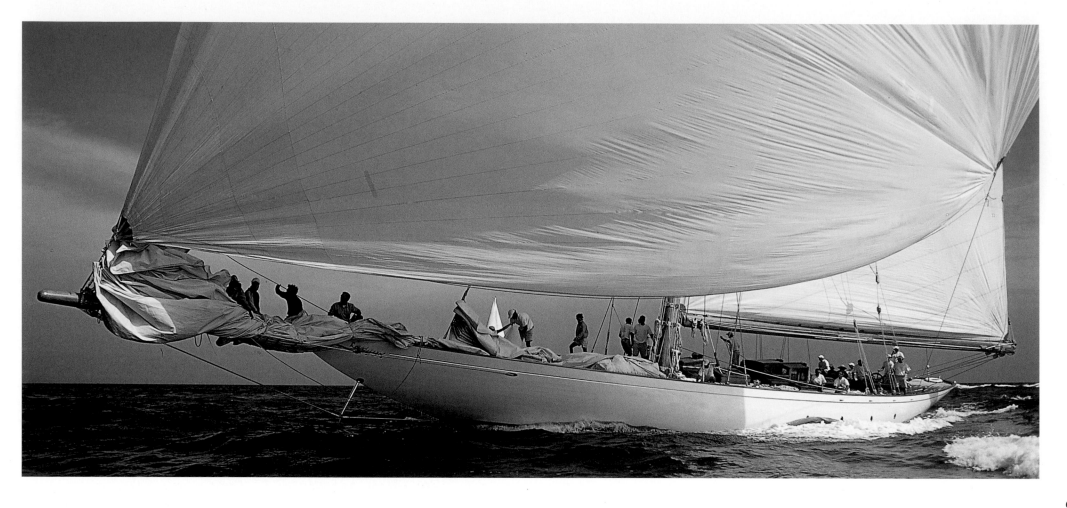

moved to the British Isles and made his home in Jersey in the British Channel Islands, which became the yacht's home port. Dutchman Ed Kastelein so admired *Westward* that he built a sister ship for her in 2000, *Eleonora*.

Other yachts in the Big Class included *Lulworth*, formerly *Terpsichore*. This large cutter was designed by Herbert W. White for Richard H. Lee and built in 1920 by White Brothers in Southampton with a hope to relaunch the Big Class after World War I, a venture encouraged by King George V. After *Terpsichore*'s owner died in 1923, the new owner, Sir Herbert Weld-Blundell, renamed her *Lulworth*, after his home, Lulworth Castle in Dorset, England, and under this name she won the King's Cup in 1925. For the next two years, Singer was her delighted owner, and in 1925 and 1926, *Lulworth* largely dominated the Big Class racers. Singer then sold her to banker Alexander Allan Paton, so he could build a new yacht, *Astra*. Paton, a newcomer to yachting, lavished much care on *Lulworth* to ready her for the following season's racing.

White Heather, the oldest of the "23-meters," was the second ship of that name and launched on April 16, 1907, at the Fife & Son shipyard in Fairlie on behalf of Myles B. Kennedy. She was the second 23-meter class built. The first, *Brynhild II*, had been named at the Camper & Nicholsons boatyard in Gosport only two days earlier on behalf of Sir James Pender (1841–1927), the man responsible for laying telephone cables across the Atlantic Ocean. Unfortunately, *Brynhild II* sank off Harwich in 1910 after her mast broke and the hull was holed by its foot. In 1920, Sir Charles Carrick Allom (1865–1947),

the famous architect and airplane designer, restored *White Heather*, giving her a Marconi rig in 1921. She had her heyday in 1924, winning seven firsts and eight seconds out of nineteen races. In the 1925 regattas, Allom sold the vessel to Lord Waring (1860–1940), an industrialist who had been responsible for assembling U.S.-made Handley-Page airplanes in Great Britain during the war. Allom converted the cutter into a J-class in 1931, re-rigging her as a Bermudan cutter without a topsail. The work was done by Nicholson, who had become a specialist in these new rigs. *White Heather* was then acquired by William L. Stephenson, owner of a chain of stores, but she was demolished at the end of the following year and her ballast was melted down to be used in a new J-class vessel, *Velsheda*, launched in Gosport, England, on April 17, 1933.

Lipton's ships dominated the Solent as they did the bay of New York since he had launched his first America's Cup challenger in 1895. Lipton was on his fifth *Shamrock* in 1928. He was particularly fond of his 23-meter yacht designed by William Fife II and launched on April 17, 1908 at Fairlie. Even though he was the winner of the most races in 1925, whenever he was overtaken Lipton would say with a smile, "I'll be back again." His perseverance was legendary and probably the reason for his business success.

Four days after *Shamrock* was launched—April clearly seemed to be the month for launching yachts—Singer's *Astra* launched at Camper & Nicholsons, though she would end her run during the following season. She was sold to Sir Howard Frank, a property developer, then to Hugh F. Paul, a brewer. Nicholson converted her to a J-class in 1931.

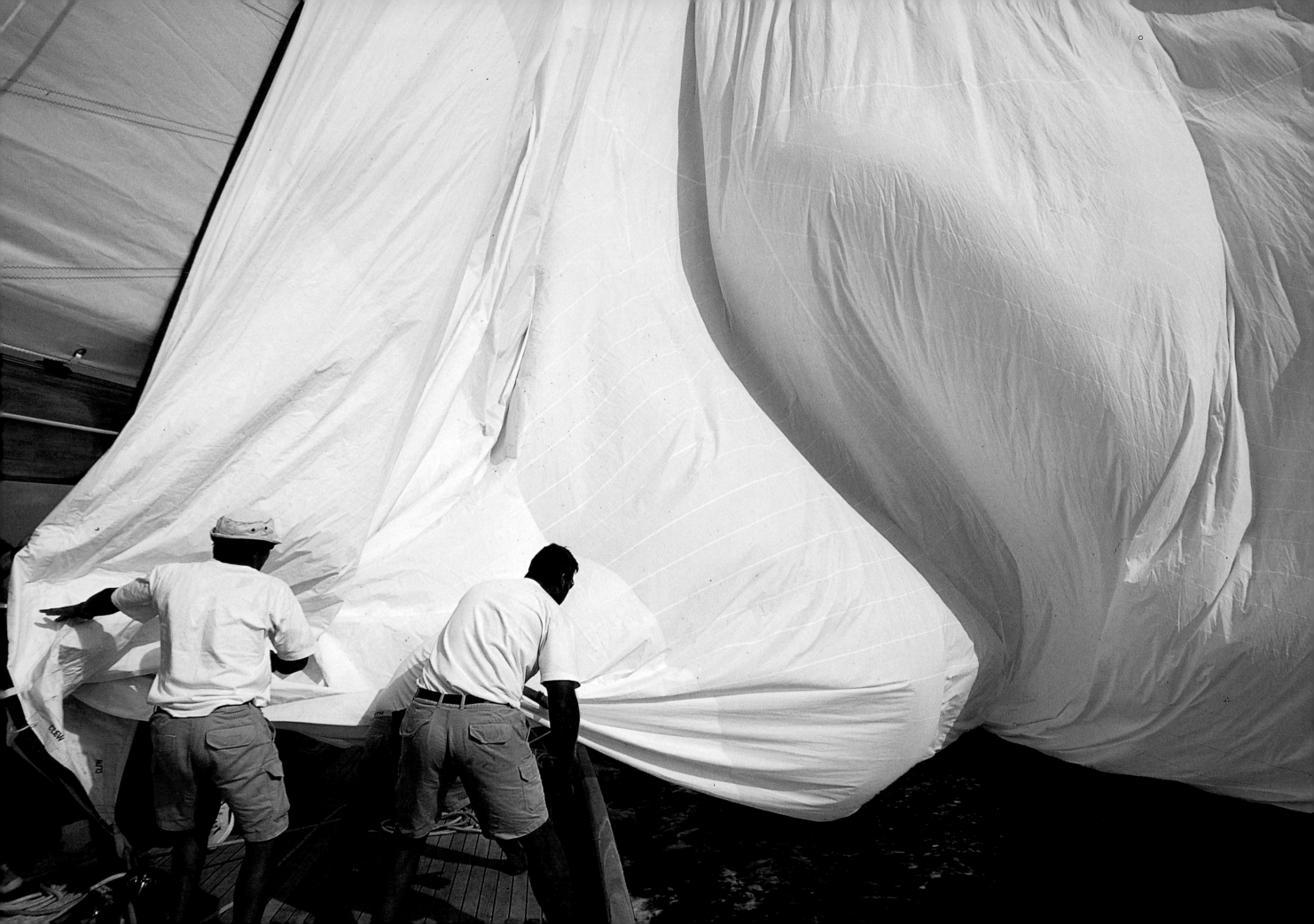

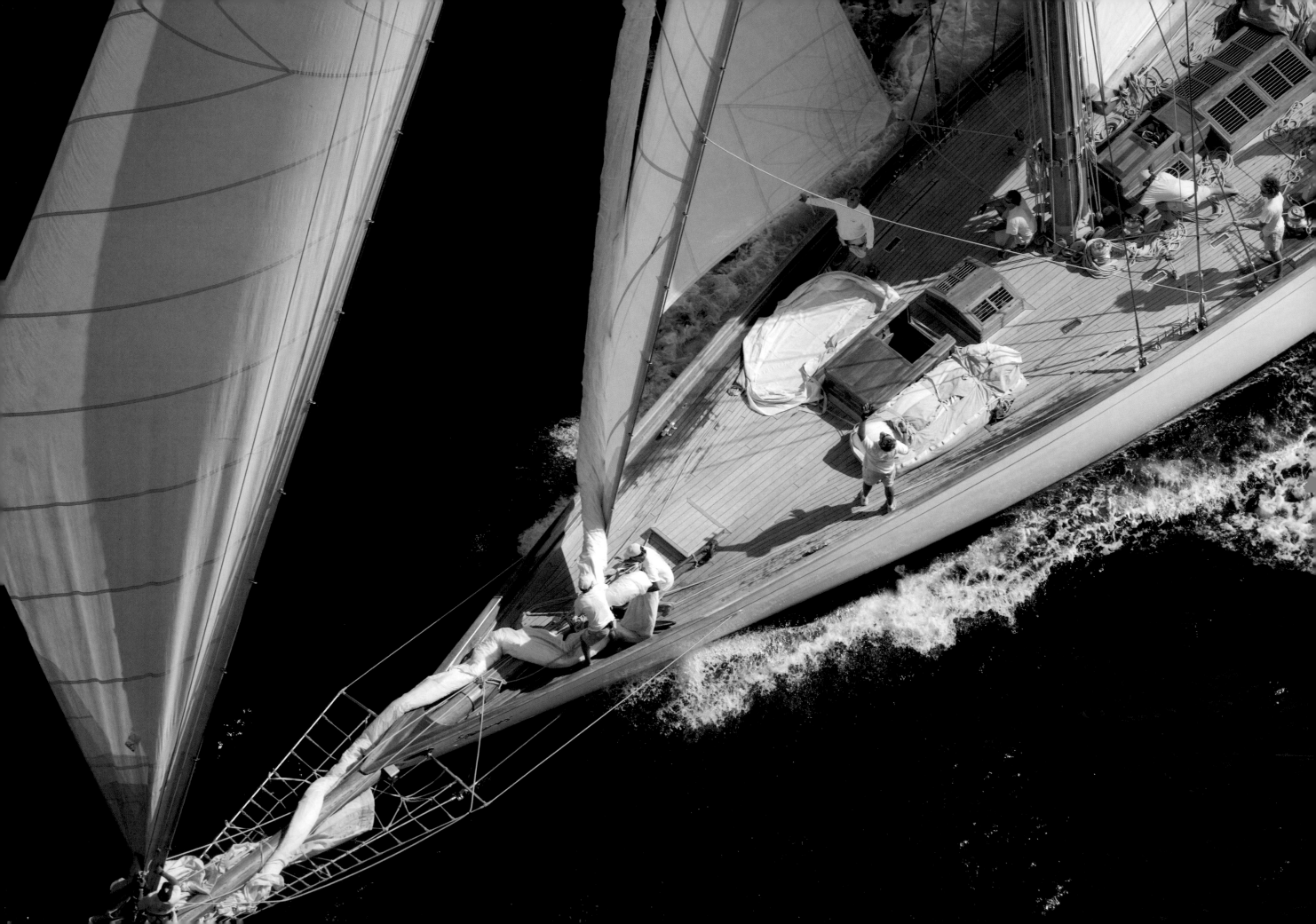

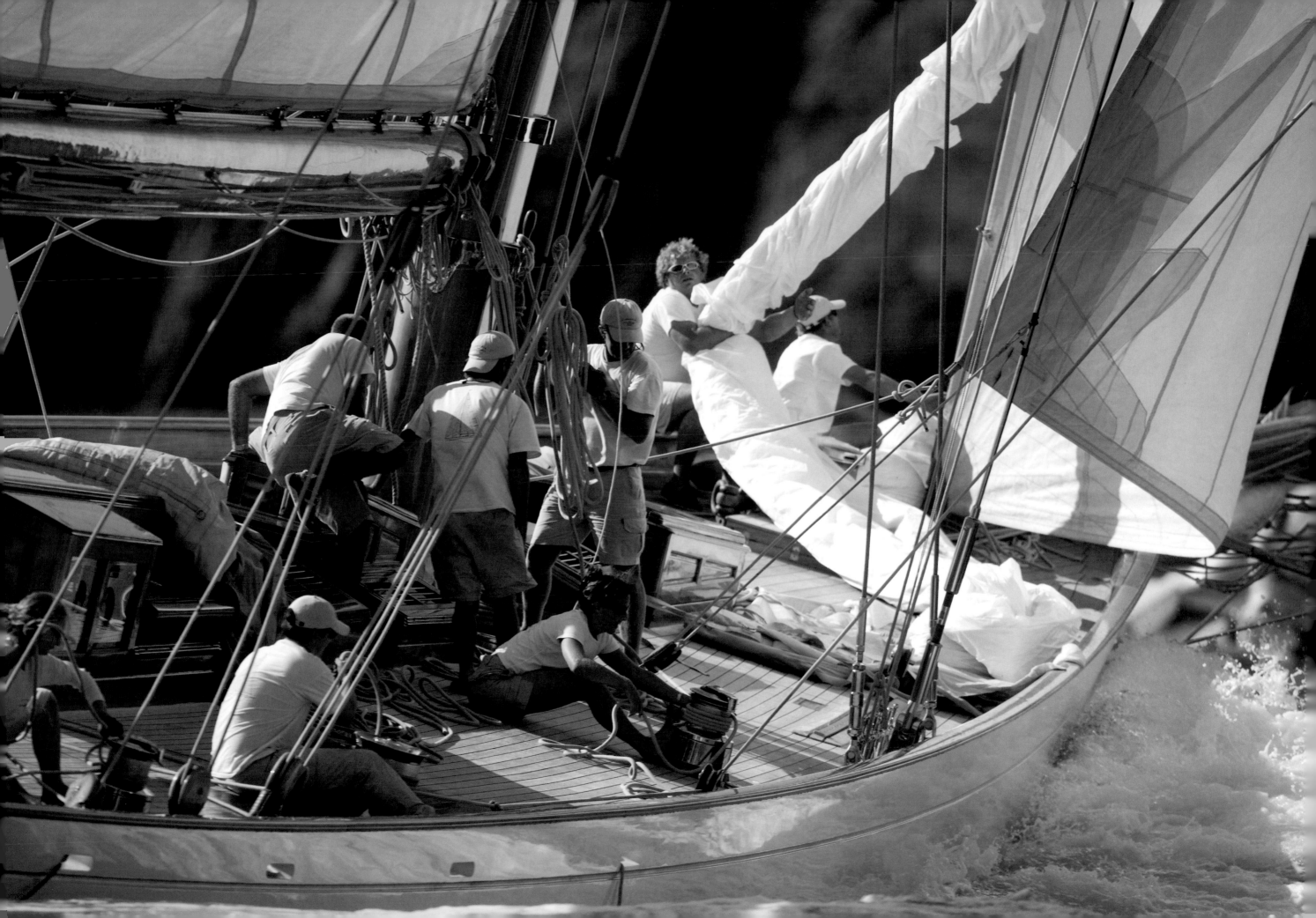

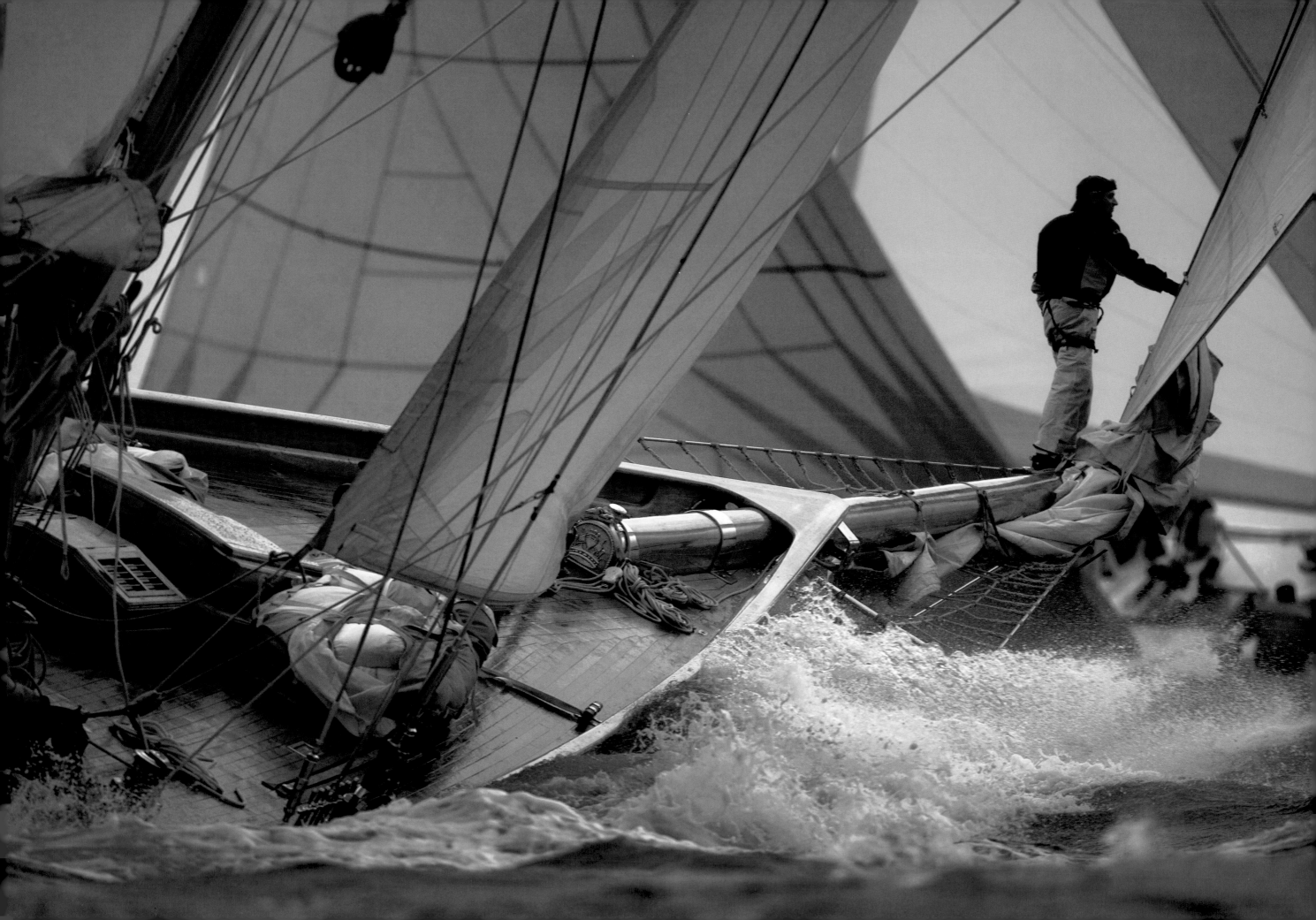

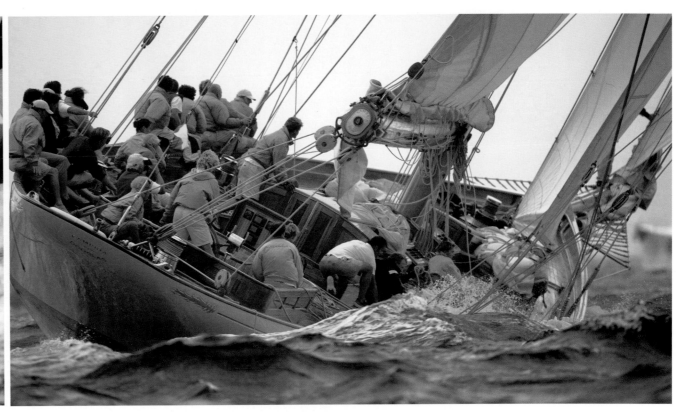

Difficult Starts

Each of these big yachts had her year to shine. This was due to the fact that the tall ships were given a time penalty based on size and age. Each year the rules were changed slightly to take into account those that were handicapped in previous races. In the 1920s, there was a sort of round robin of winners, each yacht having her hour of glory; it was just a matter of persevering.

The major question on the agenda for 1928 was what correction would be given to the two brand-new International Rule yachts, *Cambria* and *Astra*, in comparison to the older vessels in the class, *White Heather* and *Shamrock*, and the biggest, *Lulworth*, *Britannia*, and *Westward*. Naturally, Heckstall-Smith fanned the flames of the debate in his articles. There was no question of giving an advantage to the new Bermuda rig, beginning with the largest of the yachts, *Nyria* (1906) in 1921, then owned by Elizabeth Russel Workman. It was thus decided that *Westward* and *Lulworth* would be used as a reference point—*Britannia* would benefit by 7.5 seconds per mile, *White Heather* and *Shamrock* by nine, *Cambria* by 12.8, and *Astra* by fourteen seconds. The competition was all the fiercer since the yachts had a variety of rigging, including gaff, Marconi, and Bermuda.

Everyone was well aware of the advantages of the older yachts. *Britannia* would be hard to beat when nearby, *Westward* held all the trump cards in heavy weather, and *Shamrock* and *White Heather* would be difficult to overtake

when there was not much wind. In a three-cornered race at the first regatta in Harwich, East Anglia, *Cambria* outpaced *Britannia* on her own territory, taking advantage of a strong gust of wind. But as the days progressed, the newest yachts appeared to lack sail in calm and medium weather. *Cambria* participated in all the regattas but only won two races out of thirty-four. *Astra* did better, winning five firsts out of twenty-six races.

The year 1929 went by without *Britannia*, which remained berthed. Regattas multiplied, and corrected time was reviewed to make the field fairer. This encouraged banker Herman A. Andreae to have Camper & Nicholsons build him a sixth and final 23-meter yacht, *Candida*, launched in May 1929.

In 1930, *Britannia* returned to the circuit and Lipton commissioned Nicholson to build him a J-class for the America's Cup. *Shamrock V* was launched on April 14 and sailed in twenty-two regattas before crossing the Atlantic to win fifteen more. She was much unluckier in the Cup, being soundly defeated by *Enterprise*. This was a great year for *Cambria*, however, the finest since her launch, for she won forty-nine races and was awarded twenty-one prizes. She placed second fourteen times in a fleet of eight big yachts, half of them Bermuda rigs. Yet Lord Camrose, who also owned *Sona*, a handsome 192-foot (57.60-m) motor yacht built for Lord Dunraven in 1922, did not fit out his yacht for the next round of races.

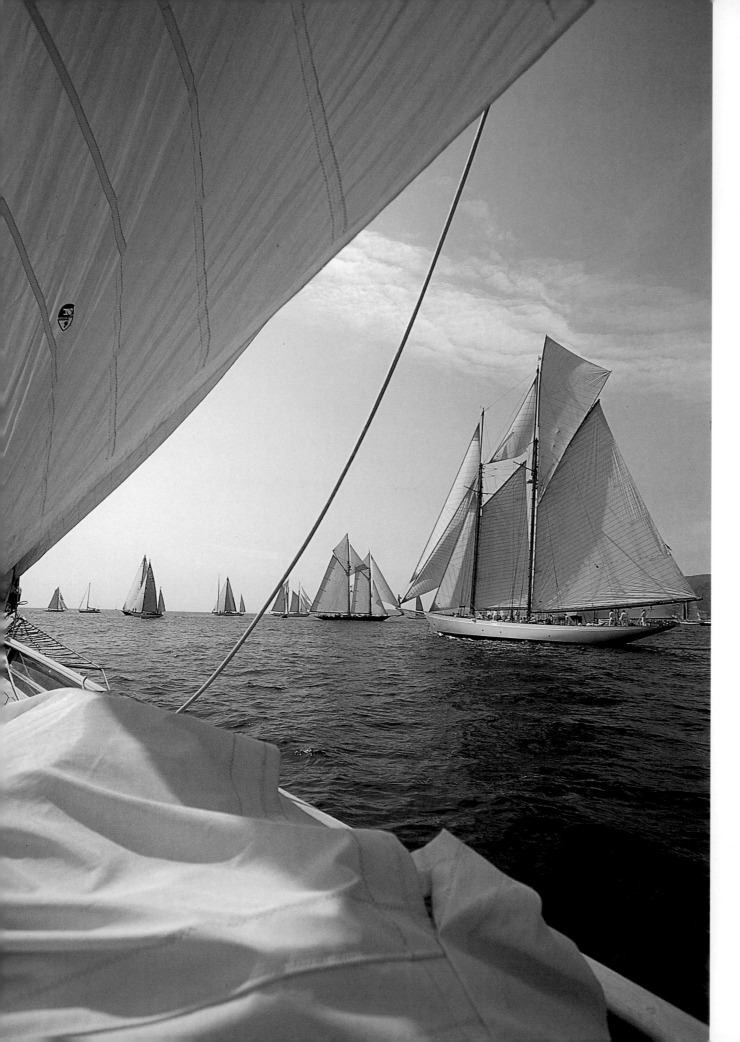

A Life of Leisure

In 1933, *Cambria* was altered radically, as she received an engine and was turned into a cruising yacht. Her name was changed to *Lillias* and she became the property of Sir Robert MacAlpine. When MacAlpine died in 1936, H. F. Giraud acquired the yacht and took her to Chios, near Izmir, Turkey, her new home port for chartering.

Lillias became part of the Turkish jet-set scene, often in conjunction with *Savarona*, the presidential yacht owned by Mustafa Kemal Atatürk, the founder of modern Turkey. It is probable that this is where the meeting was held between Joachim von Ribbentrop and Kemal Atatürk prior to World War II to discuss Turkey's position on the international scene. The last mention of *Cambria* in Lloyd's Register dates from 1939. In 1950, Giraud installed a new engine, and *Lillias* remained in Chios until 1961. She was then sold to Belgian André J. M. Verbeke, who gave the ship back her original name. *Cambria* was then based in Piraeus, Greece until 1963, where she received a new set of sails cut by Gravilis. When George Plouvier of Antwerp, a member of the Belgian Yacht Club, became her owner in 1964, he asked Ratsey to cut him new sails and installed a 190 hp Berliet engine. *Cambria* thus found herself once again based in the English Channel for a few years, though she generally cruised the Mediterranean. In September 1972, American businessman Michael Sears bought the yacht with the intention of sailing her around the world. Two years later, he found himself in the Canaries with a broken mast. She was rigged out as a ketch by Harry Spencer of Cowes, Isle of Wight, the following year. *Cambria* then crossed the Atlantic and sailed for four years in the Caribbean. In 1981, her interior was restored in Miami, and two years later, the yacht sailed through the Panama Canal and to French Polynesia. The following year found her in New Zealand, and she was berthed in Australia in 1985. From 1986 through 1987, *Cambria* sailed around Fremantle, on the west coast of Australia, where she raced in the Louis Vuitton Cup and America's Cup. Charlie Whitcombe, a New Zealander, bought her and sailed around Cape Leeuwin through the Bass Straits and into the Tasman Sea to reach Auckland. In the following year, he embarked on a tour of Australia. After this *Cambria* went on the market again in Townsville, Queensland, Australia, beside the Great Barrier Reef, in 1994.

Left
Calm weather for the start: the great classic sailing yachts, *Altaïr*, *Mariette*, and the rest are rather hesitant. There's no hurry: the wind will soon rise.

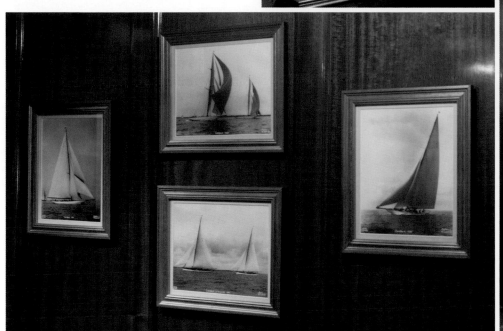

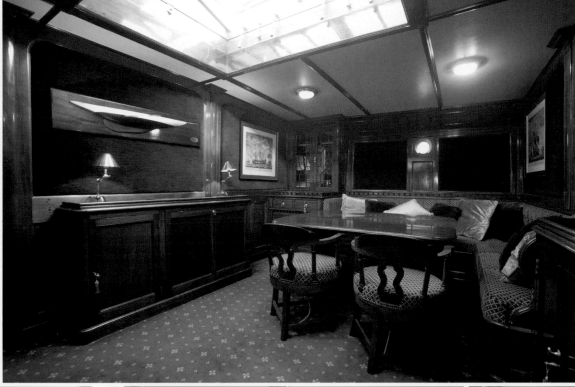

Designer William Fife built a comfortable interior for the owner and his party aboard *Cambria* in 1928. Many of the world's problems have surely been solved around the dining table.

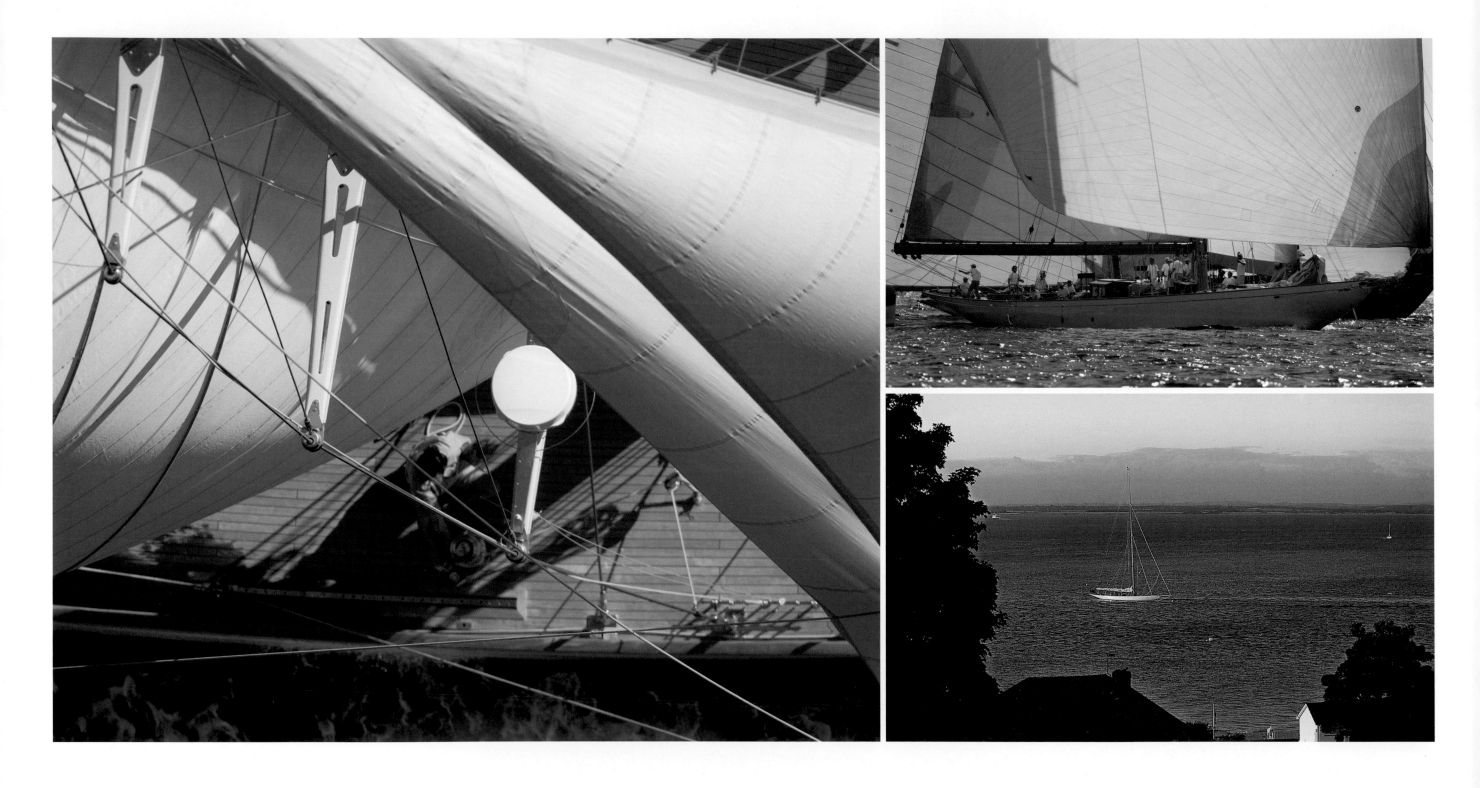

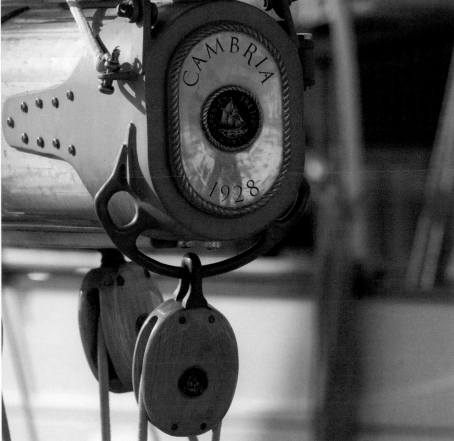

A Turn-of-the-Century Restoration

When Australian Prime Minister Paul Keating discovered *Cambria* in his country, he encouraged his friends Denis O'Neil and John David to buy the yacht and restore her to her original grandeur. In 1995, they did so and undertook a complete restoration under the management of architect Ian Murray, better known as a designer of racing yachts and himself a great helmsman. In April 1995, *Cambria* was towed to Brisbane where they dismantled her while still afloat and handed her fittings and superstructure over to local craftsmen for repair and restoration. On June 2, they placed her empty hull in dry dock at the Norman Wright & Son boatyard. The interior of her structure was remodeled by replacing or restoring damaged items. Among the parts they had to change were the mast step, the long stern timbers, the rudder head, the plates, and the steering gear. The original rivets were all removed and replaced by stainless steel bolts. The first pitch-pine layer of planking on the deck had remained intact, and they laid another course of attractive teak planking over this. They overhauled her Cummings engine and used it to work a hydraulic pump that controlled two small propellers. They remodeled the forward area of the interior for the greater comfort of the crew, and the services were improved. The saloon and the six staterooms, mostly paneled in mahogany, were restored to their original condition, although the ceiling was now covered in white-painted ply-

wood. The work lasted eight months, after which *Cambria* sailed to Sydney where she spent the next five years.

In 2001, Peter Mandin, skipper of the fifteen-meter class *Lady Anne*, another of Fife's designs dating from 1912 and restored at Fairlie in 1998, was on vacation in Australia when a broker called him and asked him to see *Cambria*, which was again for sale. Mandin was captivated and did everything he could to persuade David to bring the yacht to Cowes for the America's Cup Jubilee in 2001, sure that he would find a buyer. Five months later with the help of Fairlie Restorations, Spencer, and the North sailmakers, the yacht was restored to her original condition. With a slightly smaller mainsail and shortened boom, the tiller became incredibly sensitive. *Cambria* now sails as a charter from Antigua to Greece, including the fall regattas in the south of France where she usually grabs the elegance prize.

It would seem that the difficulty in holding *Cambria* on course is because her mast is sited far forward, at less than 33 percent of the flotation length. This position, inherited from the previous gaff rigging, causes pitching in choppy seas and makes the yacht rather unresponsive. It would be interesting to analyze this problem, as it affects all 23-meter vessels with a Bermuda rig, to see how the sitting of the mast step on J-class yachts changed from 1927 through 1937.

· FEATURES ·

Name: CAMBRIA
Architect: William Fife III
Builder: William Fife & Son, Fairlie
Rigging: Bermuda cutter
Type: 23-meter, J-class (October 4, 2003)
Launched: May 1, 1928
First owner: Sir William Ewart Berry
Other name: LILLIAS
Restorations: 1995, 2001
Boatyards (restoration): Norman Wright & Son,
Brisbane; Fairlie Restorations, Fairlie
Construction: composite, mahogany planking
on steel ribs

Overall length: 125 feet 8 inches [37.65 m]
Deck length: 115 feet 6 inches [34.66 m]
Length at waterline: 76 feet 2 inches [22.86 m]
Maximum beam: 20 feet 8 inches [6.21 m]
Draft: 14 feet 2 inches [4.26 m]
Ballast: 60 tons
Displacement: 132 tons
Approximate sail area: 8,170 square feet [759 m²]

· DECK PLAN

PORT

SKYLIGHT STAIRWAY DECKHOUSE SKYLIGHT SKYLIGHT STERN STAIRWAY BOWSPRIT

MAINSAIL STEERING WHEEL WINCH WINCH MAST CAPSTAN
TRAVELER RACK

STARBOARD

· LAYOUT

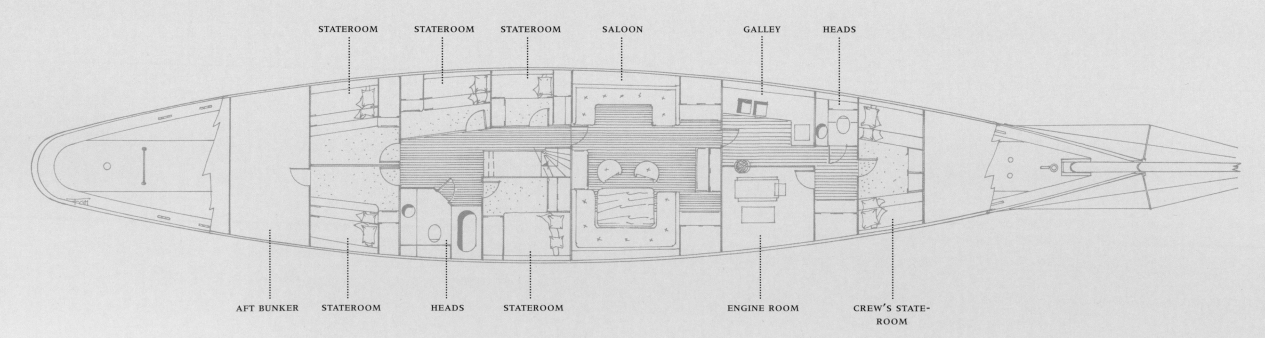

STATEROOM STATEROOM STATEROOM SALOON GALLERY HEADS

AFT BUNKER STATEROOM HEADS STATEROOM ENGINE ROOM CREW'S STATE-
ROOM

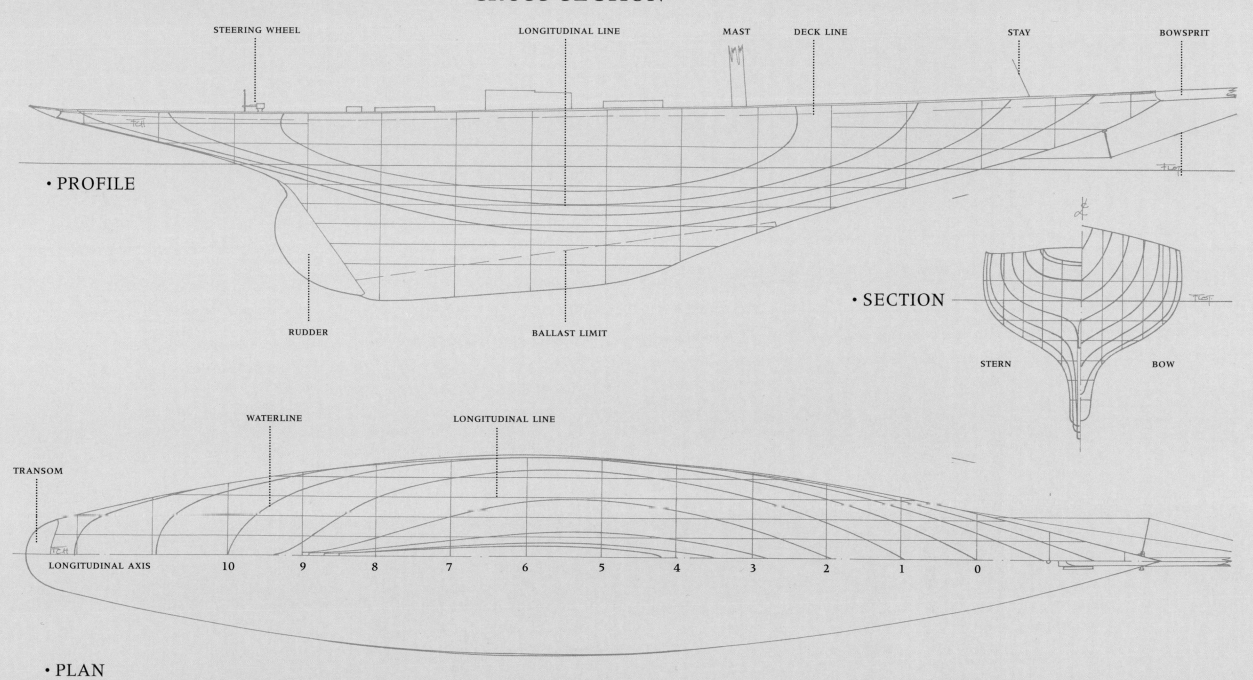

·CROSS SECTION

·PROFILE

STEERING WHEEL

LONGITUDINAL LINE

MAST

DECK LINE

STAY

BOWSPRIT

RUDDER

BALLAST LIMIT

·SECTION

STERN

BOW

WATERLINE

LONGITUDINAL LINE

TRANSOM

LONGITUDINAL AXIS 10 9 8 7 6 5 4 3 2 1 0

·PLAN

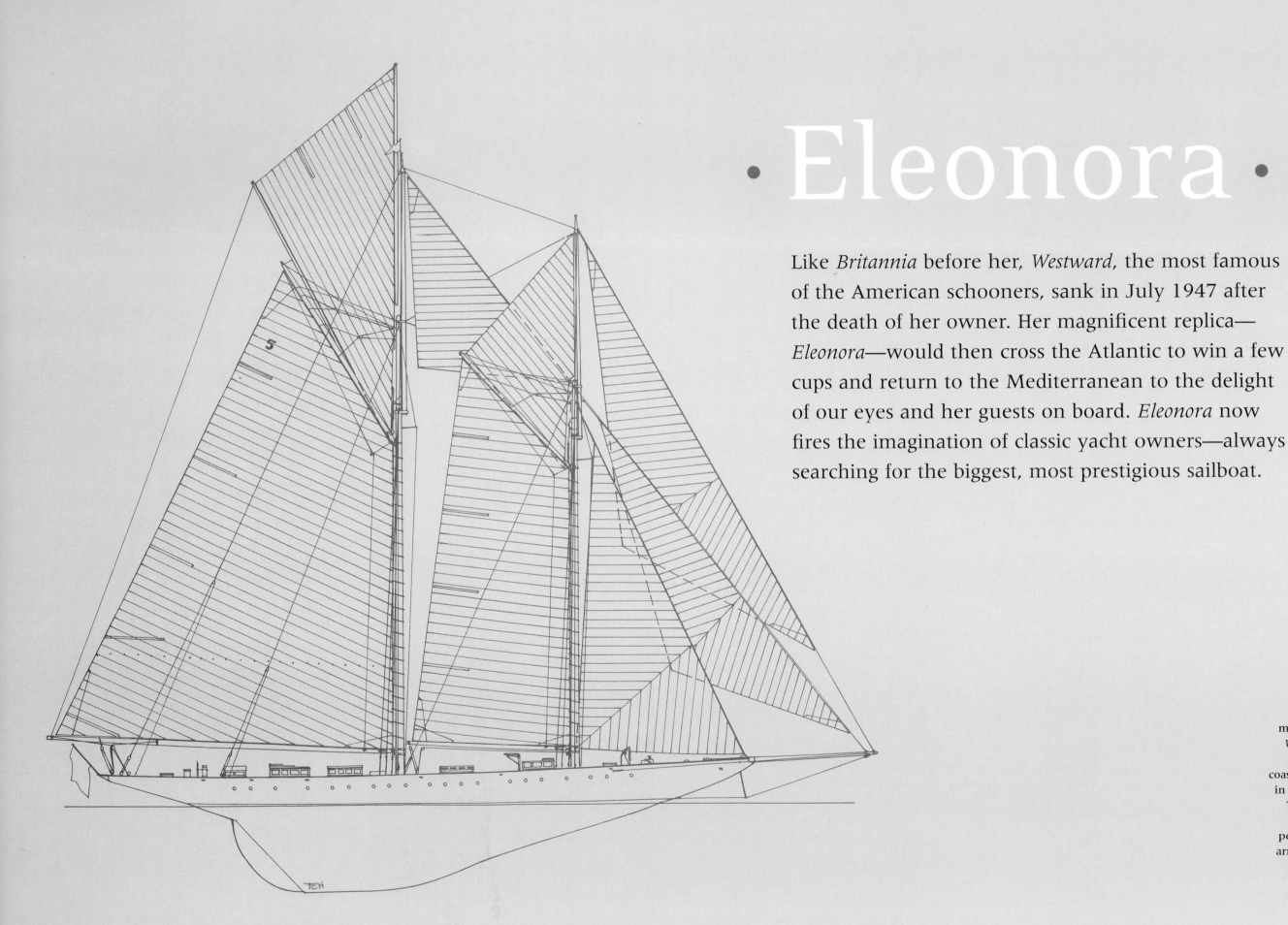

· Eleonora ·

Like *Britannia* before her, *Westward*, the most famous of the American schooners, sank in July 1947 after the death of her owner. Her magnificent replica— *Eleonora*—would then cross the Atlantic to win a few cups and return to the Mediterranean to the delight of our eyes and her guests on board. *Eleonora* now fires the imagination of classic yacht owners—always searching for the biggest, most prestigious sailboat.

Eleonora, the magnificent replica of *Westward*, silhouetted against the red rock coastline of Les Maures in the south of France. The watchtower is a wonderful vantage point to view such an array of yachts as they pass.

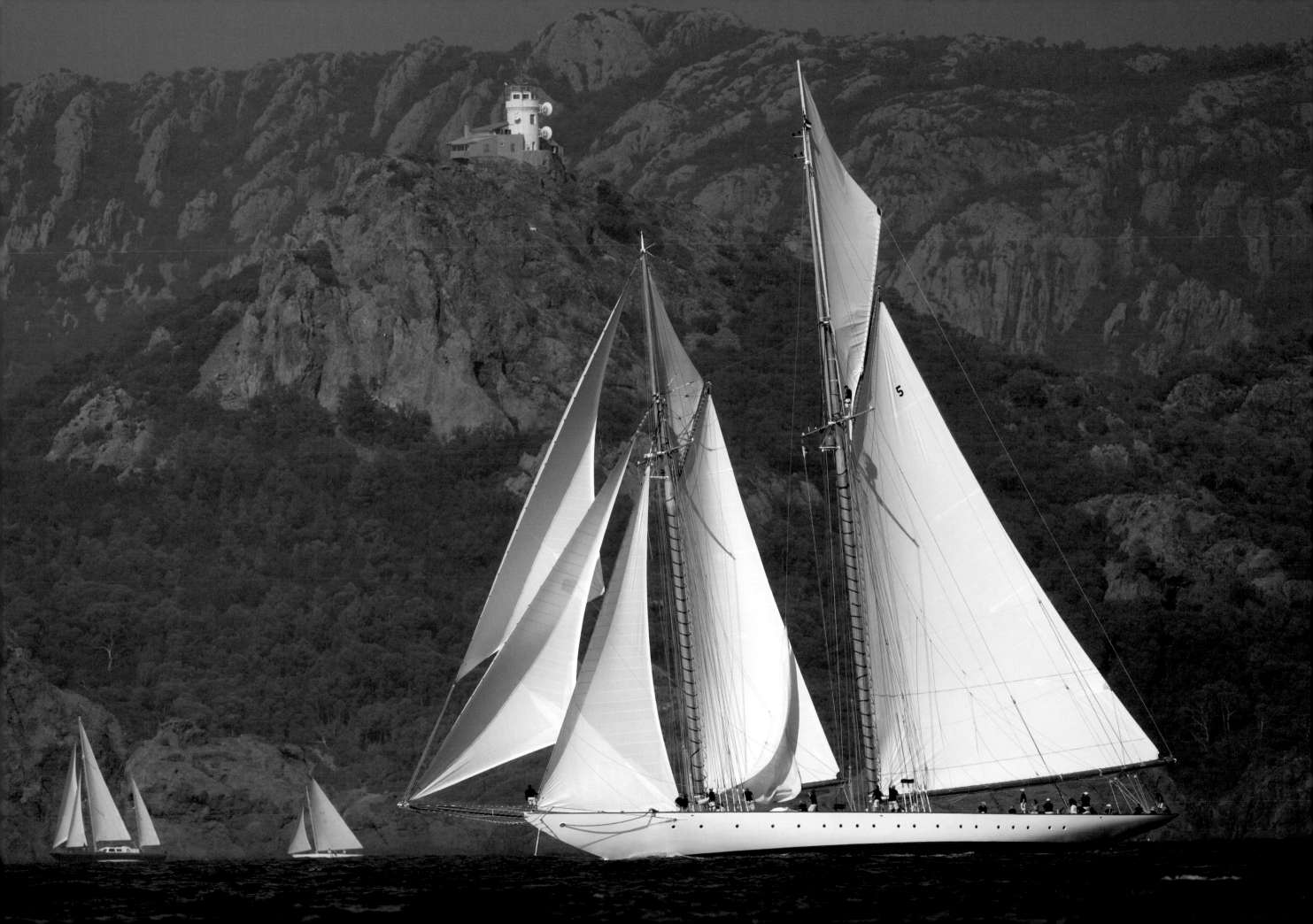

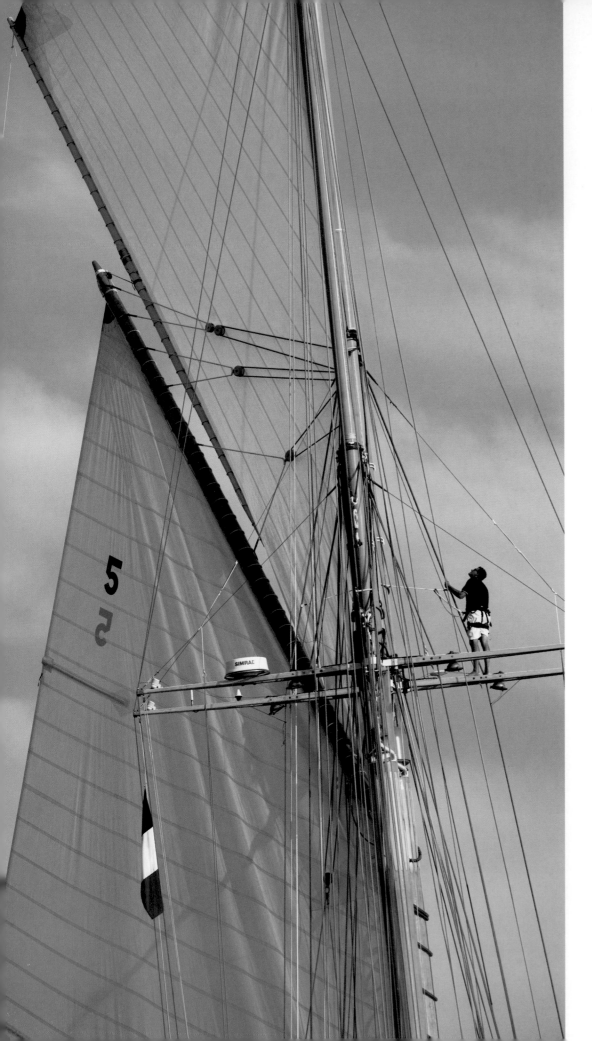

Which of these classic yachts is the most famous? The line of twin-masted schooners with unbeaten records was designed by a specialist who revolutionized naval architecture and won the America's Cup six times. Which yacht is the most famous in the United States? For overwhelmingly defeating its European rivals, in particular the yachts owned by King George V and by the German Kaiser, it has to be *Westward*. This is no "Louis XV commode," like the handsome schooners designed by the British architects William Fife III and Charles E. Nicholson, but an impressive machine bent on success, beautiful of course, but above all a powerful winner.

Eleonora is the work of sailing enthusiast Ed Kastelein who decided to reconstruct *Westward* in 1998. Kastelein is someone who does not hold back when it comes to his enthusiasms. Although a businessman, he is a descendant of generations of fishermen and sailors, so he knows his subject. Kastelein's first yacht was the *Borkumriff* (1930, Henk Lunstroo), a gaff schooner formerly owned by Baron William von Fink, 102 feet (31 m) and built in Germany. The baron subsequently owned two other neoclassical schooners of the same name, a 133-foot (40-m) vessel in 1994, then a 167-foot (50-m) in 2000. In 1987, Kastelein acquired the yawl *Aile Blanche*, formerly *Tris* and *Comet V*, a Sparkman & Stephens 68-foot (20.50-m) yacht built in 1962 by Cantieri Sangermani boatyard. A confirmed believer in technical progress, he had a replica built of Errol Flynn's famous schooner, *Zaca*, originally of 1929, but giving it a resolutely modern careen. The replica has an overall length of 147 feet (44 m) and was built by the Amstel Shipyard in the Netherlands and she launched in 1992.

The next stage—and there were plenty of them since nothing would stop Kastelein—would be the *Eleonora* venture. The pleasure and excitement of the project itself—its gestation, the research and construction of a new yacht—were at least as important as that of owning her or taking the helm. *Westward* had had a crew of forty-five, but there could be no question of employing as many men to sail her throughout the year today. So, how could the reconstruction of such a vessel be conceived without betraying her—by limiting the number of crew members to five while retaining the beauty and grace of one of the finest examples of naval architecture from the beginning of the century?

But first, there is the story behind all of this. Kastelein had long had a name in mind for his yacht. "When I was eighteen, I visited England. Like all keen yachtsmen, my friends and I visited the ports. One day, we stood admiring a very handsome tall ship that was sailing out to sea. She was called *Eleonora*. Moved by the magnificent sight, I said to myself, one day, I shall have an *Eleonora*." *Westward* would become his *Eleonora*.

Left
With so many lines and halyards used to control the sails, it is no wonder a crewman must go aloft to make sure that all is in order. The mast is wider than the man's body.

Opposite
From this vantage point, *Eleonora* almost looks like two yachts sliding through the passing swell. The crew leans forward anticipating the next wave.

Pages 52–53
Contrast the attitude of the crew in the middle of the yacht to the after-guard back aft. The mid deck is at rest while the helmsman and attendants are all focused on sailing quickly.

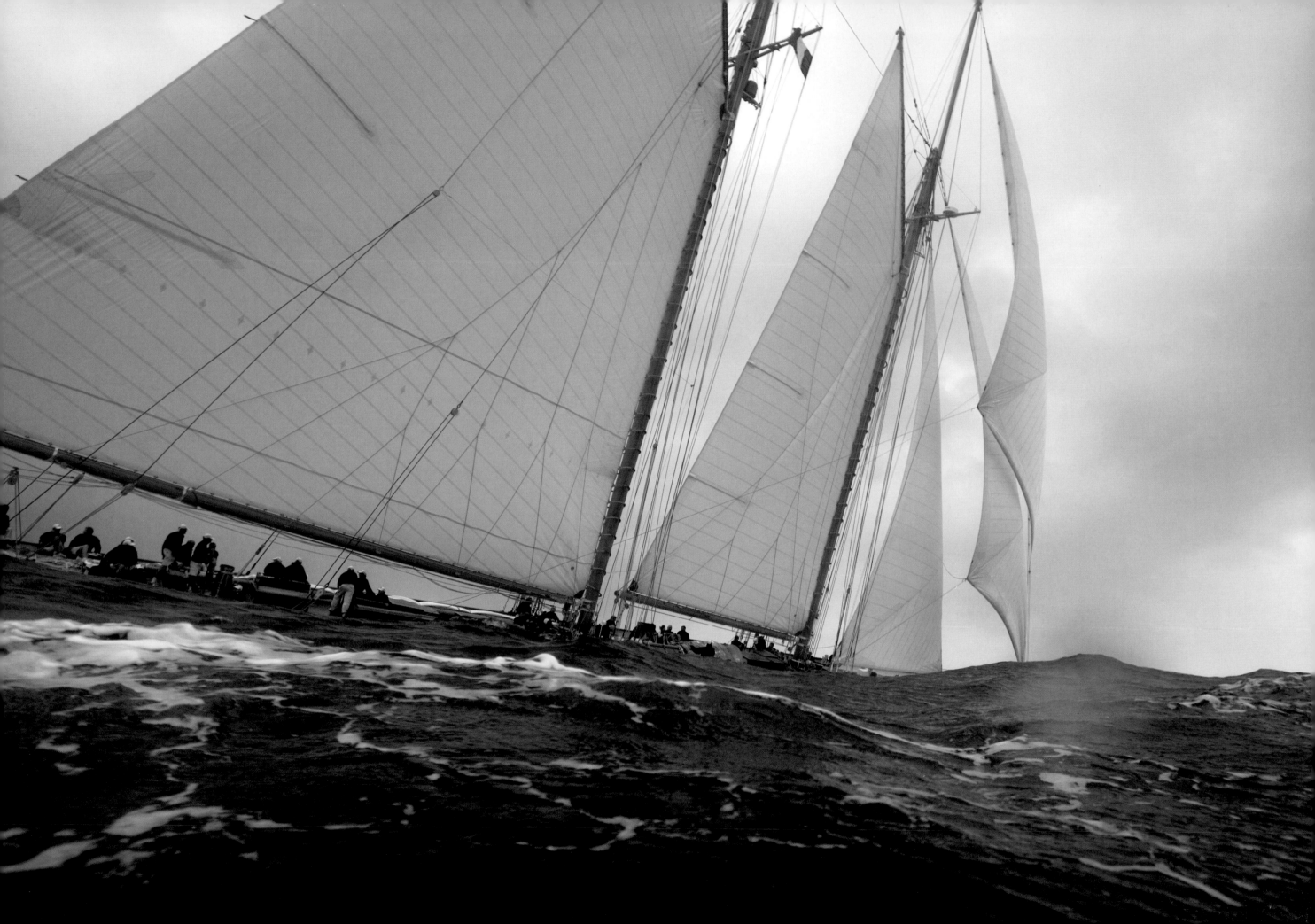

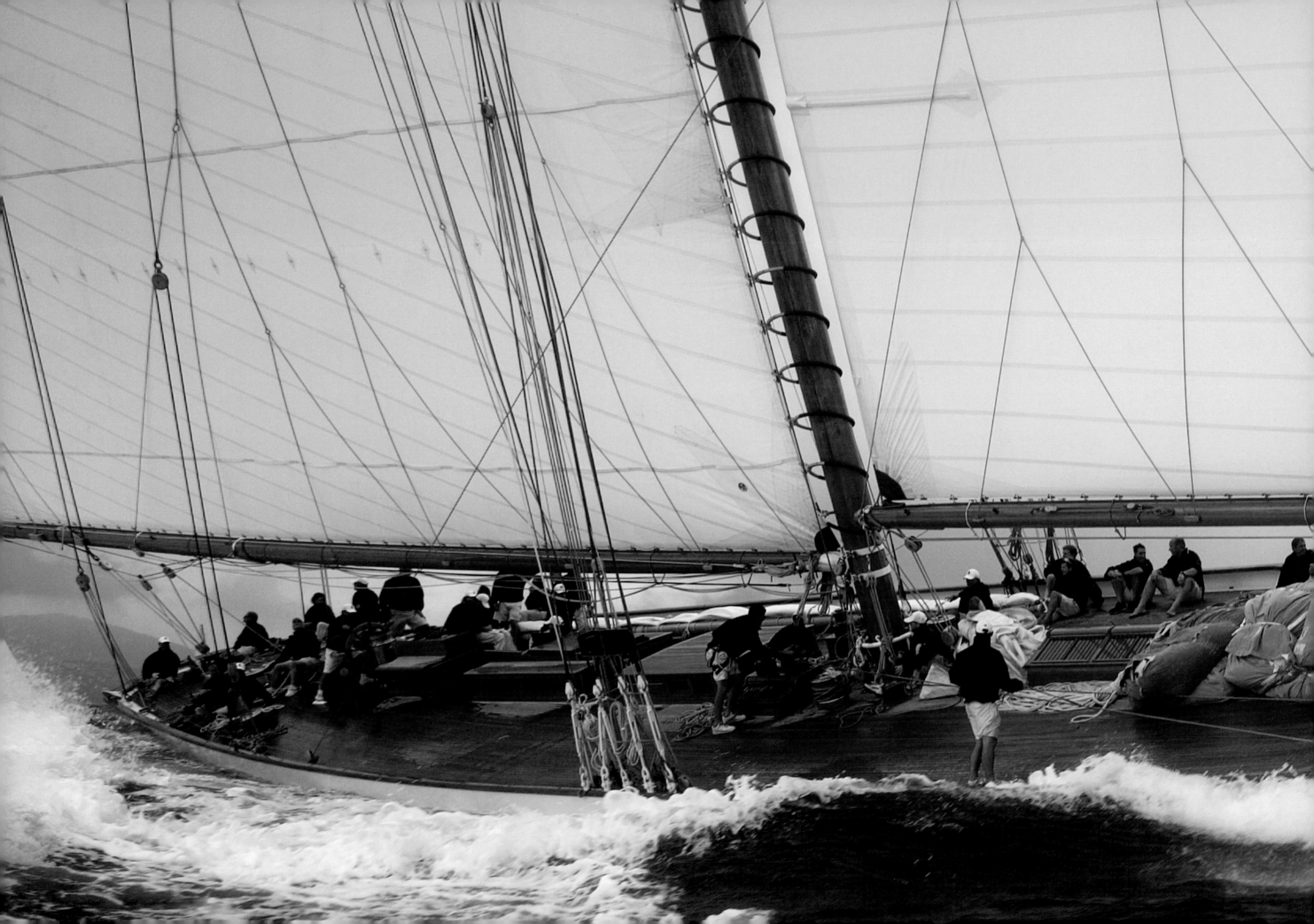

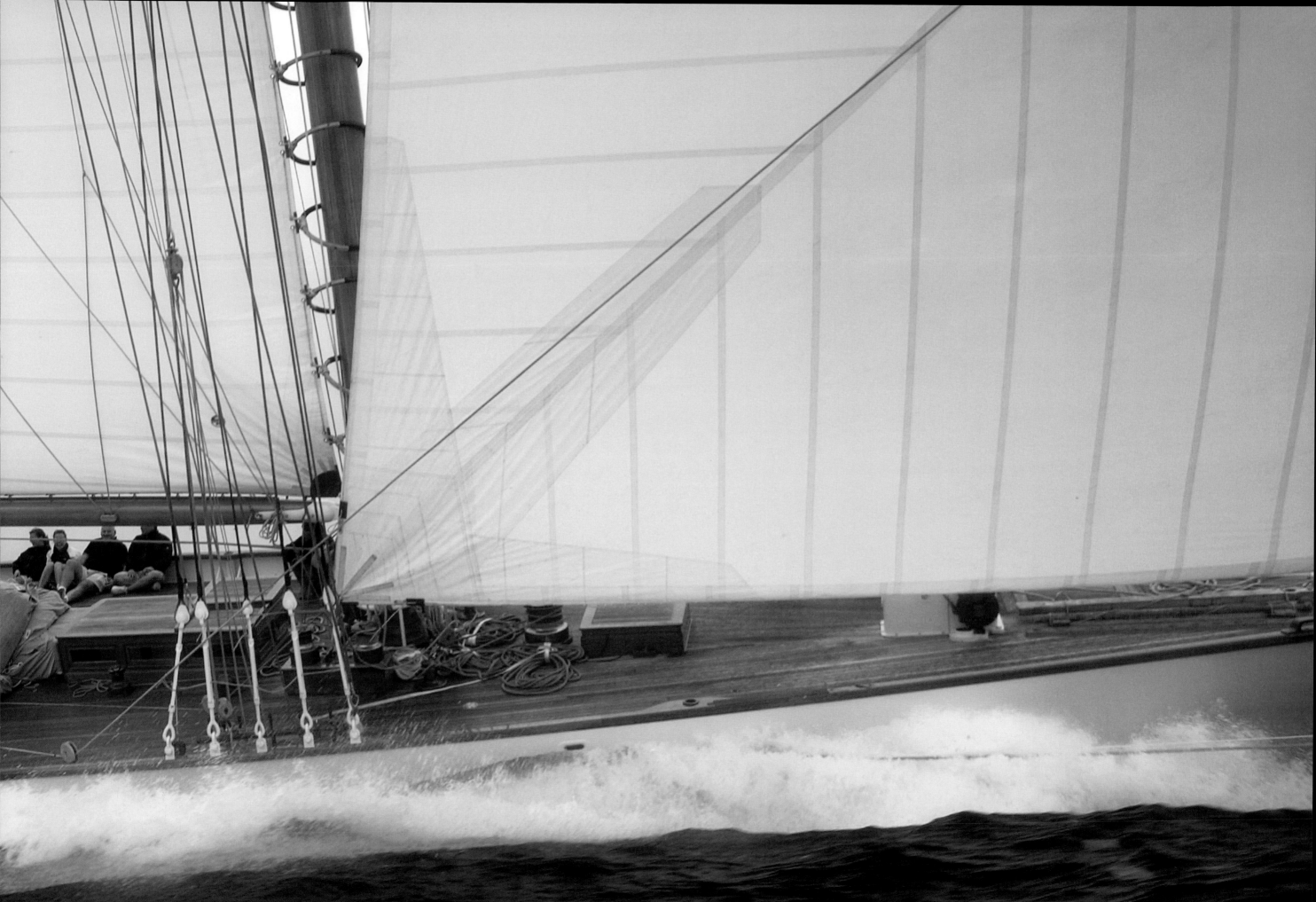

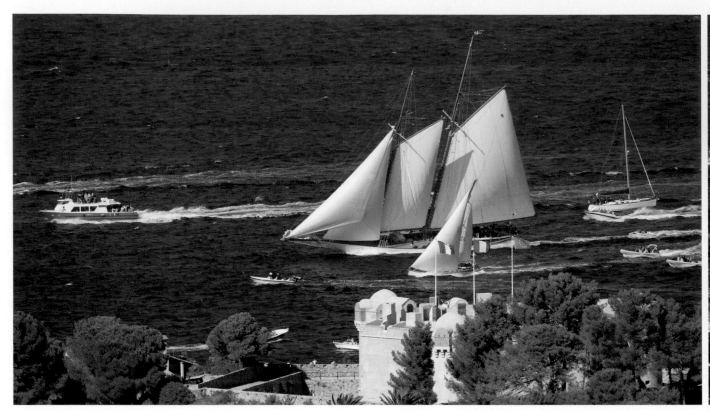

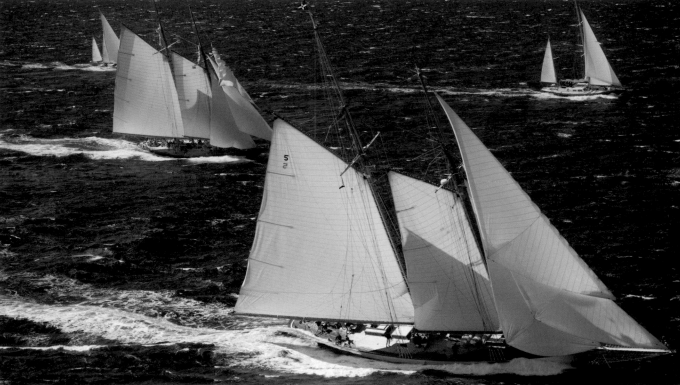

Herreshoff's First Steel Schooners

From 1893 through 1920, the two Herreshoff brothers, who had been in partnership since January 1, 1878, in the Herreshoff Manufacturing Company in Bristol, Rhode Island, would produce the greatest and most glorious tall ships. *Westward* is the most famous of the steel-structured schooners the venture produced. Nathanael Herreshoff, the "Wizard of Bristol," was the architect-designer; John Brown Herreshoff, the elder brother, who had been blind since the age of fourteen, was the builder. They were then at the peak of their profession.

The Herreshoffs became masters of big racing yacht construction. As early as 1893, they achieved success in the America's Cup. They were capable of constructing massive crafts more than 83 feet (25 m) in length at the waterline, and these became commonplace for them. They designed and built *Columbia*, Cup winner in 1899 and 1901. The finest example of their skills is possibly *Reliance* of 1903, a cutter with 16,157 square feet (1,501 m²) of sail.

Such talent attracted a clientele of wealthy yachtsmen to Bristol, and a few enthusiasts managed to convince Nathanael to design large schooners with a steel frame. Only twenty-two such schooners were built out of a total production of close to two thousand vessels. L. Francis Herreshoff explains his father's hesitation, "Captain Nat didn't like schooner rigging, he thought it too complicated and expensive, and that it was too top-heavy." When the truculent Morton F. Plant visited the Herreshoff brothers in 1902, the situation changed. Despite his reservations, Nathanael took a block of wood and modeled the lines of *Ingomar*, the first schooner in what would be an impressive lineage of steel construction.

During her first season, *Ingomar*, 89 feet (26.58 m) at the waterline, won all of the series in which she competed, including the Astor Cup. Skippered

by Charlie Barr, the American yacht crossed the Atlantic to race in Great Britain and Germany. She competed in twenty-two regattas, winning twelve, coming in second four times, and third once. The Kaiser was so impressed that he commissioned Nathanael to build a bigger vessel. He set to work with enthusiasm, but the model had hardly been completed when the Kaiser wanted to make modifications. This was an unforgivable mistake. Nathanael told him, "If you want the yacht as I designed it for you, you can have it, but I will never create one when the measurements you want are unsuitable." The schooner was never built.

In 1906, Nathanael designed a new steel schooner, *Queen*, for J. Rogers Maxwell. The order was a compliment to Nathanael because Maxwell was one of the finest U.S. amateur architects and had always preferred to design his own craft. When *Queen* was launched, she was showered with praise, "It's the finest and most elegant yacht that has ever been built," wrote *Local Press*. Soon after, Maxwell sold his schooner to E. Walter Clark, who renamed her *Irolita*. She was destroyed in a fire in 1910 at City Island.

A Legendary Schooner

On March 31, 1910, *Westward* launched in Bristol at the Herreshoff boatyard, having been commissioned by Alexander Smith Cochran. This legendary steel-hulled yacht would hold out on the British and German Big Class yachts for more than twenty-five years in the major European races. *Westward* saw the light of day thanks to Charlie Barr. During the 1909 season, he skippered Cochran's cutter *Avenger* (1907, a Herreshoff plan) and spoke of the wonderful 1904 season he had had in Europe. So in late summer 1909, Cochran decided to commission a schooner to be built for racing in Europe. He asked his

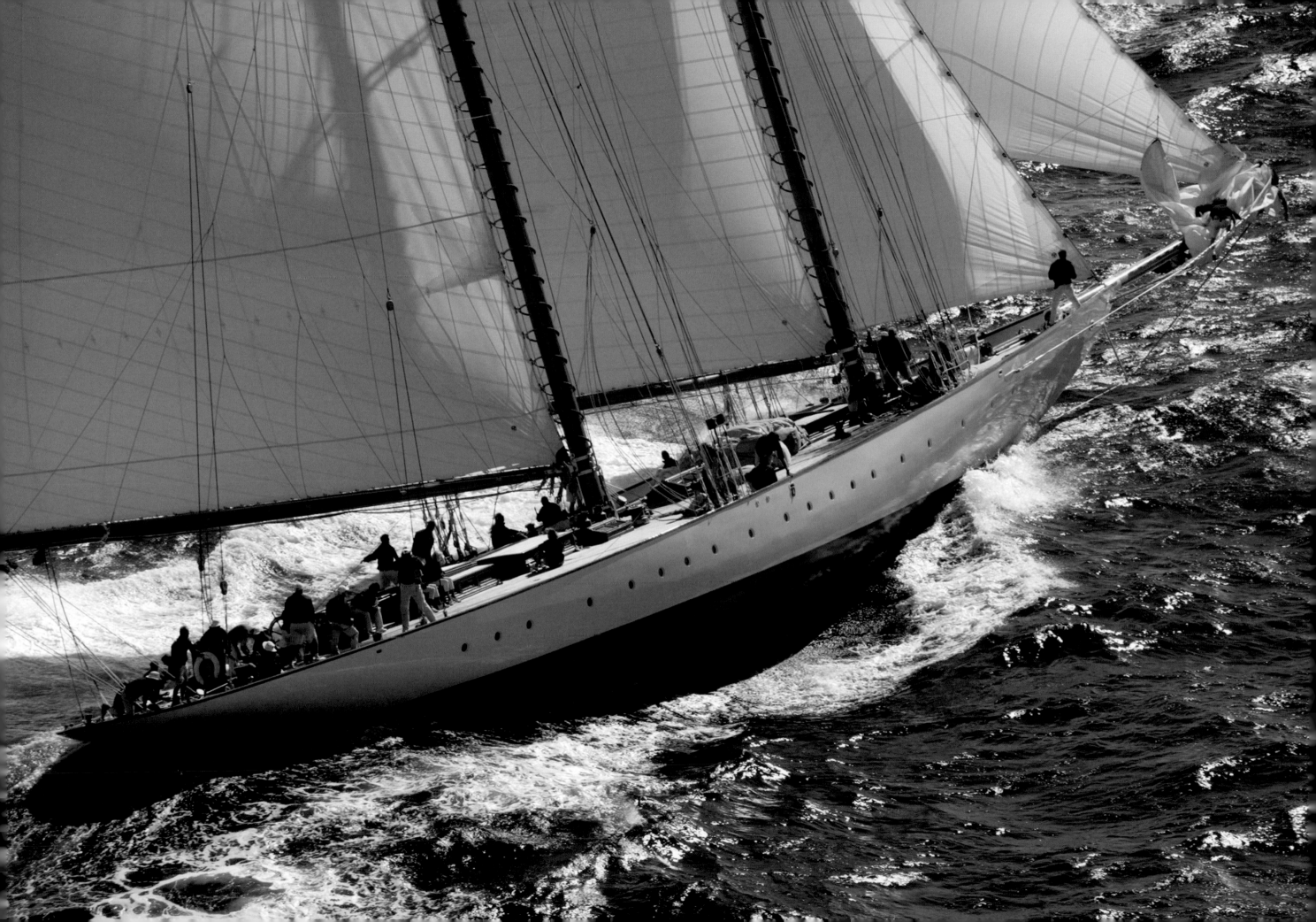

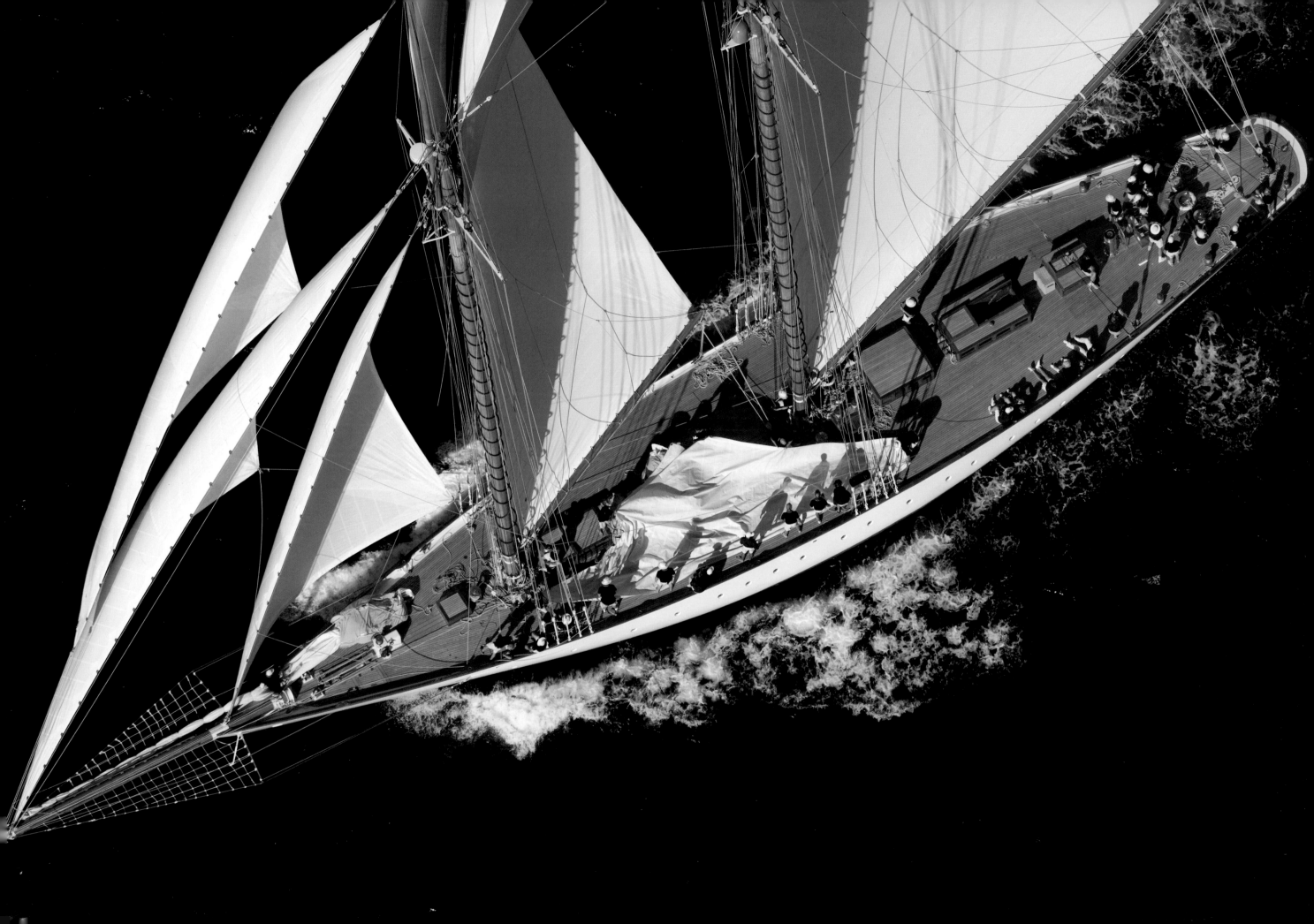

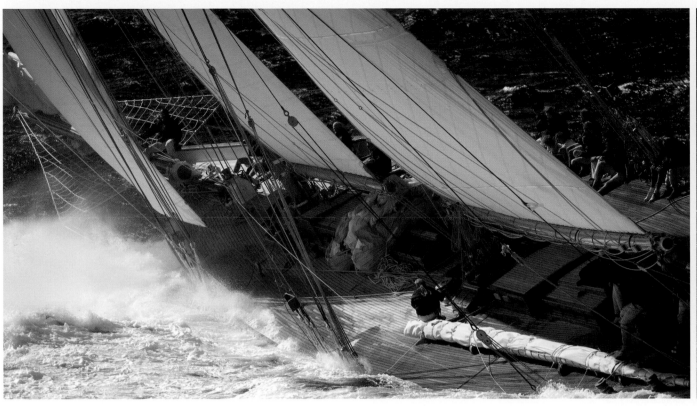

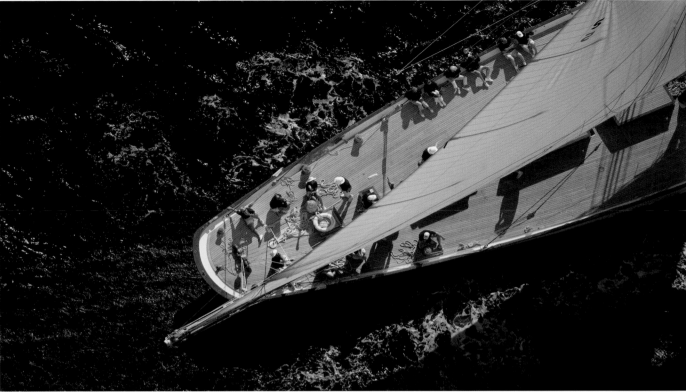

Opposite
To take advantage
of a following
wind, a schooner
can double the area
of its sail by hoist-
ing a gennaker and
a big fisherman.

skipper, "What should I do to get myself a large, high-performance sailboat, capable of crossing the Atlantic and making her mark on the finest European vessels?" The reply was unequivocal, "Herreshoff." Then Barr wisely advised Cochran, "All you have to do is go to Bristol and tell Nathanael G. Herreshoff that you want a yacht to achieve this aim. But above all, don't tell him how to design it!"

The deal was done and the Bristol master produced the model. After a few trials, the gigantic schooner, with a 140-foot (41.60 m) hull, 98 feet (29.29 m) at the waterline, left for the Old World. In Europe, *Westward* outsailed all of her British and German A-class opponents, including the Kaiser's *Meteor IV*. On July 16, Barr wrote to Nathanael: "This ship is magnificent. We encountered some strong winds during the crossing, but the water never reached the deck. There was not a single cracking sound and nothing was displaced inside, which is rare during an Atlantic storm. Out of eight races, we won eight in real time and one in compensated time!"

Westward was the last yacht to be commanded by Barr. He died in Southampton, England on January 24, 1911, at the age of forty-seven. As for *Westward*, she sailed back to the United States under the command of skipper Chris Christensen and won the Astor Cup. In October 1912, a German syndicate bought her and renamed her *Hamburg II*. The British Admiralty recovered her during World War I. From 1920, the big schooner competed in all the major European races, against all the big cutters, including the royal yacht *Britannia* and other 23-meter J-class sailboats. Her last owner, Thomas B. Davis, a South African who had settled in Jersey, in the English Channel Islands, acquired her in 1924. After he died, *Westward* was abandoned by his heirs and was scuttled in the English Channel on July, 15, 1947, in compliance with Davis's dying wish.

Herreshoff's Monster Craft

As members of the big schooner family, *Westward* and her replica *Eleonora*, confirm the exceptional skill and mastery of Nathanael Herreshoff, who always managed to surpass himself.

In 1911, Herreshoff received a call from one of his loyal customers, Morton F. Plant.

"Hallo, is that you, N. G. Herreshoff?"

"Yes, I think so. . ." replied Nathanael.

"I want a B-class schooner, and I want it to be a great success," explained Plant.

"Humph, okay," whispered Nathanael, ending the call.

The deal was done. *Eleonora*'s steel hull was the very image of that of *Westward*, although her centerboard and keel had a slightly different shape. In the year following her launch, the yacht won the Astor Cup, and again in 1913. Then, after a long period of inactivity due to her owner's death, *Eleonora* returned to the sea in 1928 under the flag of William B. Bell. During that year, skippered by John Barr, Charlie Barr's nephew, she beat *Atlantic* in the King's Cup, a race between New York and Santander, Spain.

In 1913, Harold S. Vanderbilt began to take an interest in yacht-racing and commissioned Herreshoff to build him a steel-hulled schooner. It was at the helm of *Vagrant II* (82 feet [24.38 m] at the waterline) that Commodore Harold "Mike" Vanderbilt would enter his first races. He was successful immediately, bringing home the Astor Cup in 1921, 1922, and 1925, the year in which he also won the King's Cup.

The winter of 1913–14 was a period of immense activity for the Herreshoff boatyard, with the construction of the future defender of the America's Cup,

Above
Eleonora and *Westward*
were born from a block
of wood, a half-hull
designed by the bril-
liant American archi-
tect, Nathanael Greene
Herreshoff, who was
responsible for six suc-
cessful defenses of the
America's Cup between
1893 and 1920.

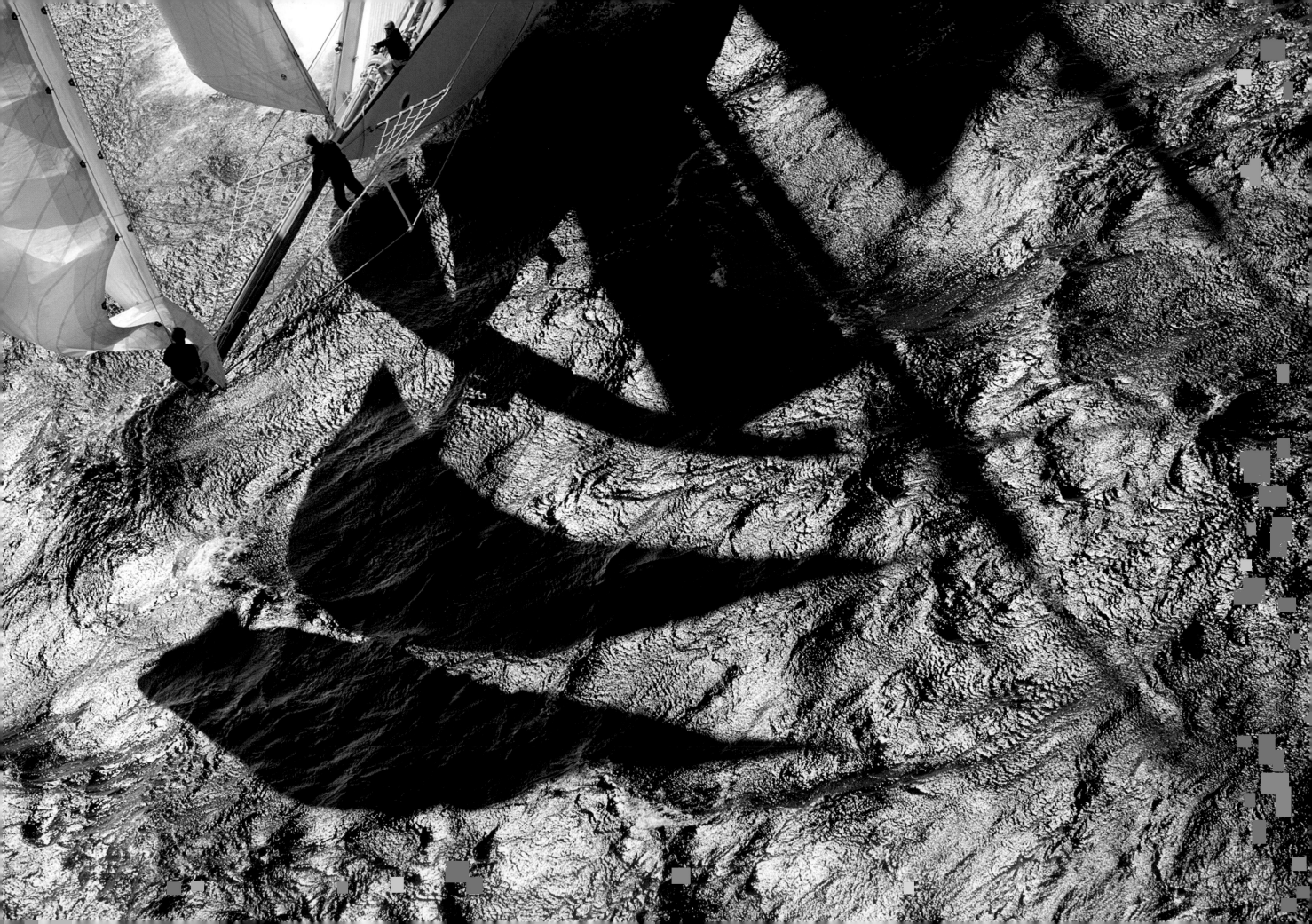

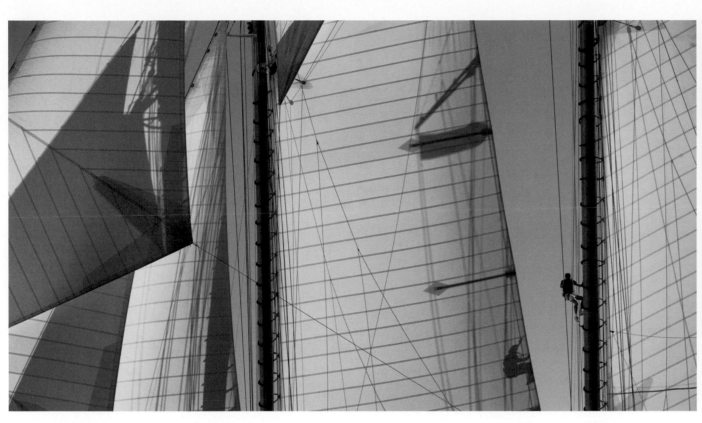

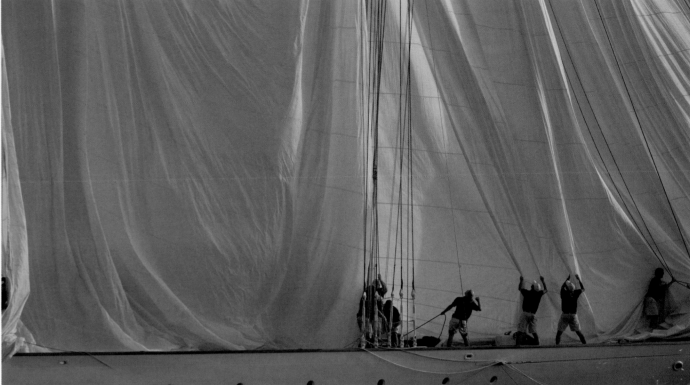

Resolute, and the building of the largest steel-hulled schooner ever assembled in Bristol, *Katoura*, for Robert E. Tod. This enormous yacht—165 feet (49.37 m) in length overall, 117 feet (35.05 m) at the waterline, with a draft of 313 tons—was fitted with the mainmast that belonged to *Reliance*, and her mizzenmast came from *Constitution* (defender of the America's Cup in 1901). *Katoura* was hard to handle, but she won the Brenton's Reef Cup three times and the Cape May Cup twice. However, World War I ruined any hope of seeing this splendid schooner reach her real potential.

John Brown Herreshoff died in 1915. The next year, *Mariette*, 81 feet (24.28 m) at the waterline, was launched for Jacob Frederick Brown. Her restoration, undertaken eighty years later by Tom Perkins, has given her back all her glory. In 1920, a final great schooner completed the series of eight prestigious vessels. This was *Ohonkara*, a steel-hulled vessel with an auxiliary engine 82 feet (24.38 m) at the waterline, designed in the same vein as *Vagrant II* and *Mariette*. Commissioned by Carl Tucker, *Ohonkara* was lost in the 1960s off the coast of Bermuda.

Ninety Years after Westward

As for Ed Kastelein, his venture was thoroughly successful. The hull of *Eleonora*, built in the Van der Graaf boatyard in the Netherlands, complied with the form and elegance, and also modern requirements, of a charter yacht. As was his working method, when building *Westward* Herreshoff first made a half-hull for the project. Then using a precision instrument he would take accurate measurements to the nearest one-sixteenth of an inch of the intersection of each plank of wood with each of the ribs on the wooden model. Everything was carefully recorded in a little notebook, with one rib per page.

These measurements traced the entire structure of the ship. In fact, no cross section plan of the original shape of *Westward* exists, only the measurements from these special notebooks. If you study the plan recreated in this book on the basis of the original measurements, you can see that the water planes are particularly original. Those that are forward are pinched to allow the water to flow past without hindrance from the top of the stem to the keel. These very extended lines continue to the widest beam, only to break and remain parallel along the whole of their length. Finally, they gradually curve inward toward the stern to form an inclined plane on which the yacht moves forward, listing and extending her length at the waterline. For the reconstruction, a cross section of the vessel had to be drafted on a computer in order to establish the structure.

On March 31, 2000, ninety years after *Westward* first launched and nine months after the first steel plates were cut, *Eleonora*'s hull slid into the waters of the River Merwede. The owner himself arranged for the rest of the work to be completed on the basis of plans preserved at MIT's Hart Nautical Museum. The most spectacular of the additional works was the huge flush deck, reconstructed to exactly match the original; the only concessions to comfort here are a few discreetly placed electrical winches made of nickel, bronze, and aluminum to help maneuver. Fortunately, she was the same size as *Westward*, and all of her plans had been preserved, including sketches of the rigging, fixtures, fittings, and layout. Although the mainsail boom is not as long as that used by *Westward* in regattas, her 75 feet (22.49 m) still project way beyond the transom. This boom is somewhere between the 88-foot (26.44-m) steel boom used in regattas and the 66-foot (19.80-m) one used when the ship is being delivered to a destination.

Today, the interior has been adapted to modern requirements for the sake of comfort, especially since the yacht is mainly chartered. The redesign has

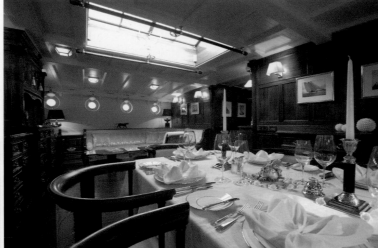

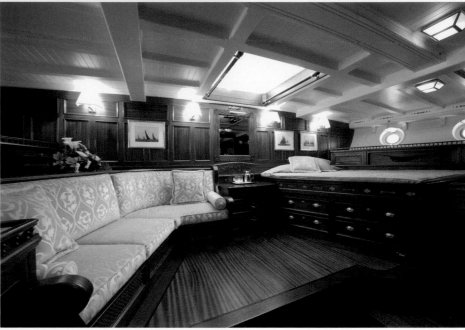

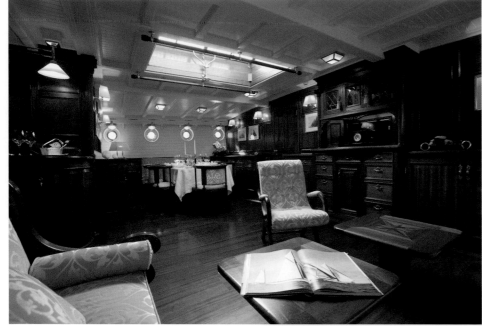

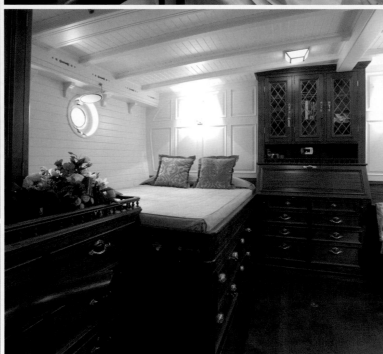

Above
The detailed drawings of the schooner *Eleonora* along with her sister ship *Westward* are preserved at the Massachusetts Institute of Technology. *Eleonora* underwent a complete overhaul of her fittings, fixtures, furnishings, and fabrics in 2006.

followed Herreshoff's guidelines, and the layout is more or less the same, with the staterooms aft and services and crew housed forward. The saloon remains in the center, taking up the whole width of the vessel, slightly shorter in length, and located farther forward. The huge galley on the starboard can easily cater for forty people. The crew are housed in three cabins and have their own heads, laundry, and wardroom. The forward station serves as a huge dormitory with three rows of foldaway bunks.

Herreshoff's first six schooners were only powered by sail. It was not until 1916, and *Mariette*, that the racing hull was fitted with an engine. Naturally, *Eleonora* is motorized with a 460 hp, 1,900 rpm Baudouin engine, for a cruising speed of ten knots. Two 42-kVA generators, a desalination plant capable of 240 quarts per an hour, and central air conditioning controlled from each stateroom, complete the facilities. Kastelein sold the schooner in July 2006 and began reconstruction of *Atlantic* (1903), a three-master which held its 1905 Blue Riband win for a scheduled ocean race across the Atlantic until *Mari-Cha*'s record in 2005.

Opposite
Eleonora overtakes *Tuiga* at the start of a race. Ed Kastelein, the developer of this reconstruction, scrupulously respected the spirit of *Westward*. The tiller on the open deck, the skipper standing by, the discreet but sturdy winches, and the guest benches on the superstructure would all make Nathanael Herreshoff proud of this reconstruction.

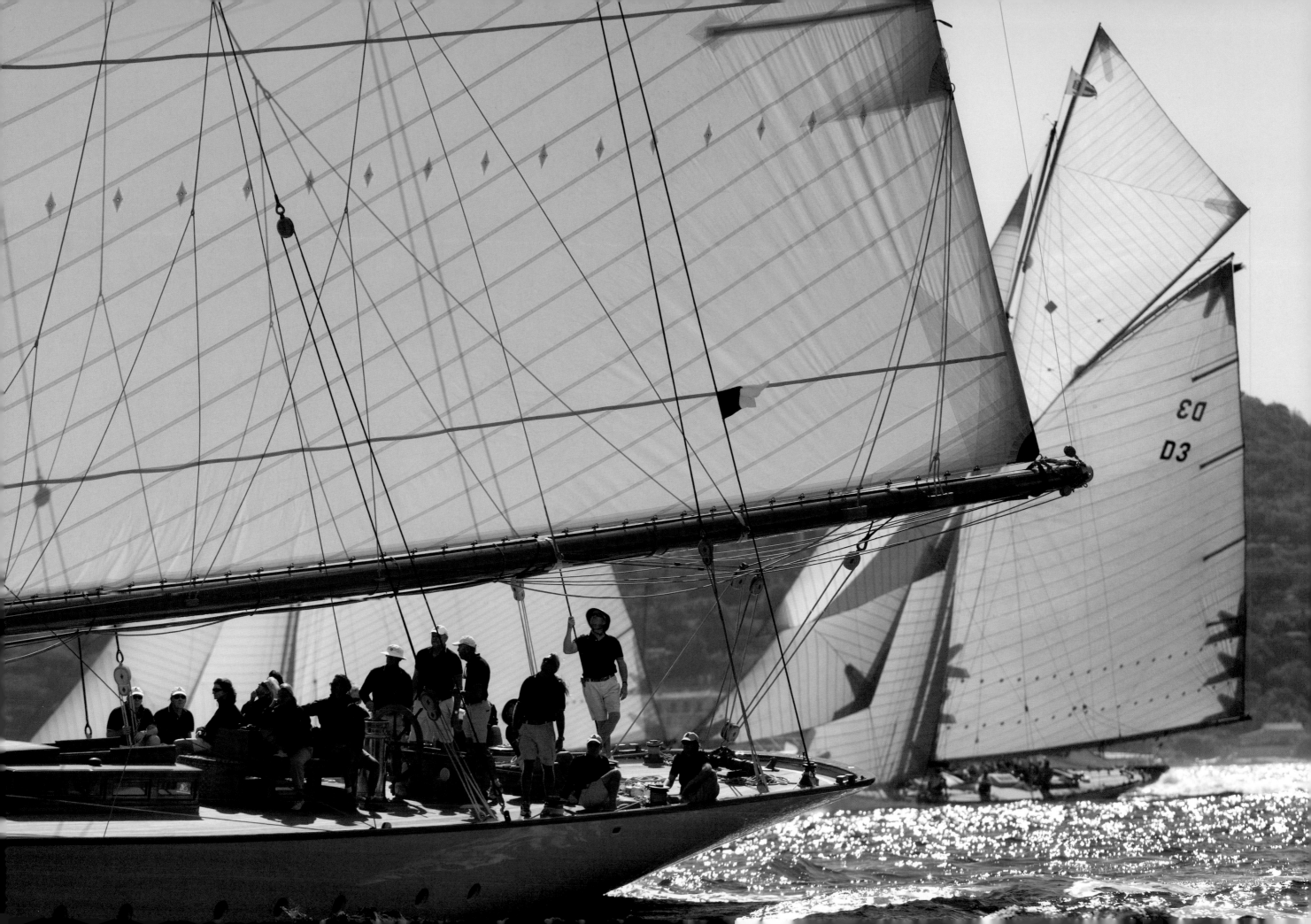

· FEATURES ·

Name: ELEONORA	*Overall length:* 163 feet 4 inches [49 m]
Architect: Nathanael G. Herreshoff	*Deck length:* 138 feet 8 inches [41.60 m]
Rigging: gaff schooner	*Length at waterline:* 99 feet 8 inches [29.29 m]
Type: replica of WESTWARD (1910)	*Maximum beam:* 27 feet 4 inches [8.20 m]
Launched: March 31, 2000	*Draft:* 17 feet 7 inches [5.28 m]
First owner: Ed Kastelein	*Ballast:* 65 tons
Reconstruction: 2000	*Displacement:* 213 tons
Boatyard (reconstruction of deck and hull): Van der Graaf	*Approximate sail area:* 3,104 square feet [932 m²]
Architect (reconstruction): Ship Design Gaastmer	*Engine:* Baudouin 6R124SR460 CV
Construction: steel	*Generator sets:* 2 x Lister Stamford 42 kVA

· DECK PLAN ·

PORT

WINCH · STAIRWAY · MAINMAST · FOREMAST · STAIRWAY · BOWSPRIT

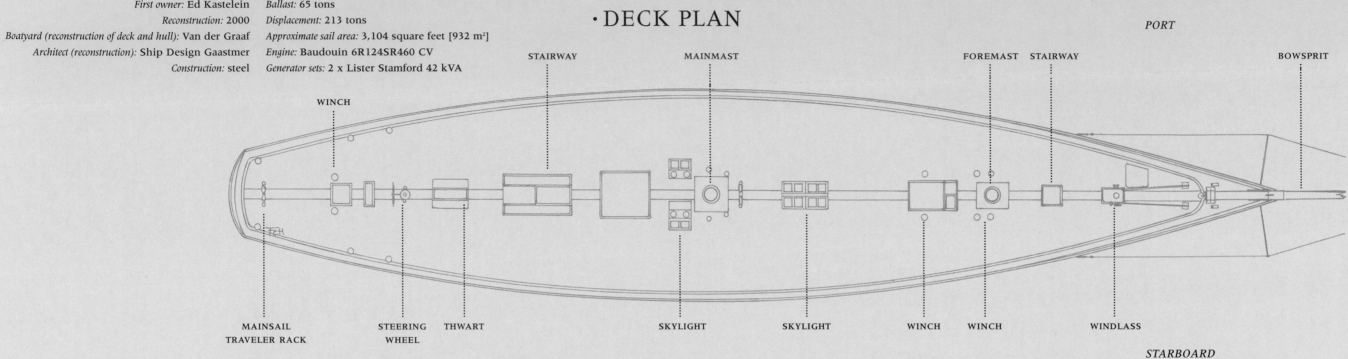

MAINSAIL TRAVELER RACK · STEERING WHEEL · THWART · SKYLIGHT · SKYLIGHT · WINCH · WINCH · WINDLASS

STARBOARD

· LAYOUT ·

OWNER'S STATEROOM · HEADS · DOUBLE STATE-ROOM · HEADS · DOUBLE STATEROOM · SALOON · SKIPPER'S STATE-ROOM · HEADS · CREW'S STATEROOM

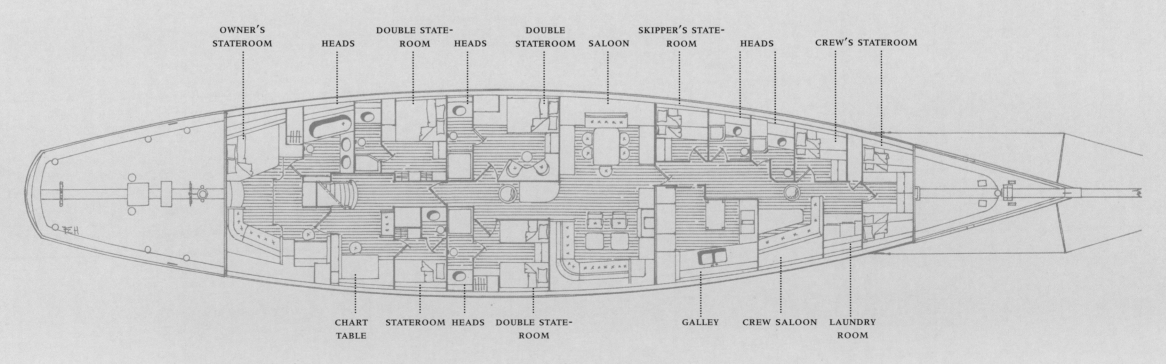

CHART TABLE · STATEROOM · HEADS · DOUBLE STATE-ROOM · GALLEY · CREW SALOON · LAUNDRY ROOM

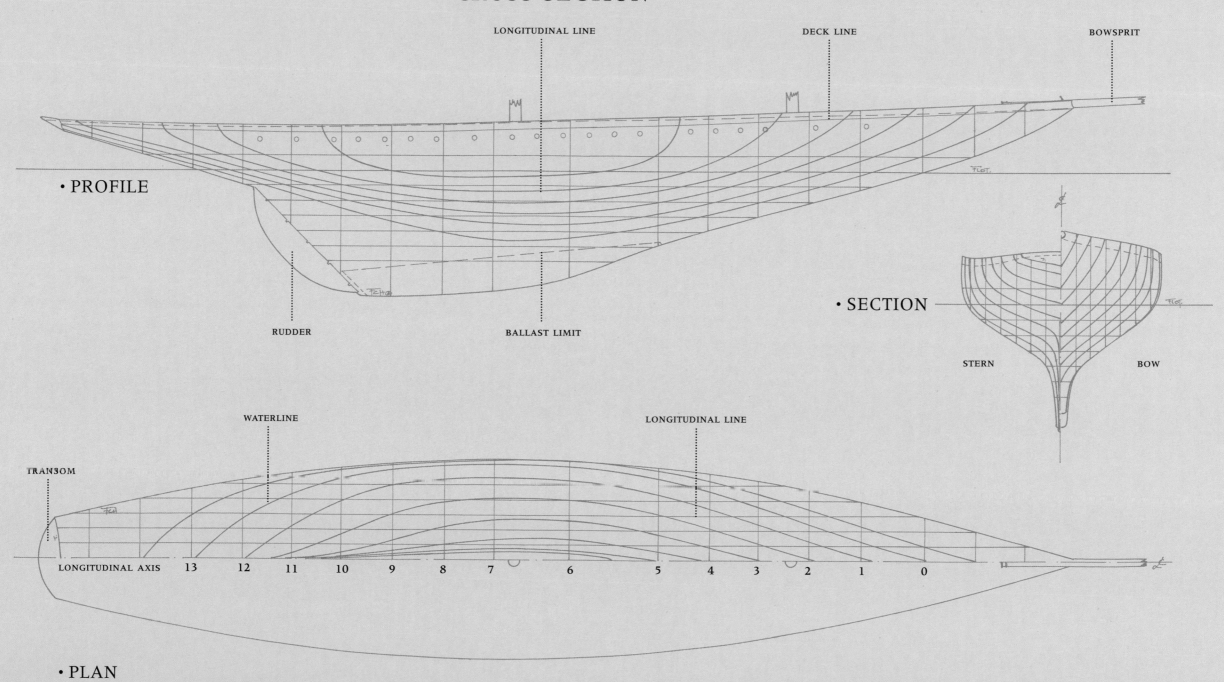

·CROSS SECTION

LONGITUDINAL LINE

DECK LINE

BOWSPRIT

·PROFILE

RUDDER

BALLAST LIMIT

·SECTION

STERN

BOW

WATERLINE

LONGITUDINAL LINE

TRANSOM

LONGITUDINAL AXIS 13 12 11 10 9 8 7 6 5 4 3 2 1 0

·PLAN

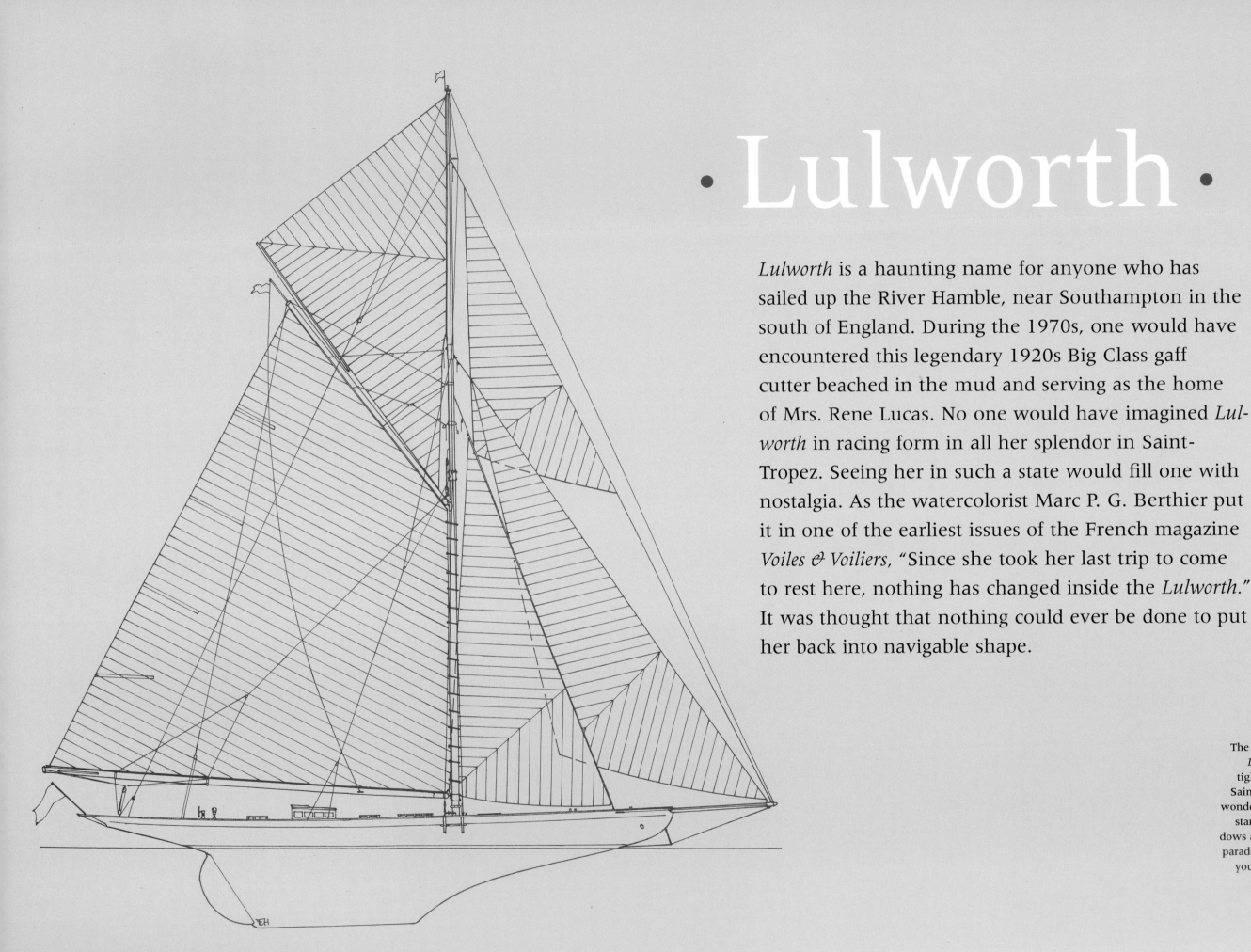

· Lulworth ·

Lulworth is a haunting name for anyone who has sailed up the River Hamble, near Southampton in the south of England. During the 1970s, one would have encountered this legendary 1920s Big Class gaff cutter beached in the mud and serving as the home of Mrs. Rene Lucas. No one would have imagined *Lulworth* in racing form in all her splendor in Saint-Tropez. Seeing her in such a state would fill one with nostalgia. As the watercolorist Marc P. G. Berthier put it in one of the earliest issues of the French magazine *Voiles & Voiliers*, "Since she took her last trip to come to rest here, nothing has changed inside the *Lulworth*." It was thought that nothing could ever be done to put her back into navigable shape.

The magnificent 23-meter *Lulworth* passes by the tightly packed village of Saint-Tropez. You have to wonder how many eyes are staring out of those windows as the stately *Lulworth* parades past. Where would you rather be: out on the water or on land?

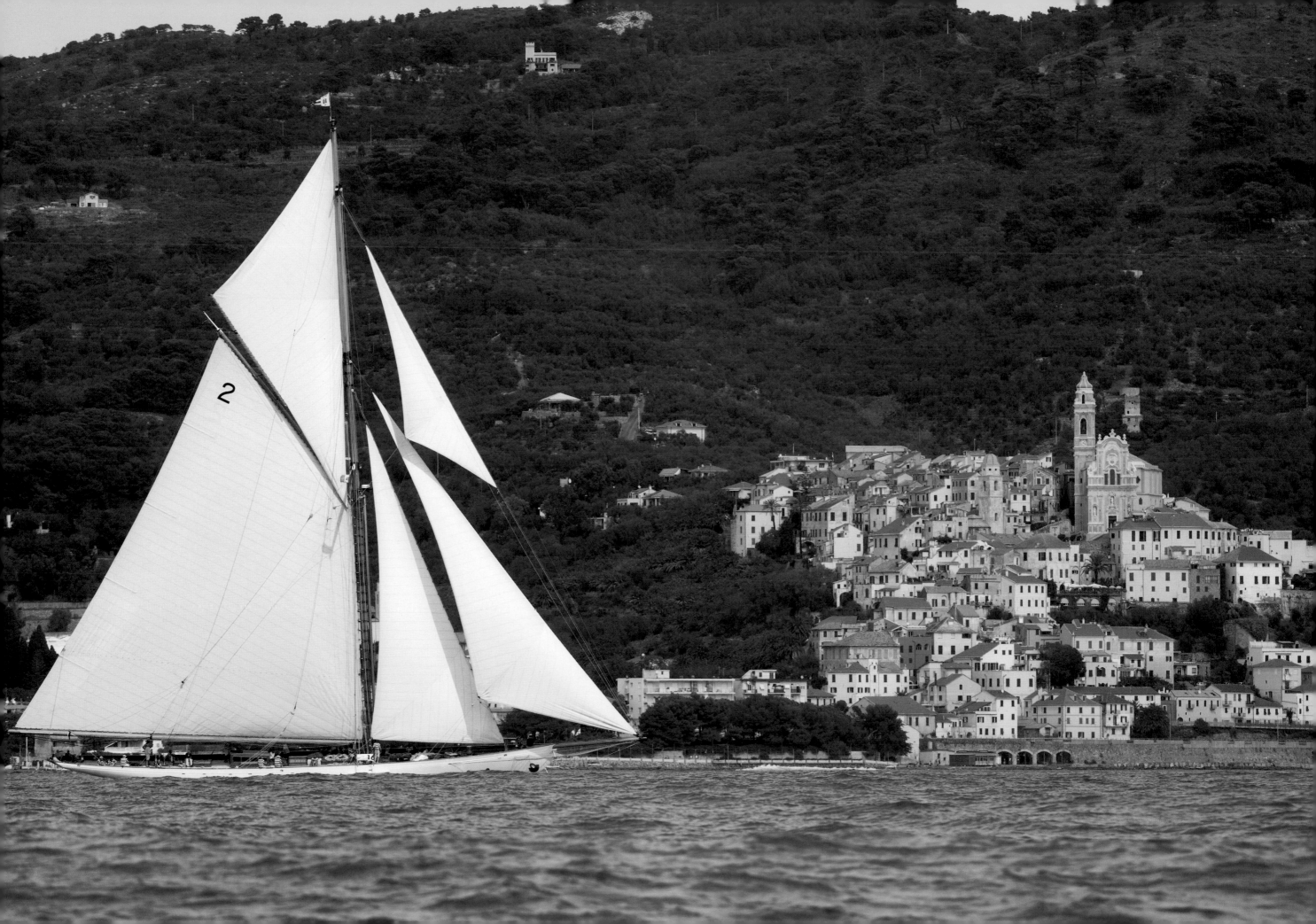

*L*ulworth formerly bore the name of *Terpsichore*, the Greek muse of singing and dancing. In 1920, the main Big Class competitors were *Britannia, Shamrock* (a 23-meter), and *Terpsichore*. The steelmasted yacht was designed by Herbert W. White and launched at White Brothers in Southampton for Richard H. Lee of Torquay. She had been specially commissioned to measure up to *Britannia*, recommissioned in 1919 and apparently very hard to beat.

In fact, *Terpsichore* was not up to the challenge. Her skipper Captain Frederick Morse and her crew did what they could with Morse working closely with his number one and second mate, the brothers Sam and Dan Cozens (Morse's daughter married Sam's son in 1925, a family romance), but the results were disappointing. In a regatta at Cowes, close to the finish line, *Terpsichore* refused to give way to Mrs. Elizabeth Russel Workman's *Nyria*, a large cutter built in 1906 for R.W.N. Young. *Terpsichore* came in first but was disqualified after an appeal. Tommy, Mrs. Workman's son, distinctly recalled the incident in 1989, "We came first, they didn't."

Despite all the care lavished upon the yacht by her owner and skipper, *Terpsichore* displayed fundamental problems of design and balance under sail. She seemed difficult to maneuver in comparison with her competitors. She only won two races out of thirteen in 1921, coming in second twice and third only once. It was in this same year that Mrs. Workman asked Charles E. Nicholson to modernize *Nyria*'s rigging to a one-piece mast Marconi rig, whereas *Britannia* still had gaff rigging. *Nyria* was also the first Big Class yacht to be Bermuda-rigged, i.e., with a triangular mainmast and no topmast. Nicholson subsequently became the ultimate specialist in this type of rigging, until the last J-class, *Endeavour II*, launched in 1937.

Lee had a better year in 1922. He replaced the sails, and she then won half her races, coming in first three times in six regattas. In his memoirs, published in 1950, Captain Tom Diaper remembered his brief service on *Terpsichore* in 1923, when he had been taken on as second mate. Out of fourteen regattas, the yacht recorded three wins and two second places. The cutter had her deck plan and rigging changed, but she was still not really up to scratch. At the end of the season, Captain Diaper was commissioned to correct whatever problem was limiting the yacht, but that winter her owner died suddenly from apoplexy while out hunting.

Terpsichore soon found a buyer in Sir Herbert Weld-Blundell. According to the local newspaper, the *Torquay Times*, the vessel sold at 15 percent less than she had cost Lee four years earlier. In the Weld family, yachting was second nature. Weld's grandfather, Joseph Weld (1777–1863) was the founder of the Royal Yacht Squadron and had had a pond dug on the grounds of Lulworth Castle, the family home near Weymouth, Dorset, so he could perform trials on model yachts. He was the owner of a number of yachts, including *Arrow* (1823), the first *Lulworth* (1828), and *Alarm* (1830), each yacht a monument to the history of English sailing. The original *Lulworth*, for example, was beaten by one second in the 1828 King's Cup, but won it the next year in revenge. *Arrow* and *Alarm* competed in the famous RYS £100 Cup around the

Isle of Wight on August 22, 1851, which gave birth to the America's Cup. In 1857, the two yachts won so many prizes that the club decided to handicap any yachts that had won the cup in the previous year. Joseph Weld took care not to accumulate too many penalties and won all of the cups the following year.

Lulworth, *Originally* Terpsichore

In spring 1924, *Terpsichore* was renamed *Lulworth* in honor of this family history, and Weld commissioned Nicholson to alter her rigging and keel and to increase her ballast. The result exceeded all expectations. In 1925 the cutter saw her finest hour; out of twenty-eight regattas, she won first prize nine times, including the King's Cup, coming in second eleven times and third eight times. She regularly outclassed *Britannia*, the cutter *White Heather II*, and the America's Cup challenger, *Shamrock IV*.

Weld, however, became more interested in exploration and archaeological research and sold *Lulworth* to Sir Mortimer Singer in 1926, who continued to win prizes with his Marconi-rigged vessel. In 1927, he separated from *Lulworth* in order to commission the 23-meter class *Astra* from the Camper & Nicholsons boatyard.

In the following year, the Big Class fleet received a new member, 23-meter class *Cambria*, and Alexander Allan Paton, banker and owner of the Royal Alliance Insurance company, became the happy owner of *Lulworth* as she continued her glorious career. Out of the 247 regattas the yacht raced in the 1920s, she won 114 prizes and 59 victories, 47 of them in the final five years.

After 1930, the American influence had reached as far as the Solent, and the rules changed. International Rule no longer governed yachts; it was replaced by the Universal Rule created in the United States in 1903 by Nathanael Herreshoff. The America's Cup was the reason for the creation of J-class yachts such as *Endeavour* and *Velsheda*. *Astra* and *Candida*, former 23-meter class yachts, were converted to J-class by the master craftsman Nicholson. Even *Britannia* succumbed to the fashions of the day. In 1933, Paton sold his big cutter for health reasons, but *Lulworth* retained her 1926 rigging and no one was prepared to invest the huge sums required to convert her into a J-class.

Immobile, *but Kept Safe*

From 1933 through 1937, *Lulworth* belonged to Mrs. May A. Beazley of Hythe, Kent, England, whose manor house almost faced the premises of the White Brothers yacht builders. In 1935, the yacht was converted into a cruising ketch, and Carl Bendicks, the chocolate magnate, then became her owner. Bendicks cut a new set of sails for her and installed a powerful six-cylinder inboard motor with the aim of sailing her around the world. However, the

Opposite
The crew of the *12* collectively breathes a sigh of relief after narrowly crossing the starboard tacking *Lulworth*, which had the right-of-way. Notice no member of the crew on either boat looks at the other, an indication that the course ahead is more important than the water left behind.

Page 68
Different boats sail different angles depending on the sails they set, the length of the waterline, and the shape of the hull. It looks as if this fleet might arrive at the same point at the same time.

Page 69
A meeting between two famous yachts. Famed ocean racer, the late Eric Tabarly, would have appreciated the revival of his legend.

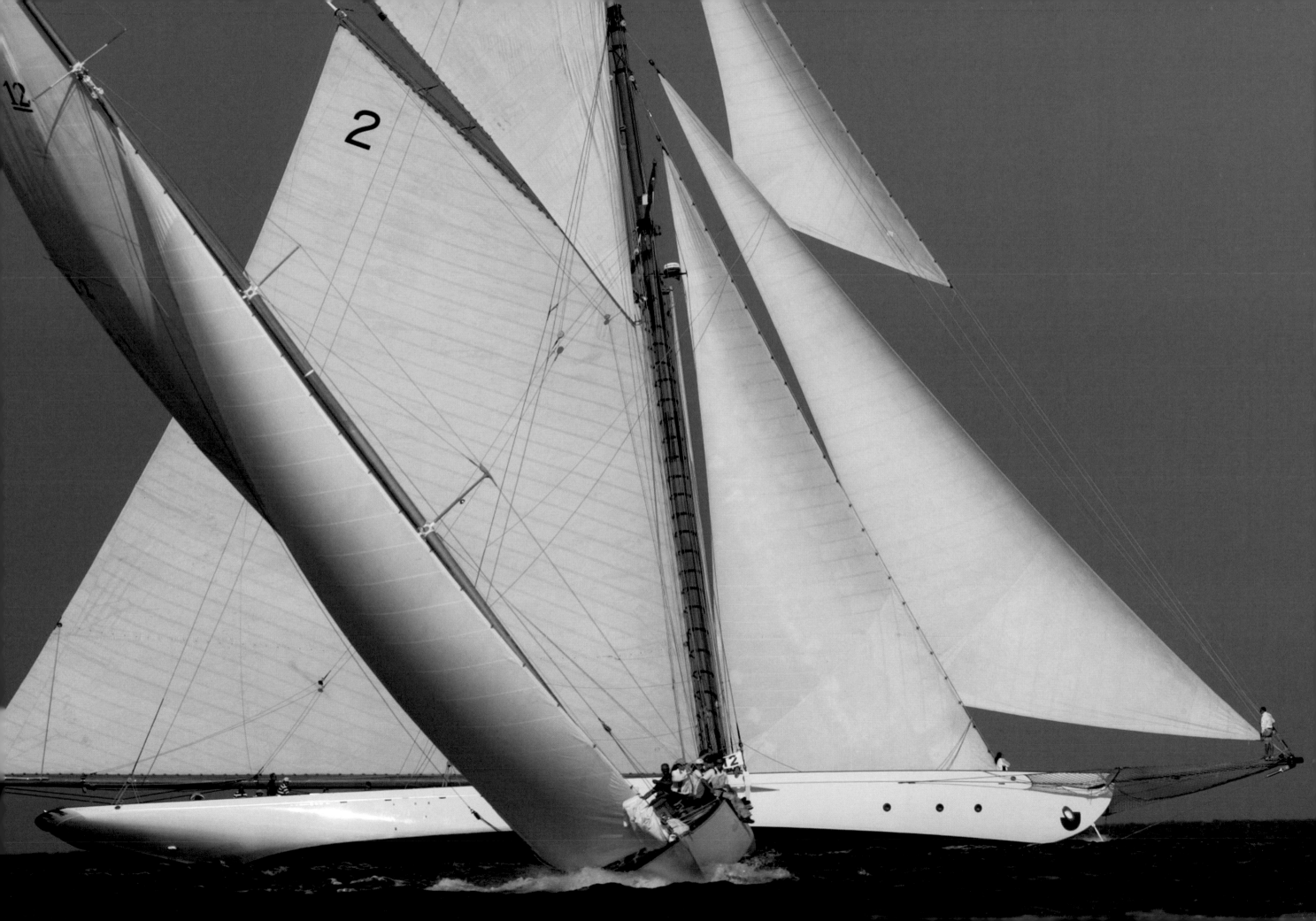

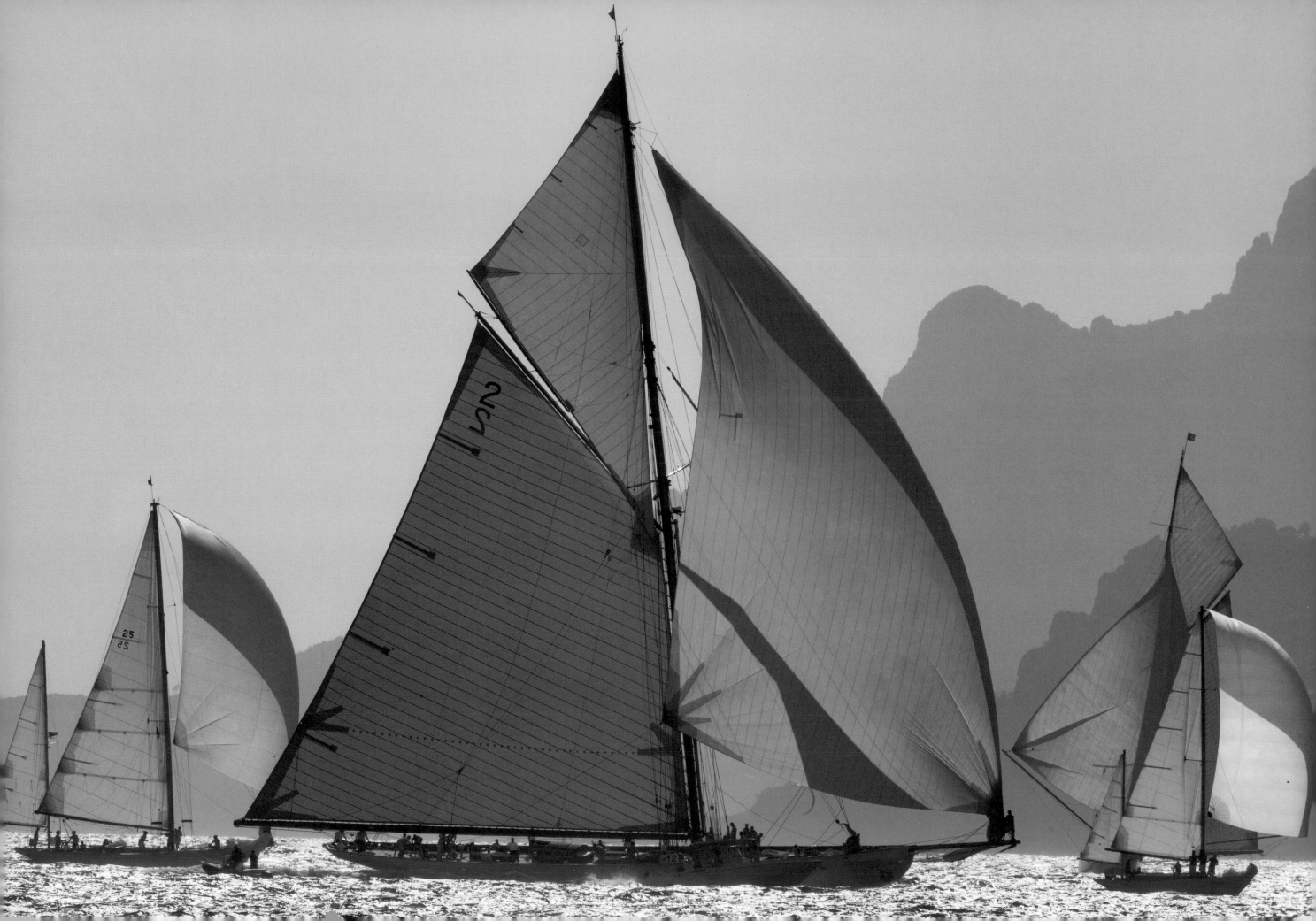

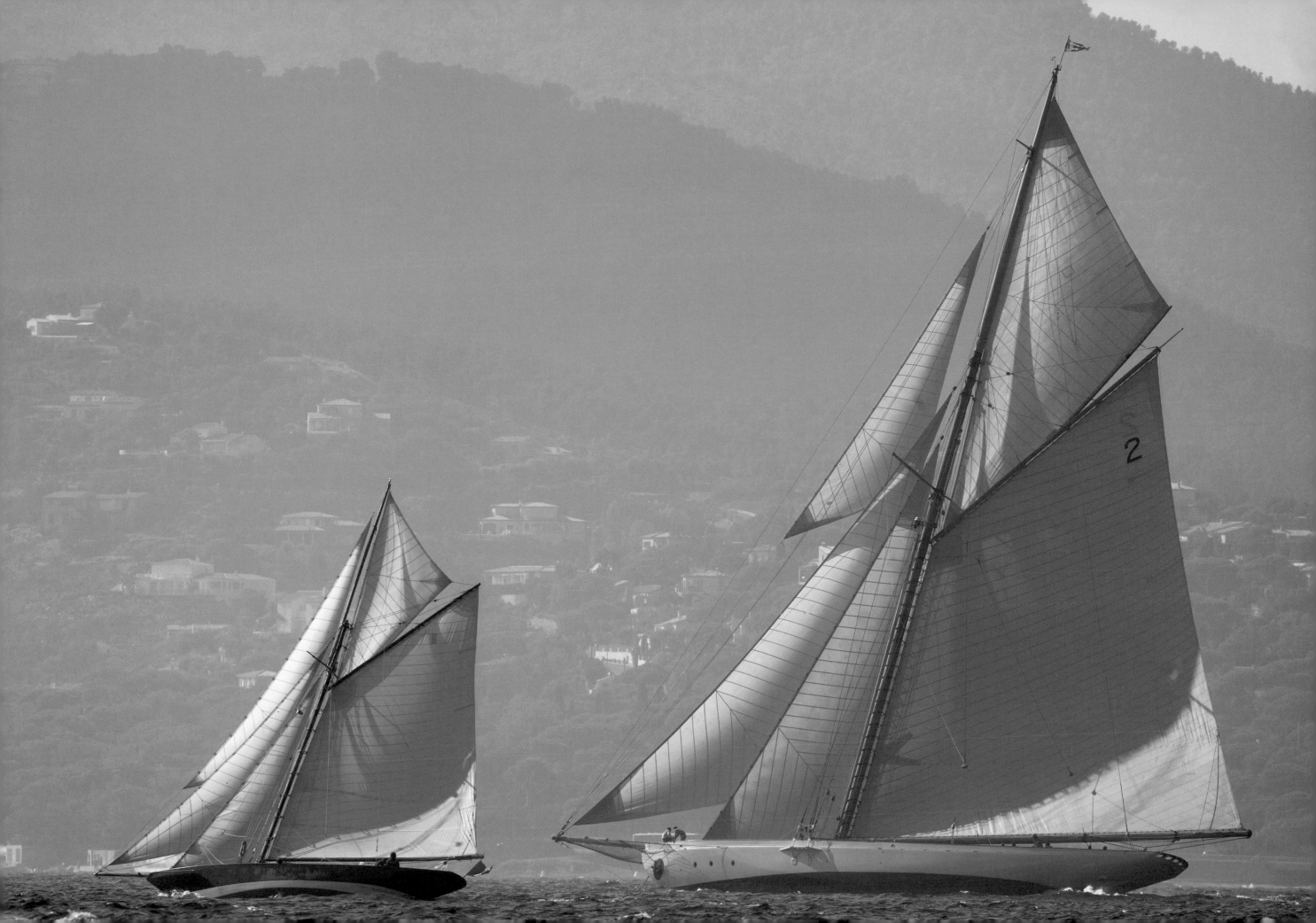

advent of the war put an end to the project, and instead he sent the yacht to Camper & Nicholsons. Bendicks sold the ketch in 1943 to Norman Hartley of Oldham, northeast of Manchester. Hartley kept her dry-docked, where she was damaged in a German air raid, her masts broken and her bulwarks damaged. The yacht was on the verge of being abandoned to a sad fate.

Mr. and Mrs. Richard Lucas recovered *Lulworth* in 1947. For four years, they persevered to give her a new chance at life. Lucas was a champion rower, five-time winner at Henley, and silver medalist in the 1920 Olympic Games. He already owned *Kingfisher*, a Brixham trawler that he had converted into a yacht, and had recovered the large J-class *Endeavour* and *Lulworth* that were destined for the breaker's yard. *Lulworth* was first sent to the White Brothers for restoration. The head of the workshop and the manager were thus once again able to work on the yacht on which they had cut their teeth. During the first stage, the Lucases spent their weekends stripping and refinishing the varnish and repairing the deck. They then decided to live aboard *Lulworth* as she sat beached in the River Hamble mud at Crableck Marina. Richard Lucas died of a heart attack in 1968 while sailing his centerboarder, so Rene Lucas remained on board, continuing to repair the varnish. Finally, in 1988, she moved out of her "home." Two years later, the hull was transported on a barge to the Beconcini boatyard at La Spezia, Italy, under the supervision of Nicholas Edmiston and William Collier, then agent for Camper & Nicholsons. The new buyers, the Colombo-Vink family, fell victim to a financial swindle and could not recover their investment, so the hull remained untouched for ten years, embroiled in legal wrangles. Fortunately, the boatyard had taken the precaution of preserving her in a closed container with all her equipment, fittings, and fixtures dismantled.

Another Fairy Tale

It is hard to imagine how a hull measuring more than 120 feet (36 m), the subject of legal machinations, abandoned and unmaintained for years, could ever be rescued. In this case, the fairy godfather was played by Giuseppe Longo, an Anglo-Italian master carpenter who at the time was working on behalf of Johan van den Bruele to complete restoration work on *Iduna*, a mixed sail and motor yacht built in 1939 by De Vries in the Netherlands. His restoration yard had been built from scratch in Viareggio, near Pisa, Italy.

Van den Bruele had previously only owned motor yachts and had only become interested in sailing shortly before *Iduna*. He knew something about restoration, however, because as a property developer he had revived a fourteenth-century monastery to convert it into a hotel, as well as several other buildings. One day, Longo took him to see *Lulworth* at the Beconcini yard. The carcass of the ship so impressed van den Bruele that he knew this was going to be his master project. With *Iduna*, he would be giving the Netherlands back the finest of its pleasure craft, and he would become one of the elite saviors of the finest yachts in the world. He would compete in Big Class regattas with *Lulworth*, the largest gaff cutter ever to be restored.

Left
There is no wake, but 14,316 square feet of sail enable this yacht to glide over the water.

Opposite
The crew member perched at the tip of the bowsprit looks too tiny to be able to handle the thousands of square feet of sail above his head.

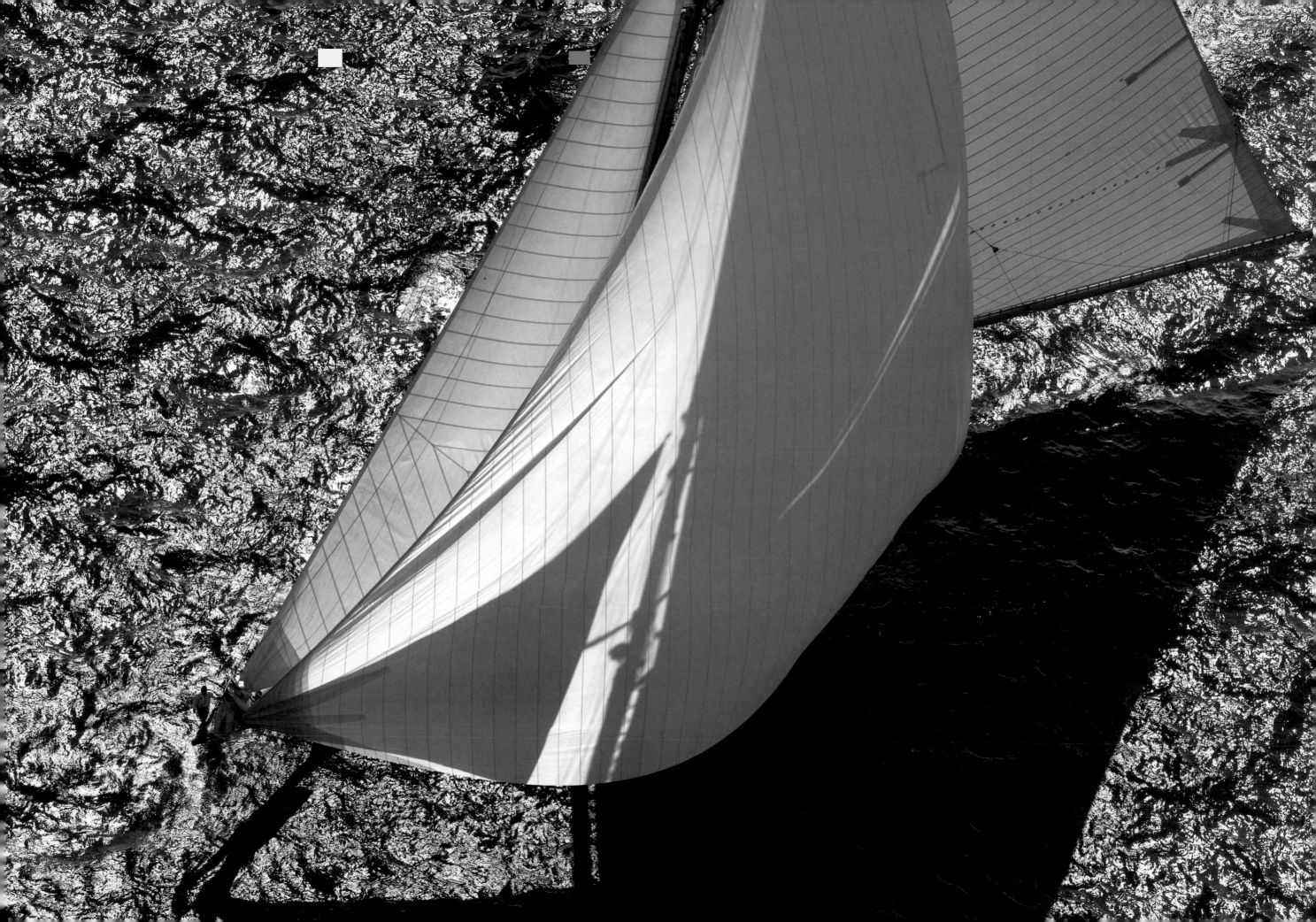

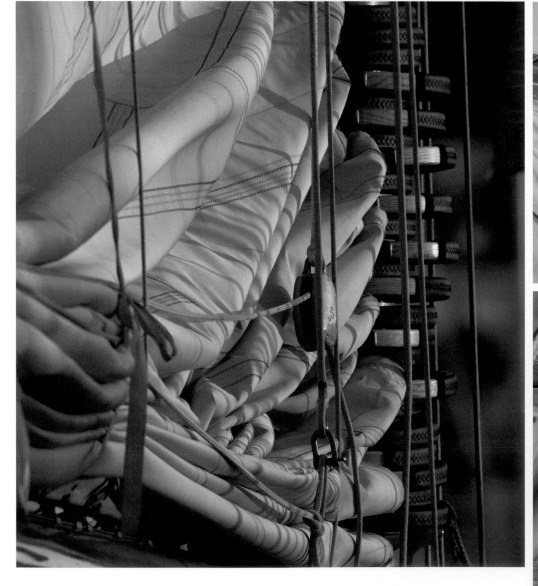

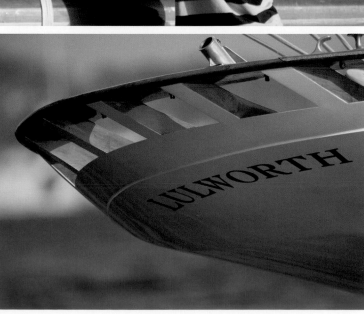

Left
Although the name on its side is *Lulworth,* the ship's bell bears her original name, *Terpsichore.* On board, experienced sailors must hoist and take down these huge canvas sails. An original fairlead and the name proudly painted on the stern.

Opposite
There's plenty of work left to do to reduce the sail to the first reef.

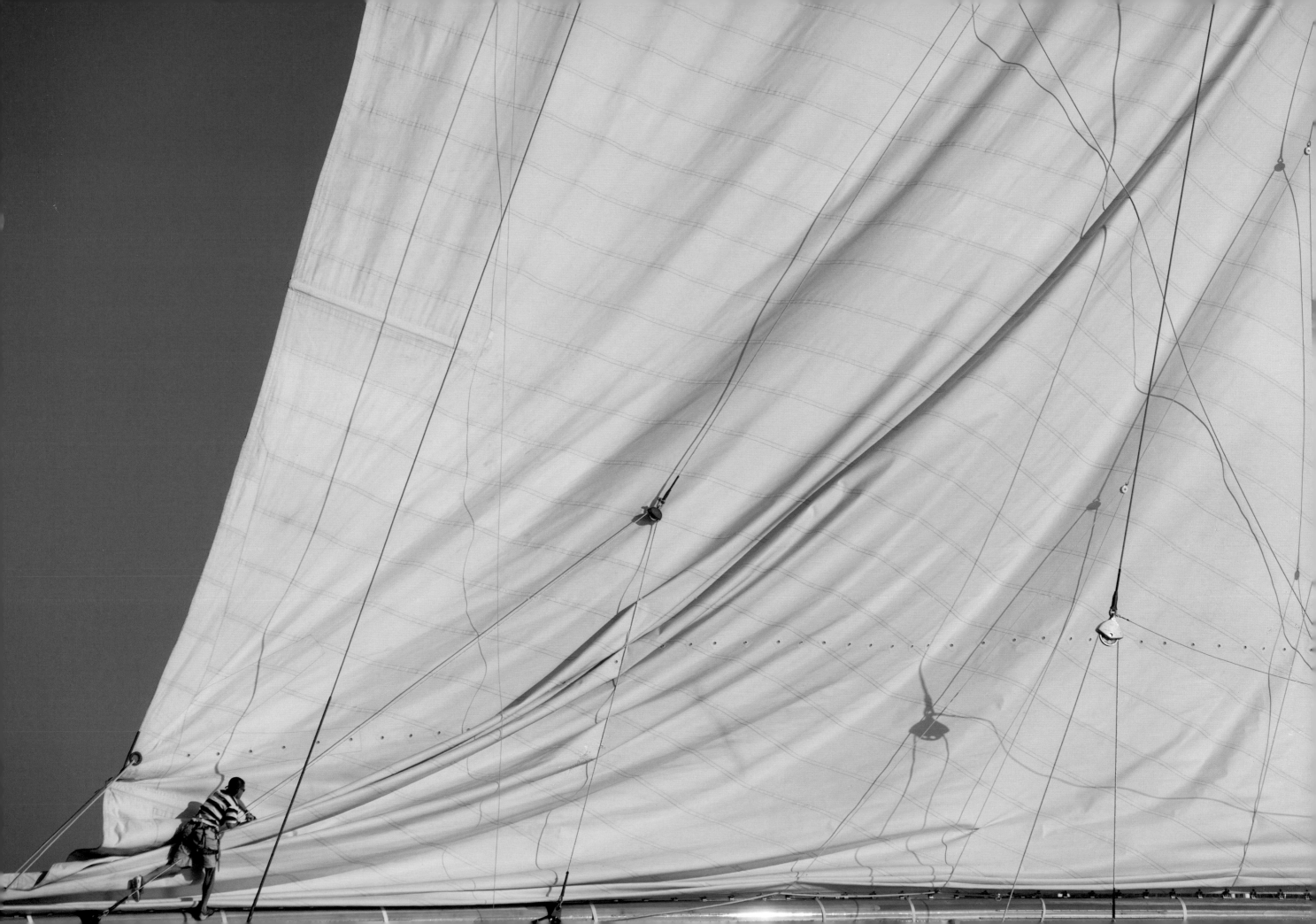

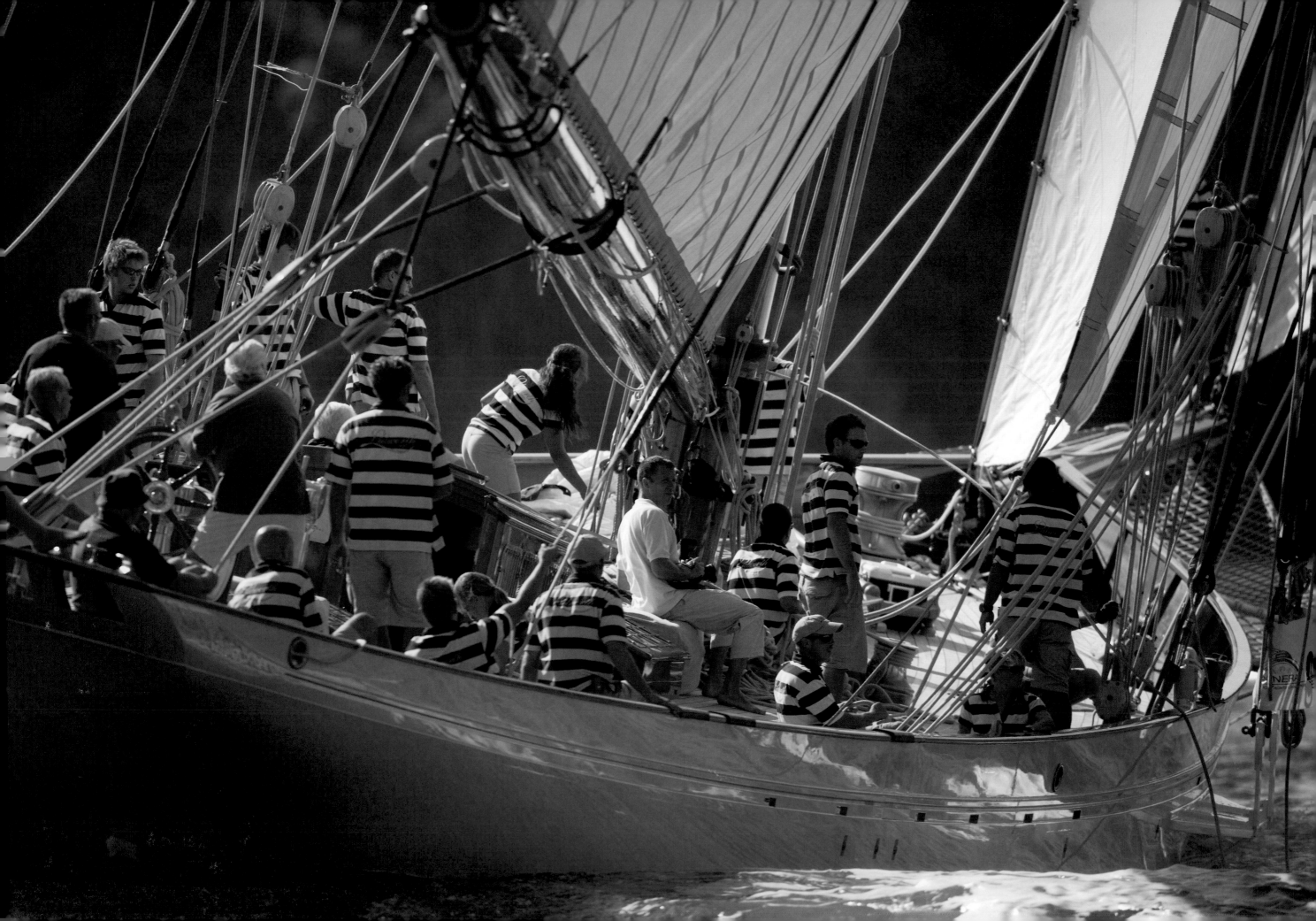

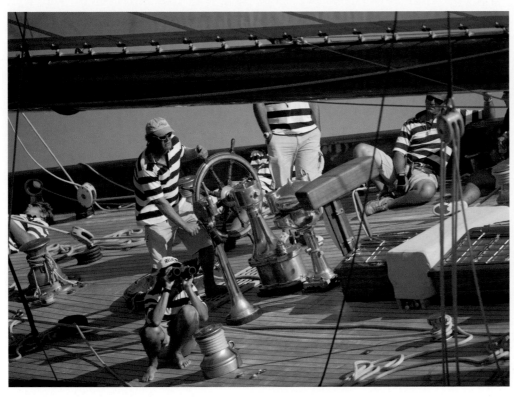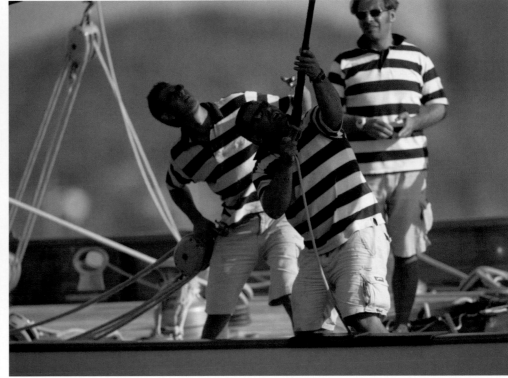

After lengthy negotiations, van den Bruele and Longo finally managed to recover the hull and drag her out of the doldrums in which she had been mired. During the summer of 2001, *Lulworth* was transported to Classic Yacht Darsena at Viareggio, where she lay next to *Iduna*. The first move by the new owner was to consult the greatest specialists and research as much as possible so that the restoration would most closely match the original condition of the yacht. He contacted all of the descendants of the former owners and consulted the archives of the National Maritime Museum and Lloyd's Register in London. The hull of the yacht was subjected to very special testing. The structure had suffered considerably from spending forty years in the mud with a water level that varied daily and then eleven years in dry dock under the burning Italian sun. A very detailed report of the condition and shape of each rib and a comparison with the original cross section plans were compiled; then everything was compiled on a computer, making it possible to establish the extent of the damage and work out a schedule of operations. A study by architect Paul Spooner showed that the lines of the boat had hardly changed.

The Restoration of the Century

Lulworth certainly survived these difficult years owing to her steel ribs and Honduras mahogany planking of the finest quality. It took eight months for her deteriorated ribs to be replaced one by one, with a cross-member RSJ keeping everything in shape. The metal was chemically analyzed to find out how much wear it had experienced and how much resistance it still had, and any damaged part was replaced by another of the same steel composition. Those involved agreed to preserve and repair those parts that still retained 25 percent of their original resistance, and to replace the rest. This meant dis-

mantling the ribs, then identifying each rivet hole and the position of each plank. None of the planking was recoverable. Nineteen Honduras mahogany logs had to be sawn into 300 47-foot (14-m) long and 2¾-inch (7-cm) thick planks. Eight men were needed to install the planks, with the help of two sets of block and tackle. No fewer than 9,800 holes were drilled for bolting the planking to the ribs, using a Teflon joint to prevent electrolytic corrosion between the steel ribs and bronze alloy bolts. Most of the planks could be installed by holding them in place with c-clamps. Those farthest to port had to be heated as on old wooden ships, with a fire below to mold them into shape.

On deck and down below everything was done to retain the turn-of-the-century look. Thanks to an unlimited budget, each part could be restored to its original condition, even if it cost twice as much. Stefano Faggioni, famous all over the world as an architect who restored antique yachts, was commissioned to design the interiors. "We religiously preserved the style. So if you open the door of a piece of furniture, you feel like you are discovering an antique." He studied the details so carefully that some of the original bronze fittings that had been preserved, such as certain lamps or the door handles on the refrigerators, were reduced in size. In fact, Longo estimates that 90 percent of the deck fittings and 80 percent of the interior are original. Since the renovation lasted for nearly five years, a number of items that had belonged to the ship could be recovered, and some were sent back voluntarily, such as the tiller, which had decorated Harry Spencer's desk in Cowes. Naturally, it was Spencer, with architect Gerard Dijkstra, who took care of the rigging, following the 1926 sail plan with the topsail bent toward the mainmast, this being the ship's finest hour.

Finally, on Valentine Day's morning in 2006, *Lulworth* was placed in the Viareggio dry dock and the gates opened to let the water in. She sails again and, according to van den Bruele, will continue to do so for at least the next hundred years.

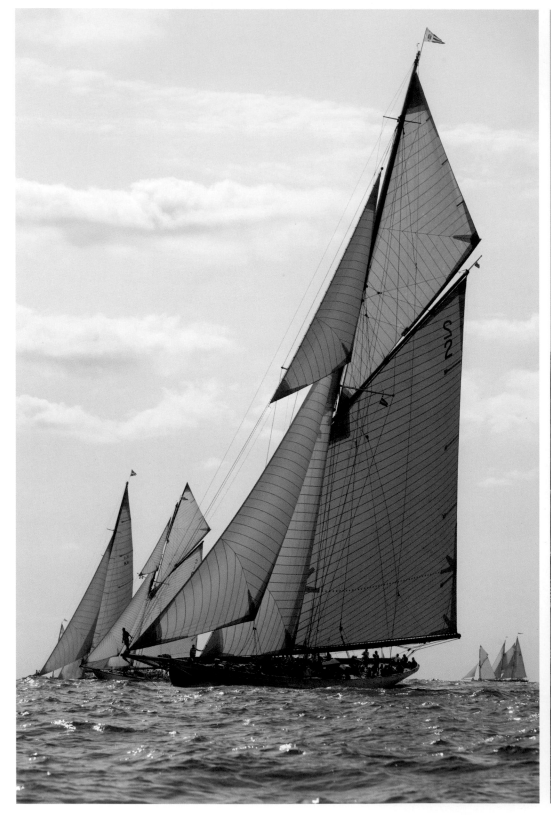

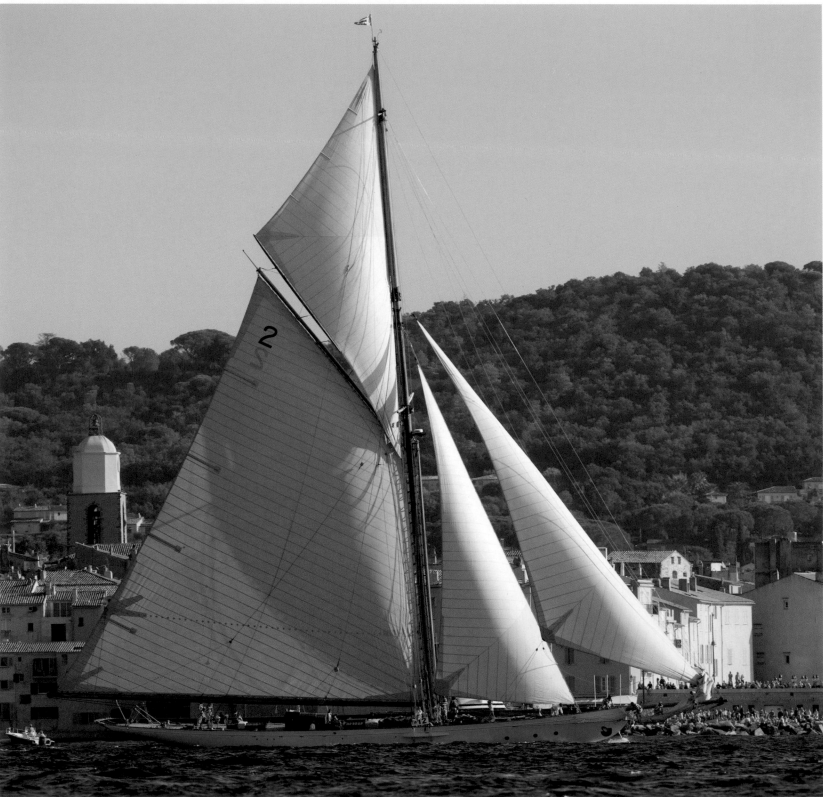

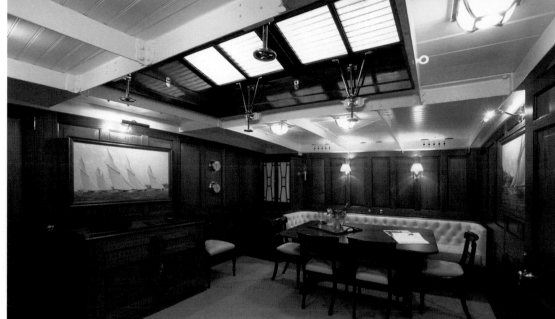

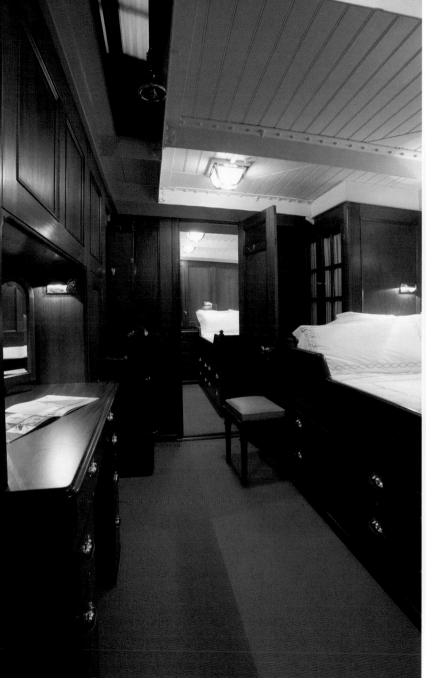

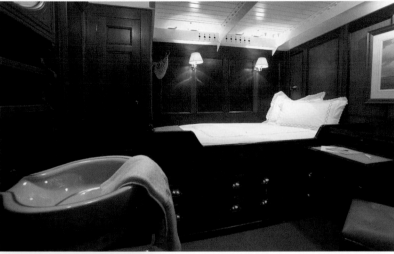

· FEATURES ·

Name: LULWORTH
Architect: Herbert W. White
Builder: White Brothers, Southampton
Rigging: gaff cutter
Launched: 1920
First owner: Richard H. Lee
Original name: TERPSICHORE
Restoration: 2006
Boatyard (restoration): Classic Yacht Darsena, Viareggio
Architect (restoration): Paul Spooner, Studio Faggioni
Construction: composite, mahogany over steel ribs

Overall length: 498 feet 5 inches [46.30 m]
Deck length: 396 feet 10 inches [36.87 m]
Length at waterline: 264 feet 10 inches [24.60 m]
Maximum beam: 77 feet 6 inches [7.20 m]
Draft: 56 feet [5.20 m]
Ballast: 78 tons
Displacement: 188 tons
Approximate sail area: 2,757 square feet [828 m²]
Engine: Yanmar 380 CV
Generator sets: Northern Lights 16 kVA

· DECK PLAN ·

PORT

DOGHOUSE SKYLIGHT CHANNELS AFT STAIRWAY BREAKWATER ANCHORAGE BOWSPRIT

HATCH

MAINSAIL TRAVELER RACK STEERING WHEEL SKYLIGHT STAIRWAY SKYLIGHT MAST PIN RAIL CLEAT WINDLASS

STARBOARD

· LAYOUT ·

HEADS GUEST STATEROOM SALOON GALLEY

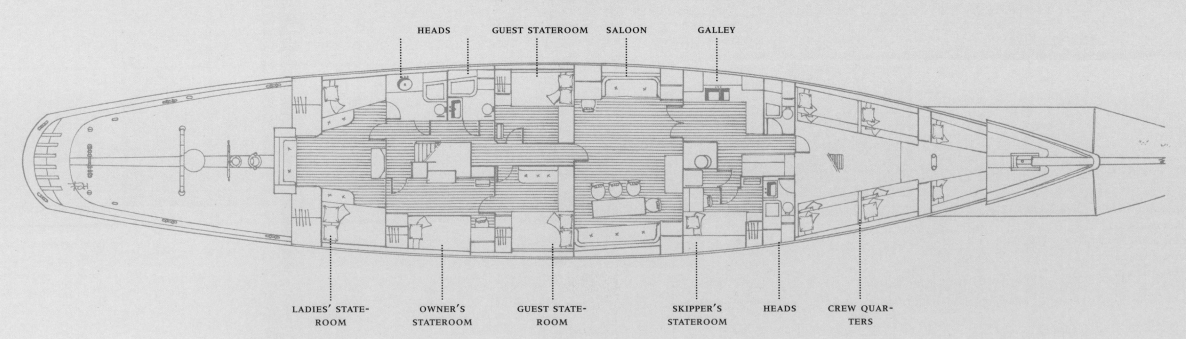

LADIES' STATE-ROOM OWNER'S STATEROOM GUEST STATE-ROOM SKIPPER'S STATEROOM HEADS CREW QUAR-TERS

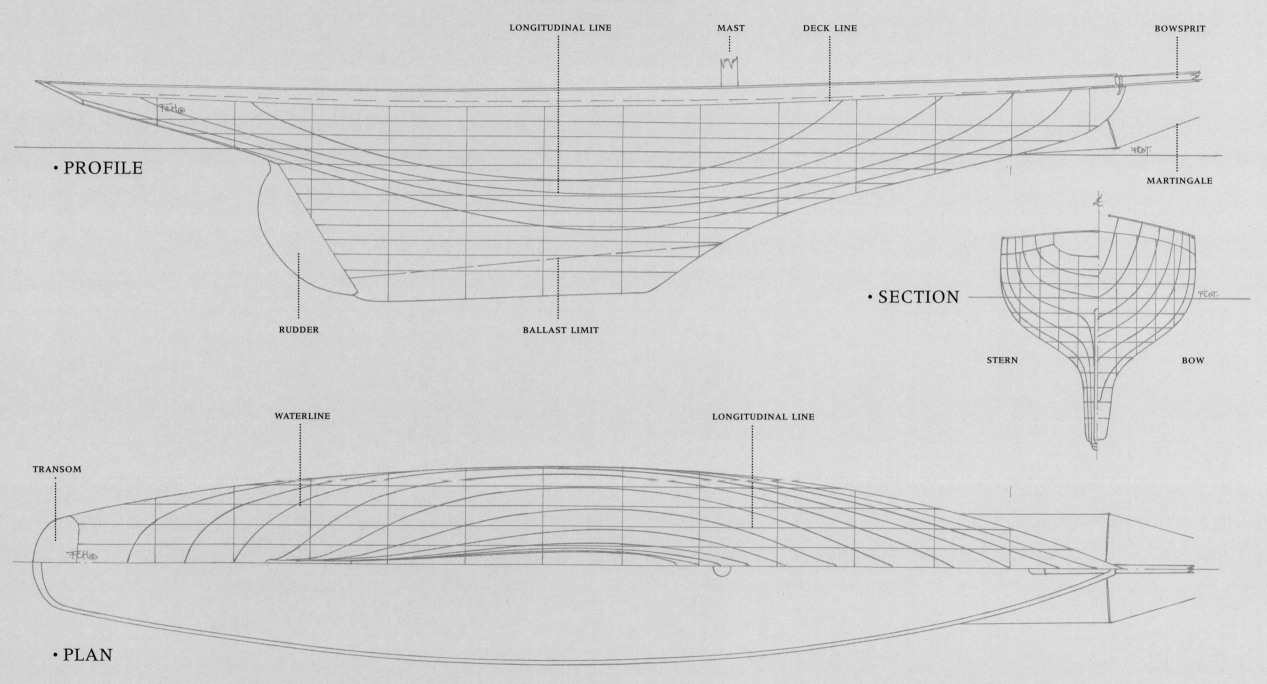

CROSS SECTION

LONGITUDINAL LINE MAST DECK LINE BOWSPRIT

• PROFILE

MARTINGALE

RUDDER BALLAST LIMIT

• SECTION

STERN BOW

WATERLINE LONGITUDINAL LINE

TRANSOM

• PLAN

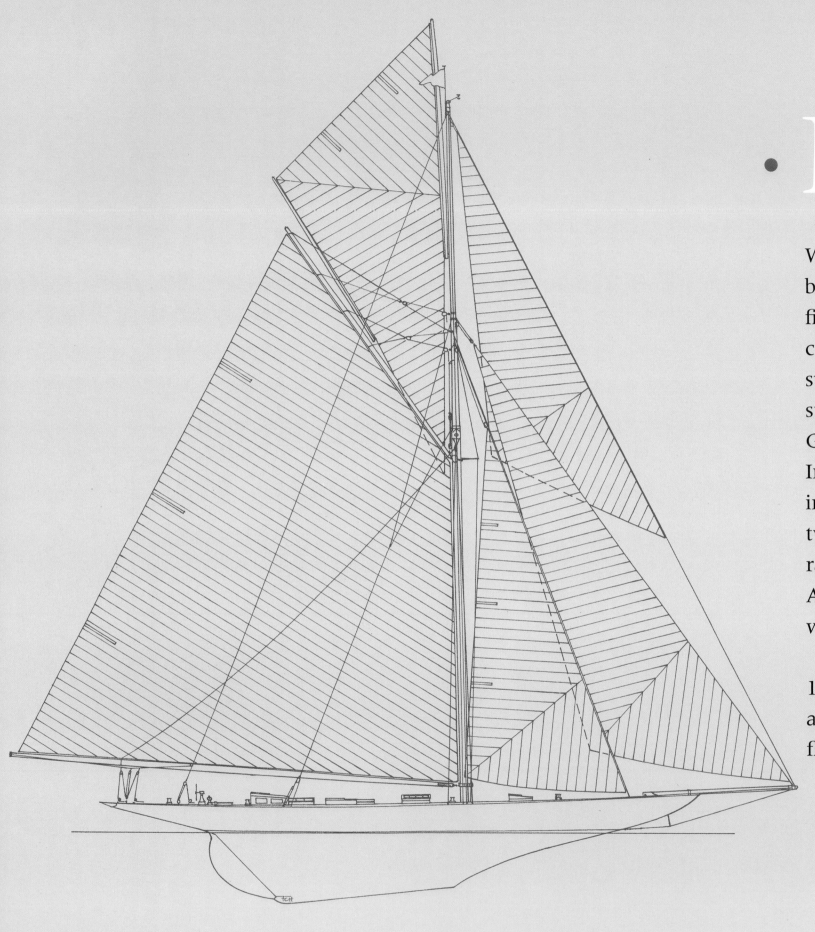

· Mariquita ·

What yacht owner doesn't dream of possessing a boat even larger than the last? Some owners of fifteen-meter yachts did not consider their interiors comfortable enough. Perhaps they got too wet in a stiff breeze or found traveling long distances— such as on the Clyde in Scotland, in Spain, or in Germany—too difficult with this size vessel. The International Rule list for 1906 was already quite important with nine series of between five– and twenty-three–meter yachts. A new nineteen-meter rating was thus added for the summer of 1911. And the International Rule nineteen-meter class was born.

Four yachts were commissioned for Christmas 1910, including *Mariquita*, which continues to sail as she did in the early days of this impressive but fleeting series.

The class one *Mariquita* (W. Fife, 1911) is the first of six nineteen-meter yachts ever built. The rest are *Corona* (W. Fife, 1911), *Octavia* (A. Mylne, 1911), *Norada* (C. & N., 1911), *Cecilie* (M. Oertz, 1913), and *Ellinor* (G. Borg, 1913).

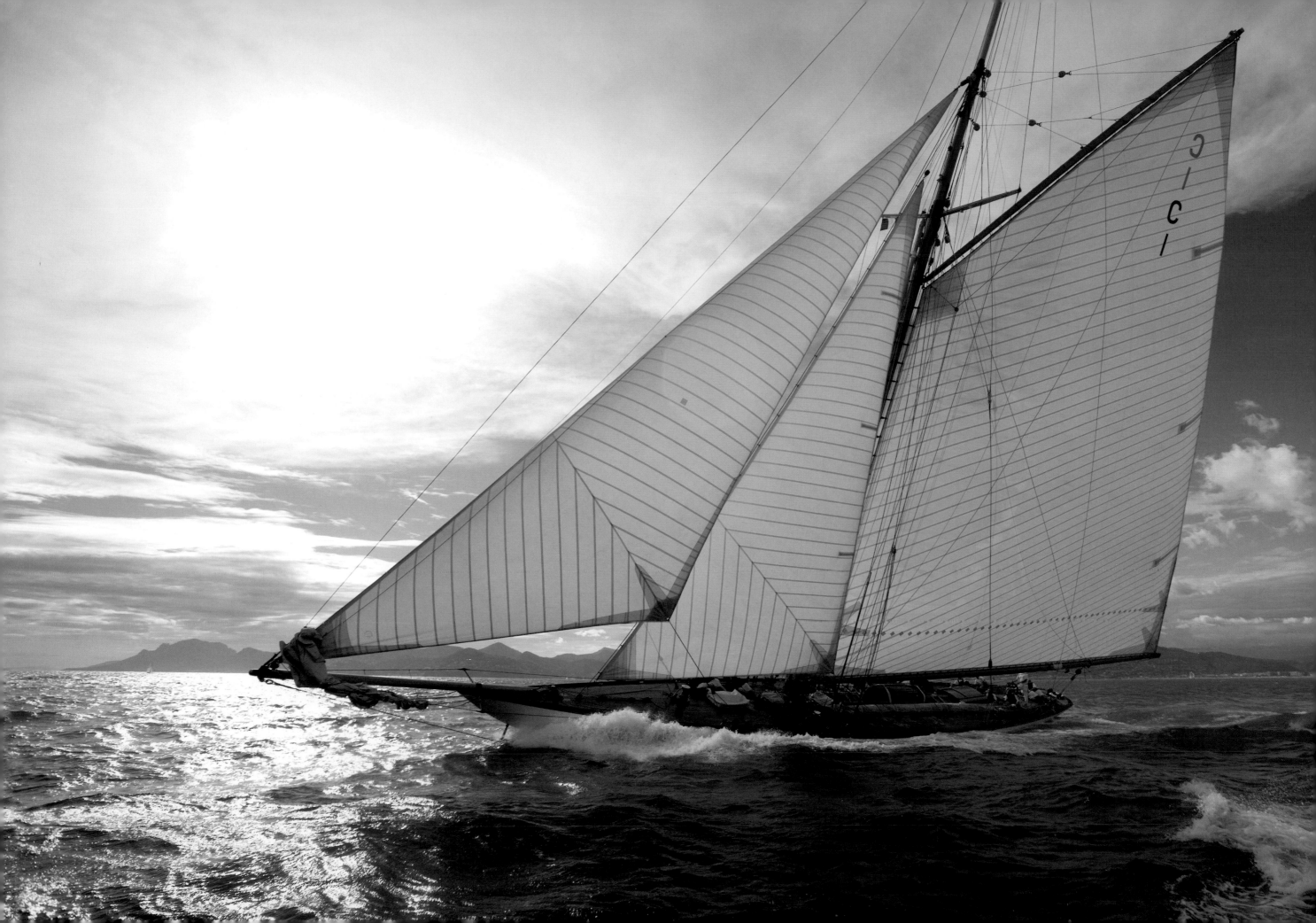

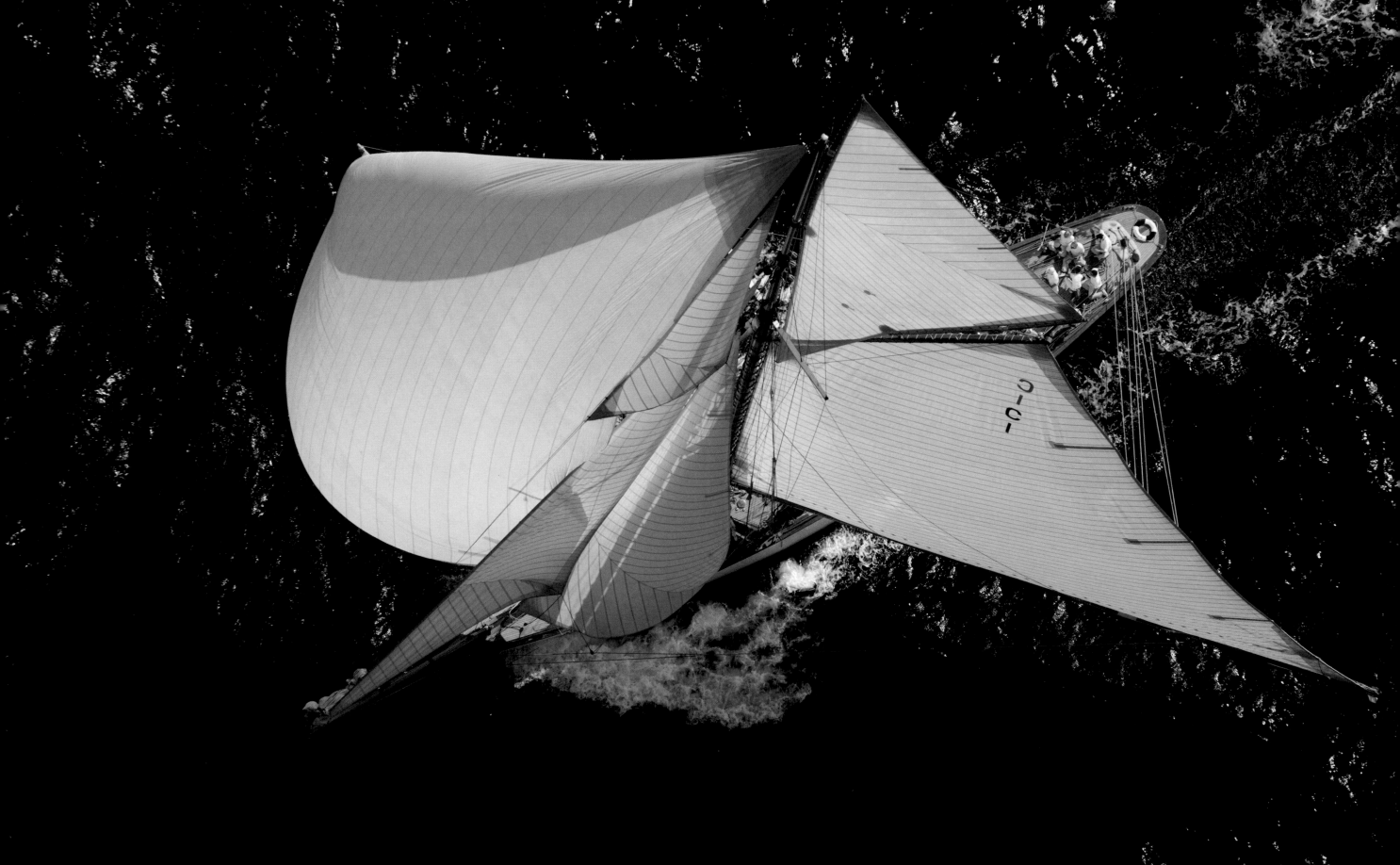

The four owners of the first nineteen-meter class yachts were connoisseurs. They wanted to do battle in vessels that came close to the Big Class, without the price tag of 23-meter yachts or schooners. They had carefully assessed the size of these yachts in relation to purchase price and cost of maintenance. Even if a nineteen-meter yacht (with a hull length of 93 to 100 feet [28 to 30 m]) was slightly more expensive to buy than a fifteen-meter, it was half the price of a 23-meter. A crew of ten or twelve would be sufficient, whereas, in addition to the captain and boatswain, six or seven men would be needed to handle a fifteen-meter yacht and around twenty for a 23-meter yacht.

A. K. Stother had commissioned several cruising yachts in the 1890s. In 1900, he ordered the handsome yawl *Nebula* by Frederick Shepherd from White Brothers, and four years later, the big yawl *Rosamond* designed by William Fife, which he raced until 1907. For the following season, Stother ordered the fifteen-meter *Mariska* from William Fife & Son at Fairlie. In the fall of 1910, he was the first person to commission a nineteen-meter from this same architect. The yacht he bought was *Mariquita*.

William P. Burton from Suffolk, England was an enthusiastic racing yachtsman and a member of ten of the most active yacht clubs in England. He captained his own yachts and even though he collected them, he would also part with them just as quickly to get the chance of ordering an even more powerful vessel. Burton had been racing in regattas since the early 1890s, he had owned four 52-foot yachts in succession, ancestors of the fifteen-meter vessels: *Penitent* (plan by Arthur Payne, 1896), *Gauntlet* (also designed by Payne, 1901), *Lucida* (a Fife plan, 1902), and *Britomart* (plan by Alfred Mylne, 1905) with which he had won no fewer than ninety-seven prizes in four years. In 1909 and 1910, Burton dominated racing in his fifteen-meter *Ostara*, a Mylne design, built by R. McAlister & Son boatyards in Dumbarton, near Glasgow, Scotland. However, at the end of the season, Burton sold *Ostara* to a Frederick Last and ordered an even bigger yacht. He entrusted the design of his second nineteen-meter vessel to Mylne once again. *Octavia*, also built by R. McAlister & Son, was his third ship from the Scottish architect.

Almeric H. Paget came from a family that had traditionally had large sailing or steam yachts, though smaller racing yachts were not ignored. He was also a member of around ten yacht clubs and vice commodore of the Royal Thames Yacht Club. In 1908 he bought the fifteen-meter *Ma'oona* (Alfred Mylne, 1907) from J. Talbot Clifton, selling her to Misters Guest & Gore so as to afford ordering the nineteen-meter *Corona* from William Fife III for the 1911 season. He purchased her jointly with Richard Hennessy, a yachtsman who owned several racing and steam yachts.

The fourth owner, Frederick Milburn, loved big boats. His schooner *Norlanda*, designed by Charles E. Nicholson in 1904 and launched in the following year in Gosport, enabled him to compete in one regatta after another. He asked his architect to design him a nineteen-meter for 1911 to allow him the option to race in regattas or to follow them, depending on his mood. Nicholson took advantage of this to try and improve on the 23-meter *Brynhild II* that he had designed two years earlier. *Norada*, Milburn's new yacht, was wider and had a far larger sail area than those of her rivals. She was certainly hard to beat, even with a captain and crew who, although excellent sailors, were not used to competing in regattas. Nicholson repeated the architectural options of *Norada* in the fifteen-meter *Istria* that he designed for Charles C. Allom a year later.

These racing vessels needed more experienced skippers to captain them. As chance would have it the Big Class was not very active during the 1911 season, so the best captains were available for nineteen-meter yachts.

Essex, Home to the Finest Crews

For *Mariquita*, Stother hired Captain Edward Sycamore, of Brightlingsea, Essex, who normally skippered Sir Thomas Lipton's 23-meter yacht. For *Corona*, Paget and Hennessy chose Captain Stephen Barbrook of Tollesbury, not far from Brightlingsea, where the young Alex Laird would find the hull of the cutter *Partridge* in 1980. The crew consisted of sailors seasoned in regatta racing, all of them from the Blackwater Estuary. Burton, as was his custom, skippered his yacht *Octavia*; his number one was the excellent Captain Albert Turner of Wivenhoe, again in the Brightlingsea region. *Norada*, skippered by the captain of Lipton's cruising schooner, had little chance of victory in competition with the old hands of the other yachts.

It is interesting to note that the wages paid to the crew could vary depending on their success in regattas. At that time, a season lasted for twenty-two weeks and wages were disbursed weekly. A captain would earn £150 (about $300), but a boatswain, cook, or steward would only get one-fourth this amount, and a crewman, one-tenth. Crew members who had to take big risks, such as the man who had to go aloft to maneuver the topsails or climb to the tip of the bowsprit to change the foresails would get around two shillings (about 50 cents) more. When racing, a crewman would earn an extra pound ($2) for a regatta won and half that if the boat lost. Wages did not include meals and the crew had to arrange for their own provisions, except during certain regattas when it was impossible to prepare food, which would then be compensated with extra pay. The owners retained the cups won as prizes, but the prize money could easily amount to a couple of thousand dollars in a good year, and sometimes even more. Prize money was distributed to the crew at the end of the season. Every year, sailing magazines would add up the prize money won and the money paid to all the winning yachtsmen. At the end of the summer, the owners laid up the yachts, and the crew members went home, back to their usual occupation of manning the fishing boats.

A Plentiful Season

The regatta season begins in late May, so April is the preferred month for launching racing yachts. Thus, in April 1911, *Mariquita* launched from the William Fife & Son boatyard on the Clyde at Fairlie, with all the standard precautions due to her deep draft. She was then fitted out at Gourock,

Opposite
All sails are forward on this yacht, and yet the crew is well aft trimming the sheets. The most forward sail (the working jib) is blanketed by the clouds of canvas behind it.

Pages 84–85
When wind and sea combine, everything must be stowed away on board, and only the spray spurts everywhere. It isn't all clear sailing, but it is navigation.

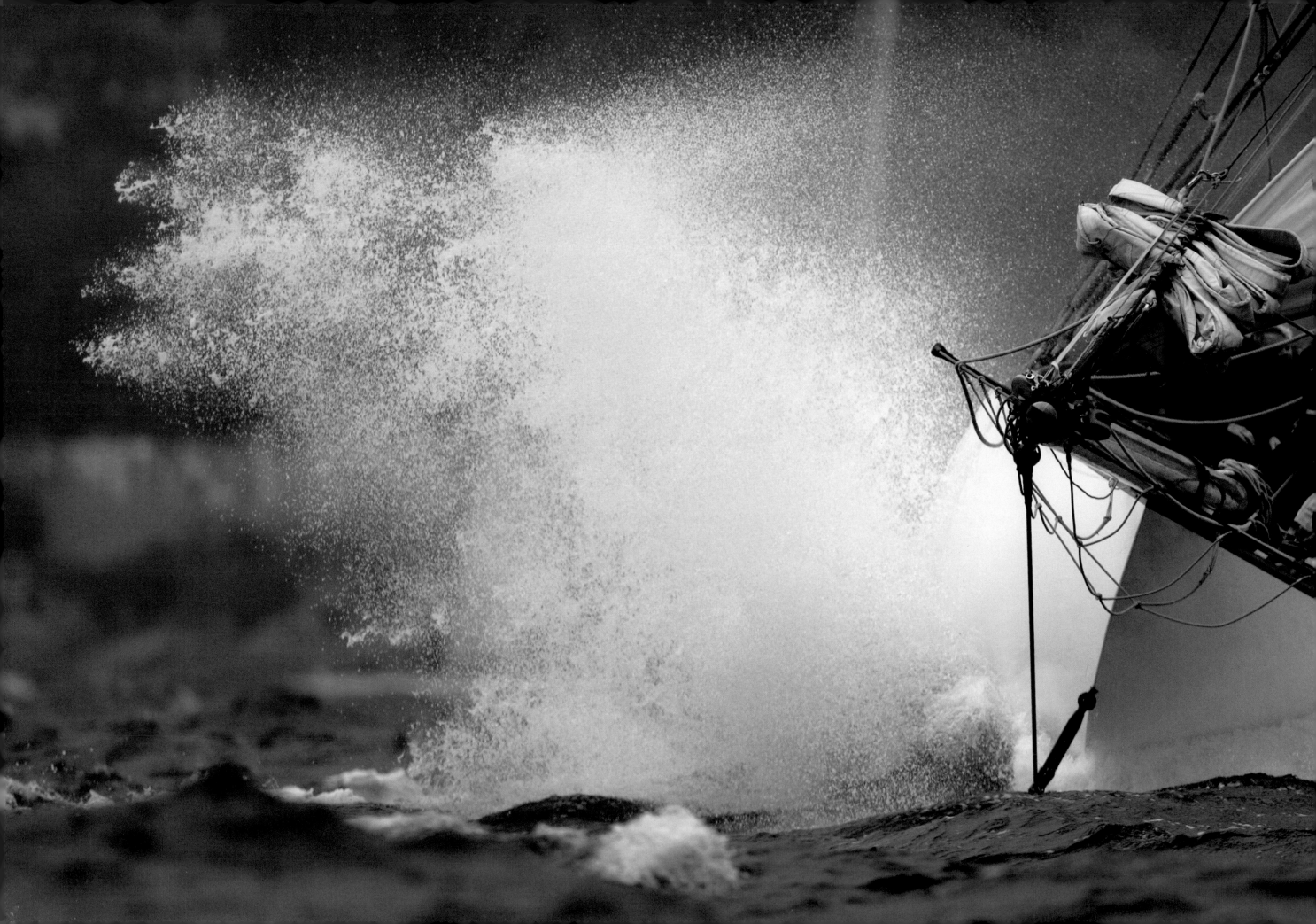

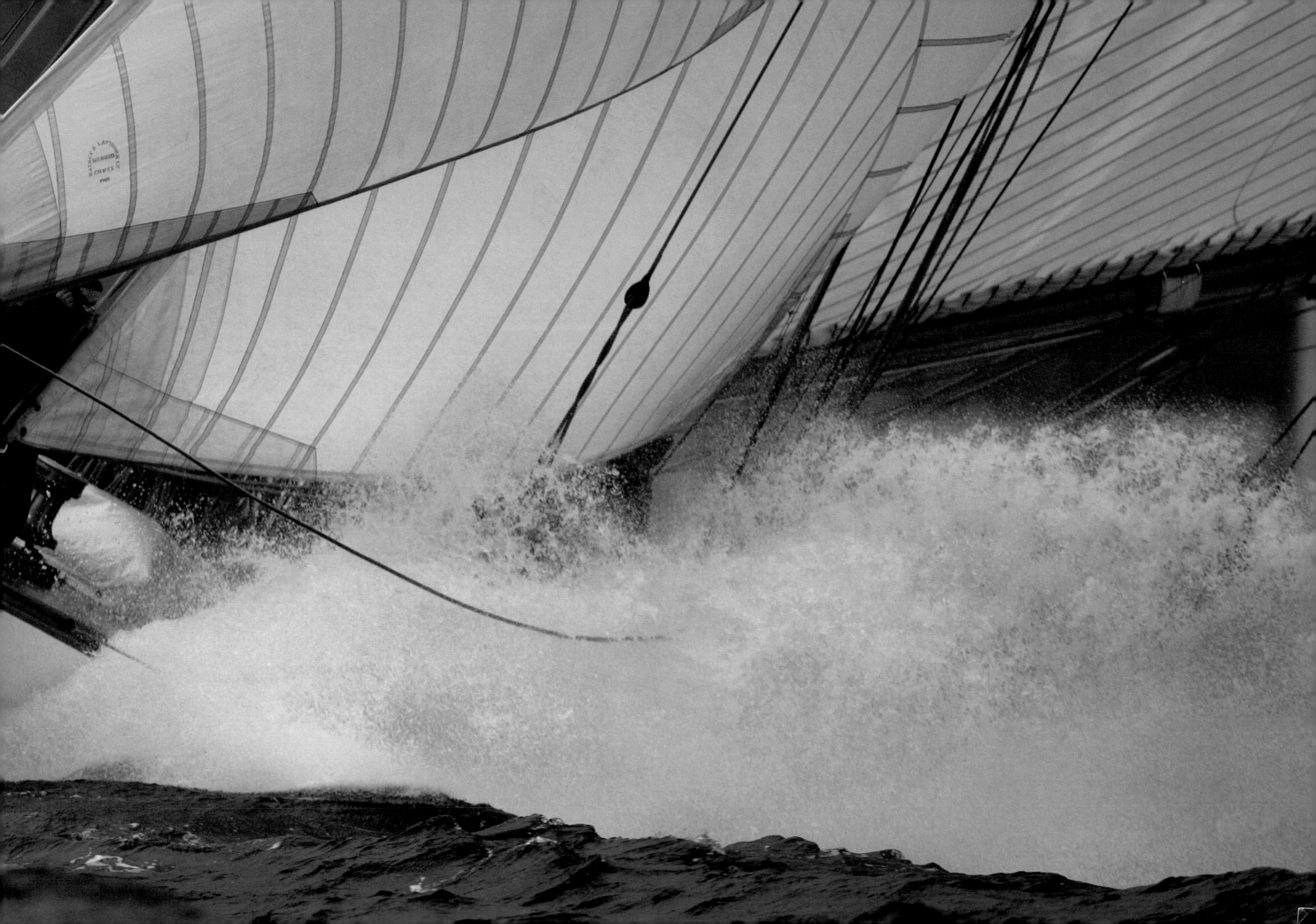

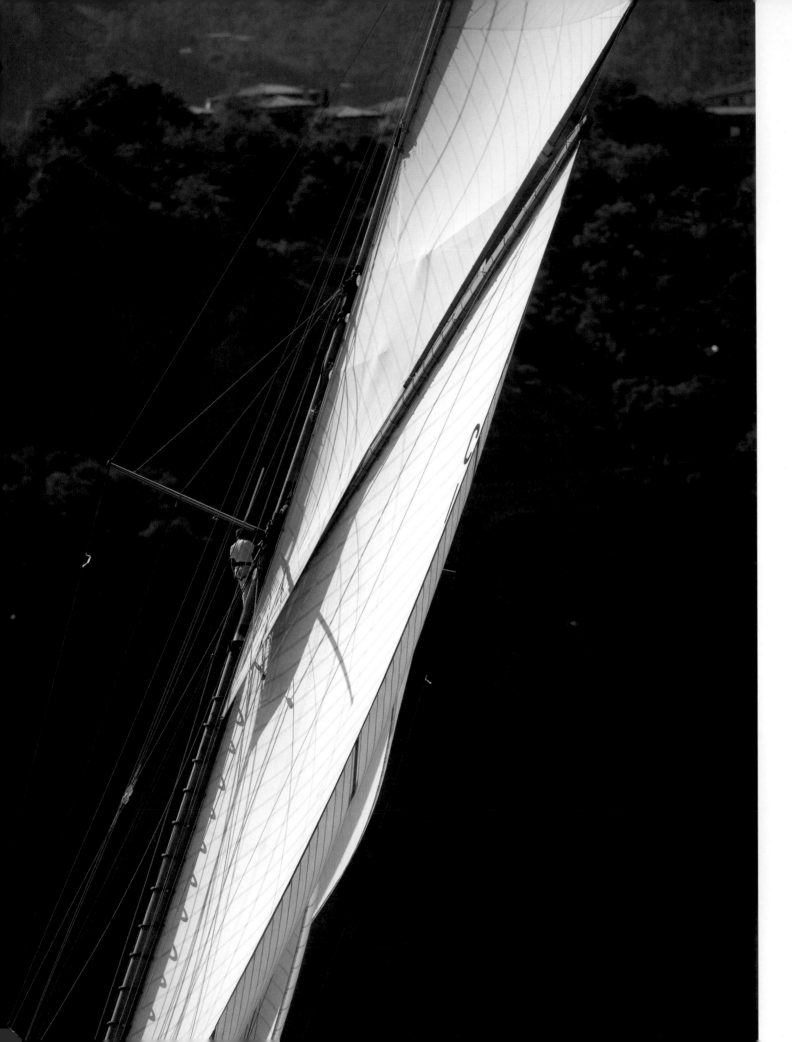

farther up the Clyde at the entrance to the port of Glasgow where the quays were capable of handling large vessels. Then it was *Corona*'s turn, in the same boatyard *Octavia* was being launched at Dumbarton on the opposite bank of the Clyde, closer to Glasgow. *Norada*, commissioned late in the year, launched last, in mid-May, at Gosport, Hampshire, the home of the Camper & Nicholsons boatyard. She was fitted out in record time; it took only nine minutes from the moment the hull touched the water to the moment she received her mast. *Norada* left to join the other nineteen-meter craft at the end of the month.

About forty thousand sailors attended the first regattas that year, held on Saturday, May 27, 1911 by the Royal Thames Yacht Club (RTYC), between the mouth of the Thames Estuary and Harwich, north of Essex, which can welcome the largest yachts. All of the captains and their crews, including Burton, were in home waters. They knew each quirk of the coastline and the slightest current and reef. An easterly breeze was blowing into the three mainsails marked with a C followed by a number. *Mariquita* (C1) finished first, after five hours, thirty-seven minutes, and twelve seconds, followed by *Corona* (C3) four minutes and ten seconds later, and *Octavia* (C2) one minute thereafter. On the following Monday and Tuesday, *Mariquita* won again at the regattas sponsored by the Royal Harwich Yacht Club. On June 5, in the Orwell Corinthian Yacht Club regatta, after *Mariquita* retired from the race, *Corona* beat *Octavia*. Two days later, Nicholson was at the helm of *Norada* (C4) and joined the three nineteen-meter yachts for the Royal Thames regatta in the estuary. *Corona* had broken her steering system and could not enter the race. However, *Norada* arrived after *Mariquita* and *Octavia*. On June 8, *Octavia* won the Essex Yacht Club race with *Norada* once again bringing up the rear. Yet Nicholson remained convinced of *Norada*'s ability; he realized that he was catching up with his competitors several times, but the crew often maneuvered the yacht clumsily, while his opponents were very rarely caught out that way.

Two days later, *Norada* beat *Octavia,* and *Mariquita* won the RTYC Nore Island race, from the middle of the Thames estuary to Dover. The next events were held off Cork, on the south coast of Ireland, on June 16 and 19. *Octavia* was the winner on the first day, *Mariquita* seizing victory on the second. On June 21 and 22, in the 50-mile race held by the Royal Irish Yacht Club, *Octavia* won the King's Cup. Two days later, during the Royal Ulster Yacht Club regattas, *Octavia* collided with *Mariquita*, the only yacht to finish—*Corona* was still having steering problems and *Norada* was having crewing problems. Three days later, it was *Mariquita*'s turn to hit *Octavia* in the stern.

The Big Cups

Next came the regattas held in Scotland on the Clyde. Nicholson persuaded Milburn to take on Captain Alfred Diaper, who had won fame for his Big Class victories on all the major European circuits, as skipper. Diaper brought his own crew with him, and the battle between the four nineteen-meter vessels became even fiercer. *Corona* won the Royal Northern Yacht Club's King's Cup on the Clyde, over a square 30-mile circuit, finishing in three hours, nineteen minutes, and twenty seconds. Two days later, *Norada* beat *Octavia*

Left
Whenever the big topsail needs to be trimmed, a crew member is sent aloft. During a regatta, he also climbs up to survey the wind.

Opposite
Mariquita labors as she sails over a wave with both sails winged out.

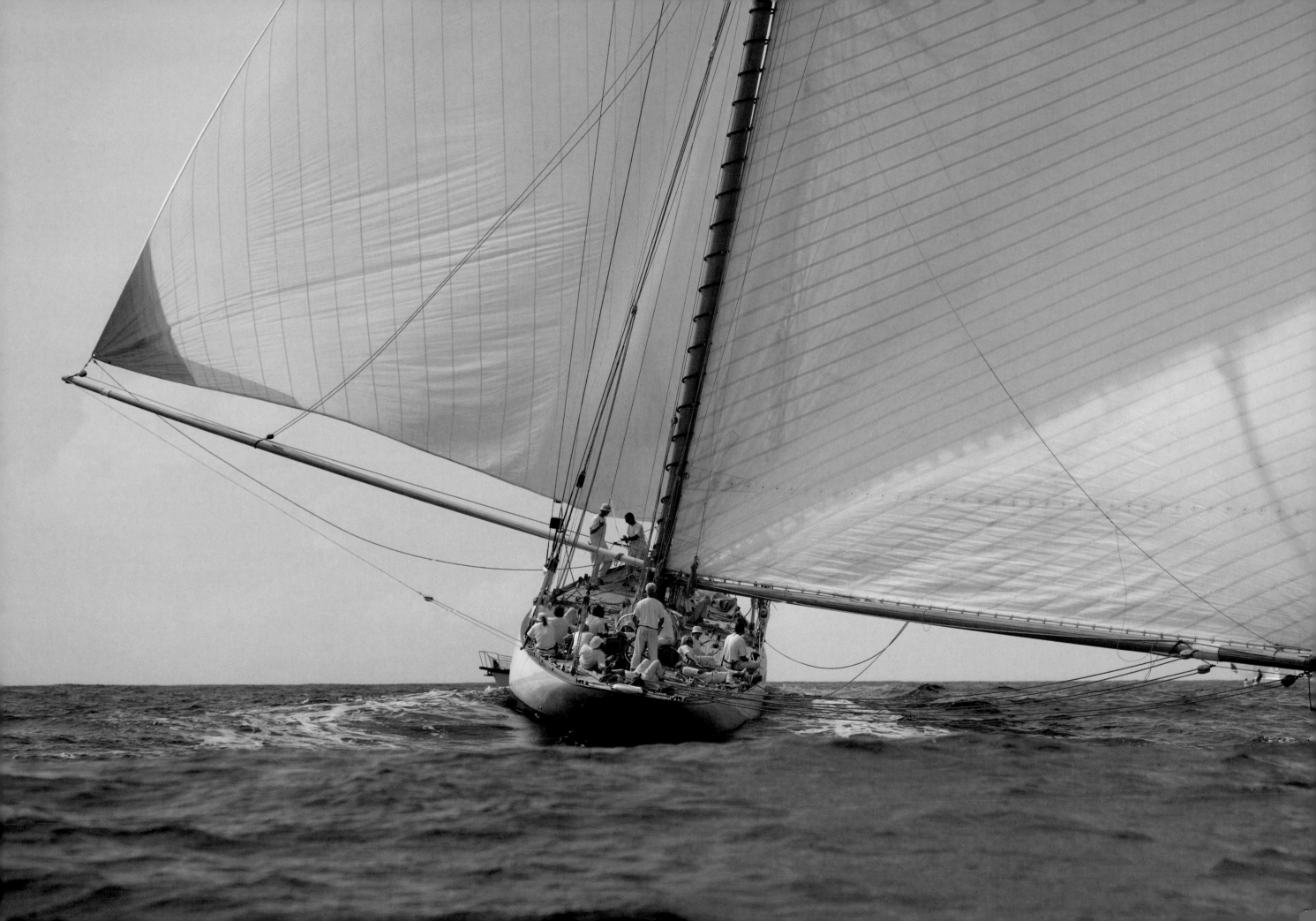

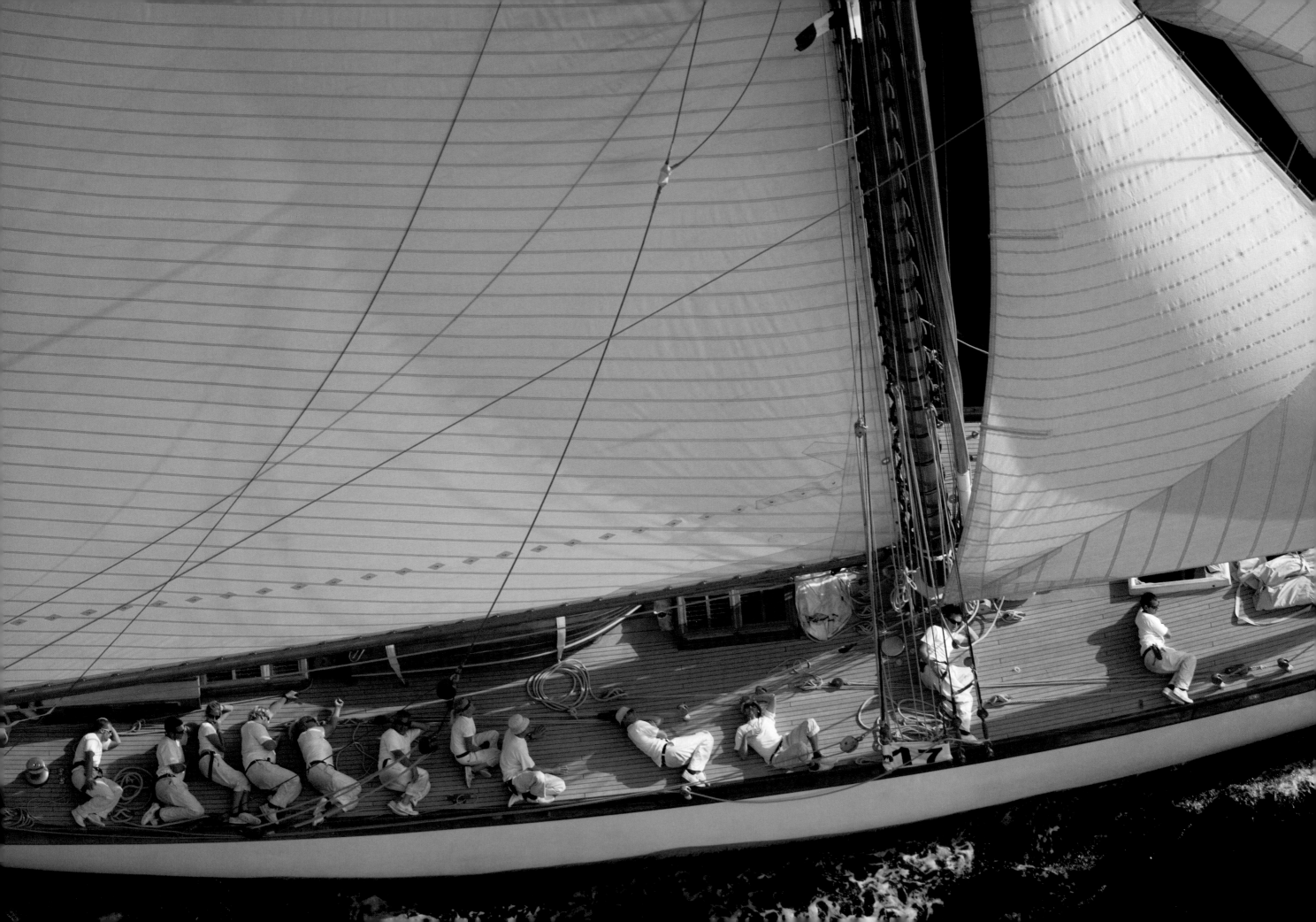

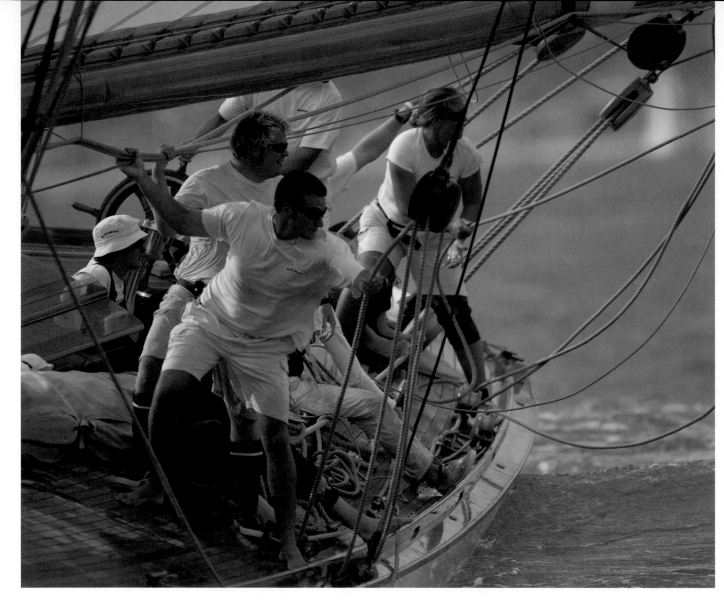

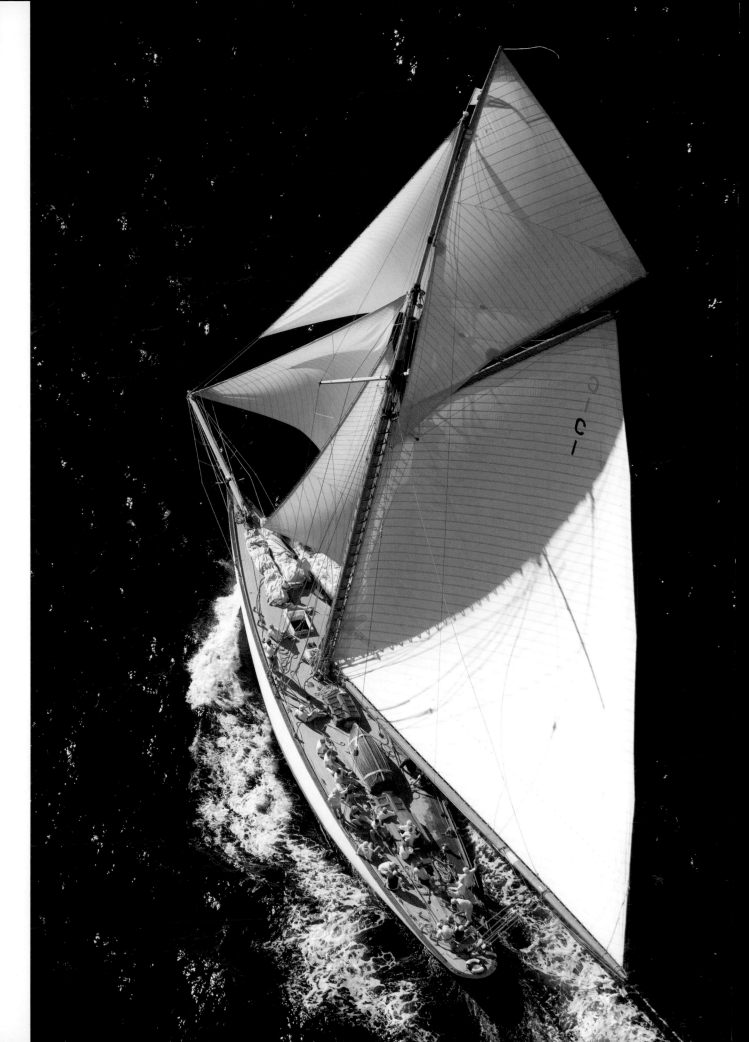

Opposite
The crew keeps their
windage low by laying
down in a spoon position.
The wind is light, and no
one has much to say.

Above
It's always a delicate oper-
ation to grab the runner
tackle under the boom
before maneuvering.

Right
Sail bags on deck, perfect
trim, a full crew: hey, it's
a regatta!

and *Mariquita*. *Mariquita* won the Royal Western Yacht Club regatta, while *Octavia* came in first in the Clyde Corinthian Yacht Club race. Before Cowes in late July, the four nineteen-meter vessels competed at Falmouth, Cornwall and again at Dover in the Dover to Boulogne race won by *Corona*. They would see each other again for the two-day Le Havre international regattas, won by *Octavia*.

In the Solent, a huge gathering of warships and craft of all kinds celebrated the coronation of King George V and Queen Mary. Boats came from all over Europe. *Norada* won the German Emperor's Cup and the Irish Cup, the finest two trophies of the season. In the Royal Yacht Squadron regattas, *Corona* dominated from day one, but *Mariquita* came in second. On the fourth day, *Norada* was the winner, and on the following day *Octavia* took the trophy, repeating the feat a few days later in the Royal Victoria Yacht Club regatta. In the International Regattas, held on August 7 and 8, *Norada* came first, but in the Royal Albert Yacht Club regattas on August 10 and 11, *Mariquita* triumphed. On the following day, *Corona* won the Royal Southampton Yacht Club regattas. And so it continued until the end of the month.

By the end of the season, *Octavia* had won fifteen of her forty-six races and came in second sixteen times. Next came *Mariquita* with twelve firsts and seven seconds out of forty-five races, followed by *Corona*, with ten firsts and ten seconds in forty-four races, and finally, *Norada*, with nine firsts and eleven seconds out of thirty-eight races.

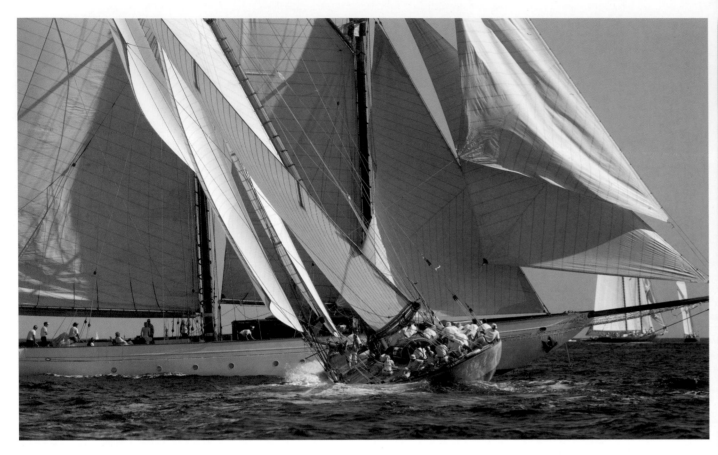

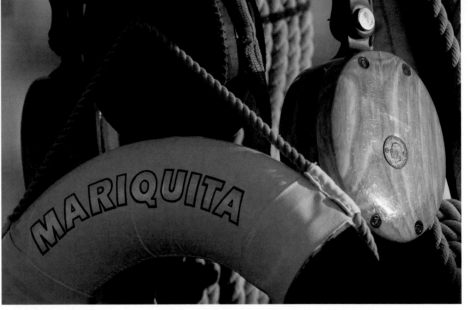

The End of the Class

A few crew changes altered the rankings for the 1912 season. Captain Sycamore took over as skipper for the 23-meter *Shamrock* handing over *Mariquita* to Robert Wringe of Brightlingsea, formerly at the helm of the original *Shamrock* and *Shamrock III* that competed in the America's Cup. Captain Diaper left *Norada* for the new fifteen-meter *Istria*, and was replaced by amateur Charles MacIver.

The start of the 1912 season was marked by the international regattas held at Kiel, Germany, in June, the Germans being very impressed by the nineteen-meters from Great Britain. *Octavia* won the largest number of prizes during the ten-day festivities. Then the Clyde season began, though the fleet ran into a storm on its way to Scotland and the series had to demonstrate their seaworthiness to the full. During the race, both *Corona* and *Octavia* broke their masts, and *Norada* only raced seventeen times before retiring, *Corona* doing the same.

The overall results for the season were very positive for *Mariquita*. She accumulated eighteen first prizes in thirty-six races compared to fifteen firsts in thirty-four races for *Octavia*. The latter yacht was bought by a German yachtsman, Count von Tiele-Winkler, who renamed her *Wendula* (C3), and two more nineteen-meter yachts were ordered in Germany. Major von Stumm asked Max Oertz to design and build *Cecilie* (C3), a nineteen-meter with a hull

Above, Left
Mariquita encounters the schooner *Orion*, sailing into the wind and moving slowly. *Mariquita*, even though she is on starboard with the right-of-way, bears off.

Above
Details of the helm, indicating the angle of the tiller and showing the maker's name, Thomas Reid & Sons of Paisley, Scotland.

Opposite
The shape of the mainsail replicates the wing of a bird. Both fly on the power of the wind.

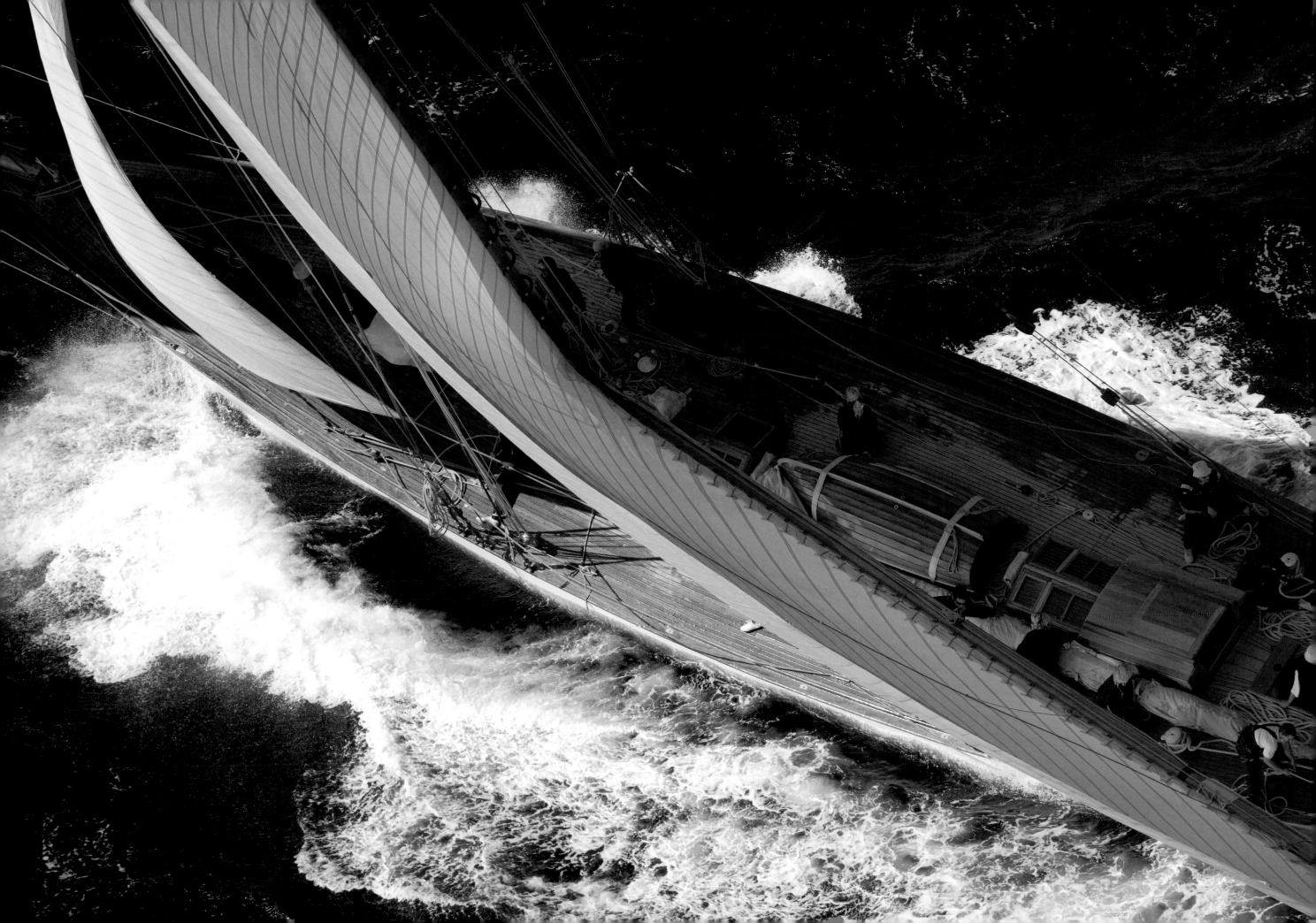

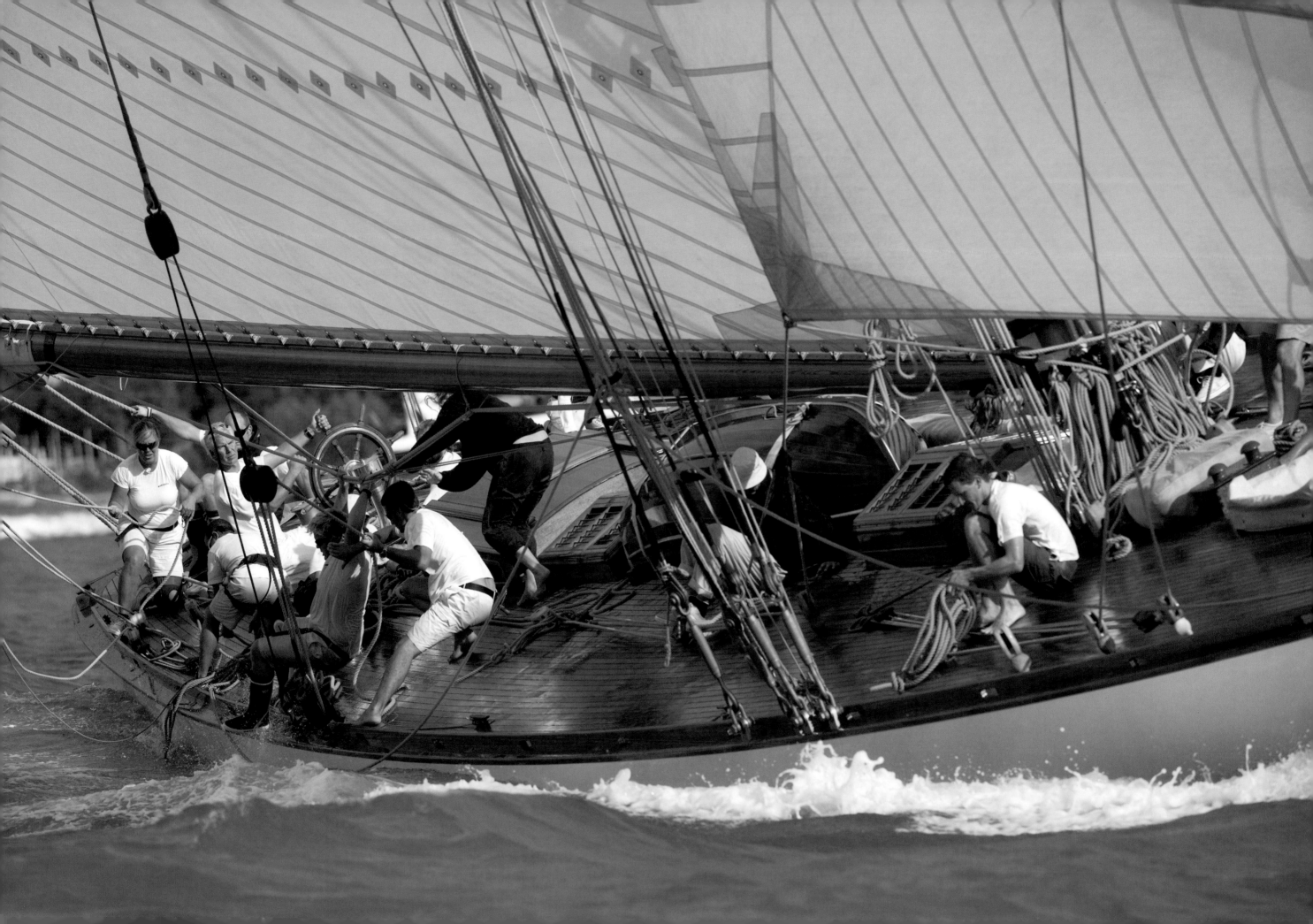

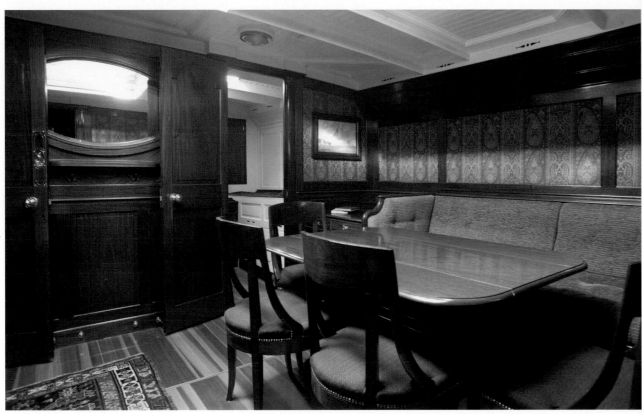

Opposite
Holding on tight, because there is no lifeline or rail to keep this crew member aboard. Mistakes like this are a result of being overanxious. Notice the helmsman never takes his eye off the sails and waves ahead.

length of over 95 feet (28.63 m) for the following season, and Julius von Wald Thousen ordered *Ellinor* (C2) from architect Gerhard Borg of Rostock, 100 feet (30 m) in length.

The 1913 season was very busy in Germany, but only *Mariquita* and *Norada* continued to race against each other, *Mariquita* being slightly ahead with seventeen wins against sixteen for *Norada*. During World War I, *Mariquita* went to Norwegian Finn Bugge who renamed her *Maud IV*. At the end of the war, the yacht got her old name back and returned to England. In 1924, Sir Edward Iliffe and Alan Messer bought her and reduced her sail area. *Mariquita* competed against her old rival again: a newly Bermuda-rigged *Norada*. Soon thereafter, Messer took over his co-owner's share and cruised from the Baltic to Scotland. Before the outbreak of World War II, Arthur Hempstead converted her into a houseboat, discarding the rigging and ballast. She subsequently moored in different rivers, remaining in the mud for sixty years. At that time William Collier, working for collector Albert Obrist, discovered the vessel and brought her to Fairlie Restorations in August 1991.

While awaiting new buyers, *Mariquita* was finally restored, with the same concern for perfection that was lavished on the fifteen-meter *Tuiga*, under the supervision of Duncan Walker. Today, she has returned to her original condition and sails of her heyday, under the command of skipper Jim Thom, who has learned how to manage this magnificent cutter from a bygone age.

Above
On pure racing yachts, the ceilings and coverings of the bulkhead panels in the saloon were often made of silk fabric, which is lighter than wooden panels.

· FEATURES ·

Name: MARIQUITA
Architect: William Fife III
Builder: William Fife & Son, Fairlie
Rigging: gaff cutter
Type: nineteen-meter International Rule
Launched: May 1911
First owner: A. K. Stother
Other name: MAUD IV
Restoration: 2004
Boatyard (restoration): Fairlie Restorations, Hamble
Construction: composite, mahogany planking on steel ribs

Overall length: 124 feet 8 inches [38 m]
Deck length: 94 feet 11 inches [28.94 m]
Length at waterline: 62 feet 10 inches [19.15 m]
Maximum beam: 17 feet 2 inches [5.23 m]
Draft: 11 feet 9 inches [3.58 m]
Ballast: 34 tons
Displacement: 77 tons
Approximate sail area: 1,938 square feet [582 m²]

· DECK PLAN ·

PORT

WINCH OWNER'S STATEROOM STAIRWAY STAIRWAY SKYLIGHT WINCH CLEAT AFT STAIRWAY BOWSPRIT

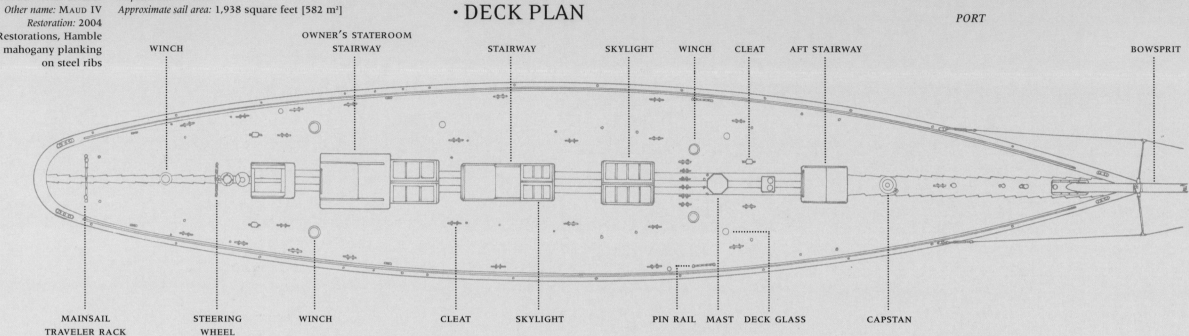

MAINSAIL TRAVELER RACK STEERING WHEEL WINCH CLEAT SKYLIGHT PIN RAIL MAST DECK GLASS CAPSTAN

STARBOARD

· LAYOUT ·

HEADS SINGLE STATE-ROOM SALOON GALLEY CREW QUARTERS

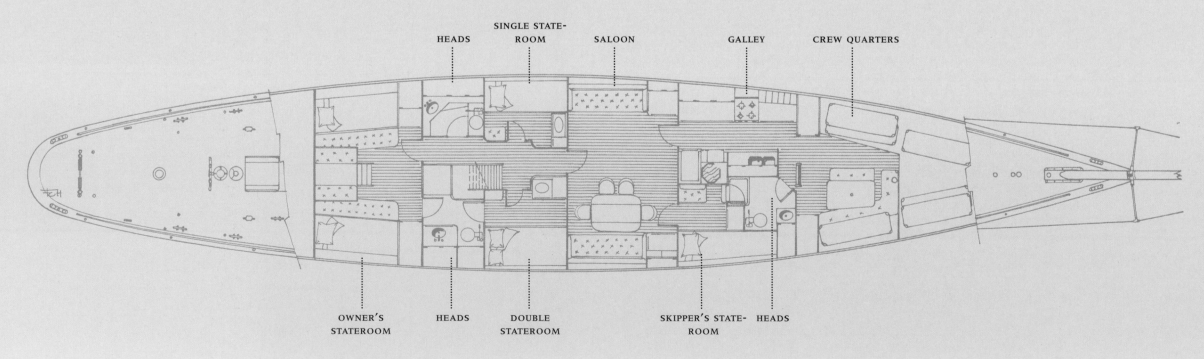

OWNER'S STATEROOM HEADS DOUBLE STATEROOM SKIPPER'S STATE-ROOM HEADS

·CROSS SECTION

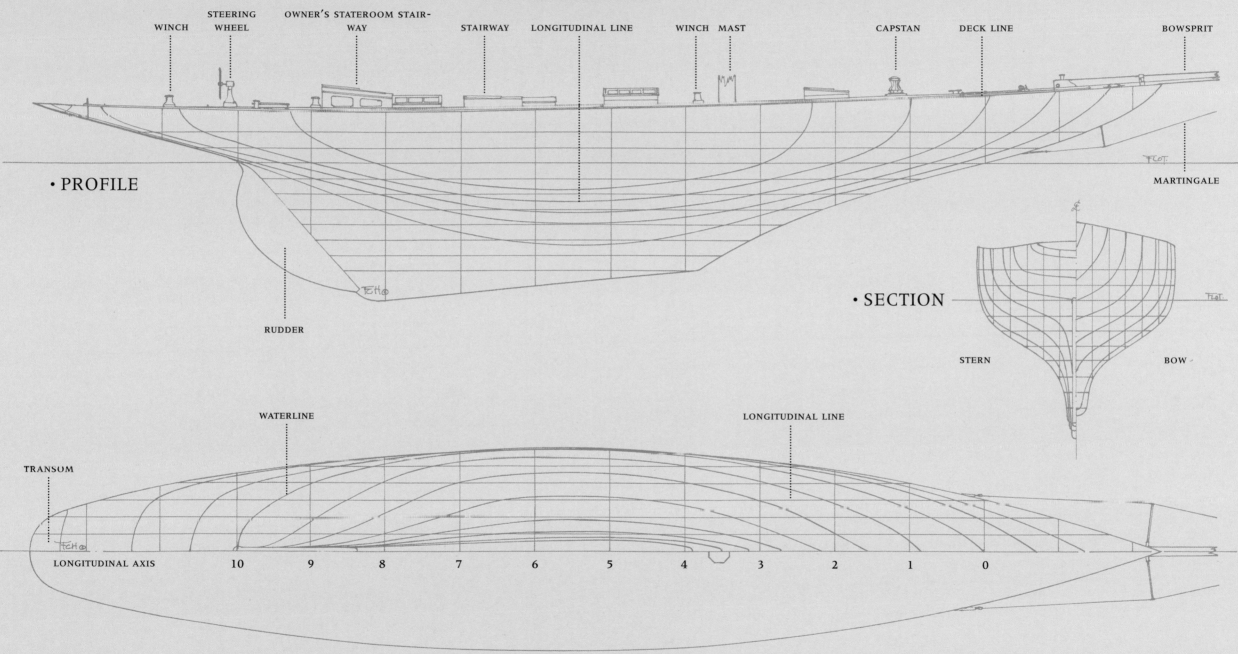

WINCH · STEERING WHEEL · OWNER'S STATEROOM STAIR-WAY · STAIRWAY · LONGITUDINAL LINE · WINCH · MAST · CAPSTAN · DECK LINE · BOWSPRIT

·PROFILE

MARTINGALE

RUDDER

·SECTION

STERN BOW

WATERLINE LONGITUDINAL LINE

TRANSUM

LONGITUDINAL AXIS 10 9 8 7 6 5 4 3 2 1 0

·PLAN

·Moonbeam IV·

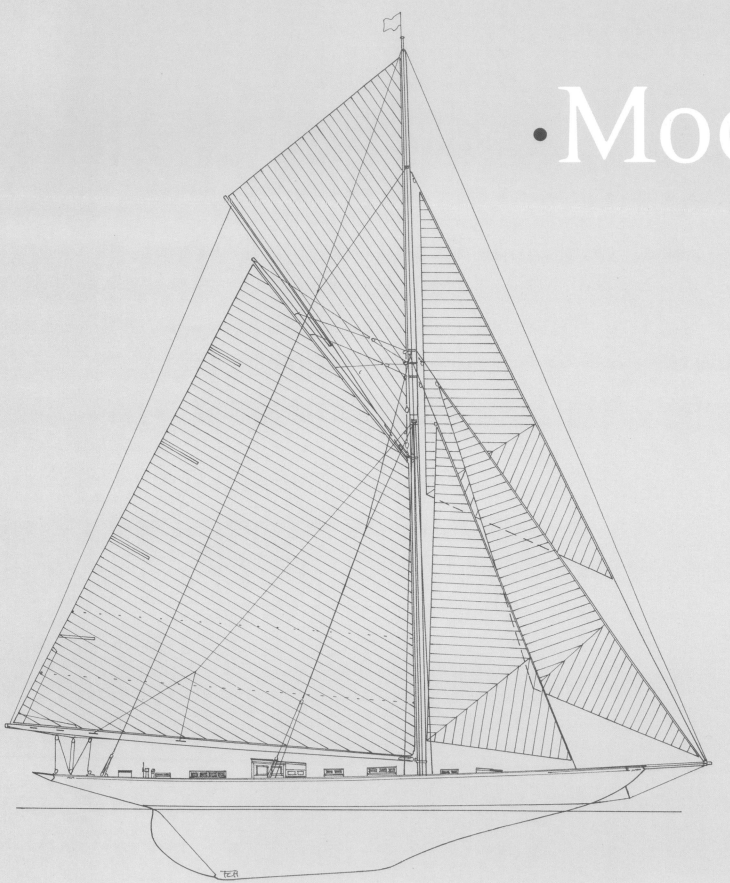

Do you know who I am?
The moonbeam.
Do you know where I came from?
Look upward.

—Guy de Maupassant (1850–1893)

Maupassant, the French writer, loved to watch his yacht gliding over the surface of the water. *Moonbeam*'s story, especially that of the fourth yacht to bear the name, seems to evoke the poet's words.

In 1995, *Moonbeam IV* operated as a charter yacht in the Aegean Sea. Poorly maintained with a massive doghouse, a white wheelhouse aft, modern ketch rigging, and no bowsprit, she no longer had much in common with the Big Class yachts of the 1920s. Yet John Murray and his wife, Françoise, fell in love with this vessel and had the crazy idea of sailing her around the world.

The fourth vessel with this name, the largest of the *Moonbeams*, was designed in 1914 by William Fife III for the British owner Charles Plumtree Johnson and launched in 1918.

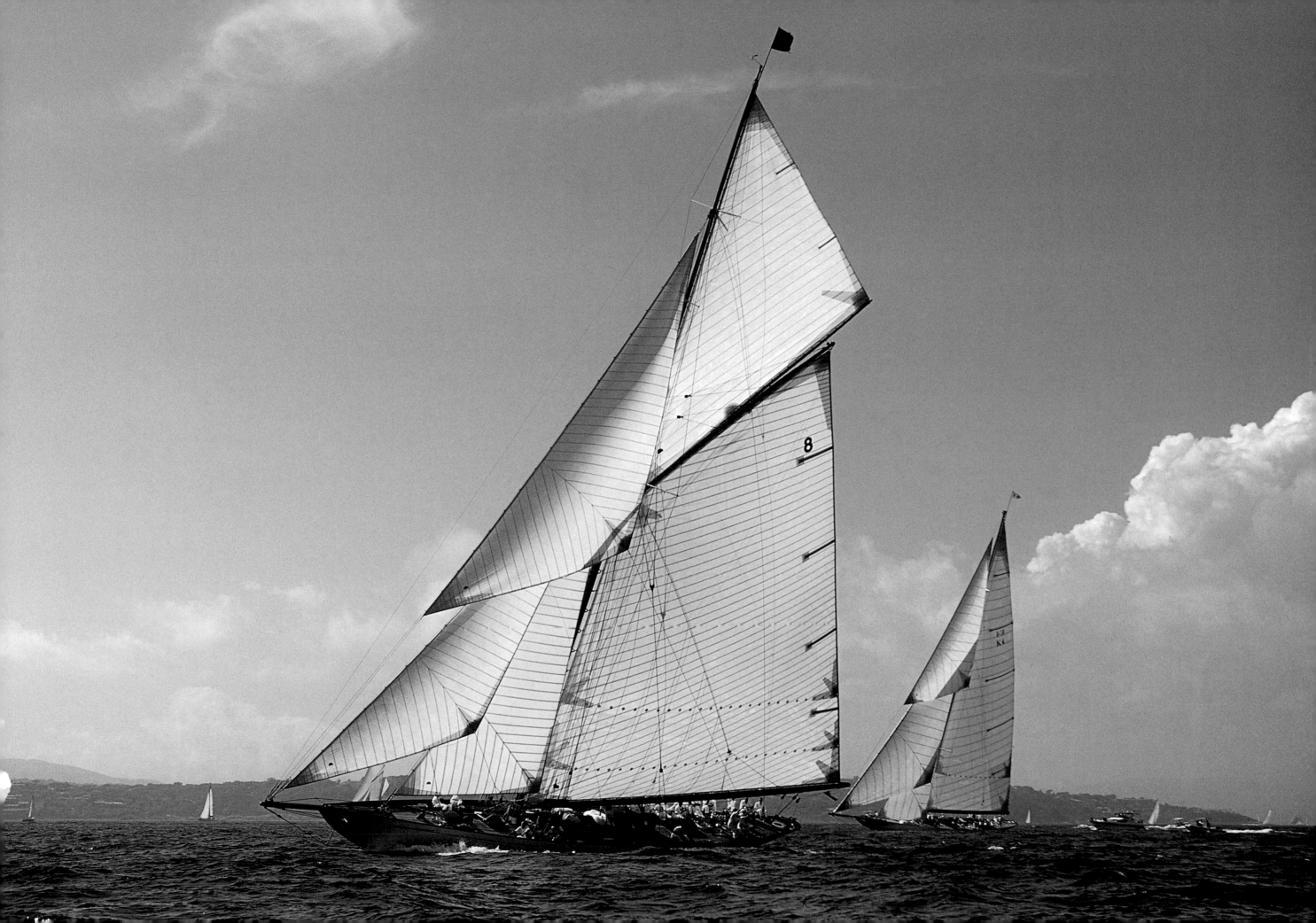

After twenty years spent in the service of a prince in Saudi Arabia, the Murrays wanted a change. Captain Mauro Mari, the Italian captain of the prince's yacht, had taught them sailing and inspired in them his passion for the sea. They had developed a love of risk-taking that cannot be explained when buying a boat, and the search began for the right craft.

The early 1990s was a boom time for pleasure-boating. In the land of black gold, Murray was used to thinking big. When *Moonbeam IV* was advertised in a magazine, she looked like she was worth viewing. "Ready to cruise but extensively modernized," the 105-foot (32-m) yacht was next to an ad for *Moonbeam III*, 23 feet (7 m) smaller and restored but being sold for a much higher price.

Captain Mari took a trip to Piraeus, near Athens, to inspect the yacht, and she looked seaworthy and well equipped. Murray joined him there and was won over by the boat's style and elegance. As an admirer of the finer things, he loved her line and appreciated the fine cabinetry of her interior, much of which was historically authentic. He decided to buy her, quite unaware of the yacht's glorious past or the reputation of her designer. He was still a novice when it came to yacht heritage and did not realize that she had been poorly maintained and that the state of her hull would be difficult to assess.

Before setting out on future voyages, the new owners put themselves in the hands of the Tréhard boatyard at Antibes and gave the boat a complete overhaul. It was there that they discovered the history of their yacht and realized that they were, in fact, the owners of a masterpiece. They gradually unraveled *Moonbeam IV*'s enthralling story.

An Impressive Lineage

Moonbeam IV was the fourth sailing yacht owned by Charles Plumtree Johnson. Johnson, born in London in 1853, was a lawyer practicing in Glasgow and the son of Queen Victoria's personal physician. In 1893 he bought a 1858 cutter with the pretty name of *Moonbeam*. She was 47 feet (14 m) long, with a thirteen-foot (3.66-m) beam, designed by William Fife & Son built by the William Fife & Son boatyard at Fairlie. Her succession of owners included P. Roberts, H. S. Holford, and W. O. Marshall. She was launched for racing and she did well in regattas. On this antique ship, Johnson learned the pleasures of sailing and for six years he entered local regattas and sailed on some great cruises.

The ambitious Johnson sold *Moonbeam* in 1899 to a certain Mr. Rice. He commissioned a new *Moonbeam*, which would be known as *Moonbeam II*, from London architect Frederick Shepherd, who specialized in yachts with auxiliary engines. The cutter was built at the White Brothers boatyard and was 60 feet (17.80 m) long with 972 square feet (292 m²) of sail. As a pleasant cruising yacht, she posted disappointing results in regattas, and even before putting her up for sale, Johnson returned to Fairlie for a new yacht from William Fife III, who had taken over his father's boatyard. Since 1884, the

architect's yachts had had a good number of wins: his *Dragon* (1889), a 20-Rater that was unbeatable on the Clyde, was the first vessel to bear the famous trademark on her bow. He was often asked to design small craft, but Fife soon became the man for producing large, handsome sailing ships, such as Sir Thomas Lipton's *Shamrock* (1898), the superb schooner *Cicely* (1902), and the challenger for the 1903 America's Cup *Shamrock III*.

Moonbeam III, now known as *Moonbeam of Fife*, was yawl-rigged and launched in April 1903. She was as powerful a yacht as Johnson had wished: elegant, comfortable, and pleasant for cruising, with a deck length of 84 feet (25 m) and 60 feet (18 m) at the waterline. She soon proved to be a keen racer as well, and the following May she came in second behind *Creole* (1890), cutter owned by G. L. Watson, in a bitterly fought regatta; after five hours at sea, the fourteen competitors completed the course within ten minutes of one another. During that season, *Moonbeam III* competed against the finest yachts afloat, and over the span of the full year she covered more than 5,000 miles between races and cruises.

In 1914, after ten years of sailing, Johnson, then sixty-one, wanted to get into the big time and sail with the extremely wealthy, and princes and kings. He had raced enough while watching the Big Class vessels trailing his by a few minutes only to forge ahead and leave him far behind. He commissioned his favorite architect to build him a new cutter, the fourth *Moonbeam*.

The specifications were detailed, Johnson having very definite ideas on how to reach his goal. For instance, he changed the description of the fittings, stressing that he wanted the hinges of the interior doors in gunmetal rather than bronze. The plans were completed in May 1914, and on June 2, the Lloyd's assessor made his first visit to the William Fife & Son boatyard. Work had slowed down due to the war. It was brought to a standstill in 1916 and 1917, but started again in early 1918. The yacht's hull finally launched on May 3 to be transported to the opposite bank of the Clyde to the Robertson & Sons boatyard, where the work was finished. The official launch finally happened on April 19, 1920.

Postwar life resumed, and King George V, owner of *Britannia* (1893), a cutter designed by G. L. Watson, gave the signal for the resumption of regattas by fitting out his yacht for the season. A few enthusiasts followed the royal example, Richard H. Lee commissioning *Terpsichore*, later named *Lulworth*, designed by Herbert W. White. Most of the yachts were refitted, including *Nyria* (1906), *Westward* (1910), the 23-meter *White Heather II* (1907), and *Zinita* (1904).

The 1920 and 1923 King's Cup Races

In 1920, Johnson sold his third *Moonbeam* to Parisian industrialist Ferdinand Maroni, who renamed the yacht *Eblis*, and based her in Brest, France. That year, Maroni won the Coupe Antonide Julien, before sailing to the Mediterranean. Nearly sixty years later, in 1979, Dr. John Poncia brought her back to England on a cargo ship. Work was only completed in 1988 when,

Opposite
A battle of the titans, skippered by the talented Philippe Lechevalier, *Moonbeam* passes beneath the newly restored *Lulworth*. In the 1923 King's Cup, *Moonbeam* left that same *Lulworth*, then named *Terpsichore*, far behind.

Page 100–101
Ten tons of ballast were added on the recommendations of the skipper. *Moonbeam*'s performance improved.

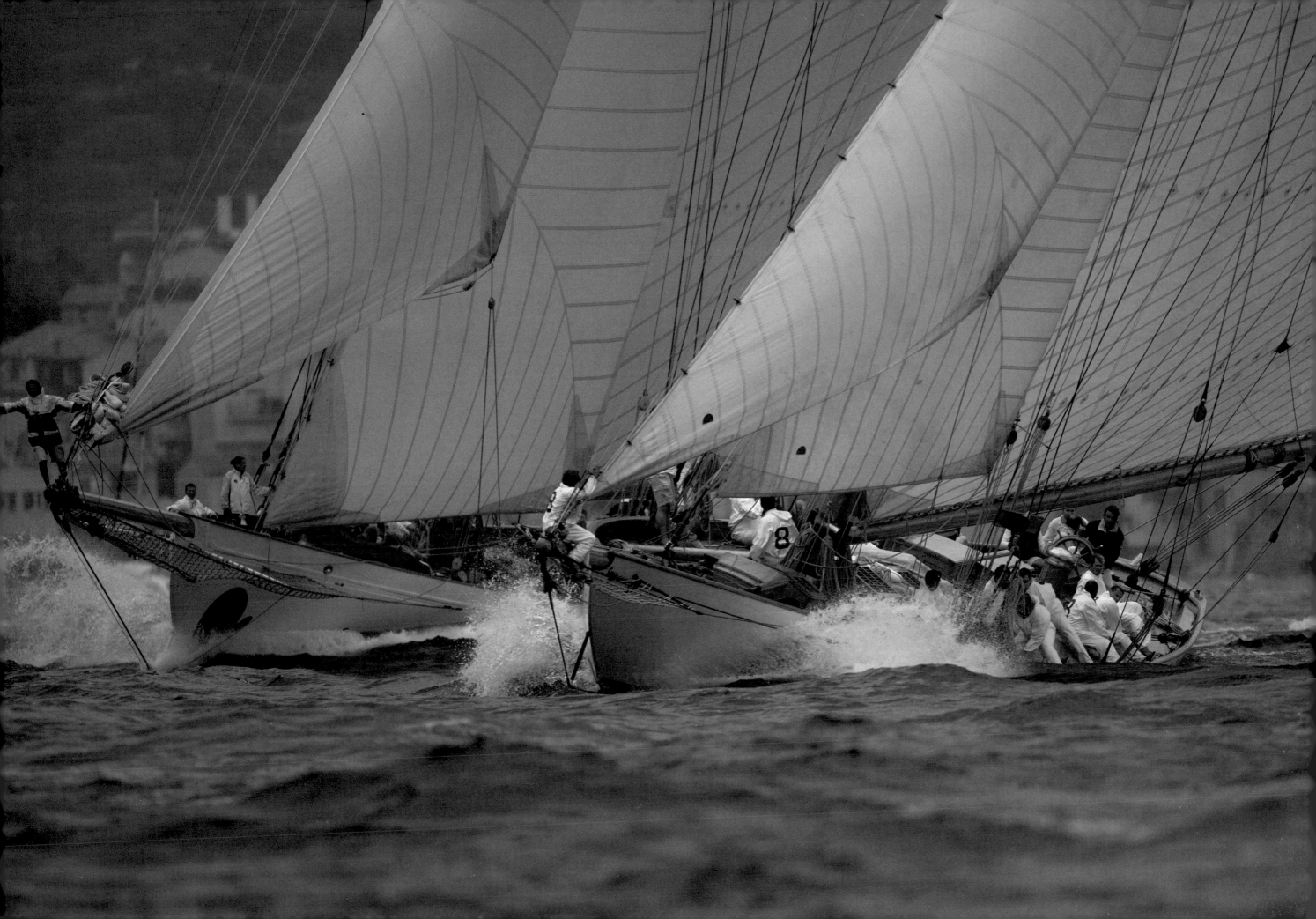

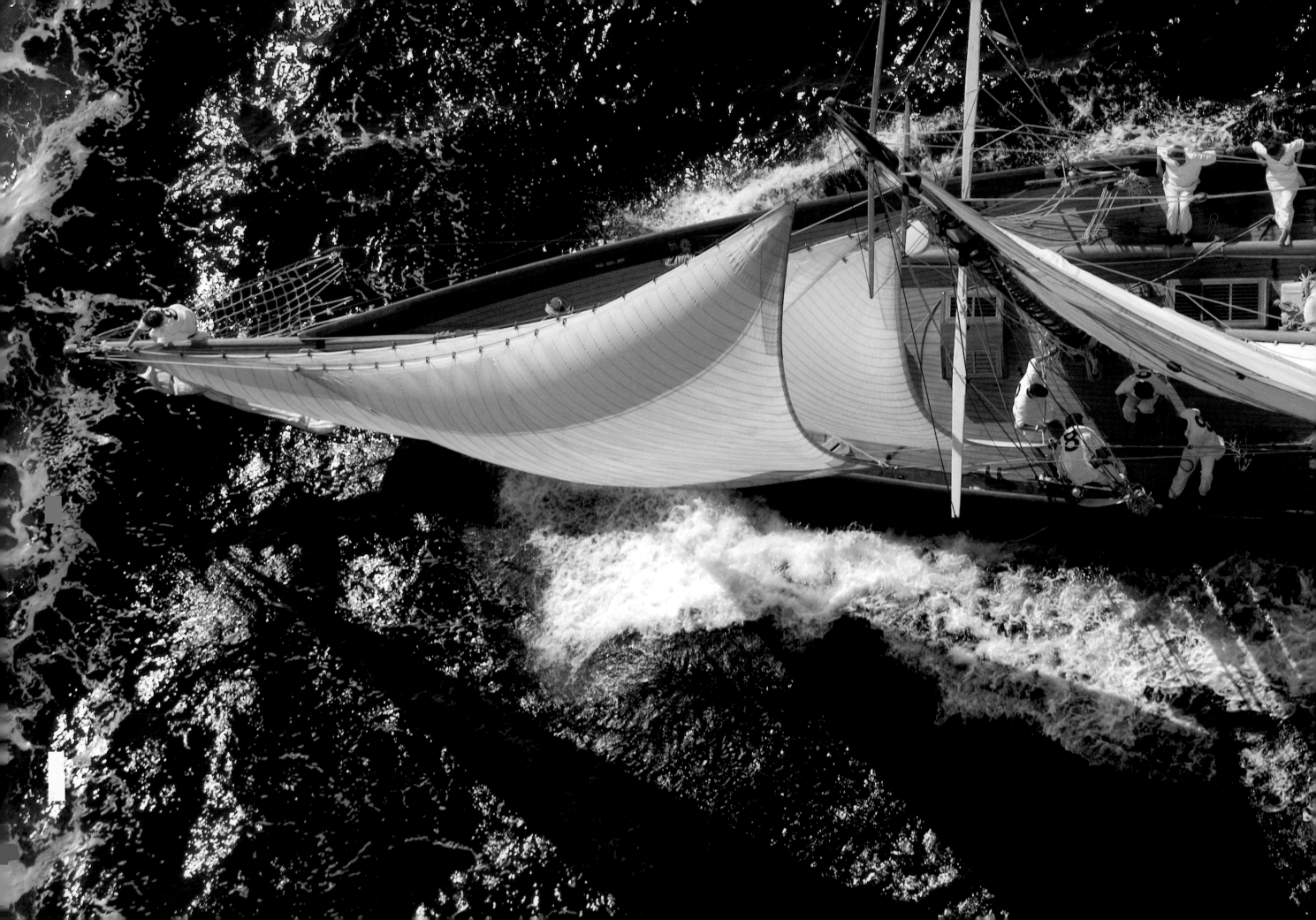

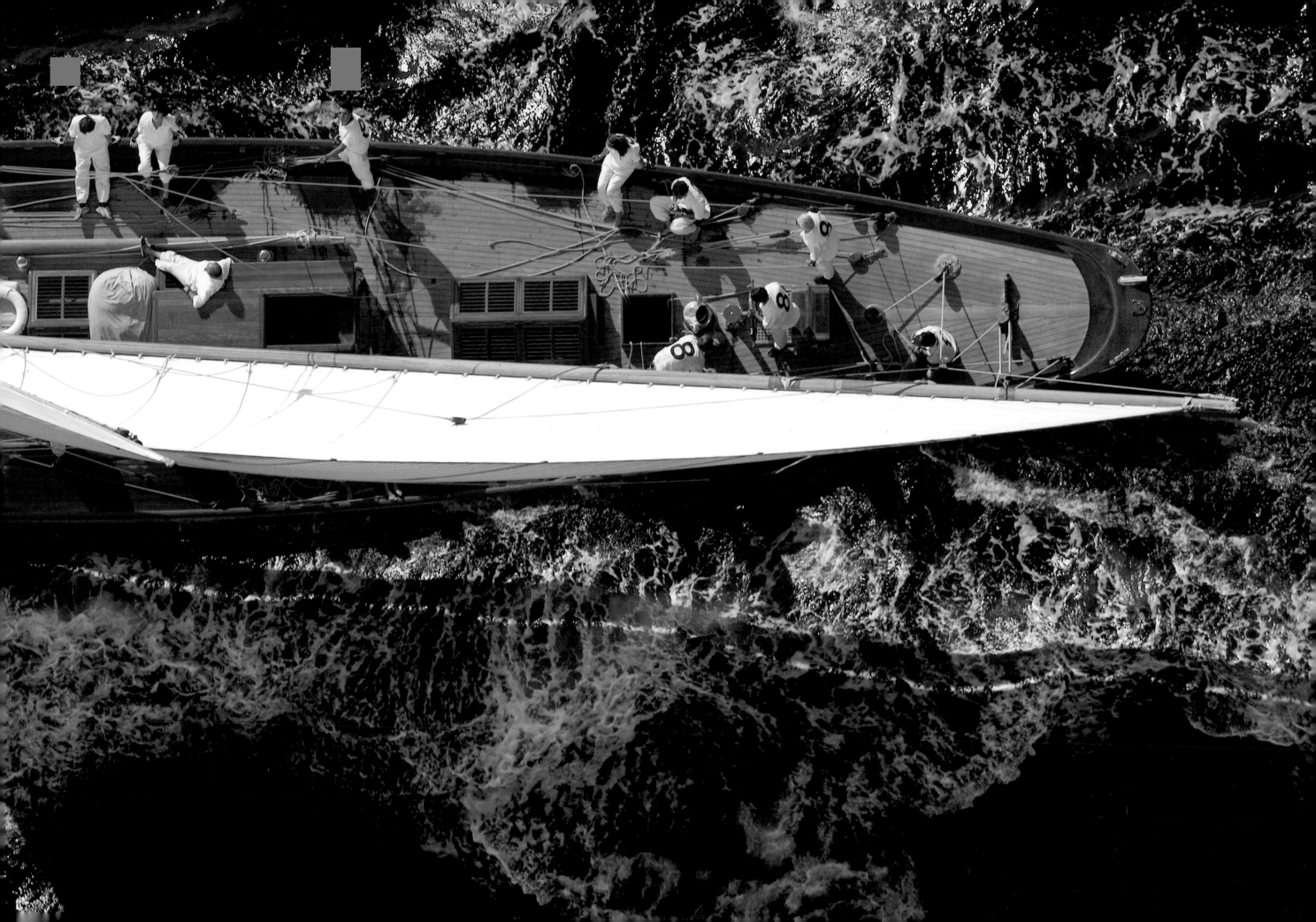

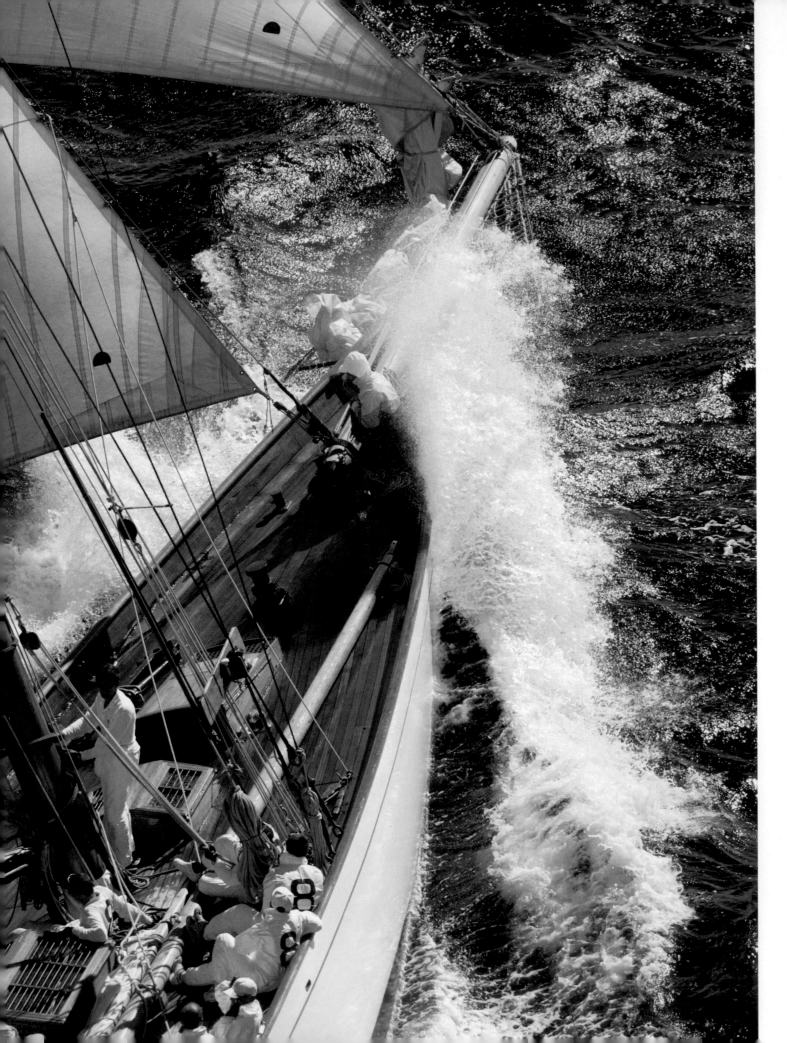

converted into a cutter, she got back her old name of *Moonbeam*. On May 31, 1989, this *Moonbeam* was auctioned by Sotheby's and acquired by a Norwegian who wanted to use her for chartering. She then became the property of G. Naigeon, a member of the Yacht Club de France (YCF), who came in second in 2001 in the America's Cup Jubilee, with Philippe Lechevalier at the helm. Today, to everyone's delight, the third *Moonbeam* races against her older sister.

To return to 1920, Johnson was finally able to compete with a yacht that was handicapped to leave last, like the largest of the competitors. *Moonbeam*, the fourth of that name, measured 107 feet (32.10 m), not counting her boom, which extended beyond the aft taffrail, and made the boat 110 feet (33.40 m) overall, with a draft of 64 feet (19.50 m) and a sail area of nearly 1,685 square feet (506 m²), or 2,524 square feet (758 m²) with her gennaker.

From her first regatta, held by the Royal Clyde Yacht Club, *Moonbeam* impressed her rivals. On July 10, 1920, she came in second in the first Royal Northern Yacht Club race. Over the next few days, she competed in all the races and gradually made her mark. Her finest victory was on August 3 when she won the most coveted of trophies, the King's Cup, in the race along the Solent organized by the Royal Yacht Squadron. She repeated this feat in 1923, outpacing *Britannia*, *Terpsichore*, and *Nyria*. But Johnson had health problems, and in 1926, the yacht was sold to another member of the Royal Yacht Squadron, Henry "Nipper" Cecil Sutton. For ten years, Sutton raced her in the great regattas, but her results were less and less satisfying with the new 23-meter and the J-class yachts leaving him little chance of winning.

A Yacht Fit for a Prince

In 1937, Sutton sold the *Moonbeam* to three associates: Reginald B. Asley, John P. T. Boscawen, and J. E. Cowie. The yacht spent World War II in Southampton. Colin C. McNeil became her new owner in 1946, fitting her with a Gardner engine and changing to a Bermuda rig. In the following year, McNeil sold his yacht to Madame M. E. Binet. *Moonbeam* was sent to the Mediterranean, where she was converted into a cruising yacht. Acquired by Prince Rainier of Monaco in 1950, she underwent a few more modifications. Her name changed to *Deo Juvante*, the family motto of the Grimaldis, and she was fitted with two powerful Baudouin engines and two propeller shafts. A huge cabin was built on deck and her rigging was changed to Bermuda ketch. The sail area was reduced from 1,685 square feet (506 m²) to 899 square feet (270 m²).

In 1953, the prince bought a motor yacht from Camper & Nicholsons. She had been built in 1928 and was 150 feet (45 m) long, and the prince named her *Deo Juvante II*, and paid little attention to his earlier purchase, which he eventually sold in 1955. Former movie star Grace Kelly, the prince's wife, is said to have spent her honeymoon night on board. The yacht went by *DulSol* for a while, but became *Moonbeam* again in 1959, when she became the property of the Société Civile de Plaisance et de Croisière in Monaco.

Left
Officially, *Moonbeam* never bore the number IV. The media gave her that number to distinguish her from her predecessors.

Opposite
The man to whom *Moonbeam* owes her renaissance, John Murray, claims that eight is a lucky number. He appears to be right.

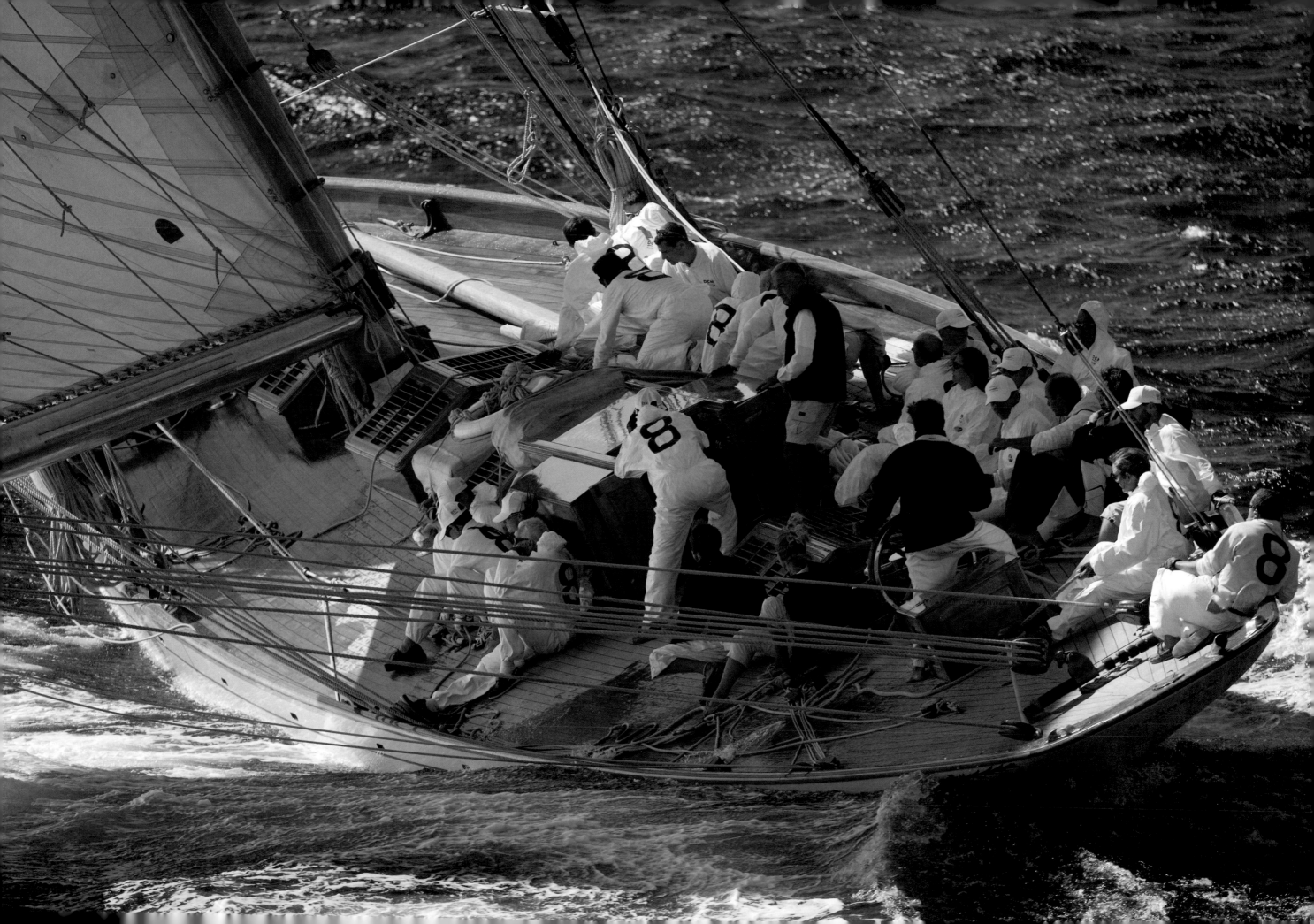

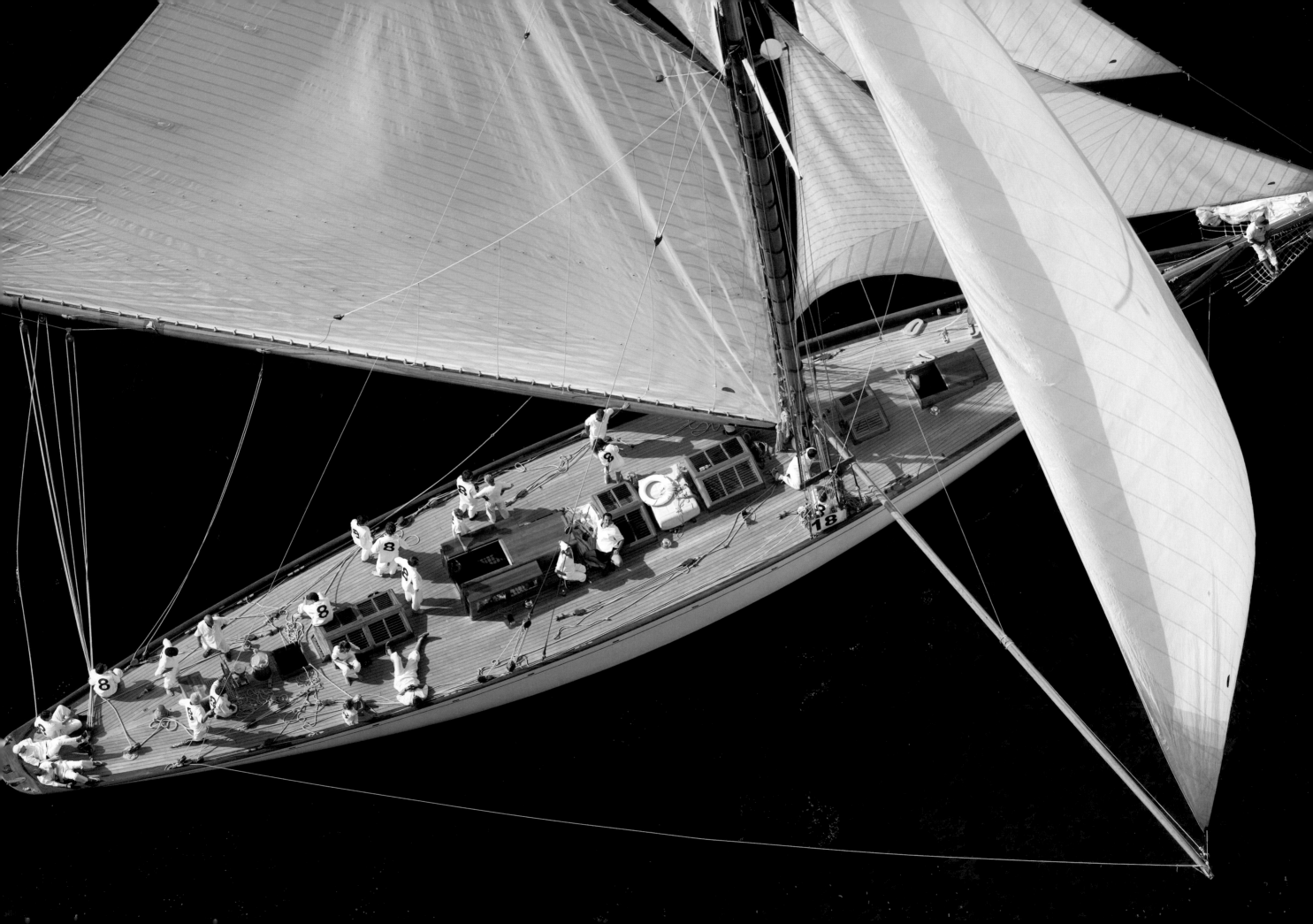

Opposite
Moonbeam could
use more wind.
Think how many
feet of line it takes
to make up the
sheets used to trim
the sails.

The yacht was sold to Hannibal Scotti and her engines were replaced with
Rolls Royce engines. In 1970 she disappeared from Lloyd's Register after
being sold to a Greek company that operated her as a charter. This was the
start of a sad period for the yacht. Yet her story was far from told.

Thus we return to John and Françoise Murray in Antibes in 1995. Euro-
pean experts were recommended to them, Fairlie Restorations in particular,
which had purchased the basic plans of William Fife III and was managed by
the talented Duncan Walker. Their conclusions alarmed the Murrays: "The
hull is worn out. The yacht has become a wreck." The estimate given for
restoring her shocked Murray. However, he believed that the hull was not in
such poor condition and there were surely other solutions that were less
costly. Murray, convinced of the quality of the initial construction, entered
Moonbeam in the Royal Regattas of Cannes and La Nioulargue in 1996. The
Murrays received a warm welcome and regained their confidence. Aware
of the quality of work coming from the countries of Southeast Asia, they de-
cided to have *Moonbeam* restored there.

Four Years in Asia

Moonbeam left Antibes on July 31, 1998, and did not return to Europe for four
years. One might have expected the most extreme weather conditions on her
outbound voyage to have been in the Indian Ocean, but it was in the Aegean
Sea where *Moonbeam* was caught in a gale with 60-knot gusts. She then ran
into a north-south storm crosswind in the Andaman Sea, only just reaching
Thailand. Her arrival in Phuket was incredible. Her hull was completely
rusted above the waterline and covered with a thick layer of shells; yet *Moon-
beam* proved to be in much better condition than some of the specialists had

Above
It takes tremendous
skill and talent to keep
the cleats, blocks, lines,
and binnacle polished
and in good working
order. Each item seems
to have a life of its own,
and all are vitally im-
portant to the perform-
ance of the yacht.

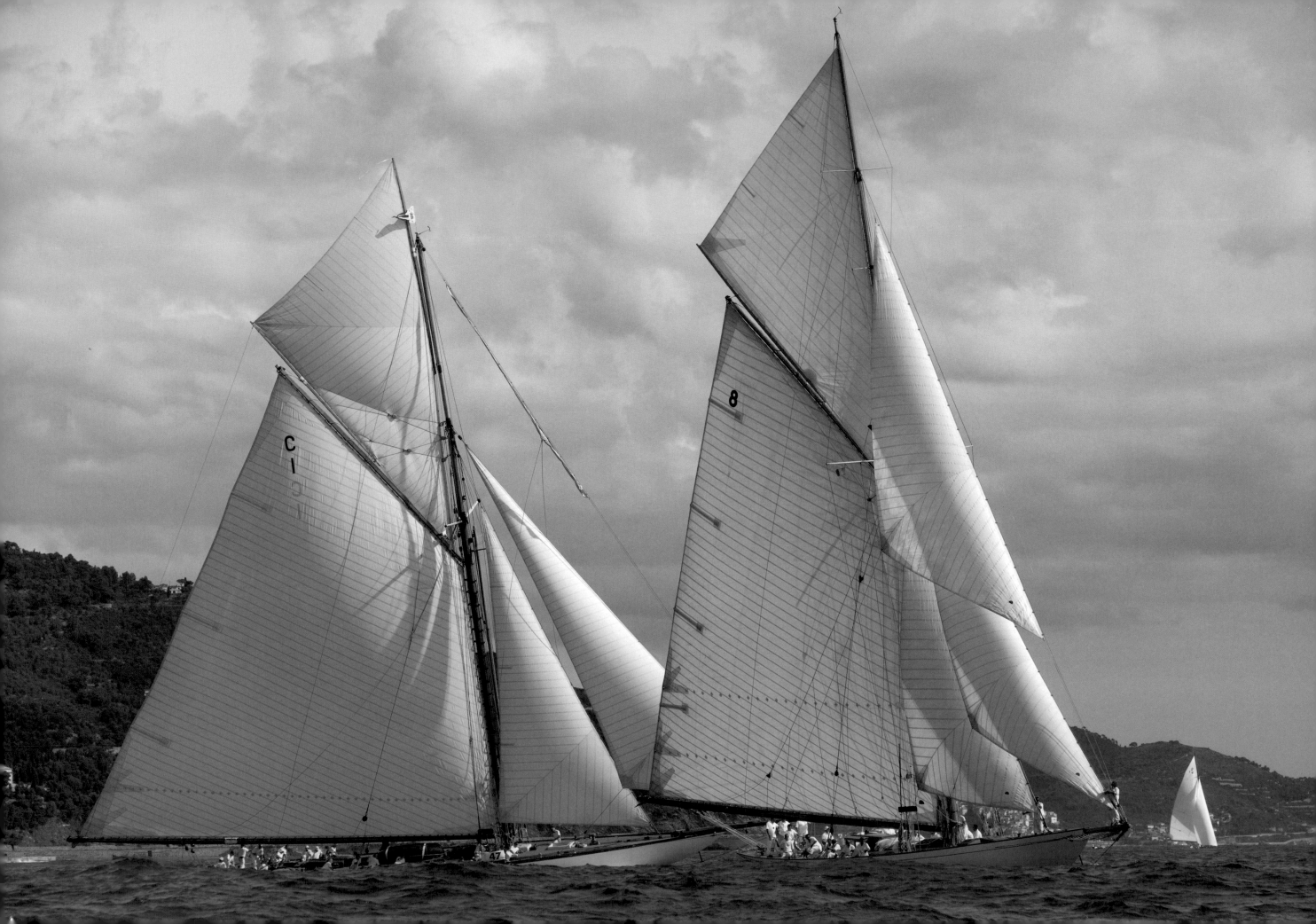

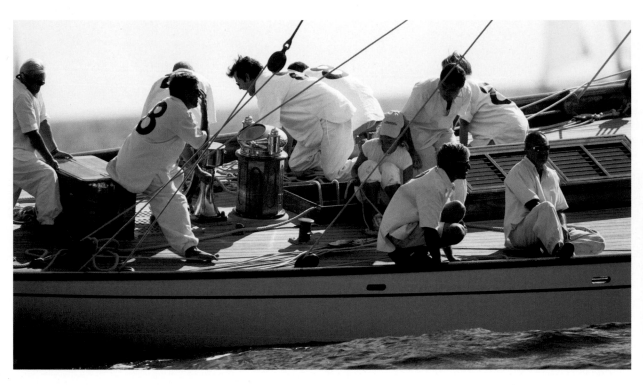

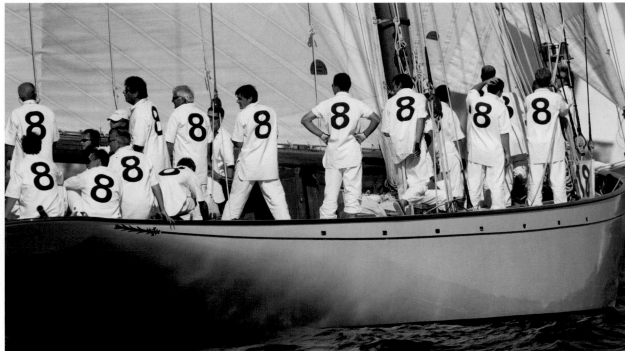

Opposite
Here *Mariquita*
and *Moonbeam*
duel in the
Voiles de Saint-
Tropez 2006 race.
Moonbeam, on
the right, seems
to be early for
the line and
slowing down
while *Mariquita*
has more speed
and also has an
extra jib ready
to roll out on the
headstay.

predicted. John made a decision: the boat needed dismantling and a gradual restoration procedure that would take a great deal of time.

Southeast Asia seemed to be the most logical place in which to embark on the project, with potentially efficient manpower steeped in a culture of wood- and metalworking, and at a cost that was far lower than anything on offer in Europe. Myanmar Shipyards, in Yangon, was finally chosen for the project. Another advantage was that the finest teak forests in the world were nearby, and it was from here that the wood for *Moonbeam*'s hull had originally come. The yacht reached Yangon in April 1999 and moored in the dockyard basin. The first job was to dismantle the vessel before sliding her onto the slipway. Her masts and rigging were removed, the five-ton doghouse and the hatches were dismantled, then the engines, equipment, all of the fixtures and fittings, and the upholstery. At the same time, a hangar was built to protect her during restoration. Finally, in June, the deconstructing of the hull could begin. First, the copper plates that had covered her bottom for more than fifty years had to be removed, and the layers of paint covering the deadworks above her waterline needed to be scraped away, right down to the first undercoat applied in 1914, to reveal the state of the original teak. The planking, which was about 2¼ inches (59 mm) thick, proved to be in satisfactory condition. The planking was carefully dismantled in two months.

Once her iron carcass was revealed, they saw it needed to be shored up by the addition of steel spars, and each metal part needed scraping. The rear beam and the ribs next to the batteries had suffered considerable damage and would require heavy restoration. All of the metal parts were finally covered with black epoxy-based anticorrosion primer. The boat passed her Lloyd's inspection on March 31, 2000.

Rebuilding most of the keel and ballast proved to be a more difficult operation which involved changing the keel bolts. After restoring the planking, piece by piece, and replacing two planks, they could begin reassembling the vessel. Nine thousand bronze rivets, slightly thicker than the originals, were welded into their former positions. The hull was now beginning to look more like a boat. They based the designs of the deck superstructures on work of that period and covered the deck in cedar followed by strips of teak.

The Murrays paid special attention to the interior layout. The general plan repeated that of Fife, but with greater comfort. The ladies' stateroom, with its bathtub, was rebuilt, and John added an elegant navigation post. The galley and the crew quarters forward were completely refitted. The style remained Victorian, with Burmese rosewood for paneling. For the spars, Alaskan spruce was specially ordered and sent over from the United States.

A Second Life

Moonbeam went back in the water in July 2002. A temporary set of sails was hoisted to enable the yacht to sail to Auckland for the America's Cup. On her first outing, she covered 8,500 miles with a few stopovers. She won the Concours d'Elégance in Cowes, chartered by the owner of *GBR Challenge*, Englishman Peter Harrison.

The yacht was sent by cargo boat to Europe to take part in the Fife regattas in Scotland in June 2003. Since then, she has been warmly welcomed by Prince Rainier and can be found at most events attended by classic yachts. Skippered by Lechevalier, she has become the yacht to beat.

Above
The number "8"
represents wealth in
China. I wonder if
this crew gets con-
fused looking at
their teammates all
wearing the same
uniform number?

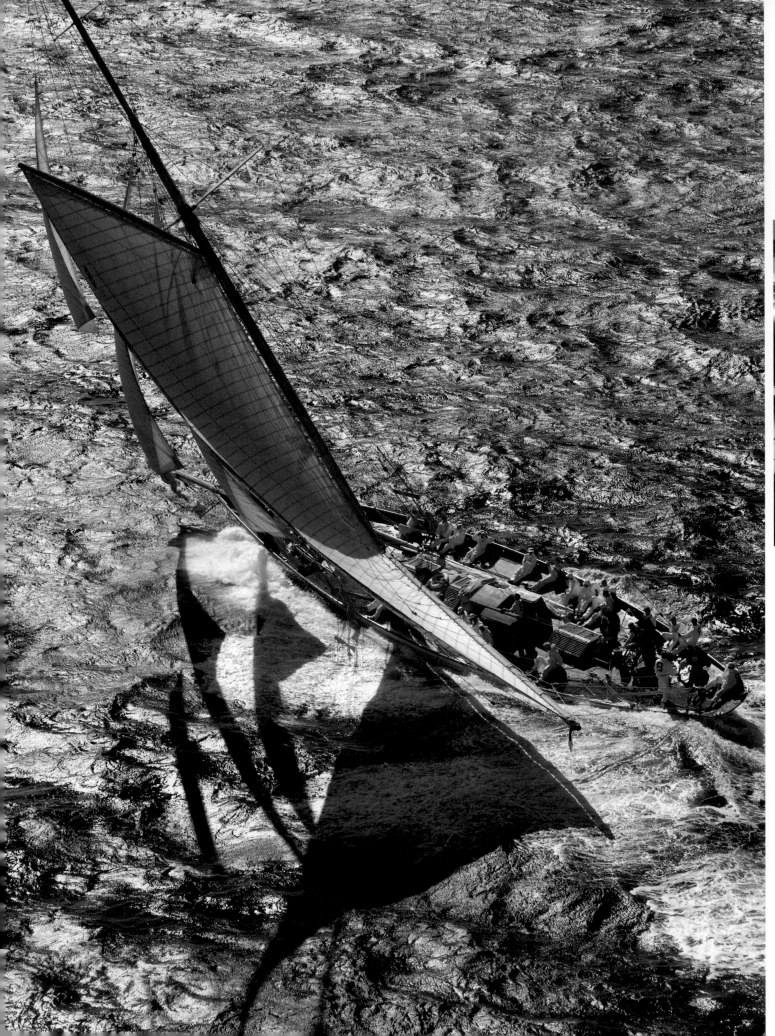

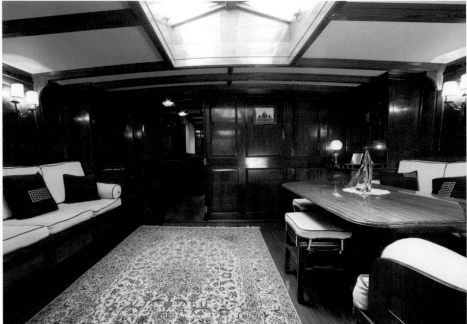

The curvature of the leech indicates that *Moonbeam* is slightly overpowered because the gaff at the top of the mast is eased way out compared with the boom down low. The shadows of the sails make a nice contrast with the yacht.

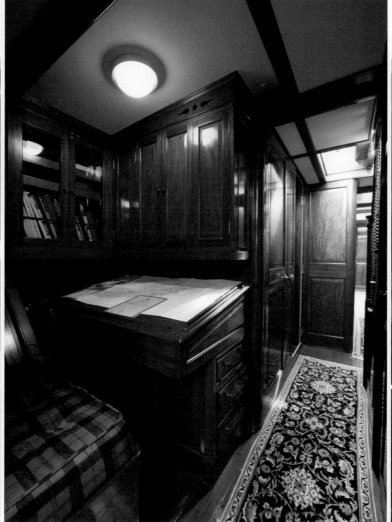

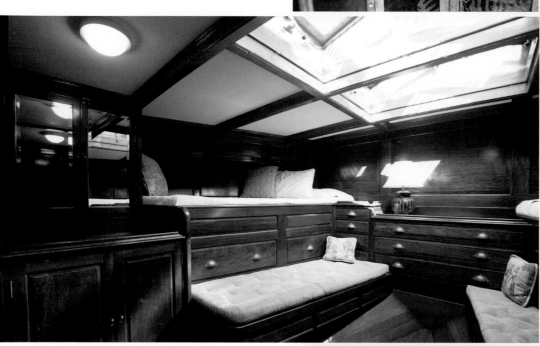

John and Françoise Murray paid special attention to the fixtures and fittings. The finish of each doorknob, the tropical woods, the patina, and carefully planned lighting offer an atmosphere of comfort and relaxation.

No garish colors or objects—the décor exudes good taste, pleasantly reinforced by comfortable yet discreet air conditioning.

· FEATURES ·

Name: MOONBEAM
Architect: William Fife III
Builder: William Fife & Son, Fairlie
Rigging: Marconi gaff cutter (1927)
Type: ocean racer
Launched: May 3, 1918
First owner: Charles Plumtree Johnson
Other names: DEO JUVANTE, DULSOL
Restoration: 1998–2002
Boatyard (restoration): Myanmar Shipyards, Yangon
Construction: composite, teak planking
on steel ribs

Overall length: 109 feet 7 inches [33.40 m]
Deck length: 94 feet 6 inches [28.80 m]
Length at waterline: 64 feet [19.50 m]
Maximum beam: 16 feet 8 inches [5.10 m]
Draft: 12 feet 10 inches [3.90 m]
Ballast: 34 tons
Displacement: 84 tons
Approximate sail area: 1,685 square feet [506 m²]
Engine: Lehmann 350 CV

· DECK PLAN ·

PORT

SKYLIGHT STAIRWAY CLEAT SKYLIGHT AFT STAIRWAY BOWSPRIT

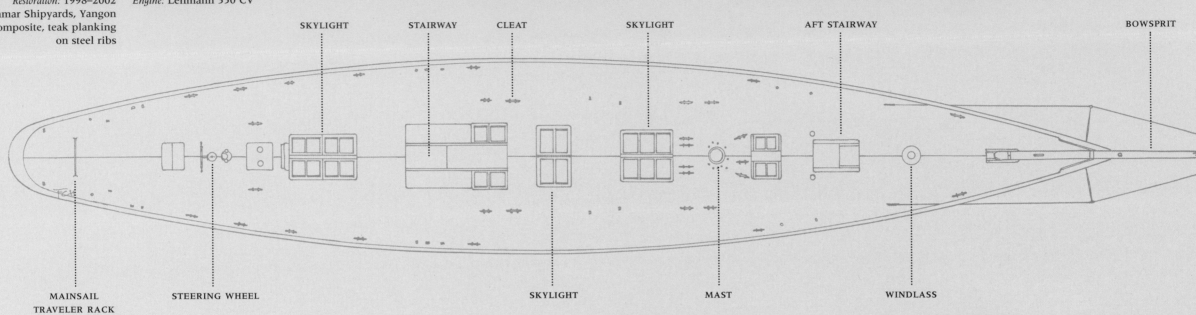

MAINSAIL
TRAVELER RACK STEERING WHEEL SKYLIGHT MAST WINDLASS

STARBOARD

· LAYOUT ·

CHART TABLE HEADS GUEST STATEROOM SALOON GALLEY

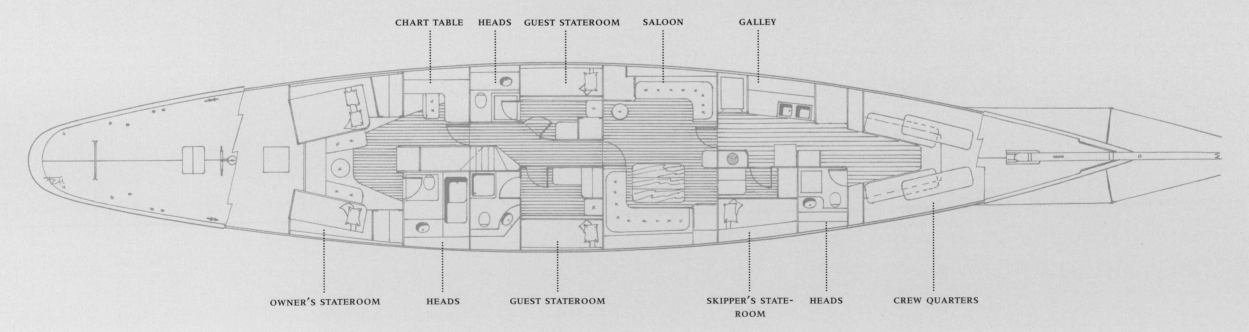

OWNER'S STATEROOM HEADS GUEST STATEROOM SKIPPER'S STATE-
ROOM HEADS CREW QUARTERS

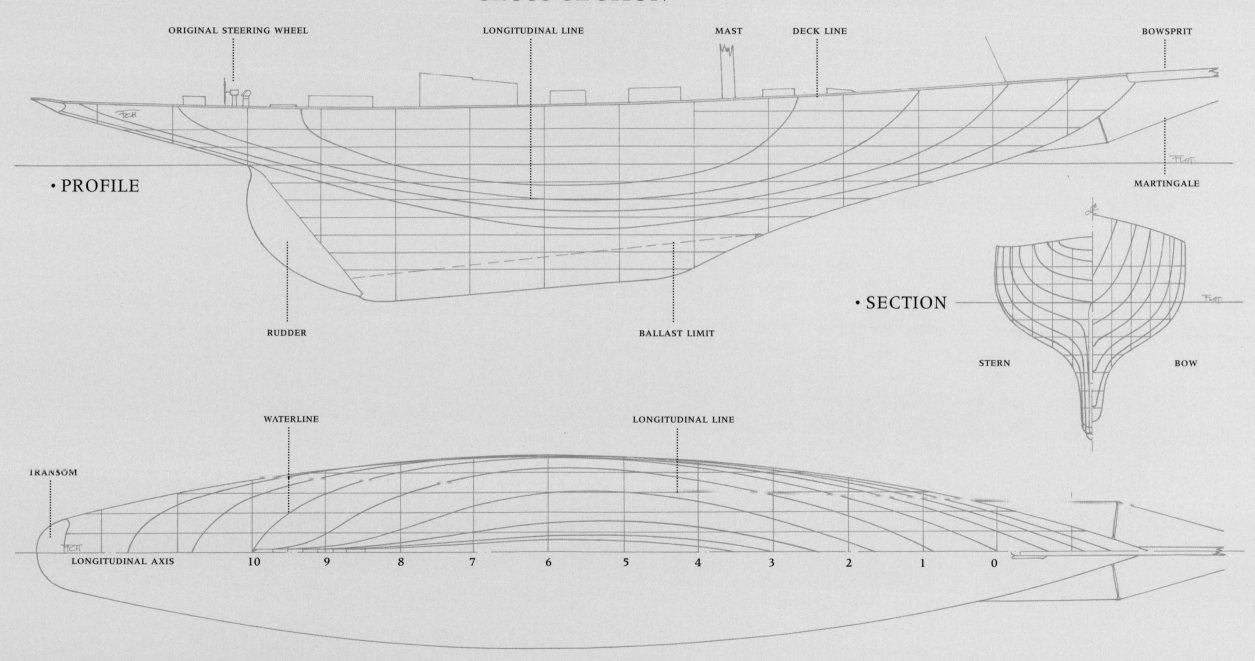

· CROSS SECTION

ORIGINAL STEERING WHEEL LONGITUDINAL LINE MAST DECK LINE BOWSPRIT

· PROFILE

MARTINGALE

RUDDER BALLAST LIMIT

· SECTION

STERN BOW

WATERLINE LONGITUDINAL LINE

TRANSOM

LONGITUDINAL AXIS 10 9 8 7 6 5 4 3 2 1 0

· PLAN

· Nan ·

Fairy tales can come true and *Nan* proves it. It's not a trick of the imagination, just read her extraordinary story—a veritable Fife tale. In December 1998, Philippe Menhinick, a collector of marine antiquities in Rothéneuf, France, was visiting sites in search of antiques. An advertisement announcing the sale of a 1932 wooden ketch at the Cap-d'Agde caught his attention. One of the photographs showed the yacht's transom, bearing the word *Nan*, which immediately brought back childhood memories. Menhinick recalled the stories of the cruises his father went on in his grandfather's ketch. Checking Lloyd's Register confirmed his memory. He found a cutter-rigged *Nan* that had been launched in 1897 and had belonged to George-Henry Menhinick. Furthermore, she was built on a plan designed by William Fife II. But, was this the same boat as the one in the advertisement?

The spray and waves provide a nice frame for *Nan*. When Philippe Menhinick rediscovered his grandfather's yacht, he restored her to her former glory.

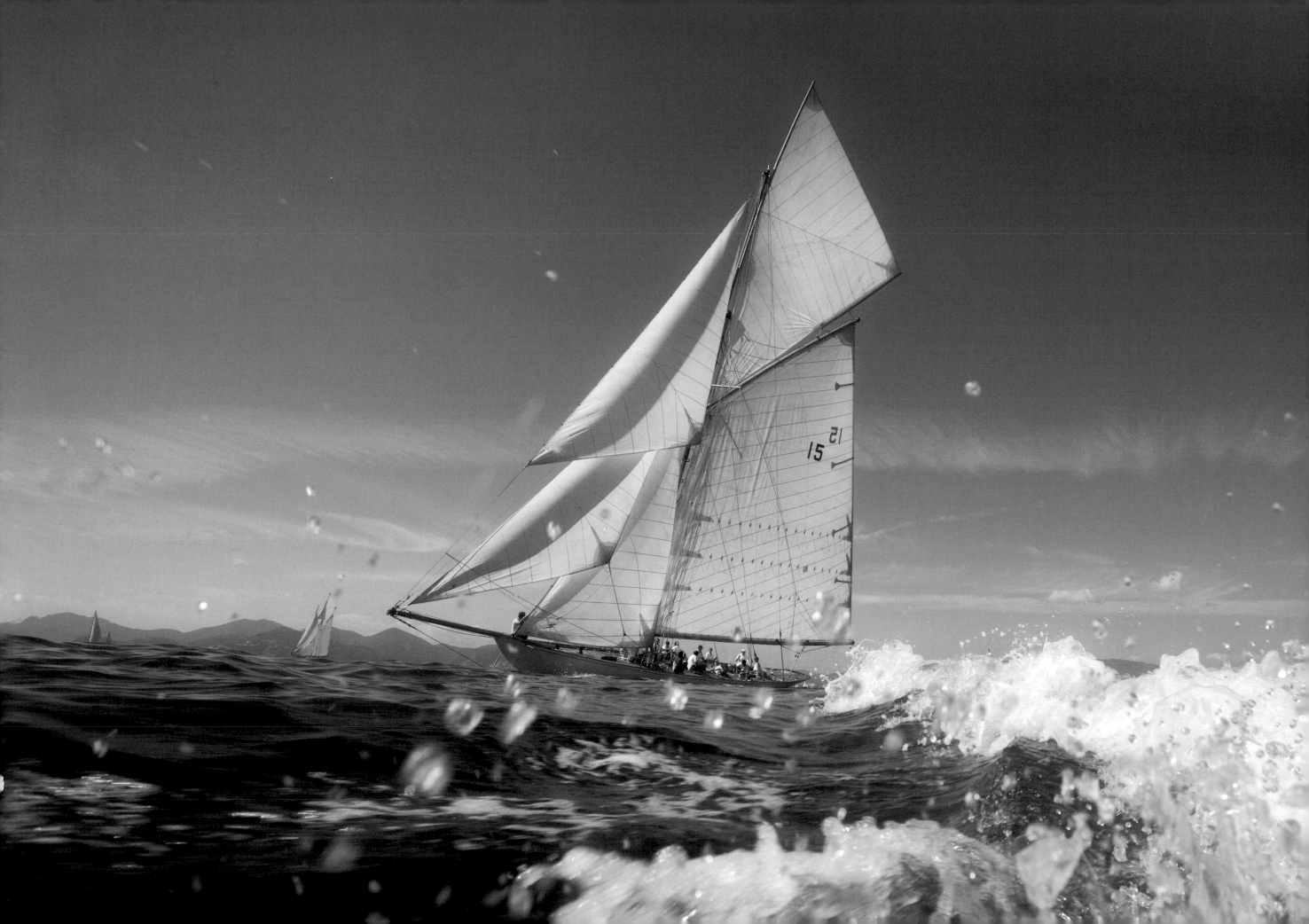

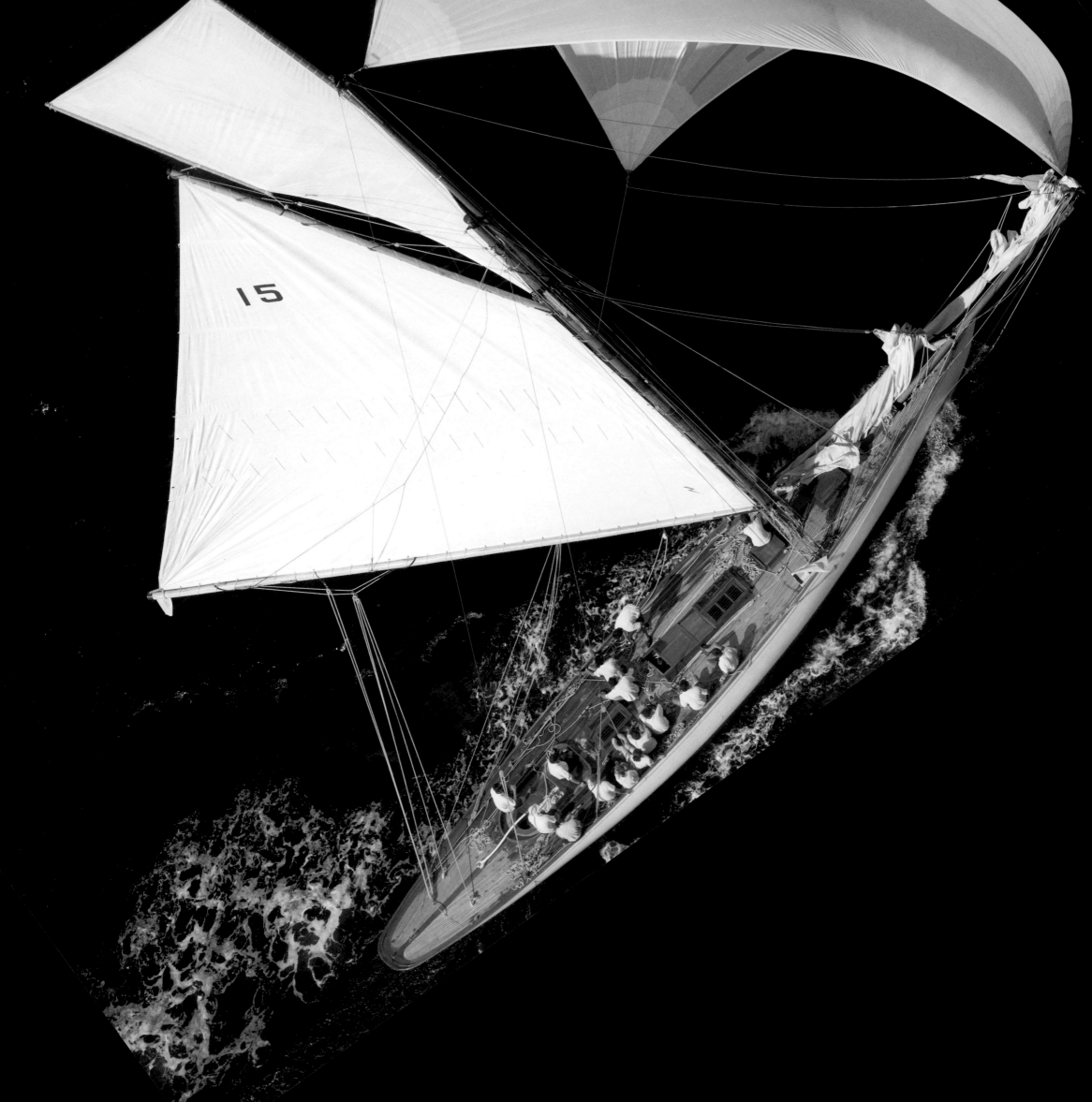

F airlie, Scotland, 1896. William Fife III, thirty-nine years old, is working on the plans for *Nan*, a racing yacht, his second-largest vessel that year. The order has come from Thomas Corby Burrowes, born in Dublin in 1856. Burrowes was only fourteen when he was given his first yacht. The Irishman grew into a dedicated yachtsman and member of fourteen yacht clubs. Eventually he owned several yachts, most of them named a variation of "Nan." His first *Nan* was based on a William Fife II plan designed in 1890. Out of thirty regattas sailed with this yacht, Burrowes won twenty-four victories and came in second three times. His next yachts were *Nansheen, Nance, Squaw, Nan, Naneen, Nanta,* and *Savourna.* Then in early April, workers at the Fairlie boatyard were kept busy on another *Nan*, launched on April 30, 1897. The yacht set out for Dublin where she was rated on June 2. Burrowes, however, preferred to race *Nance*, a two-ton sloop designed by J. E. Doyle. At the end of the 1898 season, he put *Nan* up for sale. Acquired in early 1899 by S. M. Mellor of London, a yachting enthusiast, *Nan* then embarked on a successful racing career.

The Good Times

On Monday, June 5, *Nan* raced on the River Thames and opened the 1899 season with a great victory in a moderate wind. *Nan* was granted another win at Ryde, on the Isle of Wight on August 10, in a strong breeze. She opened the 1900 season by winning her first race. During Ramsgate Week, in early July 1900, she finally beat *Cerigo* and *Yum* in both real and compensated time. A few days later, she did the same in a light wind in the regattas organized by the Royal Cinque Ports Yacht Club. In early August, during the regattas held in Le Havre to mark the Exposition Universelle, *Nan* made her first appearance in France, and she won fifth prize. In August, at Cowes, during the Royal London Yacht Club regattas, Mellor decided to part with *Nan*.

In 1901, the cutter flew beneath the flag of her joint owners, Mr. Hall-Say and Mr. Elder of London. With a new set of sails cut by Ratsey of Cowes, *Nan* won three magnificent firsts in a light wind, and one second place during Cowes Week. She also won twice in the following year. In 1903, *Nan* competed thirty-four times, winning sixteen prizes in the process. The cutter was missing from the regatta circuit in 1904, because in the following year, for Ostend Week and the Antwerp International Regattas, she ran under the flag of C. H. Holland with a home port of Glasgow, Scotland. A win and a fifth prize in Antwerp on July 26, 1905, brought honor to Holland who had followed her from Ostend Week. In that same year, *Nan* won one of the races in Cowes Week, thanks to a following wind. The year after, Holland returned to Belgium to take part in the Ostend International Regattas where he won a heat and received the Elegance Cup awarded by the Yacht Club de France. For her tenth year at sea in 1907, *Nan* returned to Ostend, where she won once again, then competed at Le Havre where she came in second.

The Bad Times

In 1908, *Nan* stopped competing on the regatta circuit. In 1926, she belonged to Major K. J. McMullen. *Nan* was then rerigged as a gaff ketch. Her structure was weakened and her handsome counter truncated; and some of her broken ribs were reinforced. In the following year, the yacht was given a Ford motor. In 1931, she was converted from a gaff ketch to a Marconi ketch. At the end of World War II she was acquired by Stephen Sparrow. Her keel disappeared, the lead having been requisitioned in 1940. She changed hands again in 1948: this time being purchased by Douglas A. Marshall who passed her on a few months later to George-Henry Menhinick, living at Hamble, near Southampton, England. It is here that the story of *Nan* took on a new twist.

In late 1951, *Nan* crossed the English Channel once again, having been acquired by Belgian Louis-Didier Zurstrassen, a friend of the Menhinick family, based in Antwerp. During the next three seasons, *Nan* cruised along the French coast. In 1955, Zurstrassen decided to move her to the Mediterranean, but in 1958–59, *Nan* disappeared from the Lloyd's Register while she was being used by a ships' chandler in Nice—Joseph Albertini, who gave her the name of *Anyway II*. When Pierre Malafosse acquired the ketch in 1968, he restored her original name. The certificate of registry issued at Sète on May 22, 1981, confirms that a yacht named "*Nan*" was imported on December 24, 1968, but under "country and year of construction," the entry reads, "Great Britain, 1932." Was *Anyway II* really *Nan*? It is quite possible.

Malafosse cruised up and down the Mediterranean every year with friends and family, but in the early 1980s, *Nan* was more often found in her berth in the port of Cap-d'Agde. In 1983, Malafosse's son-in-law Claude Comolet and his friend Serge Mas took the fate of the ketch into their own hands. They reinstated the rigging, a steering-wheel replaced the tiller, and a Perkins engine took over for the Renault Marine Couach motor. The annual cruises in the Mediterranean resumed. *Nan* spent the winter of 1990–91 at the Chantier des Baux at Sanary-sur-Mer, France, where she was overhauled. She went back into service, and each year her maintenance was assured in good order.

Hope

In December 1998, Philippe Menhinick discovered the mysterious boat. This was the start of a detective story worthy of Sherlock Holmes. Menhinick traveled to Cap-d'Agde and took photographs of the ketch. On returning to Saint-Malo, he contacted two of his grandfather's former crew members, Alain Gilbert and Claude de Possesse. They soon dispelled any doubt: the vessel moored in Cap-d'Agde was indeed the yacht that had belonged to George-Henry Menhinick. But although she had belonged to his grandfather,

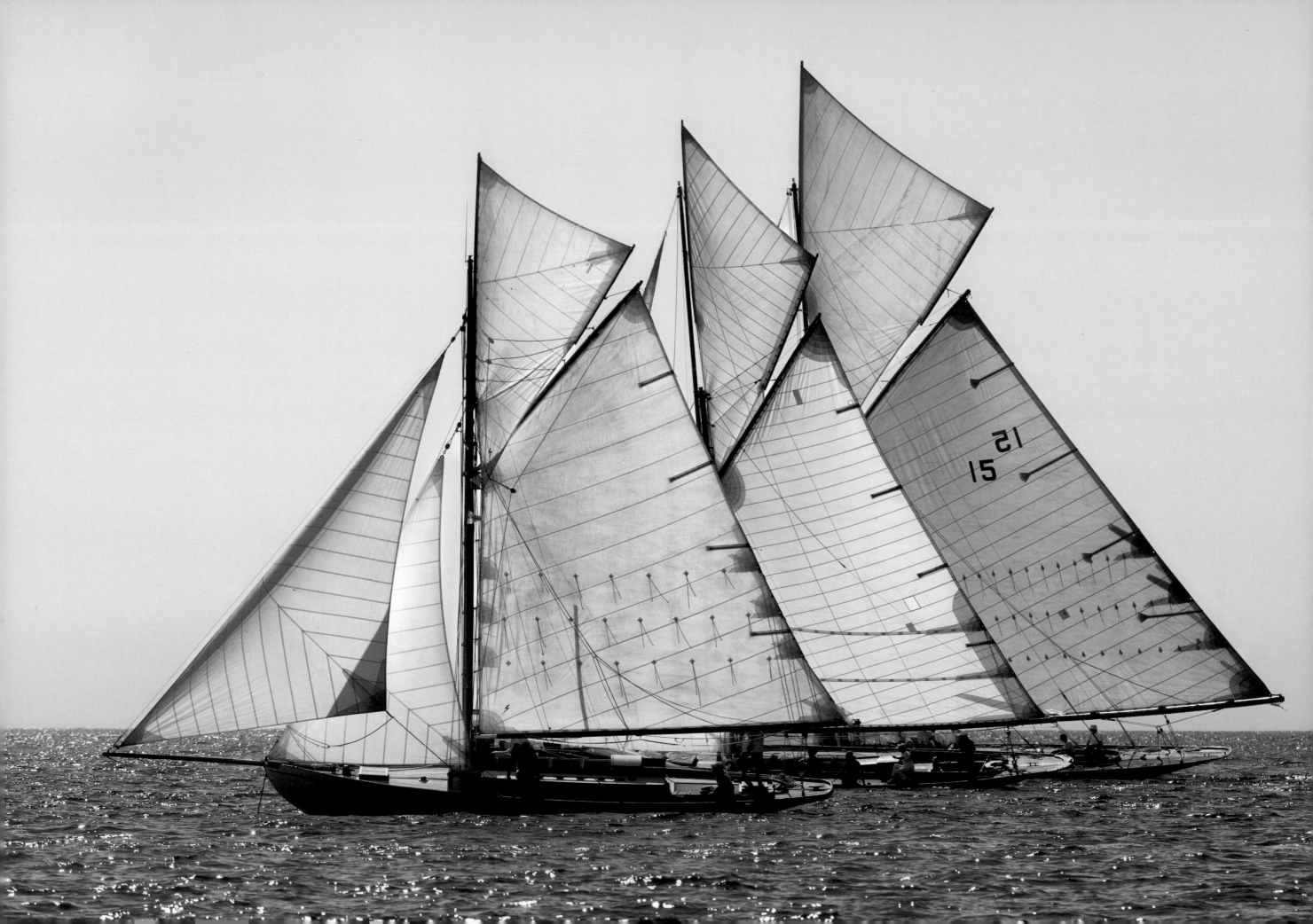

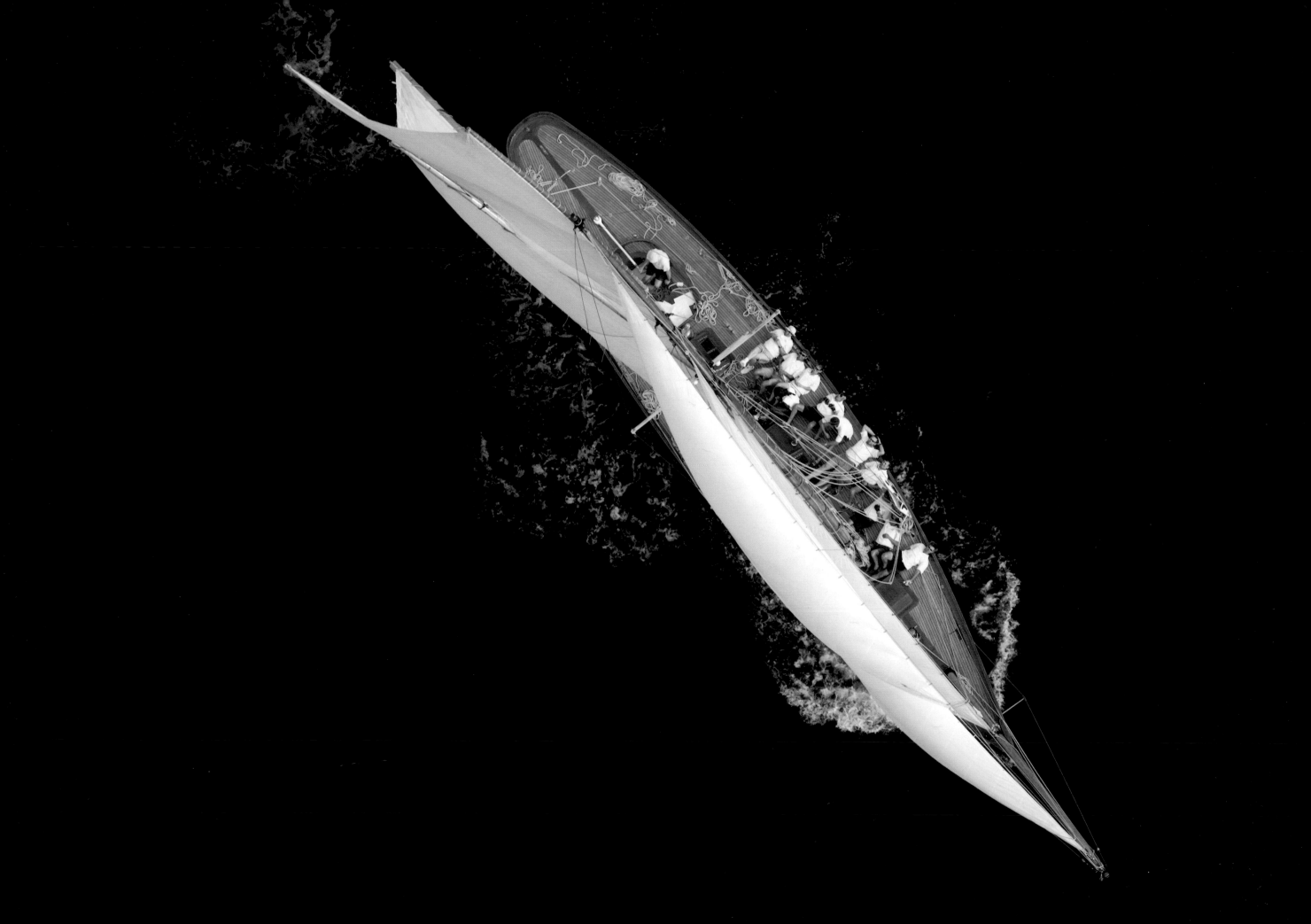

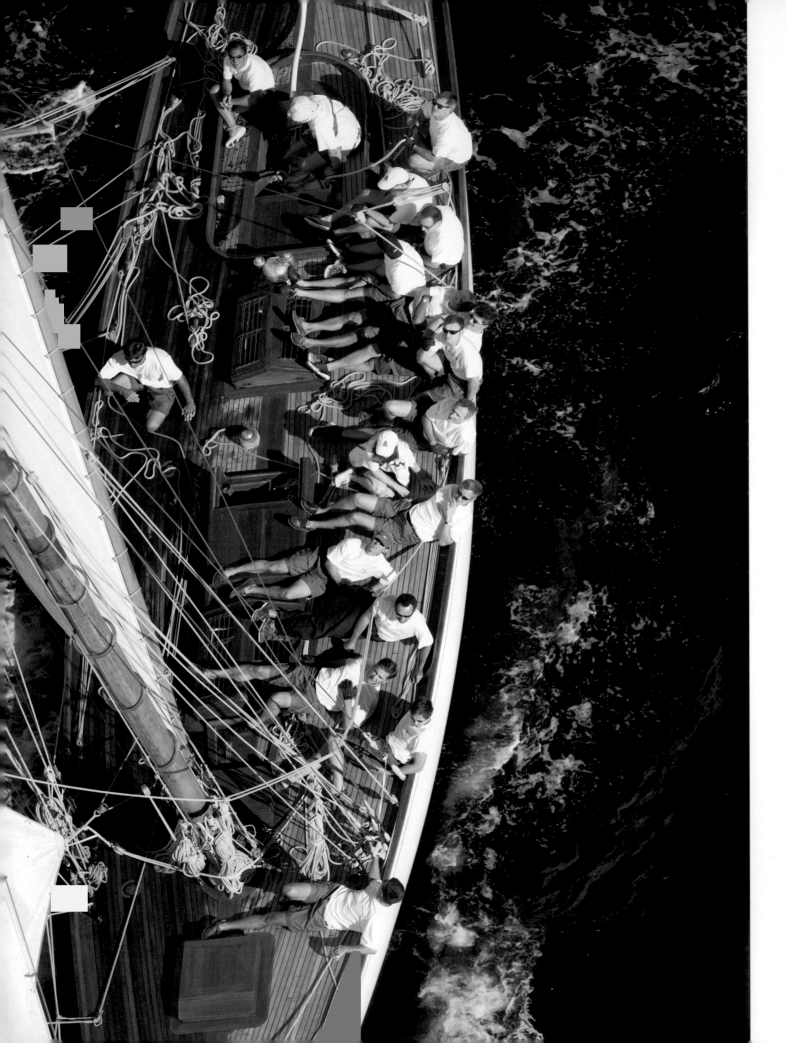

everything pointed to the fact that she had not been built in 1932 as stated in the official documents. The younger Menhinick decided to acquire the yacht and made an offer for her, which was accepted on January 20, 1999. Menhinick consulted Fairlie Restorations, but their estimate for the work needed was astronomical: four million francs (over $570,000) alone for her hull and bridge, to say nothing of the rigging and the interior. He decided instead to undertake the work himself with the help of a few good professionals. A farmer in Saint-Coulomb, France, rented him a large hangar, and in early April 1999, *Nan* found herself under cover in her Breton boatyard. In the meantime, Menhinick continued to research the origin of the vessel.

In April 1999, Menhinick began studying the documentation in the Chevalier-Taglang archives. He finally learned that the yacht was indeed plan number 377 by William Fife III, designed in 1896 for the Irishman Thomas C. Burrowes.

New Beginnings

Menhinick contacted a certain Derek Burrowes. The initial exchange was less than satisfactory, "The Burrowes family has never owned such a large boat," Menhinick was told. However, a few days later, Burrowes called back to say: "Your story has intrigued me. Someone remembered that our ancestor owned a large sailboat. I went to the city library and happened to meet Jim Grant, curator of the Scottish Maritime Museum, which contains the archives of the Fife family, and he looked up Thomas Burrowes," he explained to Menhinick. The end result was that the museum indeed had a plan of *Nan*. Menhinick traveled to Irvine, Scotland where Grant offered him a partial cross section of the yacht in question. It was the moment of truth. On August 31, 1999, the French customs officials restored the lineage of the cutter.

How on earth was this classic yacht to be restored without the aid of a personal fortune? Menhinick could not wait for that moment; she needed to be returned to her original glory as soon as possible and under the best conditions. Should he open his own boatyard? He was very familiar with yachts, but needed to get some expert advice. Raymond Labbé was still around in Saint-Malo, and his years of experience were most valuable. A little team soon formed, consisting of Gilles Baron, a ship's carpenter, and Philippe Bellion, a cabinetmaker, who plunged enthusiastically into the adventure. Jean-Bertrand Rondel also offered his help. Menhinick, as the apprentice, took care of the logistics. He bought the initial tools to allow the carpenters to start work, and they did so on September 17, 1999.

Nan finally relaunched on August 6, 2001, in Le Havre de Lupin, a little stream very close to the boatyard, with *Moonbeam III* (1903, designed by William Fife III) accompanying her. On August 15, she set off for Cowes where she was feted during the Jubilee of the America's Cup. She came second in her series, just behind *Marilee* (1926, designed by Nathanael Herreshoff). A few weeks later, she returned to the Mediterranean for the Prada Challenge trials for classic yachts and in early October 2001, she had a win—a worthy reward for Philippe Menhinick and his crew.

Nan is chartered each spring and visits the French Riviera annually to take part in classic yacht events.

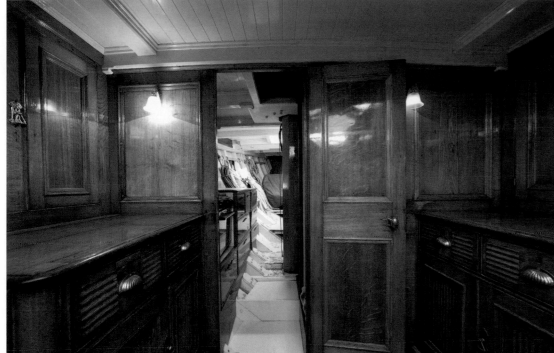

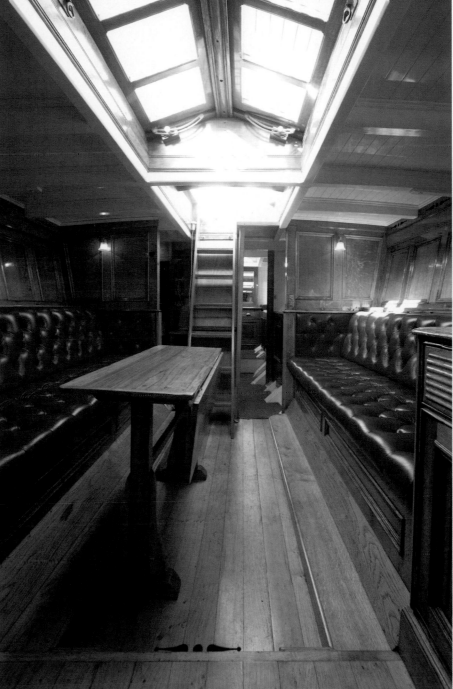

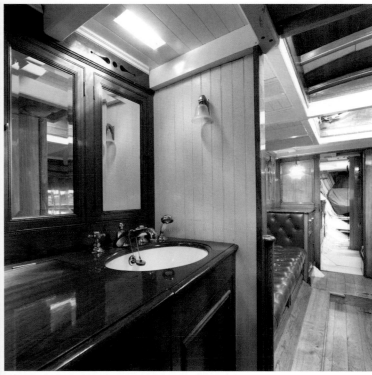

Philippe Menhinick deals in nautical antiques. He prefers his shiny period compass over more modern instruments. The saloon furnishings have been restored and reinstalled in their original layout with the storeroom still sitting at the foot of the mast.

· FEATURES ·

Name: Nan
Architect: William Fife III
Builder: William Fife & Son, Fairlie
Rigging: gaff cutter
Type: offshore racer
Launched: April 1897
First owner: Thomas C. Burrowes
Restoration: 2001
Boatyard (restoration): Nan Naval Boatyard, Saint-Coulomb, France
Architect (restoration): François Chevalier
Construction: mahogany planking on oak and acacia ribs

Overall length: 81 feet 10 inches [24.95 m]
Deck length: 63 feet 1 inch [19.23 m]
Length at waterline: 44 feet 2 inches [13.47 m]
Maximum beam: 11 feet 7 inches [3.53 m]
Draft: 8 feet 6 inches [2.59 m]
Ballast: 12 tons
Displacement: 20 tons
Approximate sail area: 1,002 square feet [301 m²]
Engine: Perkins 50 CV

· DECK PLAN

PORT

COCKPIT COMPASS CLEAT STAIRWAY SKYLIGHT AFT STAIRWAY BOWSPRIT

MAINSAIL TILLER SKYLIGHT DECK GLASS MAST CAPSTAN
TRAVELER RACK

STARBOARD

· LAYOUT

DOUBLE STATEROOM HEADS SALOON LOCKER GALLEY

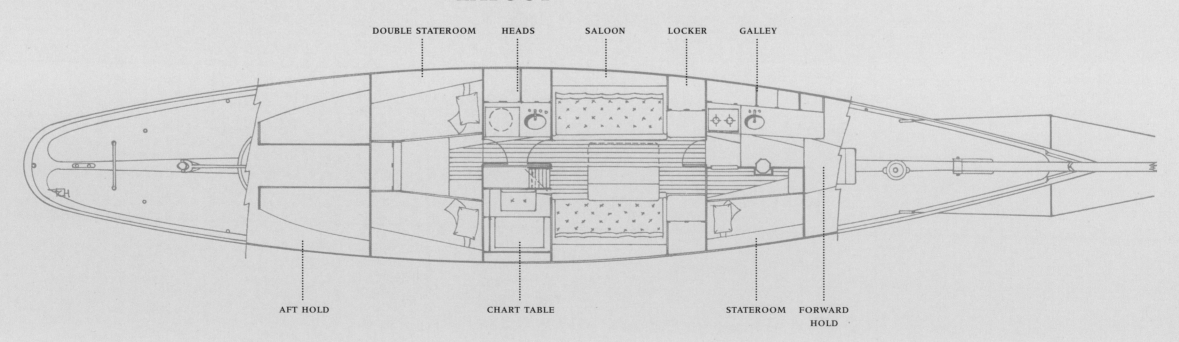

AFT HOLD CHART TABLE STATEROOM FORWARD
 HOLD

·CROSS SECTION

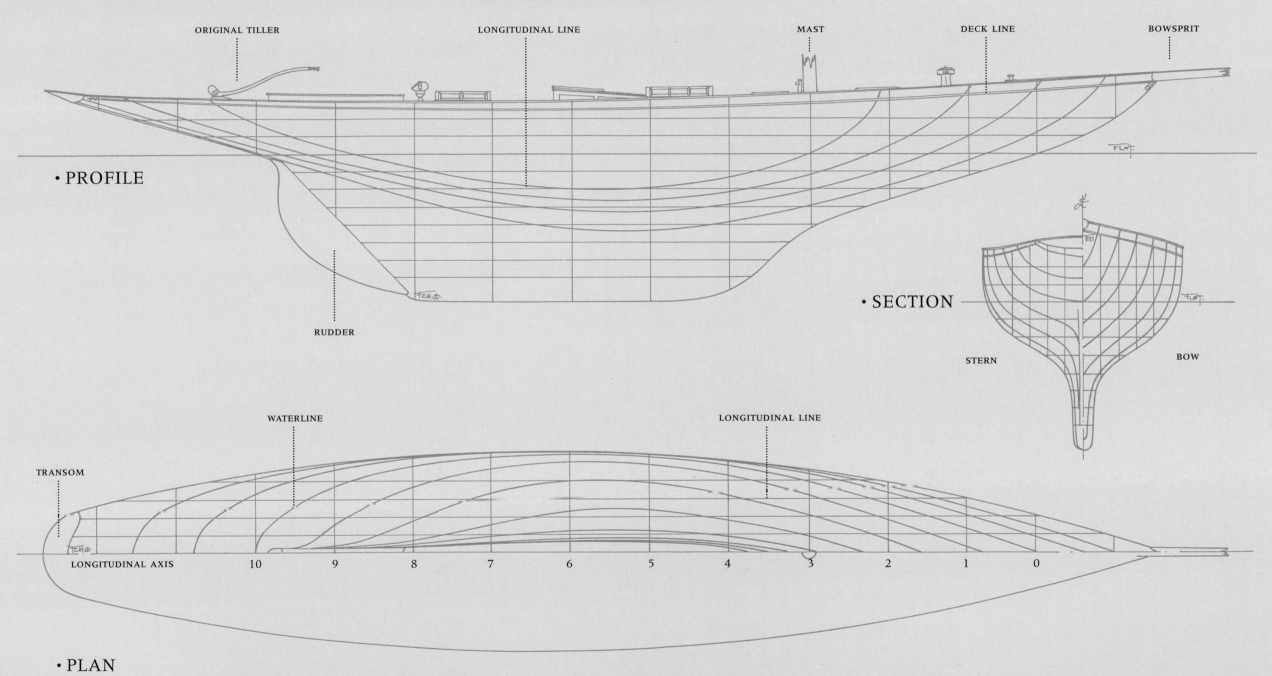

ORIGINAL TILLER · LONGITUDINAL LINE · MAST · DECK LINE · BOWSPRIT

·PROFILE

RUDDER

·SECTION

STERN · BOW

WATERLINE · LONGITUDINAL LINE

TRANSOM

LONGITUDINAL AXIS · 10 · 9 · 8 · 7 · 6 · 5 · 4 · 3 · 2 · 1 · 0

·PLAN

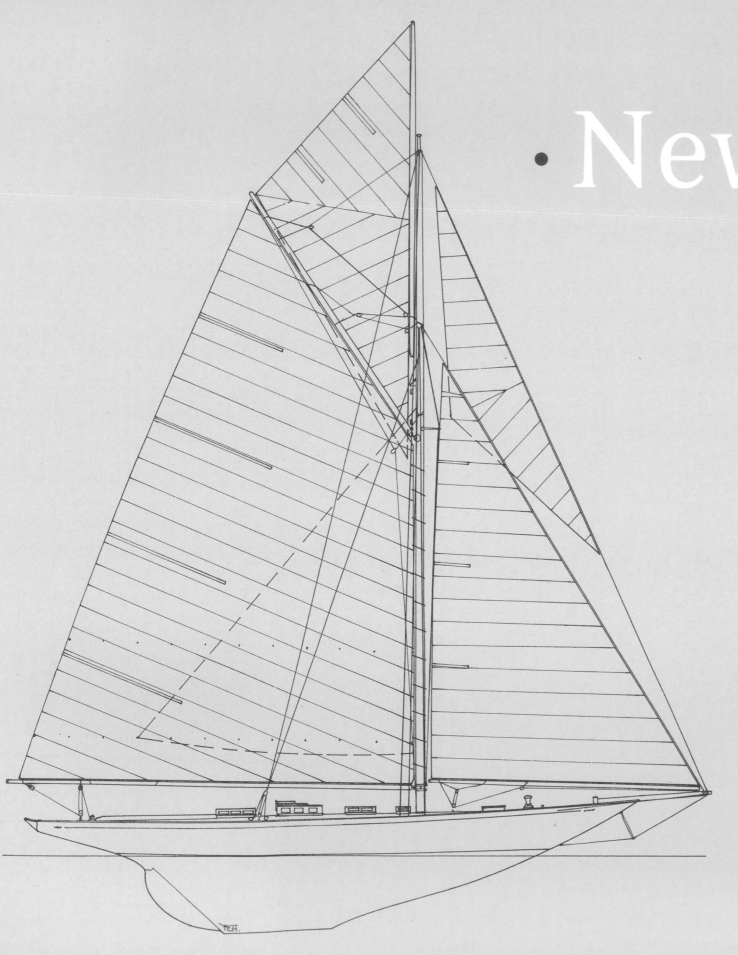

• New York 40 •

An ugly duckling? In the case of the New York 40s, it's relative.

The New York Yacht Club (NYYC) prototype sailboat for 1916, the NY 40s are seventeen feet (5 m) shorter than their older sister, the NY 50s, yet they still have a deck length of 60 feet (18 m) and their freeboard and width are nearly the same as their predecessor. The NYYC program specifically wanted a racing yacht that was comfortable, since the members of this club were rather big men.

The deck of *Marilee* is typical of American yachts which are functional and efficient. This New York 40 hull was a popular class for New York Yacht Club members.

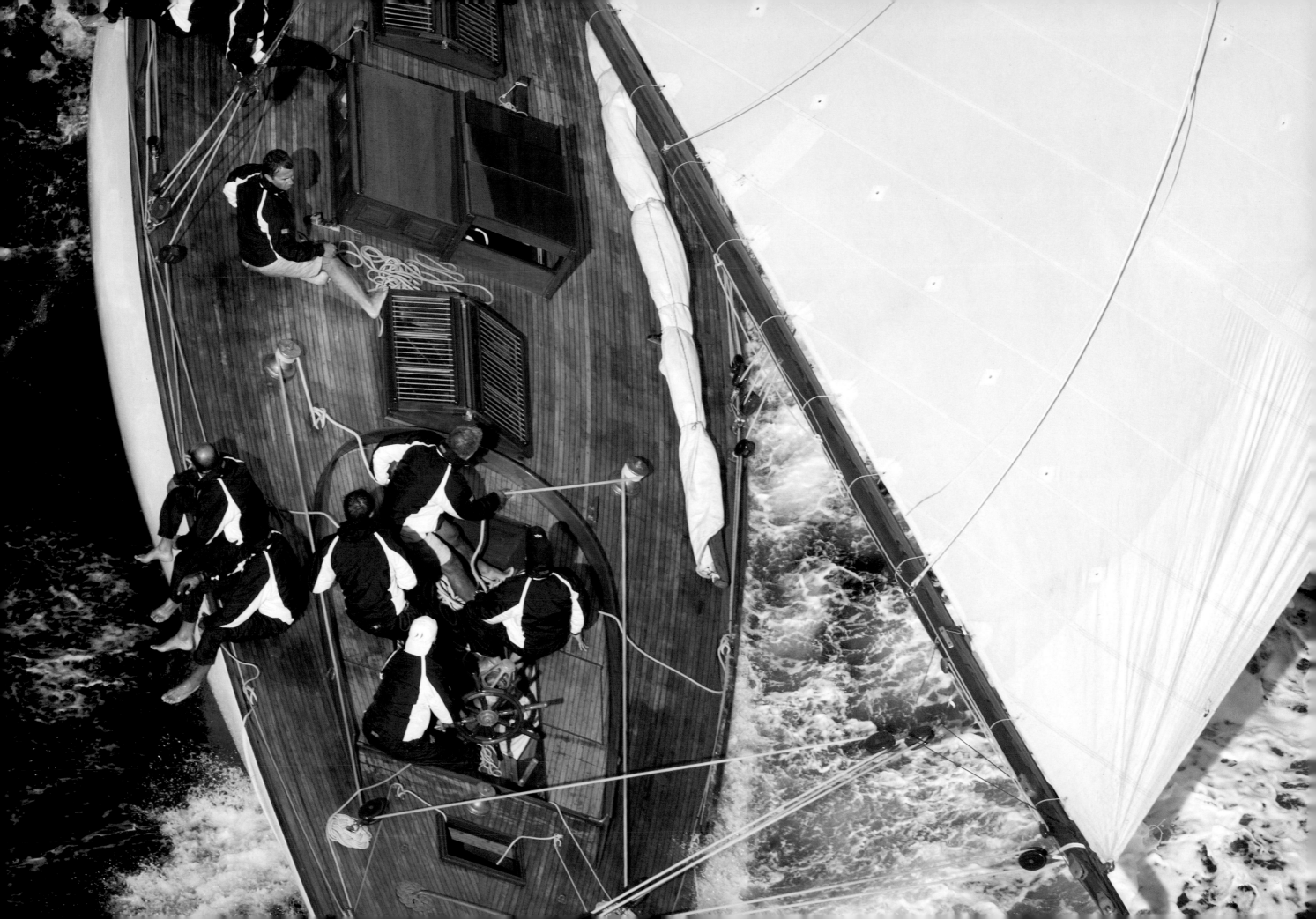

In May 1916, when the newborn vessels emerged from the Herreshoff boatyard, a storm broke out in the American press regarding the look of the yacht. The *New York Times* claimed that Nathanael Herreshoff, designer and builder of the NY 40 prototype, had merely produced a redone version of *Resolute* (1914–20), his defender for the America's Cup.

Boats built by Herreshoff, "the Wizard of Bristol," had a very distinctive look. Though narrow where they entered the water, they had massive width at the deck line, with extended lines and pinched sterns, generally making for very wide V section. These were not easy lines to design, unlike the cross section plans of William Fife or Charles Nicholson. In the case of these British builders, all that was needed was to place a weight on a flexible lathe and the lines flowed naturally. But Herreshoff did not draw yacht plans; he would first cut out a half-hull in wood, whose measurements he would record in a notebook. As he carved, he would mentally create all of the parts that would be used in the design of the boat, his plan, his calculation of the tonnage and hydrostatics, incorporating the structure and implementation problems, the deck fittings, the rigging, and the interiors. He would never let a boat leave his yard that had not been designed down to the minutest detail, including the cleats, door handles, and set of sails. His steam yachts were fitted with engines constructed in the workshops.

A man of few words, Herreshoff worked in the greatest secrecy and would reveal very little information. A famous interview from 1903 about the defense of the America's Cup aptly portrays his reticence: "What do you think of the *Reliance*, Mr. Herreshoff?" asked the journalist. "I have nothing to say." "Will she beat the *Constitution*?" No reply. "What do you think of the *Shamrock III*?" Still no reply. "Good day, Mr. Herreshoff." "Good day, sir. And write no more information than that which I have given you."

The Roaring Forties

On May 30, 1916, in their initial regatta for the spring cups over an eighteen-mile course, the first ten NY 40 prototypes competed against the NY 30s and NY 50s. In a light wind, the newcomers did not attract much enthusiasm. *Barbara*, a fifty owned by Harry Paine Whitney, placed first in front of *Carolina*, owned by George Nichols, but *Lena*, a thirty belonging to Ogden M. Reid, slid in front of four of the forties. The NY 40 *Zilph* owned by James E. Hayes Jr. won the NY 40 series, with George M. Pynchon's *Mistral* in second, and *Maisie*, belonging to Henry B. Plant, son of Morton F. Plant, third. The last regatta of the year for the championship of the series was held on September 23 over a triangular nineteen-mile course around Glen Cove. The ten-knot wind at the start became increasingly fierce. *Jessica*, owned by Wilson Marshall, with Edmond Fish at the helm, won the cup, beating *Mistral* and *Maisie*. This would be the last regatta held for four years, once the United States declared war on Germany on April 6, 1917.

It soon emerged that the sail plan of the NY 40 needed revising. There was too much sail and the boats had a tendency to move into the wind. In 1920,

the twelve yachts from the 1916 series were given a bowsprit to improve the sail balance. They still managed to do quite well, since the first season proved that the new prototype was able to hold her own in a fierce wind and could negotiate choppy seas. Furthermore, she perfectly matched the specifications: a racing yacht designed to be sailed without a professional crew that could also be used as a particularly comfortable and safe cruising yacht. In the 1920s, yachts of this class would be given the nickname of "Roaring Forties," since their owners and crews boasted of being able to sail all day long in any weather conditions and then drink heavily all night.

Marilee, *Nine Months to be Reborn*

For many years, Europeans only knew of the NY 40s through a few nice photographs taken by Stanley Rosenfeld, the NYYC's official photographer, and those taken by Edwin Levick on July 23, 1923, during the Larchmont Regattas, which showed four NY 40s, including *Rowdy*, battling a strong wind in one entitled *Forties in a Squall*.

One day in the winter of 1999, however, the NYYC decided to send a representative to the America's Cup Jubilee that was to be held in Cowes in August 2001. Of the four NY 40 yachts still afloat in the United States, only *Marilee*, the first of two built in 1926, was available. She was in a terrible state and five members of her owners' syndicate—Edward Kane, Peter Kellogg, Mitchell Shivers, Larry Snoddon, and William Waggoner—commissioned William Cannell of Maine to do the restoration. In August 2000, the yacht entered the boatyard to be restored to her original condition. The work lasted nine months, longer than it had originally taken the yards of the Herreshoff Manufacturing Company to build twelve of these vessels. In his defense, Cannell only had nine carpenters to work on the vessel, while the original boatyard employed over a hundred such craftsmen. Examination of the vessel revealed that 70 percent of the original boat needed replacing. The first problem was finding the same types of wood. The golden pine for the planing was finally discovered growing on a riverbank in northern Florida, and the white oak to replace almost all of the split or broken originals was found in New England.

All of Herreshoff's instructions were followed to the letter, and each piece of wood was replaced by its equivalent. For example, two planks in poor condition made from the finest mahogany among all the other golden pine planks on each side of the hull were replaced by new planking of the same quality. They reinforced the general structure of the yacht in the way the architect was in the habit of designing it, using crossed steel struts inside the planking beneath the deck. This arrangement increased the rigidity and reduced the sampling of the ribs and the beams, bracing the whole structure. During the reconstruction, they replaced the steel struts with bronze to extend the life span of the hull by several decades. The deck was made of pine, as it is lighter than teak. The interiors were slightly modified to adapt to the requirements of modern sailing. There is a stateroom forward with foldaway

Opposite
Marilee, sailing under reduced canvas off Saint-Tropez, is a beautiful sight. A powerboat following her enjoys the view.

Page 126
The crew looks quite content as *Marilee* sails in the lead.

Page 127
The helmsman's hat, on backwards, just doesn't seem to fit with this beautiful classic. Clearly there is a lot of discussion going on among the crew. Did they win the race? No one seems sure.

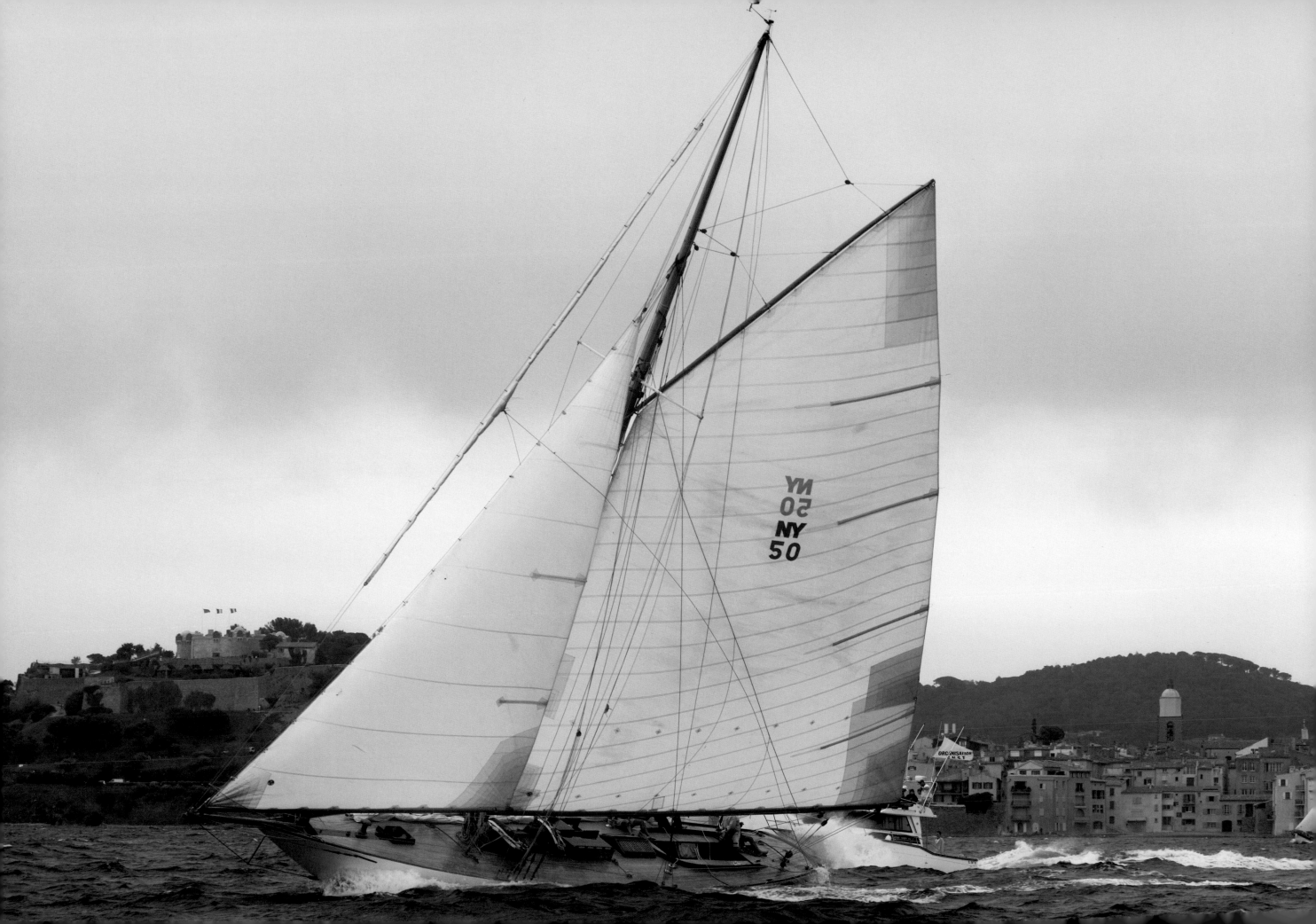

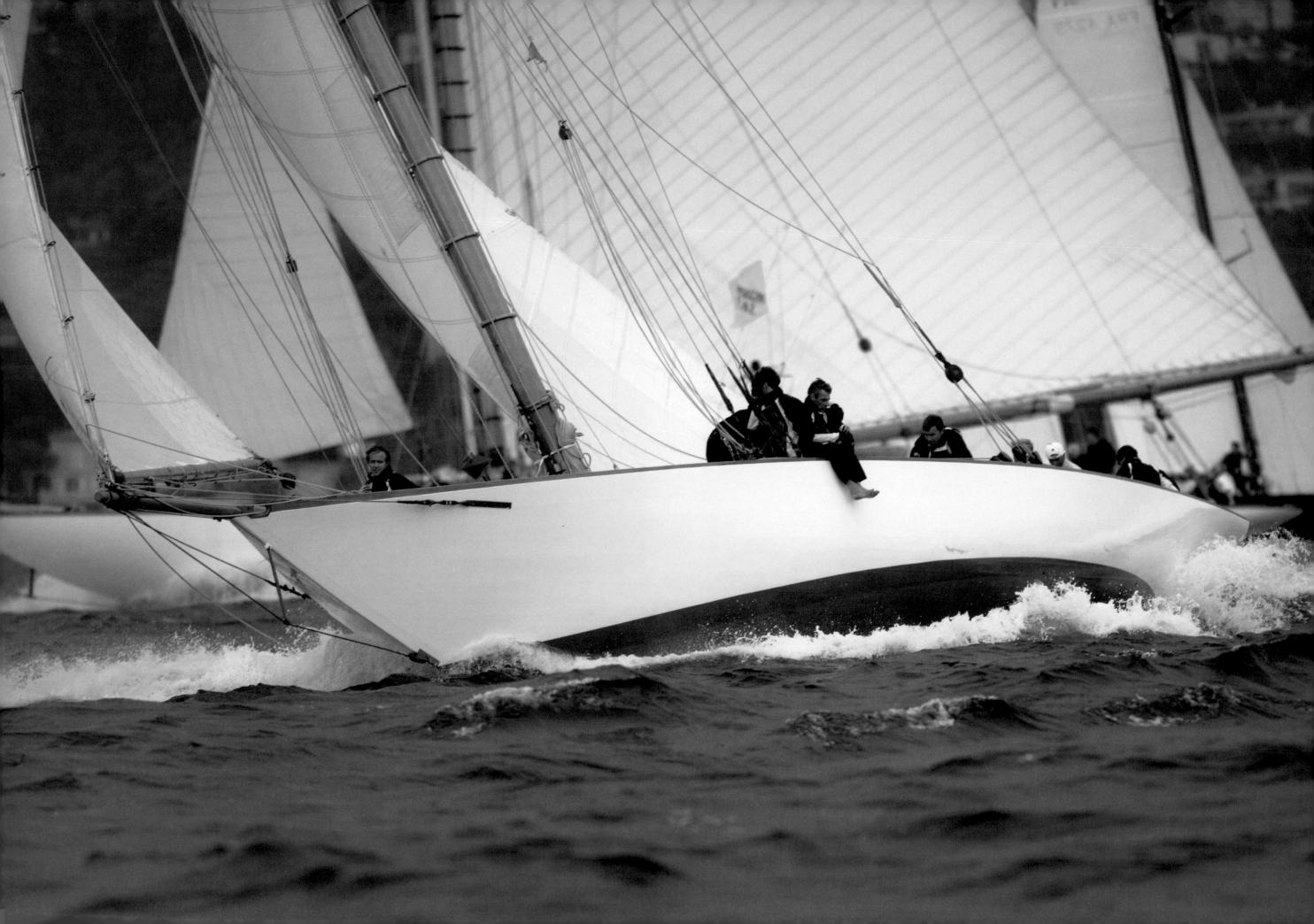

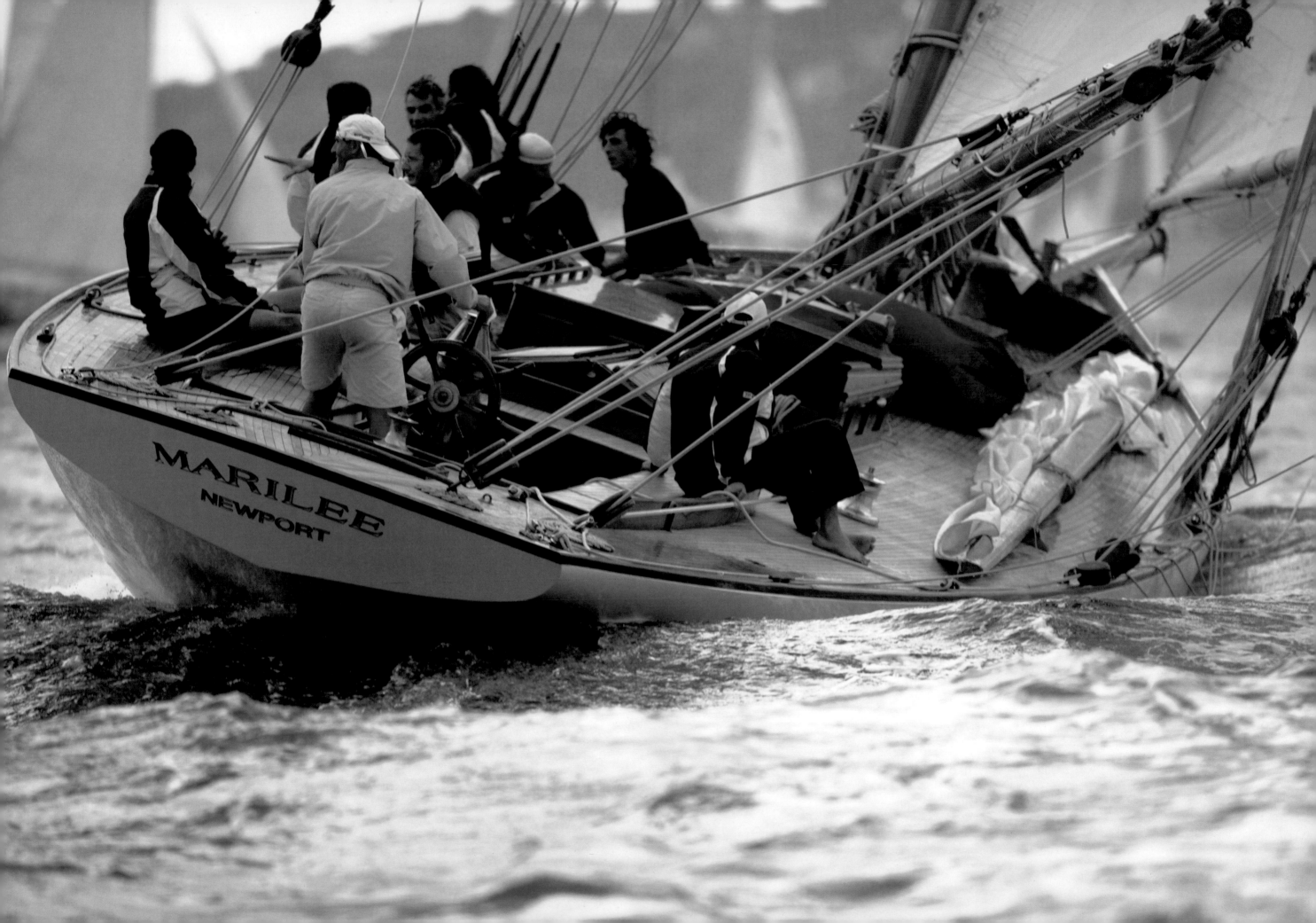

Above
Marilee is a shipshape
vessel as exhibited by the
waterproof canvas at the
mast step, the neatly coiled
line, and the polished
brass binnacle. There
should be an award given
to a yacht kept so nicely.

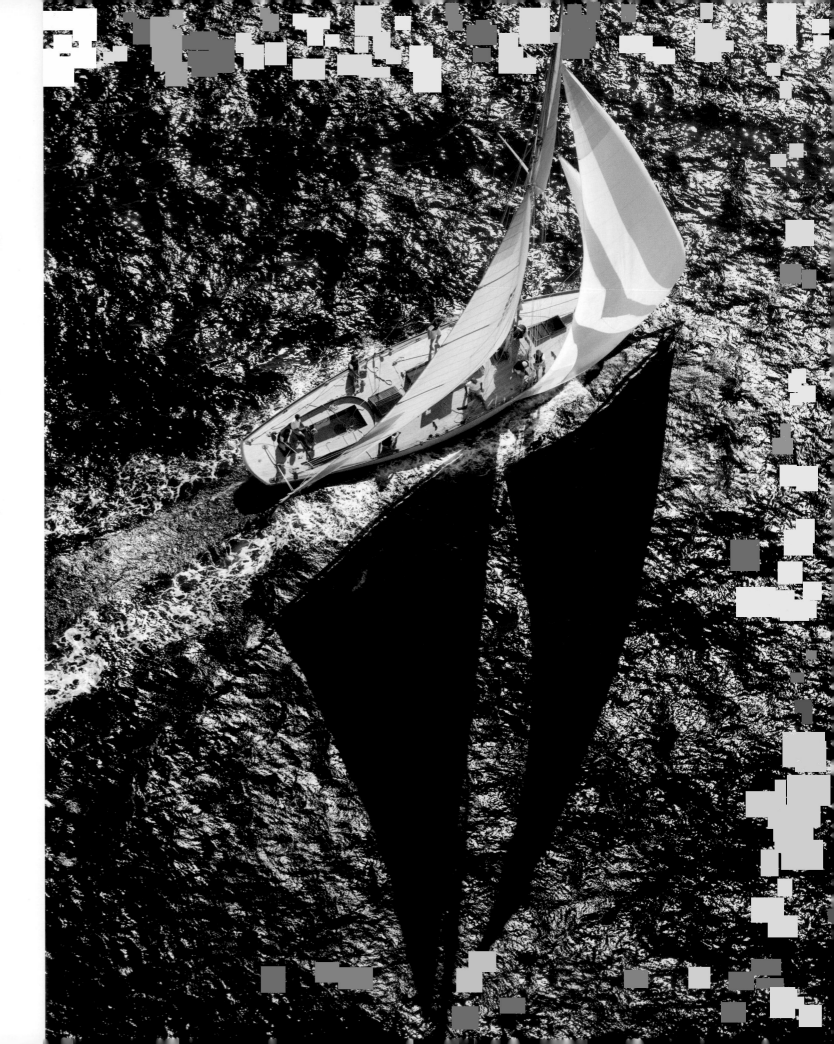

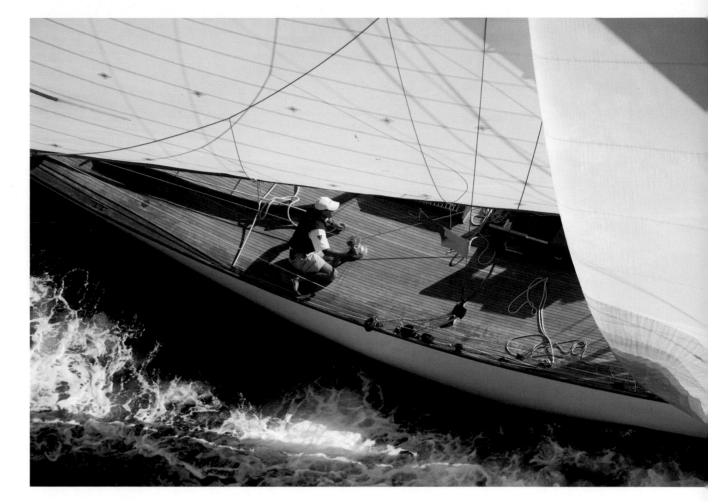

bunks and a head, then a saloon with two berths above the thwarts and another head with two doors to forward and aft, facing the galley. A master stateroom aft with two symmetrical bunks completes a spacious, comfortable interior.

The height below the beams gives the impression that the yacht is bigger than she actually is. The restorers heightened this impression by painting the bulkheads in cream, as was the fashion. Nowadays everything is highly varnished, bringing out the quality of the wood, but also giving them a slightly Victorian air. All of the spars were rebuilt in the restoration workshop owned by the Philadelphia Seaport Museum. They were constructed of Douglas fir, the long fibers that give American yachts their unique look. North Sails, Annapolis cut the NorDac sails.

After a few trials, *Marilee* traveled to England on a special cargo vessel filled with American yachts set to parade in the Solent for the America's Cup Jubilee in 2001. Another NY 40, *Rugosa II*, owned by Halsey Herreshoff, went with them on the trip. Once again demonstrating the genius of Halsey's grandfather, the two yachts would make their mark amid the European classic yachts, as the first vessels of this class to be seen on the other side of the Atlantic. *Marilee* won the race around the Isle of Wight. The following month, she traveled to the Mediterranean and placed first in the Royal Regattas of Cannes and second in the Prada Challenge that included the fall trials. During a second season when she upset the divisions of classic yachts—would the rule produce a gap in the rules that had been devised to enable all types of antique yachts to participate?—*Marilee* was again loaded on a fast cargo ship to attend the winter meets in the Caribbean, and then returned to Newport for the following summer.

Marilee, *An Emblematic NY 40*

A problem for the rule classifiers since her restoration, *Marilee* is an emblematic NY 40. She was named for the wife of her first owner, Edward I. Cudahy, a Chicago publisher. He sailed with his wife and son at Marion, near New Bedford in Buzzards Bay, Massachusetts, a popular area with other NY 40s, including *Chinook, Mistral,* and *Rowdy.* One day, on August 5, 1930, while racing in the bay with a strong following wind, a competitor got his boom tangled in *Marilee*'s rigging. The topmast was broken, the boat jibed, and Cudahy was thrown overboard. He ended up with three broken ribs. During the same regatta, *Mistral* also lost her mast and *Chinook*'s jib burst. The forty had already proved to be a formidable racing yacht in the open sea. In 1926, Robert N. Bavier won the Bermuda Race with *Memory,* and Russell Grinnell won the 1928 event with *Rugosa II.* In 1933, Cudahy installed an engine to make it easier to get back to port. After the death of his wife, Cudahy sold *Marilee* to C. Brook Stevens, owner of a textile mill, who used her for cruising along the coast with his family.

Edward Stevens, his grandson, tells of the fear he experienced in 1940, when he was eighteen: "As we sailed down the coast of New England, there were 40-knot squalls blowing. Captain Parry, the skipper, refused to reduce the sail, even during the strongest gusts. I am amazed that everything turned out well!"

It is under such extreme conditions that the NY 40 proves herself. Thanks to a ballast ratio of more than 50 percent and an extreme width, these vessels cannot exceed a certain angle of list and carry their sails well. When the topsail and the flying jib are hauled down, the sails' center of gravity is very low, and the hull slides along its inclined side at top speed. No wonder these boats have also been nicknamed "the Fighting Forties," since they can cope with any weather.

In 1948, Stevens sold *Marilee* to Loring Washburn of Greenwich, Connecticut. In the following year, Washburn changed the engine and the head, keeping *Marilee* until 1954. Thomas B. Suttner, then a student at New York University, made her his second home at the club in Larchmont for about ten years. He altered her rigging to that of a yawl and had a set of sails cut by the famous Ratsey sailmakers in 1960. In 1964, he sold *Marilee* to Dr. Alvin A. Bicker of New York, after having the hull of the yacht laminated.

Bicker kept her for thirty-six years, until the syndicate of NYYC owners finally purchased her.

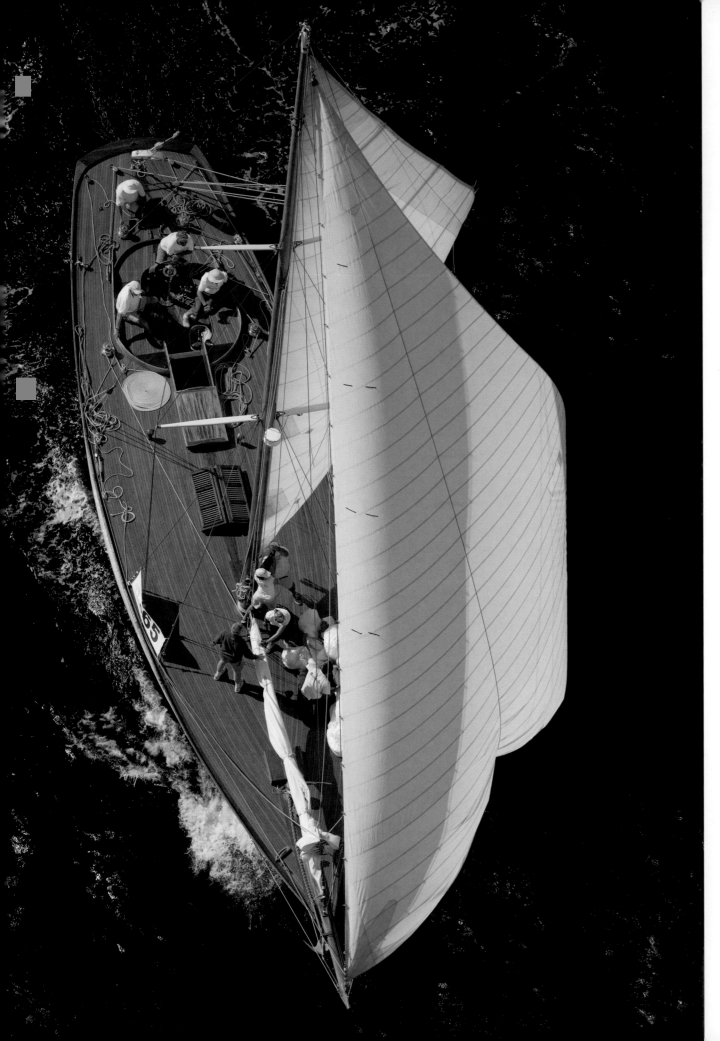

Seven Out of Fourteen

Today, seven of the fourteen NY 40s launched between 1916 and 1926 are still afloat. As seen, *Marilee*, represented the NYYC in classic yacht regattas on the U.S. eastern seaboard.

Chinook, formerly *Pauline*, then *Banshee*, owned by Henry L. Maxwell, took this name in 1929 under Howard F. Whitney and was yawl-rigged in 1937. She belonged successively to August A. Boorstein, William M. Fulton, James B. Knight, and John M. Blomgren in the 1970s, and is still taken out to sea. She is now owned by Dr. George Schimert and is based in St. Thomas in the Virgin Islands.

Mistral, built for Pynchon, who had been the owner of a NY 30, *Neola II* in 1905, and a NY 65, *Istalena* in 1907, has certainly covered the greatest mileage. She is currently in northern Europe, owned by a German.

Rowdy, owned by Senator Holland S. Duell and his family until 1940, won forty cups between 1920 and 1931. In 1941, the Duells sold the yacht to Frank Linden, then in the following year she went to Kenneth W. Martin. In 1948 after World War II, the yacht was given an engine and became the property of Frank Zima. In 1950, she was owned by George F. Stacy of Detroit and sailed on the Great Lakes. To reduce her draft, the ballast was cut down by eighteen inches (45 cm), and she was rigged as a Marconi sloop, without a bowsprit. In 1953 Stacy sold her to Dr. Chaignon Brown, and in 1955 she passed to Donald Major, then three years later to Aurelia Wiggle, a former Navy diver. In 1969, *Rowdy* was in Florida, the property of Frank Wynn who owned her until 1971. John Barkhurst then bought the yacht and took her to California through the Panama Canal. She had another four owners until being sold by the Blue Whale Sailing School of Santa Barbara to Chris Madsen, who completely restored her on-site between 1998 and 2002. Since March 2006, *Rowdy* has been based in Monaco.

Rugosa II still sails regularly. Herreshoff had her restored in 2000 at a boatyard in Westport, Massachusetts, and she is now the flagship of the Herreshoff Museum in Bristol.

The hull of *Vixen II*, formerly *Jessica*, winner of her class in 1916, was molded in reinforced concrete and extended by eleven feet eight inches (3.50 m), then laminated and schooner-rigged in 1978. She is now twice as heavy as she was originally and sails in Maine.

Dolly Brown is owned by Alexander S. Cochran, who also owned the schooner *Westward* and *Vanitie*, the defending challenger in the America's Cup (1914–20). After being renamed three times, she became *Wizard of Bristol* in 1970. Until recently, she was rigged as a ketch and chartering out of Hawaii.

The NY 40 series was not spared the wrath of the sea. Four of these vessels sank not far off the U.S. coast. *Shawara*, owned by F. T. Bedford, sank in a storm off of Cape May, New Jersey on her way back from the Gibson Island Race in 1933. The oil tanker *Yorba Linda* rescued the seven crew members. The yawl-rigged *Black Duck*, renamed *Memory*, sank in a storm in 1955 off

The hulls of *Marilee* and *Rowdy* were mass produced at the Herreshoff Manufacturing Company in Bristol, Rhode Island. Their rivalry continues today. The cockpit layouts are slightly different, however.

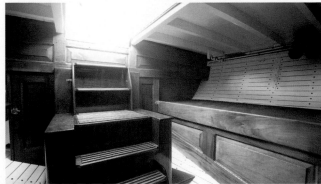

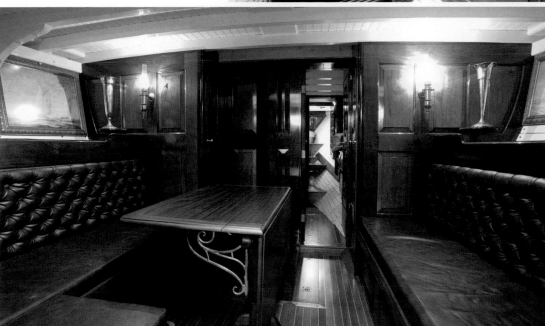

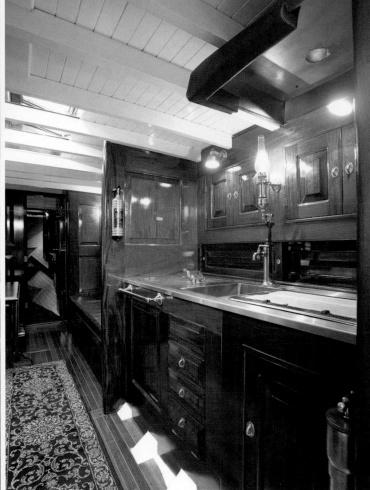

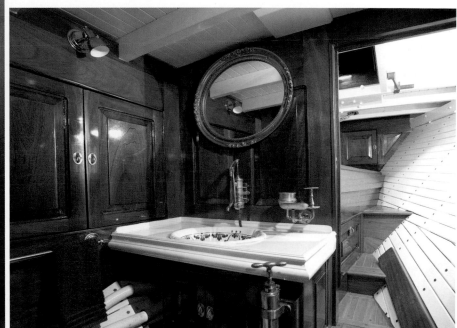

The New York 40s were built for speed and racing, but their owners could live comfortably down below. The placement of the furniture and cabinets was an important consideration for the designer. On *Rowdy*, the galley is at the bottom of the companionway, while on *Marilee* it is farther forward at the foot of the mast.

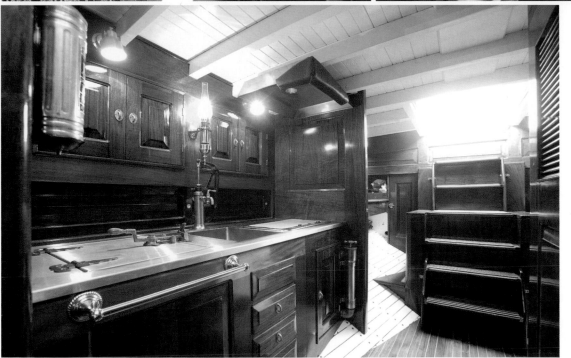

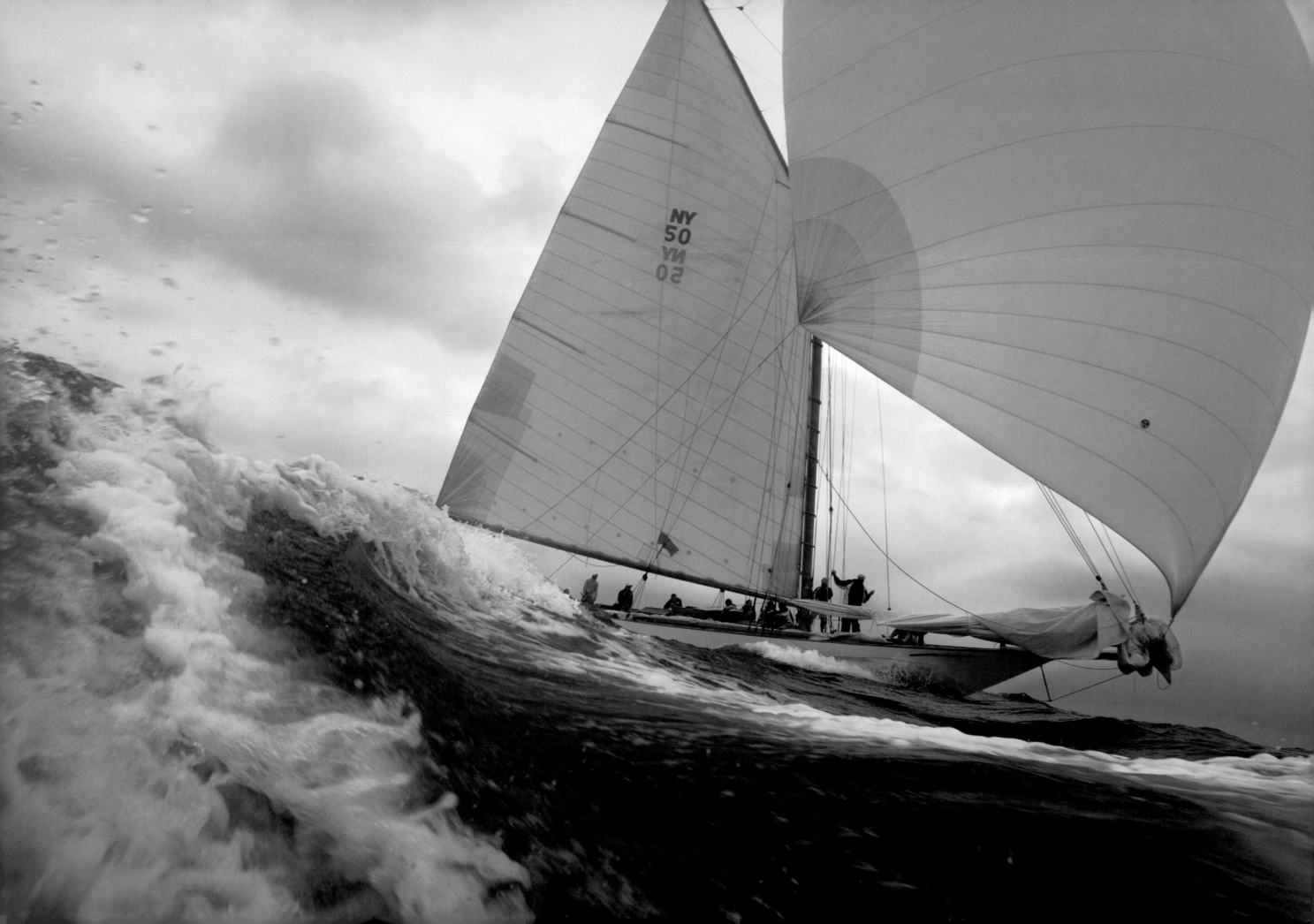

Opposite
This New York 40 looks ready to catch a wave and sit on top of the world. The crew also looks very relaxed as this beautiful wave passes by.

Block Island, as she was returning to New York. *Typhoon* was lost at sea north of Cape May in 1959, as her owner, Francis Branin, was sailing her to Oxford, Maryland to lay her up for the winter. She was formerly known as *Maisie* and owned by the Plants, both shipowners, who also owned the schooner *Elena* and the steam yacht *Parthenia*. The yawl-rigged *Squaw*, renamed *Blue Smoke* by the McNeil brothers in 1953, sank in 1970.

Diverse Fates

Katharine never changed her name. She belonged to L. Levinson of New York when, in 1974, she was broken up at the Jacobson boatyard in Oyster Bay, and her yawl rigging was recovered by Halsey for *Rugosa II*.

As for *Pamparo*, yawl-rigged in 1936 and motorized, she left for California after World War II, under the name of *Traveler*. In 1955, she was rediscovered in Honolulu belonging to Lyle Allen. Three years later, Frederick L. Stowell acquired her. She was declared ownerless between 1969 and 1971, and then disappears from Lloyd's Register.

Zilph was yawl-rigged and motorized in 1925. Her name was changed to *Dolly Bowen*, then to *Iris*, and finally to *Marjee*, but she disappeared from Lloyd's Register during World War II.

Today, however, the continuation of the line is assured. The forties are not ready to disappear, and it would be interesting to bring together the six or seven still competing in regattas, as they did in the 1920s.

Above
The hull of *Rowdy* must look familiar to passing sealife. After sailing for the New York Yacht Club, she raced on the Great Lakes for many years and now flies under the burgee of the Monaco Yacht Club.

· FEATURES ·

Name: NY40, Marilee
Architect: Nathanael G. Herreshoff
Builder: Herreshoff Manufacturing Company,
Bristol, Rhode Island
Rigging: gaff sloop
Type: prototype of the New York Yacht Club,
New York 40
Launched: 1926 (plan of 1915)
First owner: Edward I. Cudahy
Restoration: 2001
Boatyard (restoration): William Cannell,
Camden, Maine
Construction: golden pine planking on
curved white oak ribs

Overall length: 65 feet [19.80 m]
Deck length: 63 feet 1 inch [17.98 m]
Length at waterline: 44 feet 2 inches [12.19 m]
Maximum beam: 14 feet 5 inches [4.39 m]
Draft: 8 feet [2.44 m]
Ballast: 11 tons
Displacement: 21.70 tons
Approximate sail area: 666 square feet [200 m²]

· DECK PLAN

PORT

STEERING
WHEEL COCKPIT SKYLIGHT STAIRWAY SKYLIGHT MAST AFT STAIRWAY BOWSPRIT

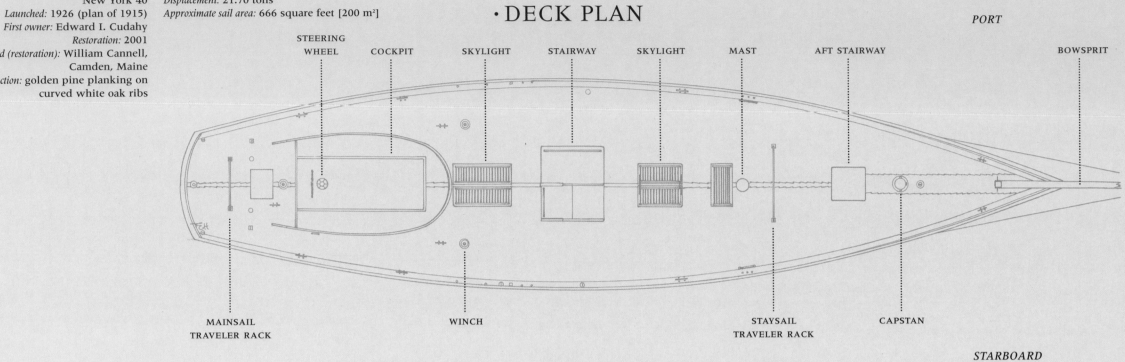

MAINSAIL
TRAVELER RACK WINCH STAYSAIL
TRAVELER RACK CAPSTAN

STARBOARD

· LAYOUT

AFT HOLD HEADS SALOON HEADS

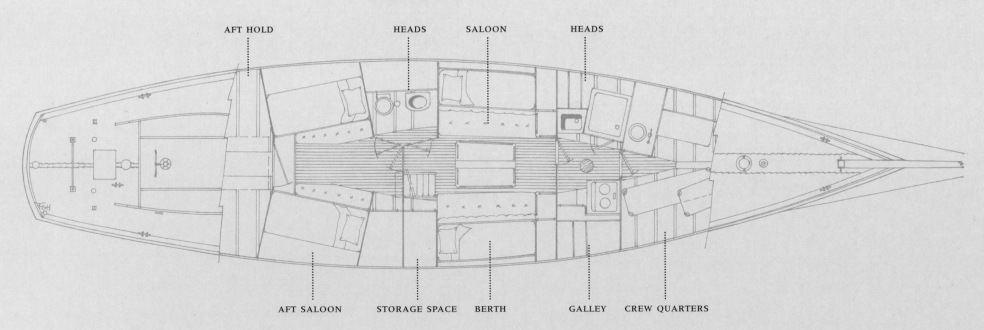

AFT SALOON STORAGE SPACE BERTH GALLEY CREW QUARTERS

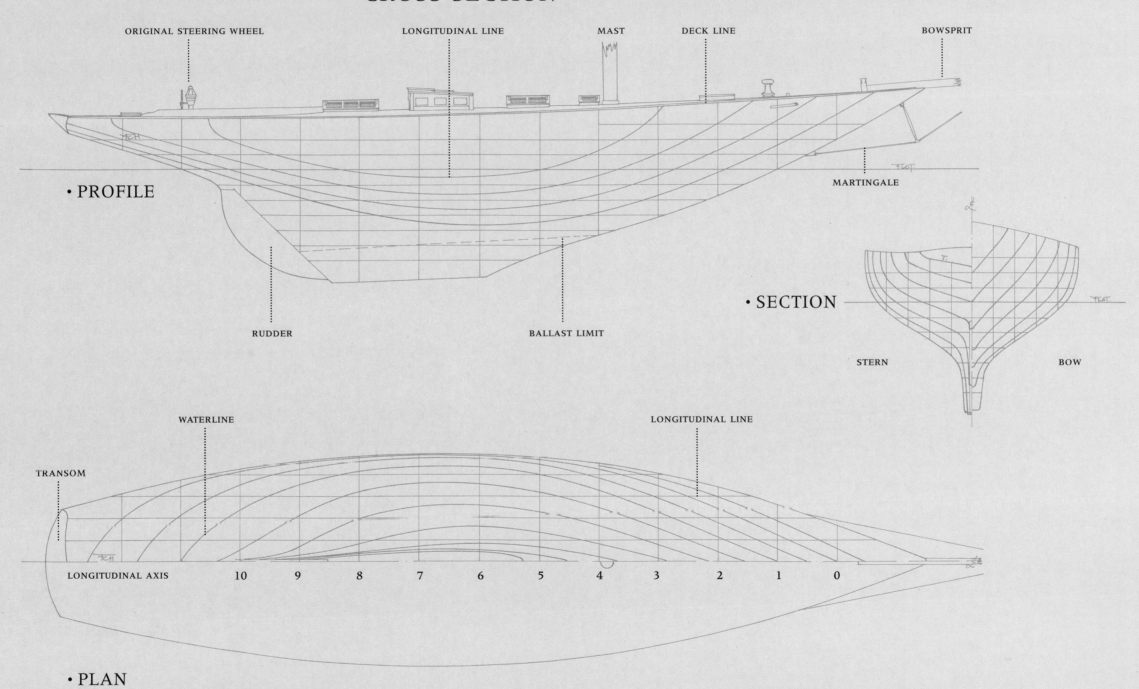

·CROSS SECTION

ORIGINAL STEERING WHEEL LONGITUDINAL LINE MAST DECK LINE BOWSPRIT

MARTINGALE

·PROFILE

RUDDER BALLAST LIMIT

·SECTION

STERN BOW

WATERLINE LONGITUDINAL LINE

TRANSOM

LONGITUDINAL AXIS 10 9 8 7 6 5 4 3 2 1 0

·PLAN

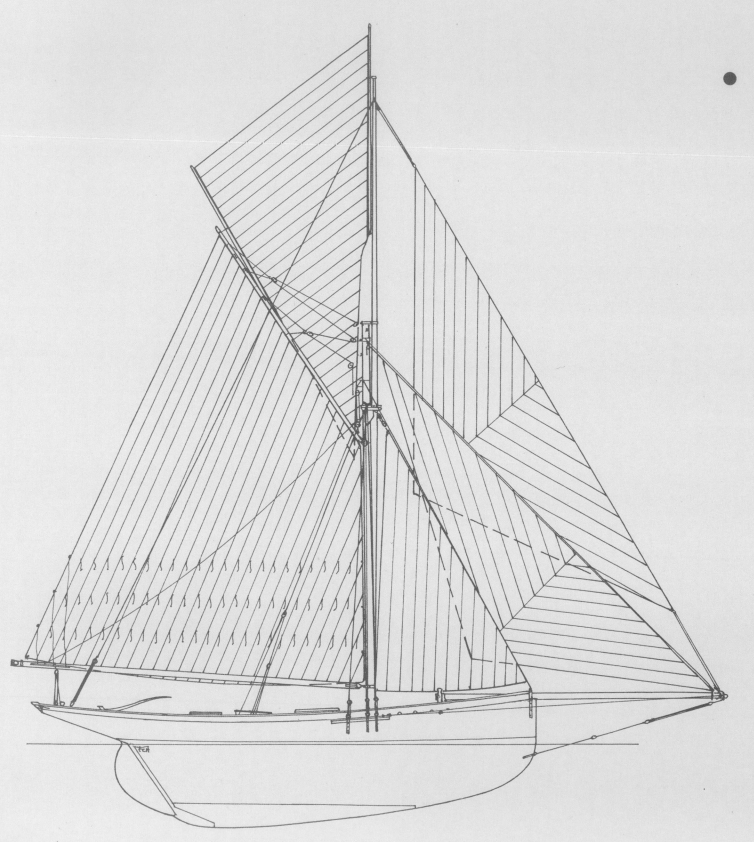

· Partridge ·

Few late nineteenth-century British cutters have survived. *Partridge*, along with *Marigold* and *Germaine*, is one of the few remaining yachts that glided down the Clyde or the Solent to the excitement of American architects. These three vessels share a history. As with Alex Laird's *Partridge*—designed by John Beavor-Webb and built by Camper & Nicholson in 1884—it was a passion for classic boat restorations that led Greg Powlesland to devote several years to renovating *Marigold*, a ship built by Camper & Nicholson in 1892. The third yacht of this era and boatyard, *Germaine*, a yawl built in 1882, is currently being restored, at the time of writing, in Lowestoft, East Anglia.

In the nineteenth century, British sailing yachts were taxed based on the length measured in front of the rudder, which explains the narrow stern and backward slope on this vessel.

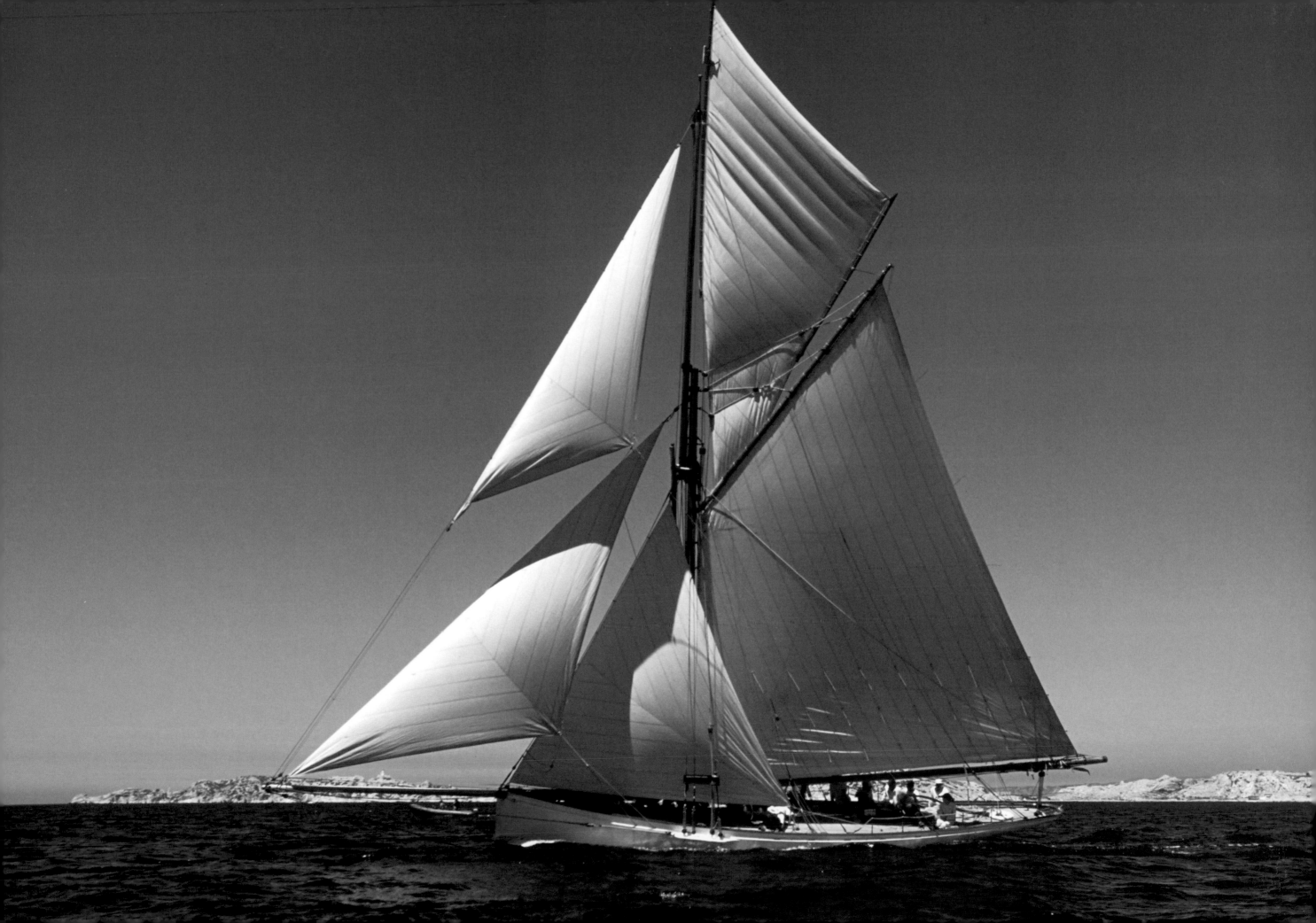

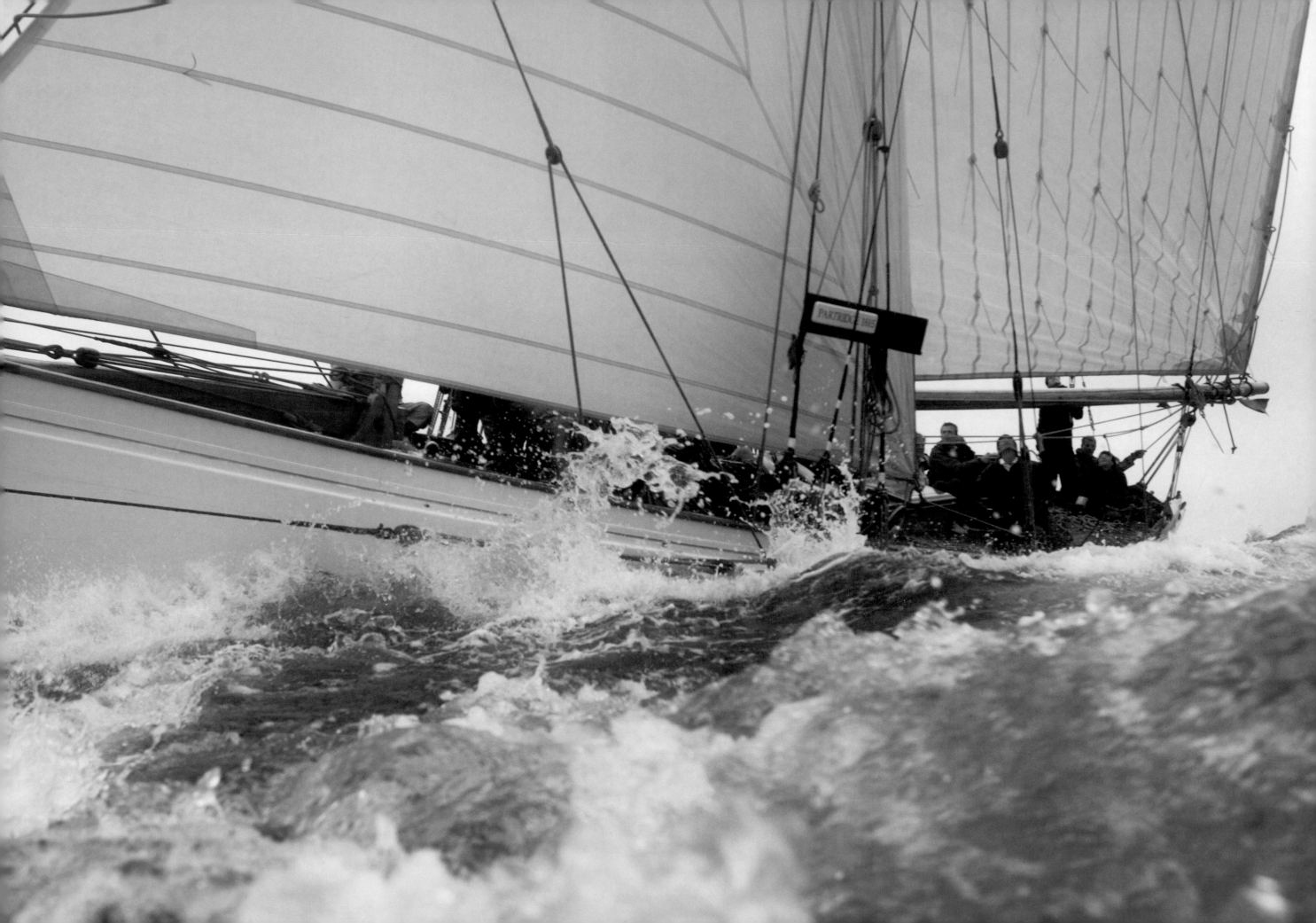

In 1884, Charles E. Nicholson was still at school. His father, Benjamin Nicholson (1828–1906) ran the boatyard and drafting office. Before *Partridge*, the Baillie brothers had had other yachts built by Camper & Nicholson. One of these was the 60-ton yawl of 1878, which Richard Baillie co-owned with his brother, J. H. Baillie. Four years later, a large cutter, *Dandelion*, designed by John Beavor-Webb (1848–1927), launched from the same yard. This architect was an Irishman who had been apprenticed to Dan Hatcher and whose first creation, *Freda*, in the 20-ton class, had dominated the 1880 season, winning sixteen first prizes and five second prizes out of thirty-three regattas. In 1883, Beavor-Webb won orders from Americans, including for *Butterfly*, a cutter of some 45 feet (12 m), for his future rival at the America's Cup, a certain Edward Burgess (1848–1891). *Rondina*, the first design for Burgess executed in the following year at George Lawley & Son in the United States, was largely inspired by the plan John Beavor-Webb produced for *Butterfly*. Burgess did not rest on his laurels, however, because in 1885 and 1886, with *Puritan* and *Mayflower*, he crushed the two British challengers for the America's Cup, *Genesta* and *Galatea*, both Beavor-Webb designs.

As for the Baillie brothers, their dreams were not of victories but of pleasant cruises. In 1884, they commissioned two sister ships from their favorite architect, Beavor-Webb. One was a cutter, *Partridge*, for J. H., and the other a yawl, *Polyanthus*, for Richard. Both were built at Camper & Nicholson.

Richard only kept *Polyanthus* for two years. The yacht was converted into a cutter by its new owner, Alexander H. Edmonds, who renamed her *Cruiser*. This was an addition to Edmonds's fleet, which consisted of two steam yachts, *Adeline* and *Iris*, and a small, two-ton cutter, *Oxbird*. *Cruiser* later sailed under the name of *Chiquita*.

This changing of names led to a bit of a historical mystery. The list of boats built by the yard written in 1992 by William J. Collier, former representative of Camper & Nicholsons, includes four similar yachts built in the same year of 1884: *Partridge*, *Polyanthus*, *Cruiser*, and *Rupee*. In 2001, historian Ian Dear published a history of the boatyard with a list at the end of the book mentioning three yachts designed by Beavor-Webb: *Polyanthus*, *Cruiser*, and *Partridge*. The Chevalier-Taglang archives were thus consulted to find out why three clients would have ordered the same boat, practically at the same time, as the dates do not vary from one list to another. By leafing through Hunt's Universal Yacht List and the Yacht Register of Lloyd's Register of Shipping, it clearly emerges that only the Baillie brothers ordered the sister ships, *Polyanthus* and *Partridge*, and that these subsequently had their names changed to *Cruiser* and *Rupee*, respectively.

A Rare Gem

It is something of a fairy tale, this renaissance of *Partridge*, as is the case with so many yachts from a bygone age. How could such a great adventure be considered otherwise? One fine day in August 1980, the young Alex Laird, then serving as an apprentice at the Fairey Marine shipyard in Cowes,

Right
This crew is very much at ease aboard *Partridge* with five well-trimmed sails.

Opposite
The crew of *Partridge* studies their sails carefully as the decks connect with the passing waves.

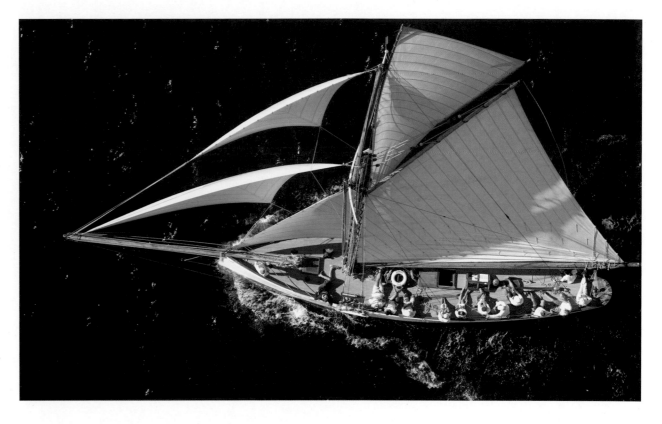

received a letter from his only uncle, Peter Saxby. The content sounded promising, "I'd like to know if the following proposal might be interest: we are buying an old boat and you can do it up." What could be better, at the age of nineteen, than being up to one's neck in polyester and metal amid sailboats being repaired? All you think about is the ship's carpentry and expensive woods, and you sometimes even get to cut out marine hardboard panels.

So this was an offer that required attention and that ought not to be postponed. There was little chance of finding a rare gem at Cowes. Laird was well aware that in East Anglia, north of the Thames estuary, there were a few muddy banks on which half-abandoned hulls could be found that were just begging to be rescued.

After four days of exploring the ragged coastline of Essex, between Southend-on-Sea and Mersea, Laird and his friend Chris Tomsett reached Tollesbury where, in the mud of the Blackwater River, there lay a long and handsome black hull, the most elegant they had ever seen. This was a real antique, a cutter built a hundred years ago or more, that seemed to be begging them to get her out of there. Both of them were enchanted with the boat, and each decided that he was the one to do it, and no one else. When the friends tried to find out more about her, a broker informed them that it would take around three years of hard labor to save her, which seemed an eternity to him. They went in search of the owner, who, when approached, was delighted to hand over what was left of the yacht for £400 (about $800). The young buyer returned to the Isle of Wight, his head full of exciting projects and interminable lists.

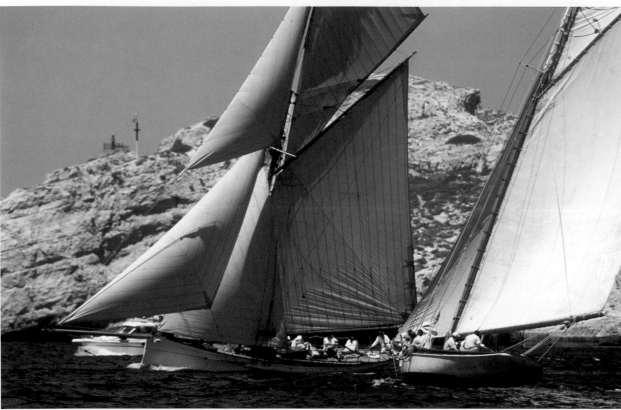

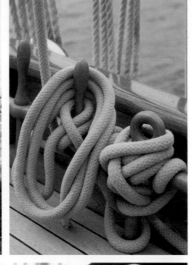

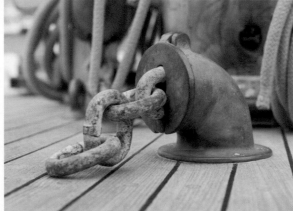

Opposite
On English cutters of the 1880s, the shrouds had to be taken down on channels, the deck being too narrow for the masting.

Top
Thelma (A. Logan, 1897) crosses *Partridge*.

Above and Right
Halyard pin rail, tiller crossbar in the shape of a monkey's fist knot, futtock shrouds, foresail tack tackle, fairlead, and its column stop—the weird jargon of the sea.

A Long History

Laird recalls: "A month later, we towed the hull from the black waters of the river and brought it up to Tollesbury. Dennis Debbage of Ipswich came along with his 25-ton crane to lift the boat out of the clutches of the Essex mud, and two days later, it was taking up most of the room in my parents' garden at Shalfleet, on the Isle of Wight."

There was little for the new owners to go on to reestablish the identity of the yacht. It had been called *Tanagra* and an inscription on a deck beam bore the carved words, "Harry 1885."

Research began. The name *Tanagra* appeared in the Yacht Register for 1923 and was mentioned in the supplement that specified that the vessel had been sold to a Belgian and converted into a houseboat; she therefore disappeared from the lists of the Lloyd's Register.

Before that, L.H.F. Damen of Burnham-on-Crouch, Essex had acquired her in 1921 when she was called *Pollie*. From further research, it emerged that she had had no fewer than ten owners since 1890 before Albert Wood had given her that name. Before World War I, one of her owners, Ebenezer Southgate of Brightlingsea, also kept *Marigold*, another cutter that had been preserved from the Victorian era. *Pollie* had once belonged to the Goldsmid family of London who had sold her to Southgate. The name Harris on the beam turned out to be Henry "Buster" Harris, also of London, and a member of the Royal London Yacht Club, who owned her for about a dozen years at the turn of the century. Before *Pollie*, the yacht bore the name of *Rupee*, the Indian currency, as a bit of a joke. Charles P. Henderson Jr. of Torquay had bought her from J. H. Baillie in 1886 after selling his boat *Zephyr*, and he passed her on to Francis Fitzpatrick Tower in 1888.

Partridge had been commissioned in the winter of 1883 from John Beavor-Webb by J. H. Baillie, and was built in five months by Camper & Nicholson—the name of this yacht builder was not yet plural. It only became Camper & Nicholsons in 1895 when the two brothers, Charles and Benjamin Nicholson, took over their father's business. On June 2, 1884, *Partridge* was launched by Nora Lapthorn, daughter of Edwin Lapthorn of Ratsey & Lapthorn of Gosport. Of course, the Baillie brothers had always fitted out their yachts with sails cut by Ratsey & Lapthorn, but inferring that there was any special link between them would be fairly far-fetched, since most London yachtsmen used these sailmakers.

As soon as the identity of the yacht was definitively confirmed, *Partridge* was reregistered under her original name, with Southampton as her home port. Although her original boatyard had preserved very few records from the period, Lloyd's had kept her construction certificates, with samples and the cut of her master beam.

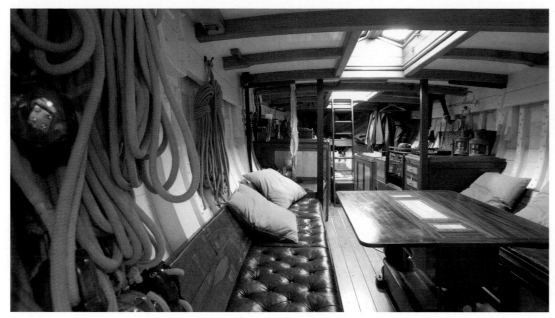

The Birth of a Masterpiece

For the young Laird, there was no question of starting a restoration without a perfect mastery of ship's carpentry and architecture. So he began training, financed by his wooden boatbuilder employer, at Newport Technical College. After spending a year learning the basics of ship carpentry, Laird studied naval architecture in Southampton for three years. The yacht stayed in the garden under a shelter built for her by Laird, but she dried out to such an extent that light shone through the gaps between her planks.

Once he had acquired the relevant skills, Laird drew her cross section and side views and produced a set of plans based on the technical documentation of the period. Then, over a period of several years, while still working at his day job, he completely restored the yacht. According to him, it is easier to restore than to reconstruct, because all you need to do is replace each part based on the original model. Not content with saving this cutter, Laird had the opportunity to help out Greg Powlesland, who was short of funds while restoring *Marigold*, by arranging the first auction of classic yachts for Sotheby's, which created the necessary backing for *Marigold* to be renovated.

In 1987, *Partridge*'s hull was completed, and Laird transported her to the Hythe Marine Service boatyard in Southampton. It took another ten years before she would be seaworthy again. After more than seventeen years of patience and enthusiasm, a masterpiece was born. Today, Laird pursues his passion at La Ciotat in southeast France, running Classic Works, his maintenance and restoration boatyard, where *Partridge* is the flagship.

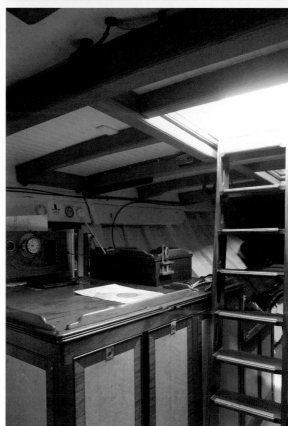

Opposite
The crew watches the photographers snap their portrait while the helmsman keeps both hands on the tiller and his eyes focused forward. His grip looks strong as he braces his feet against the cockpit paneling. *Partridge* must have a lot of windward helm.

Above
Regrettably the plans of the original interiors by Camper & Nicholsons have been lost due to fires and air raids, but this living monument still exists as a tribute to the designers and craftsmen of the past. Alex Laird has recreated a minimalist interior.

· FEATURES ·

Name: PARTRIDGE
Architect: John Beavor-Webb
Builder: Camper & Nicholson, Gosport
Rigging: gaff cutter
Type: ocean racer
Launched: June 2, 1884
First owner: J. H. Baillie
Other names: RUPEE, POLLIE, TANAGRA
Restoration: 1997
Boatyards (restoration): Alex Laird, Hythe Marine
Services, Southampton
Architect (restoration): Alex Laird
Construction: pitch-pine and teak-edged on oak ribs

Overall length: 71 feet 10 inches [21.90 m]
Deck length: 49 feet 6 inches [15.09 m]
Length at waterline: 42 feet [12.80 m]
Maximum beam: 10 feet 11 inches [3.33 m]
Draft: 8 feet 6 inches [2.60 m]
Ballast: 10 tons
Interior ballast: 5 tons
Displacement: 28 tons
Approximate sail area: 649 square feet [195 m²]

· DECK PLAN

PORT

COMPASS STAIRWAY SKYLIGHT PIN RAIL CHANNELS WINDSAIL BOWSPRIT

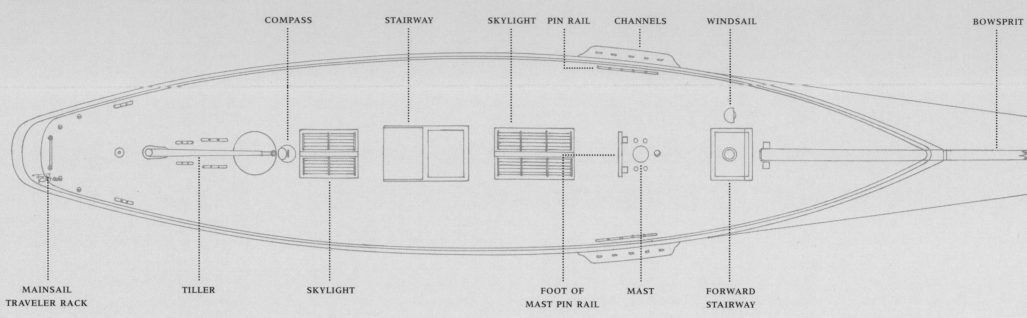

MAINSAIL
TRAVELER RACK TILLER SKYLIGHT FOOT OF MAST FORWARD
 MAST PIN RAIL STAIRWAY

STARBOARD

· LAYOUT

AFT HOLD GALLEY SALOON CREW QUARTERS

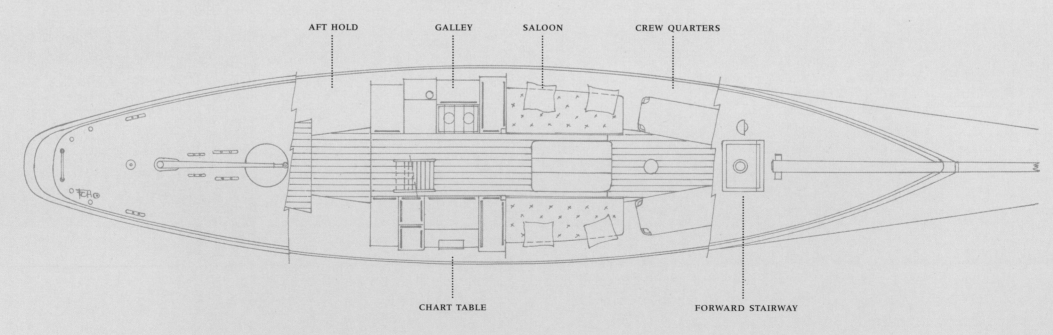

CHART TABLE FORWARD STAIRWAY

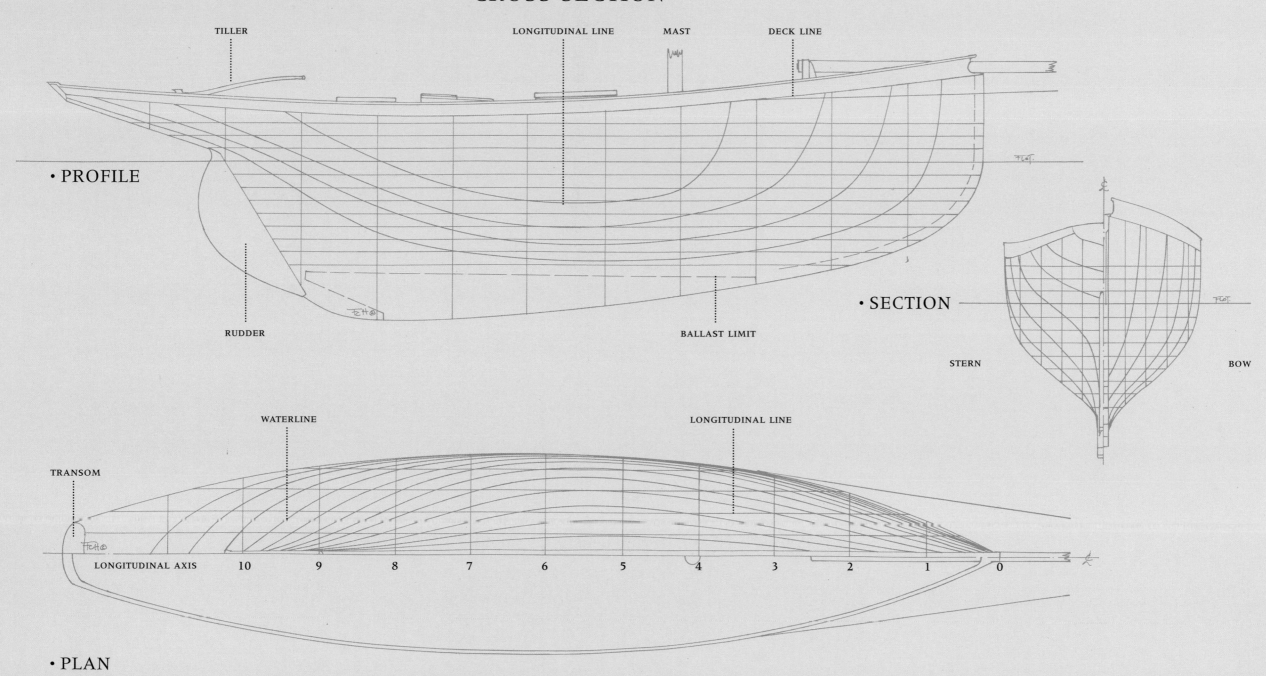

·CROSS SECTION

TILLER LONGITUDINAL LINE MAST DECK LINE

·PROFILE

RUDDER BALLAST LIMIT

·SECTION

STERN BOW

WATERLINE LONGITUDINAL LINE

TRANSOM

LONGITUDINAL AXIS 10 9 8 7 6 5 4 3 2 1 0

·PLAN

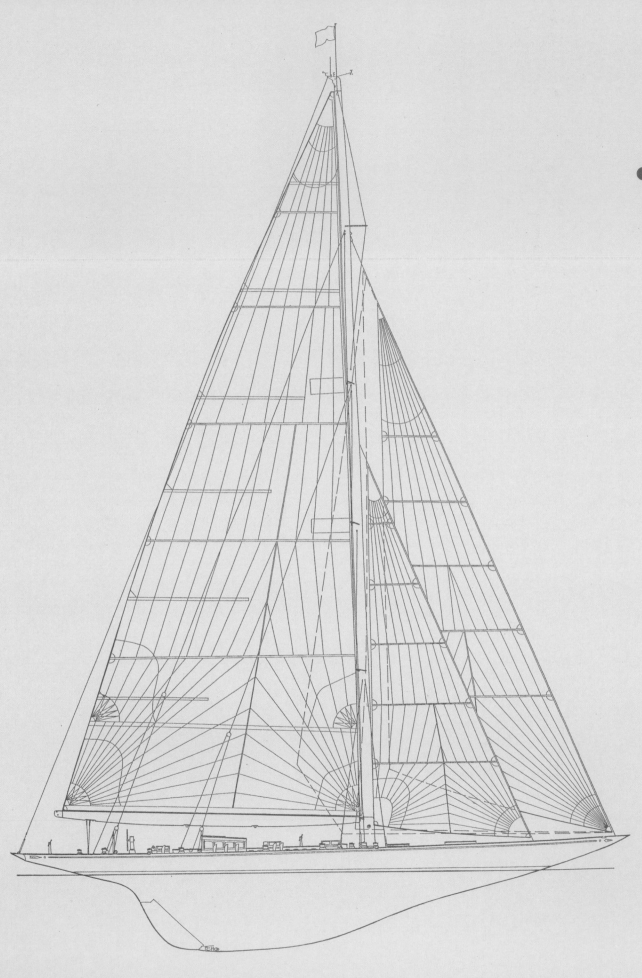

· Shamrock V ·

In the afternoon on September 18, 1930, *Enterprise*, defender of the America's Cup, broke through the finishing line in the fourth regatta off Newport, Rhode Island. This dashed the hopes of the challenger, Sir Thomas Lipton's *Shamrock*, the fifth yacht of that name to try her luck, finishing a mile behind the winner. The bitter contest so long awaited between these two J-class vessels was something of a disappointment. After five attempts in thirty-one years, and at the age of over eighty, Lipton hid his disappointment and followed tradition. At the moment *Shamrock V* crossed the line, the 305-foot (91.5-m) *Erin*, his steam yacht, moved closer to *Enterprise* and the assembled crew gave three cheers to the winner.

After a perfectly windy day, the crew of the *Shamrock V* J-boat arrives in Saint-Tropez, France.

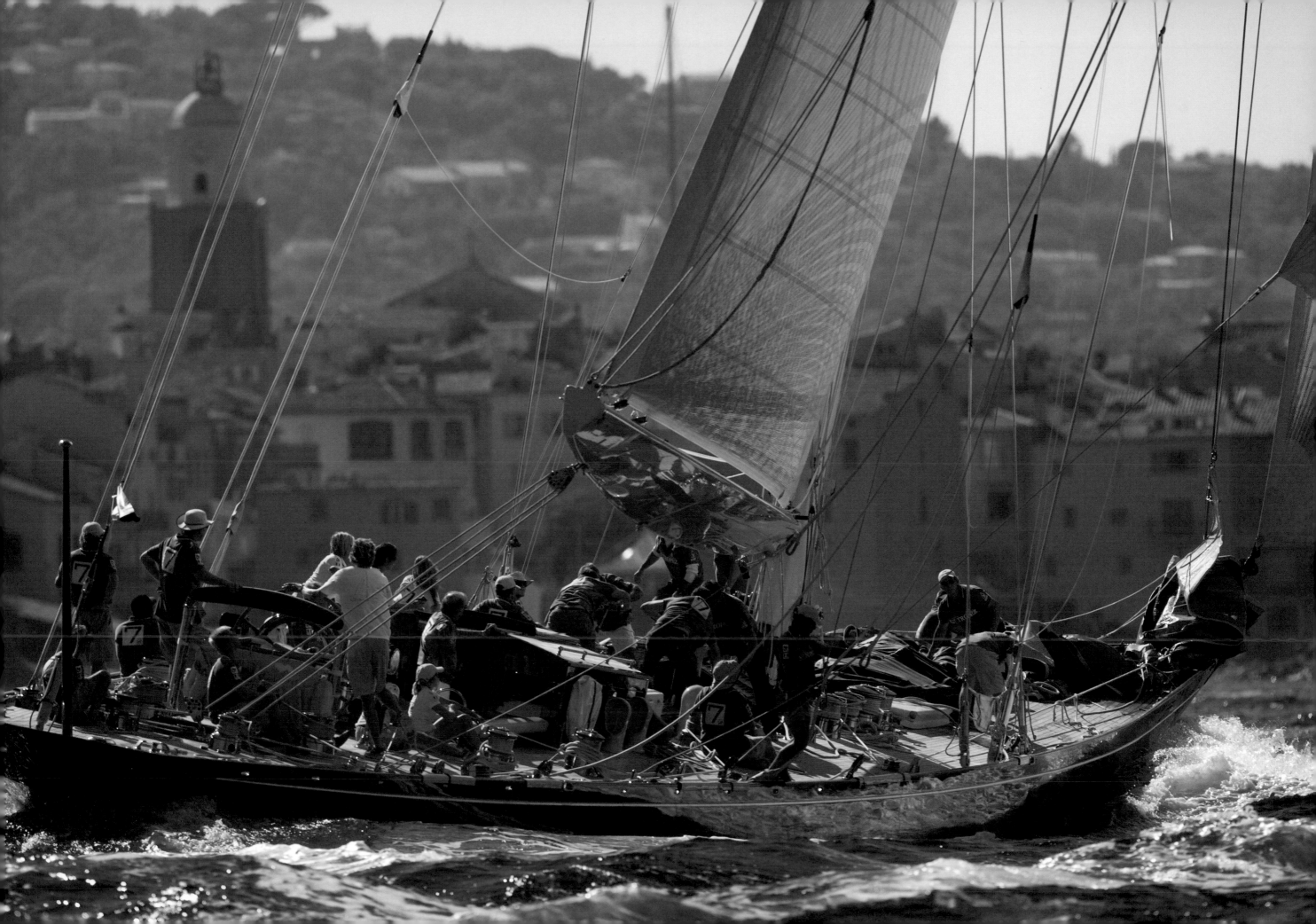

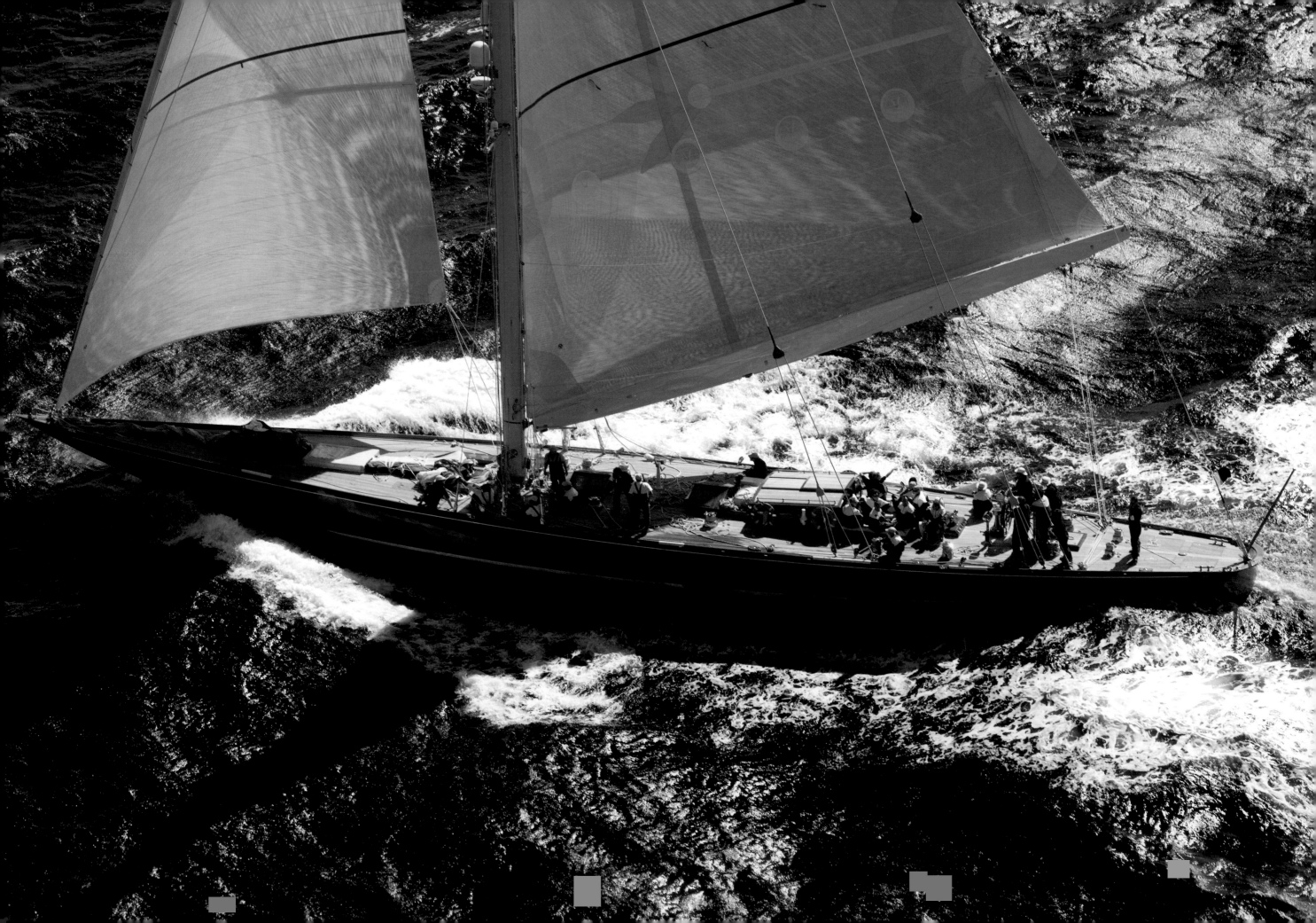

A host of excursion steamers, pleasure boats, small craft with out-board motors, sailboats of all sizes, and the big yachts owned by members of the New York Yacht Club (NYYC), including the 347-foot (104-m) *Corsair* owned by the Morgan family, the Astors' 267-foot (80-m) *Nourmahal*, the 270-foot (81-m) *Hi-Estamo* of the Manvilles, and the 220-foot (66-m) *Aloha* owned by the Jameses, sounded their horns to cele-brate the great victory, the winning of the America's Cup.

It had been ten years since the previous America's Cup, the oldest interna-tional sporting trophy, and Lipton had been chasing the silver pitcher since 1899. There had been quite a wealth of correspondence between Lipton and the NYYC before they were able to reach common ground. Lipton had to swallow a lot of pride and show good faith in accepting all of the stipulations laid down by the defender. On May 28, 1929, he undertook the building of a yacht that would comply with the J-class rating of the NYYC rule, i.e., the Universal Rule created in 1903 by Nathanael Herreshoff. The challenger needed to have a flotation length of between 76 feet (22.80 m) and 89 feet (26.50 m), and meet the requirements of Lloyd's in respect to the construc-tion. The two protagonists, challenger and defender, would compete in the Newport Regatta and there would be no time handicap. The first yacht to win four victories would be declared the winner. The American, or so-called Uni-versal, Rule differs from the International Rule in that the area of sail hardly changes (by less than 5 percent) based on the flotation length chosen. The draft (the weight of the boat), however, can vary from 120 to 160 metric tons.

As soon as his challenge had been officially accepted, Lipton sent the archi-tect Charles E. Nicholson an order to build *Shamrock V*. Aware that the winds are generally fairly light in Newport in September, Nicholson chose a flota-tion length of 82 feet (24.40 m), with a draft of 134 metric tons, a choice that was seen to be very similar to that of the defender, *Enterprise*.

Shamrock V, *the First British J-class*

Shamrock V was named by Lady Shaftesbury and launched at Gosport on April 14, 1930, a few hours before the defending *Enterprise*, launched in the United States. Everyone admired the elegance of Lipton's J-class vessel. The low sheer, the result of the American rule, was slightly disappointing for those who loved the cambers that were a feature of the International Rule, but Nicholson managed to personalize his creation. "Yacht architecture is still more of an art than an exact science and will remain so. It cannot be mod-ernized by the scientific precision of mathematicians. We draw and redraw, but speed depends on the harmony of lines, the area of sail, and its effective-ness, the wind, and the way the ship handles, nothing more," he stated calmly to a journalist who was interviewing him. The reaction of American architects when they read such statements can only be imagined. If the new generation of yacht builders consisted of artists, they were certainly more mathematical and scientific than their European counterparts. They calculated, tested the resistance of materials, performed trials in dry dock and in wind

The carbon fiber sails flown by *Shamrock V* look powerful com-pared with the tradi-tional staysail rig aboard *Cambria* to windward. *Shamrock*'s original owner, Lip-ton, would surely have liked to have had these powerful sails available when he vied for the Amer-ica's Cup in 1930.

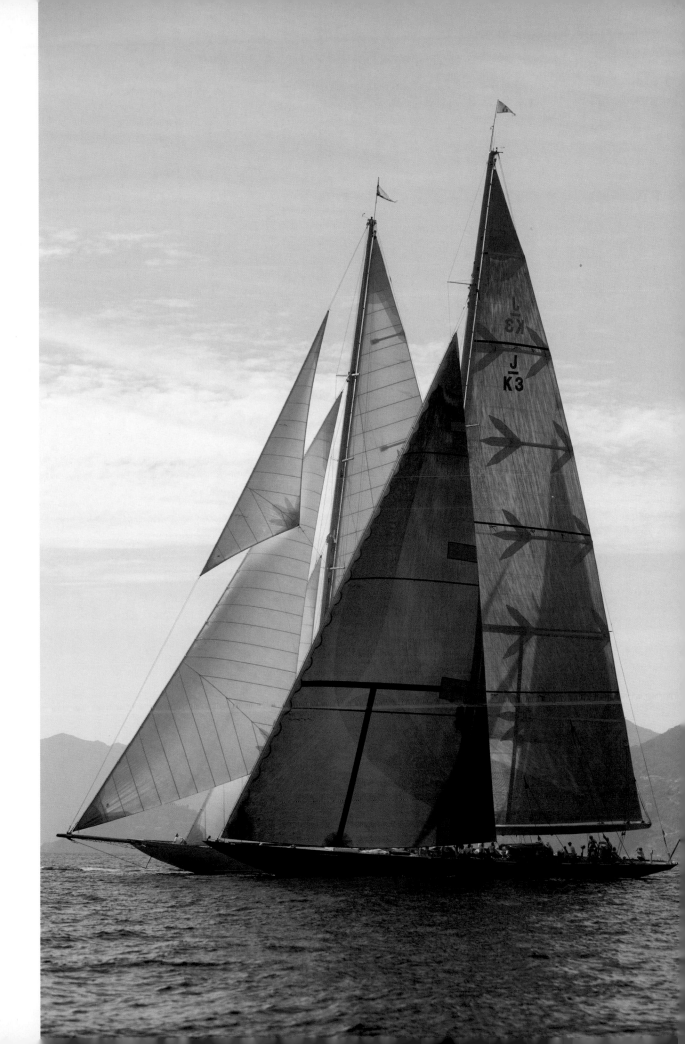

tunnels, and made a host of calculations before adopting a particular solution. In his memoirs, the British architect John Nicholson, son of Charles Nicholson, who witnessed the Newport races in 1930, remembers spending a whole afternoon on board *Erin* in the company of the architect Edward Burgess and admits having been subjected to an interminable math lesson of which he understood nothing. So, two very different philosophies were at work here.

The construction of *Shamrock V* was of a composite type utilizing both steel and wood. The keel was made of elm, with teak stem, sternpost, and ribbands. Toward the sternpost, a centerboard well cut through the 80 metric tons of lead ballast allowed room for a teak daggerboard covered with bronze plates and ballasted with lead. Seventy steel ribs were distributed along the keel. Diagonal steel crosspieces reinforced the structure inside the planking. At the point where the mast stood, this reinforcement was doubled, enclosing the hull. The deck was of white pine, laid over steel beams. The lengthwise planking was mahogany 1¼ inch (3.5 cm) thick and painted green, Lipton's color and that of Ireland. The hollow mast stood 165 feet (49.4 m) high and was made of spruce. The shrouds were fixed on chain plates mounted on skids that extended beyond the hull on each side because the deck was not wide enough to give them sufficient lateral holding power.

Before leaving England, *Shamrock V* ran in a series of twenty-two races, and had fifteen wins, coming in second four times. British observers were less than enthusiastic about these results. They had forgotten rather quickly, or refused to accept, some of the factors that made these performances relative. In order to be able to measure up against the large vessels with which she was competing—such as *Lulworth*, 23-meter *Shamrock* (William Fife, 1908), *White Heather II*, *Candida*, *Astra*, and *Cambria*—Lipton's challenger was given a too-favorable handicap in the first six races. The handicap was subsequently corrected to make things fairer. Furthermore, unlike her local competitors, *Shamrock V* had a hollow mast and a daggerboard, but no interior furnishings with the exception of what was strictly necessary, since Universal Rule did not permit a lot of interior fixtures. Finally, the Bermuda rigging proved to be very efficient, but though the yacht seemed to sail quickly in a following wind, she moved more laboriously inshore and did not steer a proper course. In the light breeze of the Clyde Regatta *Shamrock V* did not turn well into the wind and did not produce the hoped for compromise between speed and course. The America's Cup challenger was soundly beaten by *Lulworth* at the end of a memorable regatta.

Shamrock V's *Opponents: The American Defense*

In 1929, the Americans already had three J-class yachts. *Blackshear*, formerly *Katoura*, designed by Burgess in 1927, regularly competed against other yachts of the M-class, though she was in the J-class. The two gaff-rigged *Vanitie* and *Resolute* who had competed in the America's Cup in 1914 and 1920, were schooner-rigged in 1926. In the fall of 1928, E. Walter Clark, tired of being beaten by *Vanitie*, decided to remodel *Resolute* into a Bermuda-rigged

sloop. Harry Payne Whitney sold *Vanitie* to Gerard B. Lambert, who already owned the schooner *Atlantic*. During the winter of 1929, the two yachts were both Bermuda-rigged, the former designed by Nathanael Herreshoff, the other by William Starling Burgess, and they entered the J-class. For the architects involved in creating future candidates for the America's Cup, the presence of these yachts was the occasion for verifying their suppositions and performing various analyses and checks.

As soon as Lipton accepted the challenge in May 1929, a very special atmosphere prevailed in sailing circles. The results of the Bermuda-rigged M-class 1929 season would be decisive for naming the designers of the new J-class yachts. Very soon, a variety of names were put forward, including Charles Mower, who had designed the excellent M-class *Windward*; Junius S. Morgan, Sherman Hoyt, and W. S. Burgess, whose M-class *Prestige*, owned by Commodore Vanderbilt, remained very competitive. There were also L. Francis Herreshoff, who had just delivered the most recent M-class *Istalena* to George M. Pynchon, and John G. Alden, known for his Q-classes.

Although Lipton remained the only challenger, the U.S. defenders of the America's Cup organized themselves to construct four new J-class yachts. Two separate syndicates, both sponsored by the NYYC, were formed in late May 1929: one, the initiative of Winthrop W. Aldrich and Harold "Mike" S. Vanderbilt, and the other at the behest of Junius S. Morgan and George Nichols. Before the end of the fall, two other groups would throw themselves into the defense. The first was established by New Yorker Landon K. Thorne and by Paul Lyman Hammond; the second was formed on the initiative of the Bostonian Chandler Hovey. On July 29, 1929, Morgan confirmed that he would be able to build two boats to defend the title, maybe even more.

The Thorne-Hammond syndicate appointed Herreshoff as the project's architect. *Whirlwind* was built by the George Lawley & Son Corporation. The J-class vessel, named by Phoebe Thorne, launched on May 7, 1930. With a length of 88 feet (26.20 m) at the waterline and a draft of 158 metric tons, *Whirlwind* was the longest and heaviest vessel in the fleet. She was also the only American J-class of composite construction. Her hull was original in shape, the stern being pinched like a canoe. *Whirlwind*'s mast was designed to carry the first Genoa jib ever used on a J-class. Herreshoff introduced further innovations, such as measuring instruments attached to the masthead and connected electrically to dials that could constantly indicate the speed and direction of the prevailing wind. A tape-fed acceleration repeater provided exact information on the efficacy of the maneuvers ordered by the tactician.

The naval architect Frank C. Paine was a member of the Boston syndicate. Paine was one of the sons of the General Paine who had successfully defended the Cup three times, from 1885 through 1887. His brother, John B. Paine, had designed the amazing *Jubilee* in 1893. When tracing the lines for *Yankee*, Frank Paine wanted a powerful steel-hulled sailboat that was not too long to keep the same amount of sail. At 23 feet (6.85 m) she was the widest sailboat launched in 1930. The deck was covered in pine slats laid over steel beams and surrounded by a wide, deep bronze channel.

Yankee launched three days after *Whirlwind* from the George Lawley & Son boatyard at Neponset, near Boston.

Opposite
Even the biggest yachts can be overpowered. *Shamrock V* flogged her mainsail with the traveler all the way down and a reef in the sail. There is considerable sag in the headstay. The decks are awash and the crew all sits to windward looking for maximum gain.

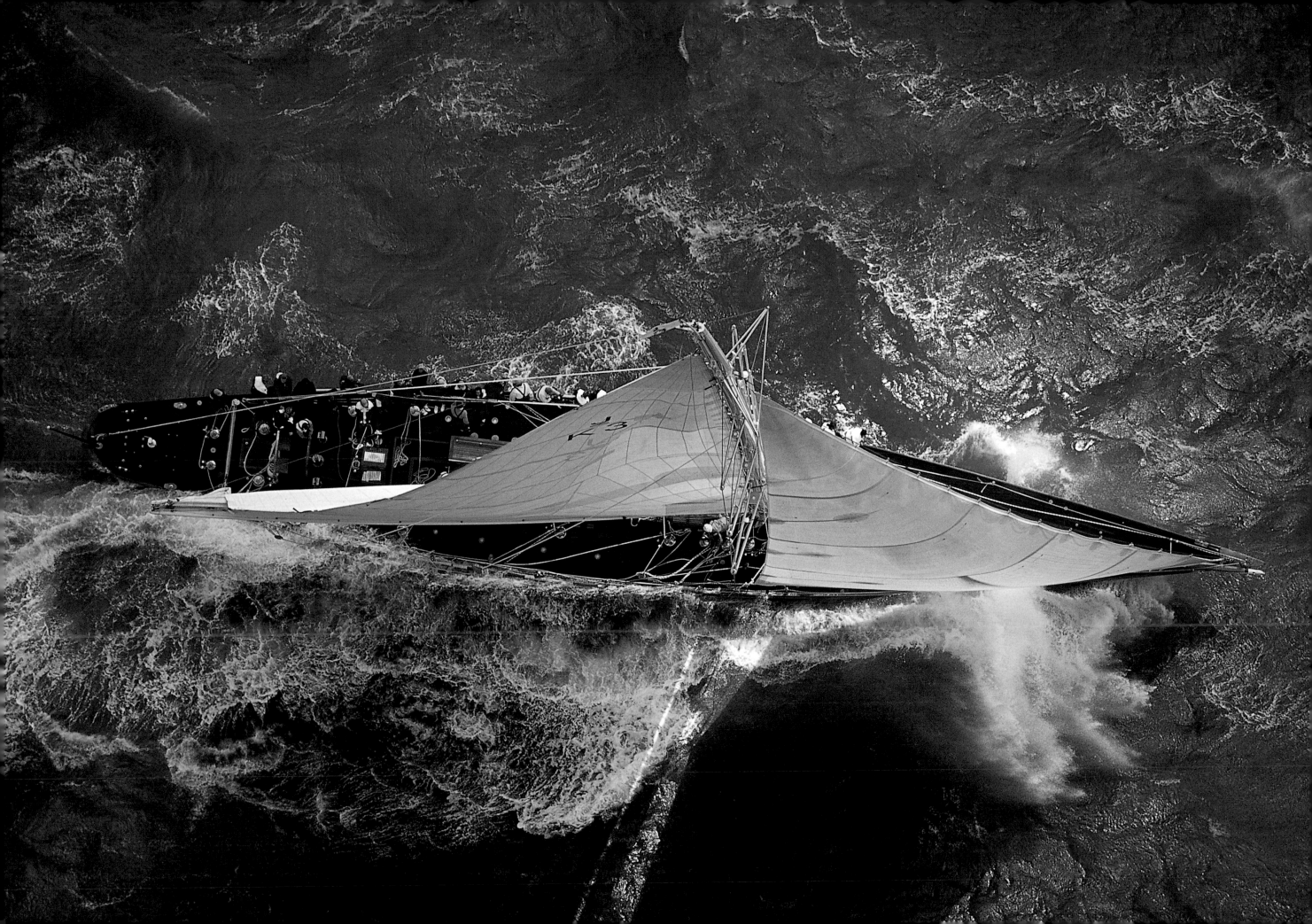

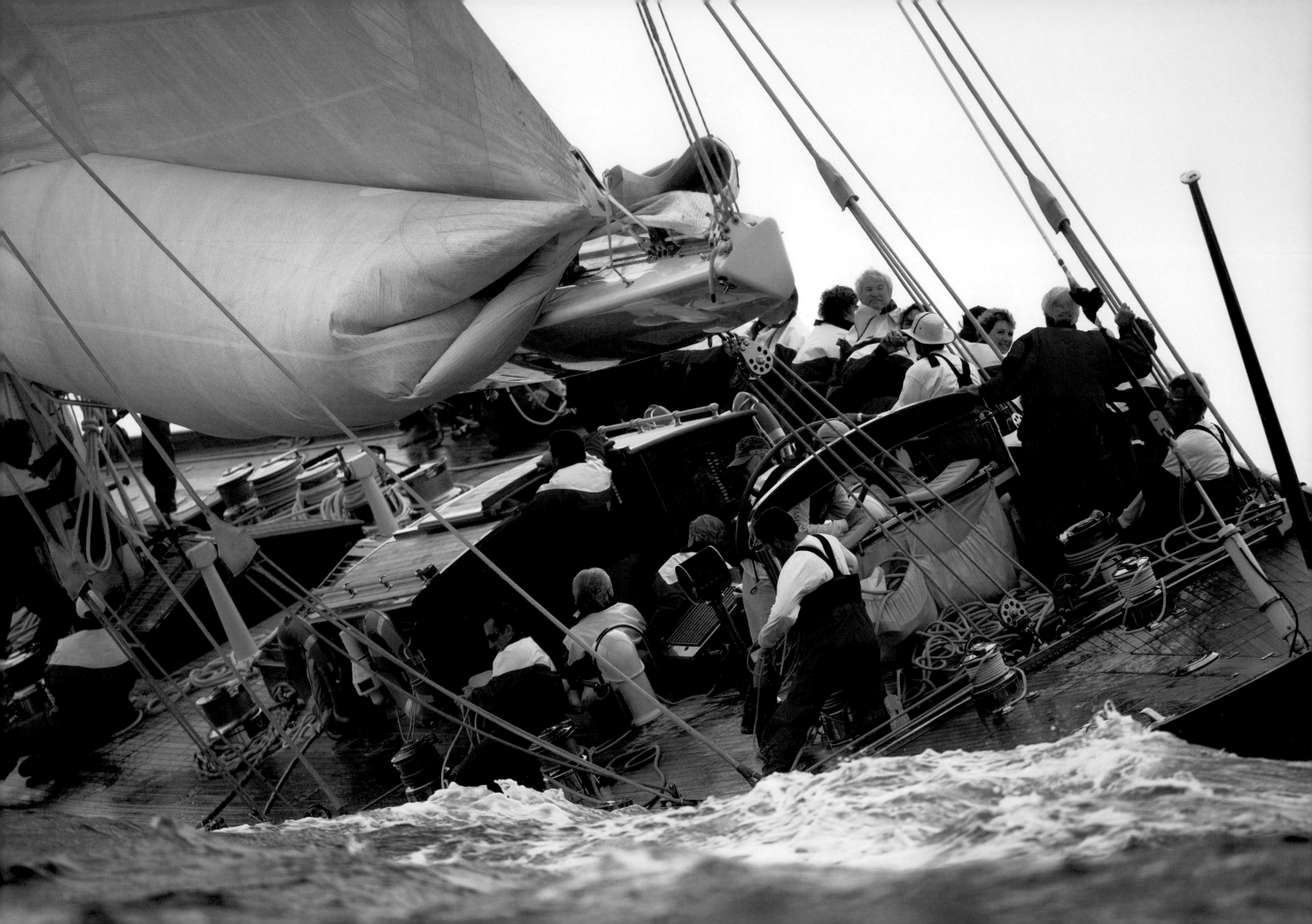

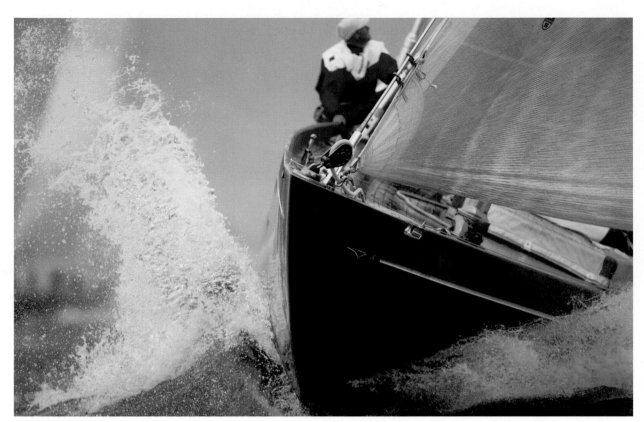

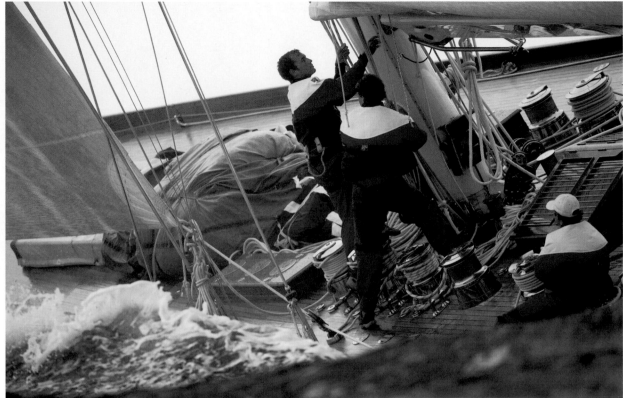

Contacted on July 22, 1929, the architect Clinton Crane first submitted his plans to the Nichols-Morgan syndicate in early August. The Herreshoff Manufacturing Company was commissioned to build the boat in Tobin bronze on steel ribs. *Weetamoe*, a heavy J-class, launched just after having been named by Jane Nichols, on the same day as *Whirlwind*, but in the afternoon.

Enterprise, *A Mechanical J-class Vessel*

Commodore Harold "Mike" Stirling Vanderbilt had just one obsession—to make the selections for the defense of the America's Cup and win against Lipton's *Shamrock V*. "There is no second!" is the motto of the America's Cup, and even after the crash of the stock exchange on Black Tuesday, October 29, 1929, not a single crew backed out of the race.

According to Vanderbilt and his syndicate, management of the time trials was one of the first keys to success. Before the end of May 1929, Burgess was chosen to design the future defender, and they commissioned the Herreshoff Manufacturing Company to build the future J-class *Enterprise*. Vanderbilt also researched the weather reports for Newport recorded for the previous twenty years. After analyzing the figures, Burgess performed a series of tests on a model in the Naval Model Basin in Washington, D.C. and discovered that a hull 82 feet (24.38 m) in length presented the least resistance to forward movement.

Construction of the vessel began on October 5, 1929 and, *Enterprise* launched on April 14, 1930, named by Winthrop W. Aldrich. *Enterprise* had a choice of fifty sails, including seven mainsails, two hollow, wooden masts, and a Duralumin mast that only weighed 3,993 pounds (1,815 kg) as opposed to the average 5,984 pounds (2,720 kg) of wooden masts. She also used the famous "Park Avenue" beam that could govern the trough of the mainsail. Maneuvers were dispatched to the inside of the hull, and a third of those aboard—thirty-one on a J-class—remained below, not being needed on deck.

When *Shamrock V* reached Newport in August 1930, after crossing the Atlantic under yawl rigging, the American selection for the defense of the Cup had not yet been completed. Lipton and the British were obliged to note that they were not in the same league. The budget for *Enterprise* was four times greater than their own.

Enterprise was completed, and the rest is history. She easily won the America's Cup 4-0.

The Only J to Remain Seaworthy

Lipton was moved by the current of sympathy among the Americans. He could not help repeating, "I'll be back, yes, I'll try again," but Lipton could not keep his promise—he died on October 2, 1931, just a few months after being accepted for membership in the Royal Yacht Squadron. After his death, the famous aircraft builder Thomas O. M. Sopwith, who had made his fortune during World War I, bought *Shamrock V* and familiarized himself with the J-class by sailing her. Then, he convinced the Royal Yacht Squadron to launch another challenge.

Sopwith was a skilled yachtsman and a formidable challenger on the water. The Royal Yacht *Britannia*, owned by King George V, and the two 23-meter class yachts, *Astra* and *Candida*, were converted into J-classes. With the launch of his new yacht, *Endeavour*, Sopwith sold *Shamrock V* to his fellow aviator, Sir

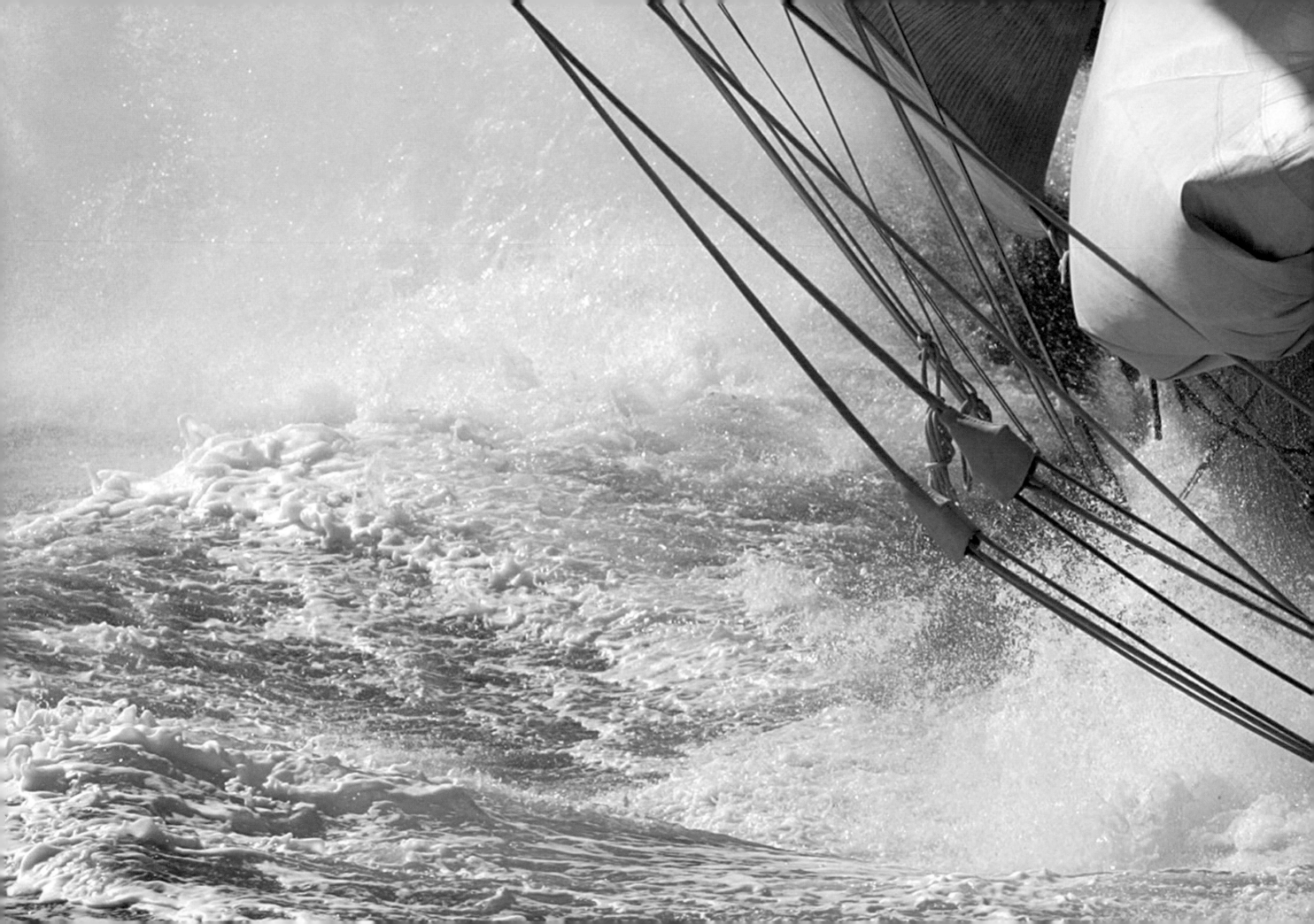

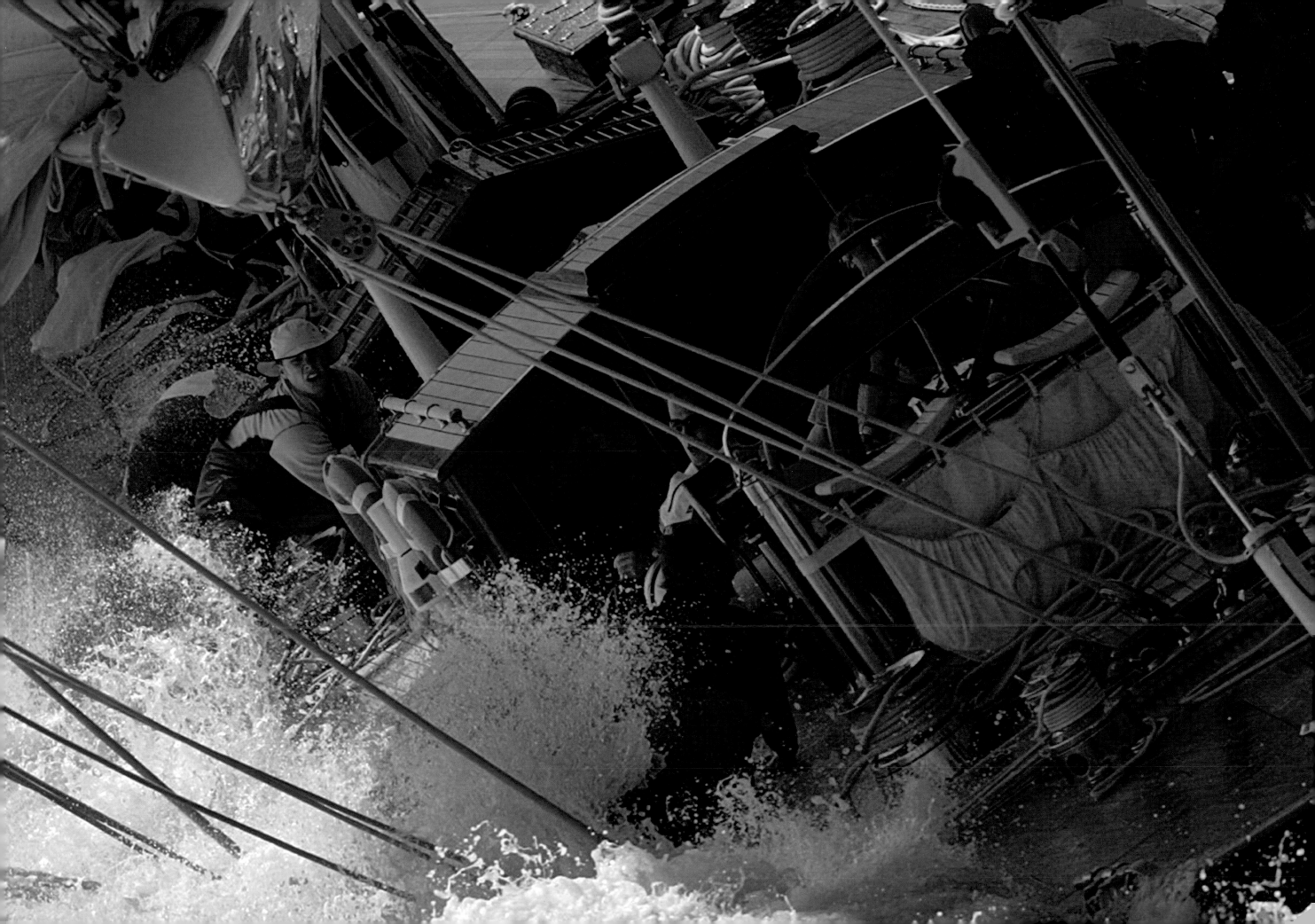

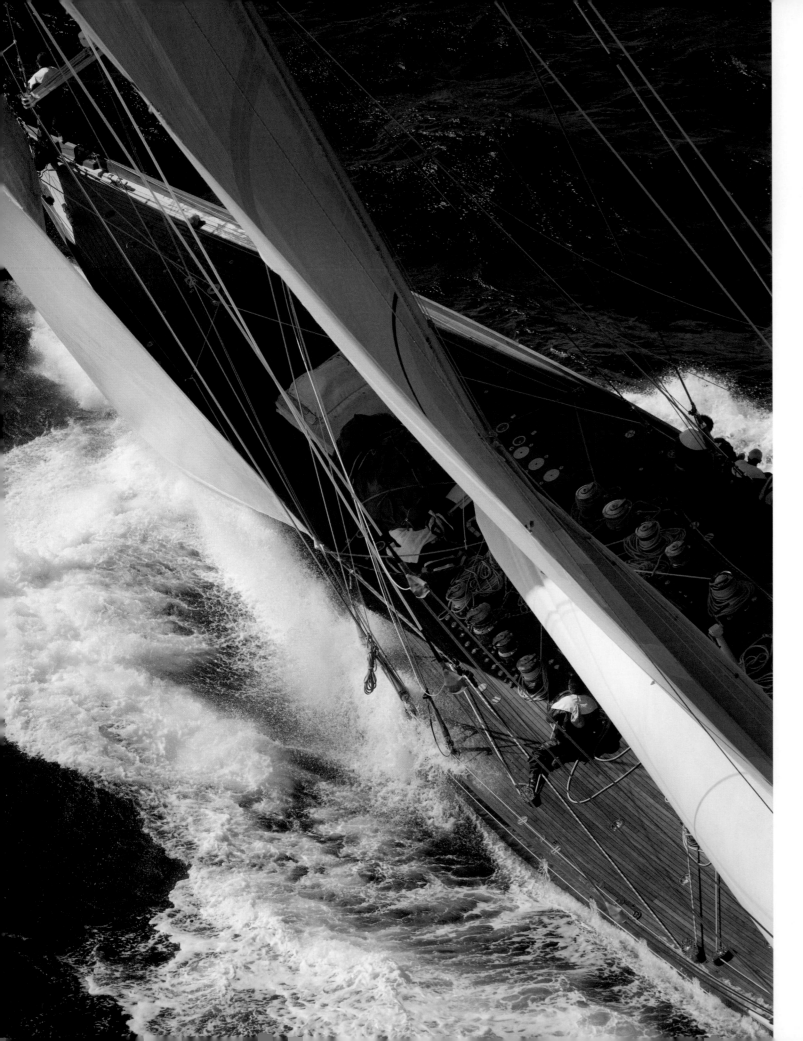

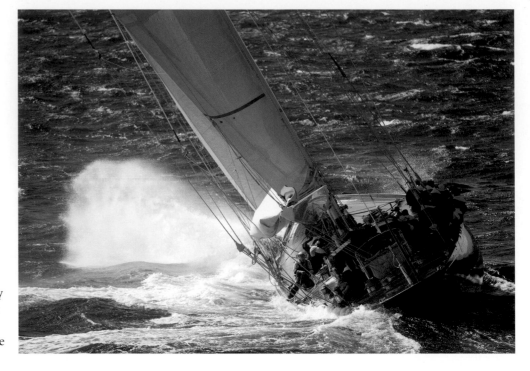

Left and Right
Shamrock's winch system around the mast area demonstrates the need for lots of power. Every crew member must understand precisely how each line works. For over seventy years *Shamrock V* has proven to be a sturdy yacht. She has crossed the Atlantic more than half a dozen times during her career.

Opposite
The bowman is dwarfed by the immense jib and mainsail set behind him. From this position he must feel that he is standing on top of the world as *Shamrock* glides effortlessly on a reach.

Richard Fairey (1887–1956), creator of Fairey Aviation in 1915. At the time, Fairey Aviation was building half the RAF's aircraft. The J-class was used as the trial horse and raced along with two new steel-hulled J-class yachts, *Velsheda* and *Endeavour* in 1934, then *Yankee* during the following season. In 1938, Fairey handed over his yacht to Italian newspaper editor Senator Mario Crespi who changed her name to *Sea Song*, fitting her with an auxiliary engine and raising her bulwarks. In 1945 after the war, Crespi sold the yacht to a Mr. Martin, who kept her until 1962. The next owner, Piero Scanu, another Italian, renamed her *Quadrifolio* (Italian for "shamrock"). In 1967, she underwent an initial restoration at Camper & Nicholsons where her planking was removed and her metal structure sanded, followed with new deck planking in teak. In 1986, the Lipton Tea Company bought the yacht from Scanu and donated her to the Newport, Rhode Island Museum of Yachting, which gave her back her original name: *Shamrock V*. Elizabeth Meyer, who had already had J-class *Endeavour* restored, did the same for *Shamrock V* in 1989. In 1995, she was purchased by the International Yacht Restoration School of Newport and resold to the Newport *Shamrock V* Corporation, which operated her as a charter. She is the only J-class to have stood the test of time, although three other J-classes, *Yankee*, *Endeavour II*, and *Svea* (a 1937 Swedish yacht), are undergoing reconstruction at the time of writing.

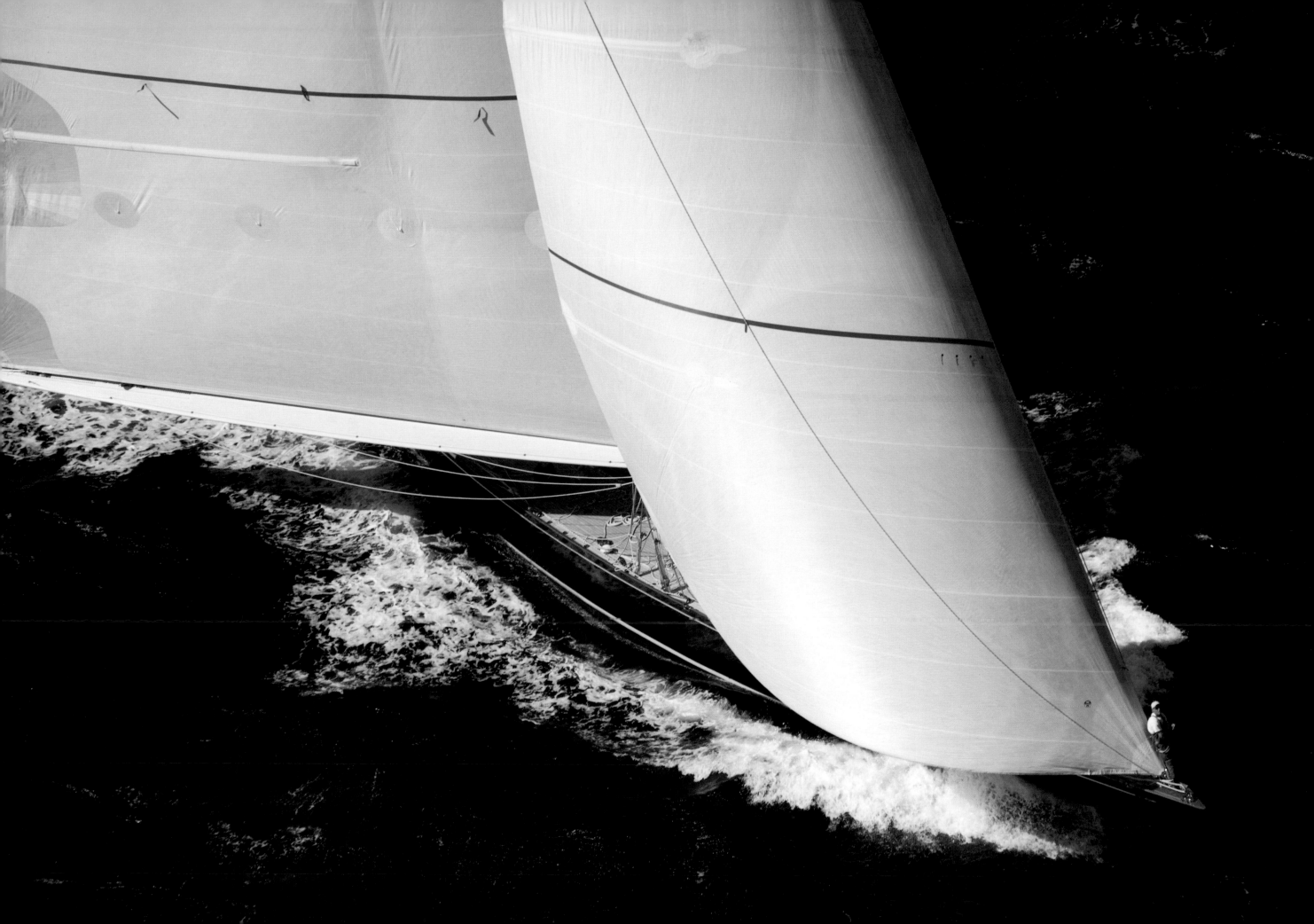

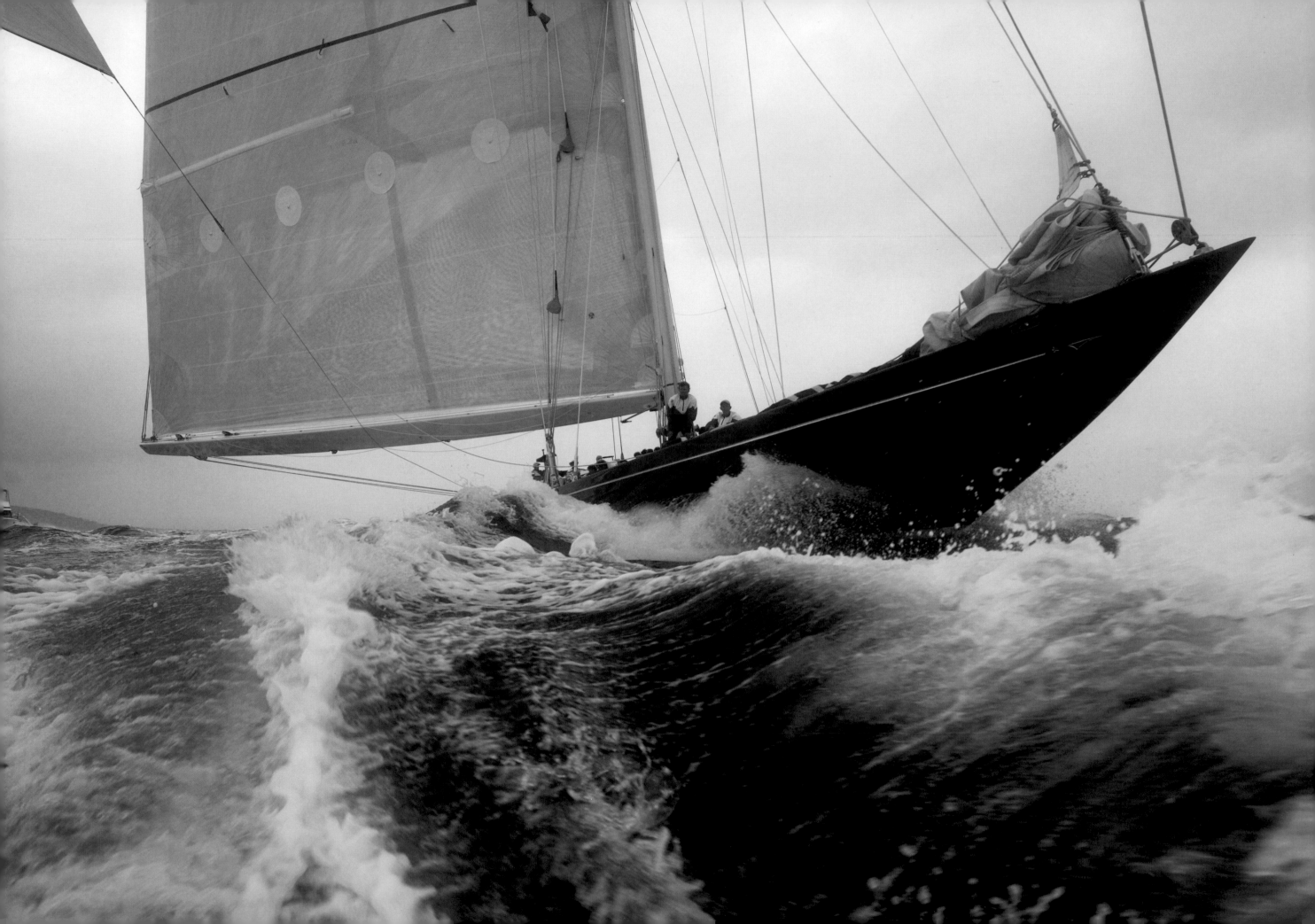

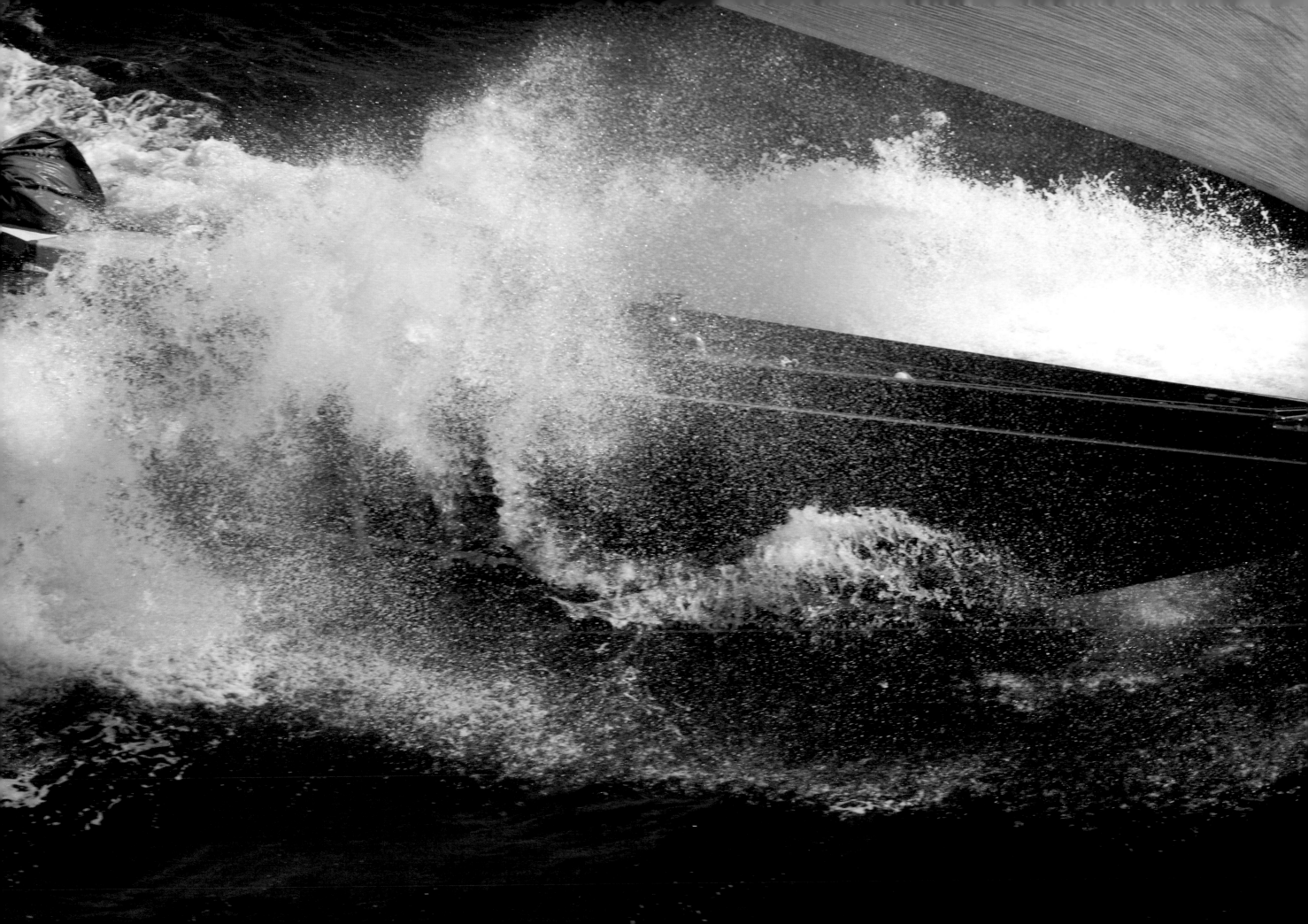

· FEATURES ·

Name: SHAMROCK
Architect: Charles E. Nicholson
Builder: Camper & Nicholsons, Gosport
Rigging: Bermudan cutter
Type: J-class
Launched: April 14, 1930
First owner: Sir Thomas Lipton
Other name: QUADRIFOLIO
Restorations: 1970, 1990, 2000
Boatyards (restoration): Camper & Nicholsons,
Gosport; Pendennis Shipyard, Falmouth
Architect (restoration): Gerard Dijkstra
Construction: composite, teak planking
on steel ribs

Overall length: 119 feet 9 inches [36.50 m]
Length at waterline: 88 feet 9 inches [27.06 m]
Maximum beam: 19 feet 8 inches [6 m]
Draft: 15 feet 9 inches [4.81 m]
Ballast: 80 tons
Displacement: 172 tons
Approximate sail area: 2,414 feet [725 m²]
Engine: 2 x Caterpillar 250 CV
Generators: 26 kVA

·DECK PLAN·

PORT

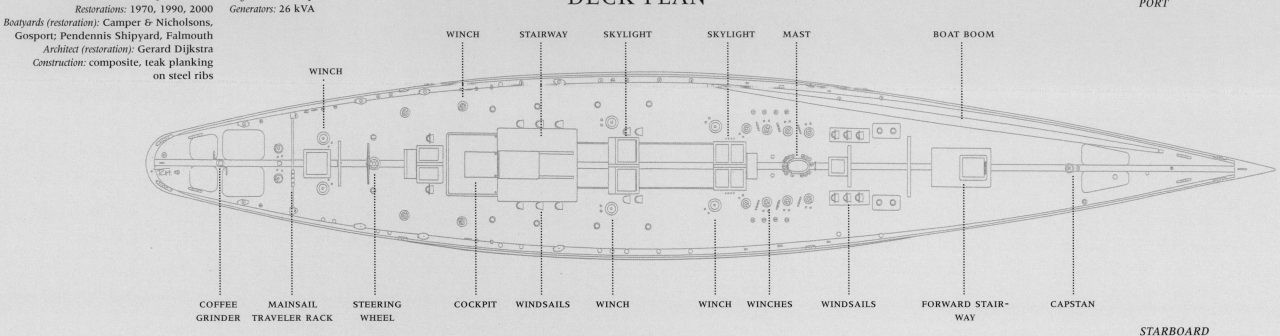

WINCH STAIRWAY SKYLIGHT SKYLIGHT MAST BOAT BOOM

WINCH

COFFEE GRINDER MAINSAIL TRAVELER RACK STEERING WHEEL COCKPIT WINDSAILS WINCH WINCH WINCHES WINDSAILS FORWARD STAIR-WAY CAPSTAN

STARBOARD

·LAYOUT·

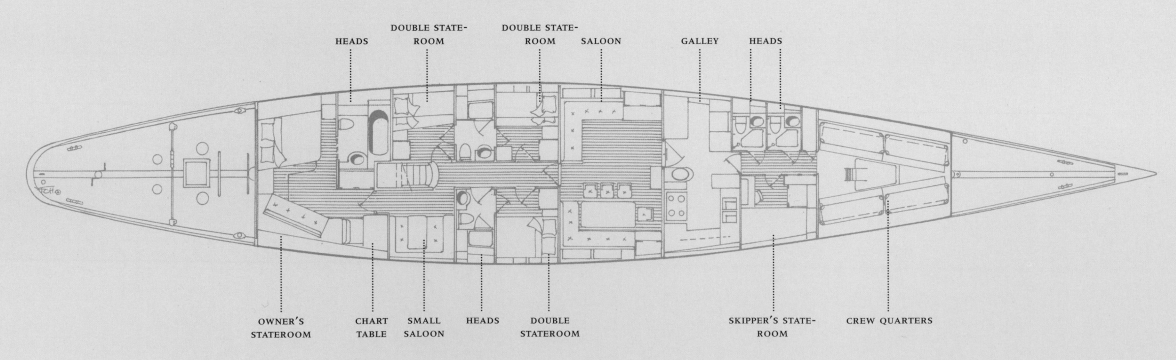

HEADS DOUBLE STATE-ROOM DOUBLE STATE-ROOM SALOON GALLEY HEADS

OWNER'S STATEROOM CHART TABLE SMALL SALOON HEADS DOUBLE STATEROOM SKIPPER'S STATE-ROOM CREW QUARTERS

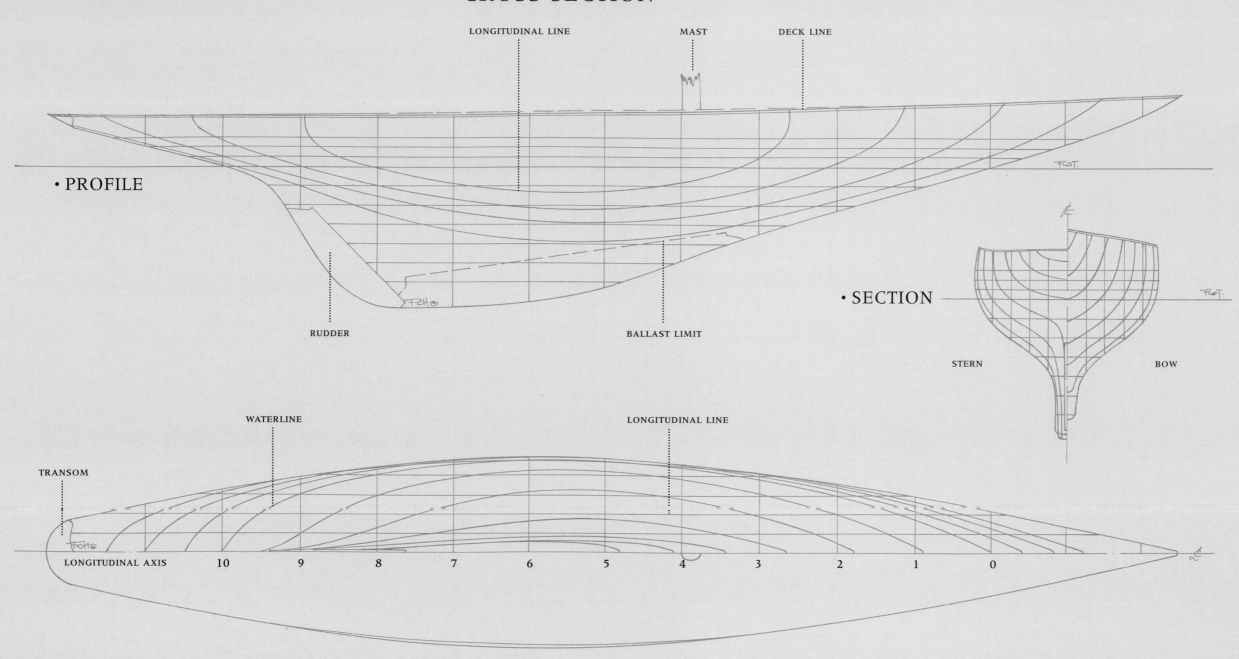

·CROSS SECTION

LONGITUDINAL LINE MAST DECK LINE

· PROFILE

RUDDER BALLAST LIMIT

· SECTION

STERN BOW

WATERLINE LONGITUDINAL LINE

TRANSOM

LONGITUDINAL AXIS 10 9 8 7 6 5 4 3 2 1 0

· PLAN

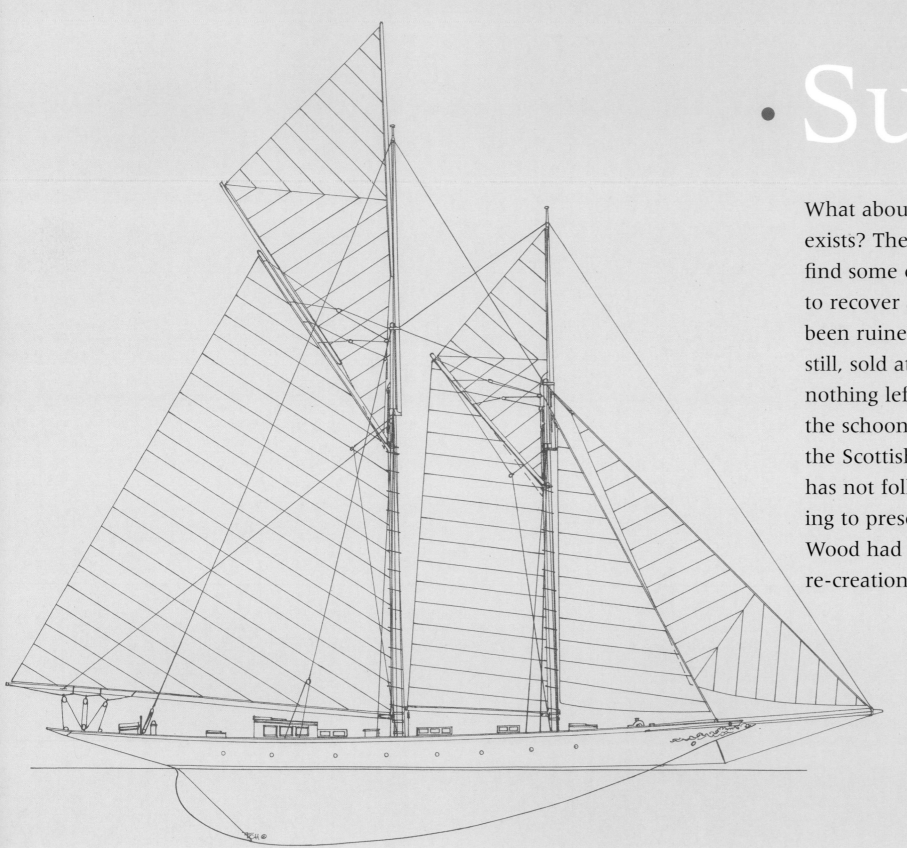

Sunshine

What about reproducing a yacht that no longer exists? The advantage is that all you need to do is find some old photographs, rather than working to recover an old, abandoned hull or one that has been ruined by multiple modernizations or, worse still, sold at a sky-high price even though there is nothing left that is worth keeping. The replica of the schooner *Sunshine*, another masterpiece by the Scottish architect William Fife III from 1901, has not followed the traditional course. With nothing to preserve, her captain and developer Peter Wood had enough originality to embark on this re-creation with simple love and enthusiasm.

Who would believe that this schooner is a reconstruction of a William Fife design? The skipper, Peter Wood, took a chance and was very successful. Clearly, *Sunshine* lives again and is resplendent. A few of the crew are working hard to trim the upper sails.

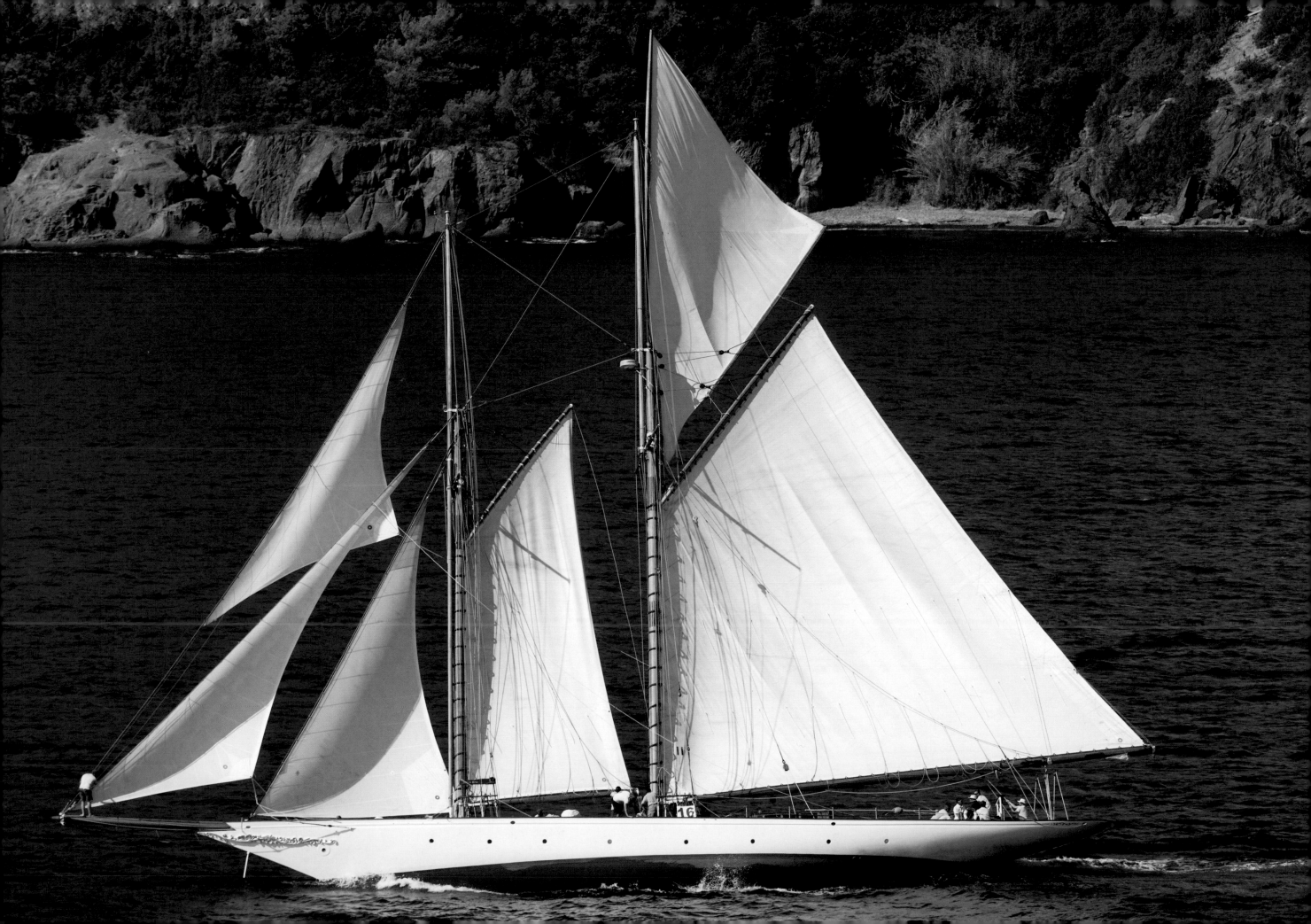

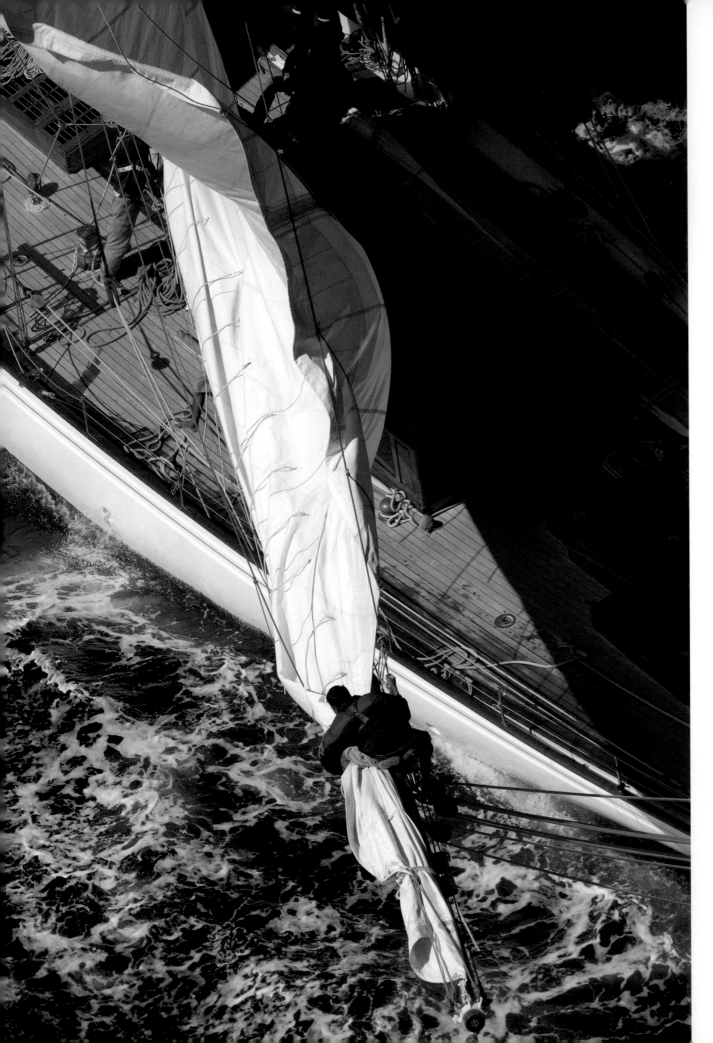

I f you were to ask Peter Wood why he wanted *Sunshine* and no other
yacht, he would answer that the fact the yacht had belonged to the
Queen of Portugal was sufficient reason to justify such an enterprise.
However, the background of this choice is rather more complex. At the be-
ginning of the twentieth century, the William Fife & Son boatyard at Fairlie,
Scotland had built two sister ships on the same plan, *Sunshine* in 1901 and
Asthore the following year. *Asthore* also bore the name of *Sunshine* for nine-
teen years, from 1906 through 1925. In fact, the two yachts were both called
Sunshine during this period. So could the boatyard build a third vessel with
the same name?

Wood's logic is not all that clear, but it is relentless. He wanted to build yet
another sister ship. His encounter with the vessel dates from 1988, from the
time when he was skipper of the schooner *Altaïr*, another of William Fife's
masterpieces, built in 1931 and restored in 1987. In fact the owner of *Altaïr*
from 1933 to 1938, Walter Runciman, had been the owner of *Asthore*, the
original sister ship of *Sunshine*.

A Plethora of Names

The first *Sunshine* had been built by Glen F. McAndrew who lived in Largs
Castle very near Fife's boatyard at Fairlie on the banks of the Clyde. From his
stately home, McAndrew could see the yachts sailing up the Clyde to the
regattas held at Hunter's Quay. The magazine *Yachting World* described the
launch of the schooner in April 1901, concluding that, "*Sunshine* is a very
handsome boat and cannot fail to be a speedy one." McAndrew kept his
schooner until 1905, at which date she passed to the Portuguese royal family
and was based in Lisbon. In 1906 and in the official records as the property
of Queen Amelia de Palacio das Necessides, she was renamed *Maris Stella*. The
queen enjoyed sailing and took part in several regattas. She also owned a
small yacht with lateen sails, the nine-meter *Medusa* with triangular mainsail.
In 1910, the Saxe-Bragança dynasty lost the throne when the Portuguese
Republic was proclaimed, and *Maris Stella* was sold the following year.

E. A. Lazarus-Barlow acquired *Maris Stella* the next year, bringing her back
to Southampton and renaming her after his previous schooner, *Roseneath*, an
1898 Shepherd design. He sailed her for three seasons. Upon his death, his
widow kept the yacht for another year and then sold her to Dane Erik Plum,
who revived her original name. *Sunshine* cruised between the Baltic, Den-
mark, and the Bay of Kiel with its thousands of islands. She stayed in the
Plum family until 1922, when Harald Plum sold her to J. G. Walker. Once
again moored in Fairlie, where she had been built, *Sunshine* changed names
yet again, being known as *Adele* for at least the next two years. Then, in
1925, she became the property of Sir John Espen of Canterbury, who restored
the name *Sunshine* yet again. Her home port became Ayr, 22 miles (35 km)
south of Fairlie. Espen also owned a schooner with an auxiliary engine, *Allah
Karim*, built at White Brothers in 1906, and two-and-a-half times heavier

Left
Hold on tight. One crew
member sits on the end
of the boom working
hard to take control of
the reefed mainsail. This
is a dangerous position
to work.

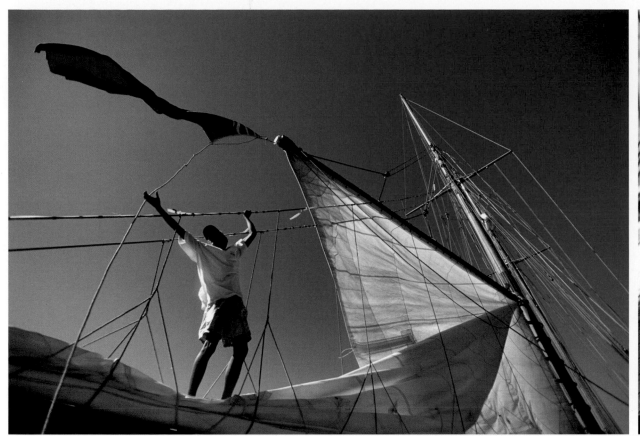

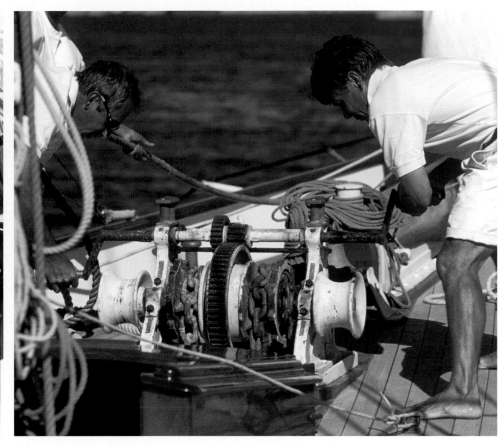

Above
As this yacht's colors are hoisted, one wonders if the crew is following the etiquette of a vexillologist. The wheel stands ready for the helmsman to take control. The windlass mechanism is watched with great care as the anchor is hoisted on deck.

Page 166
On huge classic yachts, sails are often trimmed one at a time. The headsails are in good order, but the mainsail needs a little work in this picture. No doubt the crew improved things within a few minutes.

Page 167
This impressive schooner, pushed by a wind from land-ward, glides over the waves. The staysail is stowed in its bag at the top of the mizzenmast.

than *Sunshine*. In the following year, 1926, *Sunshine* belonged to F. Simmonds, who put in a four-cylinder Bergius engine and based her in Ayr until 1930. The schooner subsequently disappeared from the British register, but her sister ship *Asthore* was found in New York in 1931, under her original name. No trace of *Sunshine*, however.

A Boatyard in Myanmar

When Wood began his investigation in 1999 with the hope of building a new *Sunshine*, he thought he would find a boatyard in Vietnam. He had visited several firms when he discovered that the cutter *Moonbeam IV* (a 1920 William Fife design) was at the Myanmar Shipyards in Yangon, the capital of the country formerly known as Burma, for a complete restoration.

He went to Yangon to find out the conditions for a possible reconstruction and was delighted with the reception he got, the relaxed atmosphere, and the charm of the Burmese, management and craftsmen alike. By the late 1990s, the Burmese attitude to foreigners had completely changed, even though in Europe everyone believed that the country was mired in a state of terror. With a long seafaring tradition, Yangon had remained a very active center of shipbuilding and had adapted to market changes while retaining its expertise. In the past, the great shipyards of the Clyde had recruited much of their manpower in Burma, then a British colony, since the skill of the Burmese was greatly appreciated. They were capable of building a container

ship as well as cutting decorative marquetry, so the shipyards there were perfectly suited to Wood's project. As an added bonus, Myanmar is a leading producer of the hardwoods used by the European restoration boatyards. Wood chose Myanmar Shipyards for the reconstruction, and work was then able to get underway.

Wood wanted a steel hull for ease of maintenance and to keep costs down. Based on the original William Fife cross section plans preserved in the Scottish Maritime Museum at Irvine, Scotland, Wood commissioned the Scheeps en Jachtonwerp Gaastmeer firm in the Netherlands to laser-cut his hull. This was done on the basis of redrawn, computerized plans, with steel coming from Germany. The yacht complies with the European standards with four waterproof bulkheads even though, as a replica, *Sunshine* is not subject to the standards applicable to passenger ships, but has to meet the criteria of a yacht destined for chartering instead.

Once the sheet metal and structure had been bought in Yangon, the construction could begin in earnest. The hull was turned upside down, keel in the air, as the Herreshoff yards had done at the beginning of the century at Bristol, Rhode Island. The builders added the deck sheet metal, known as the deck-stringer, at the edge of the deck, and the structure, the skeleton of the boat, was placed on top. The planking sheets were then shaped and welded in place, both sides of the boat being added simultaneously to prevent warping. They also lined the keel to give it a lead ballast, the whole being a solid structure and so less likely to be damaged if *Sunshine* hit a reef. As was the case with the plans, the whole construction was supervised and approved by Lloyd's.

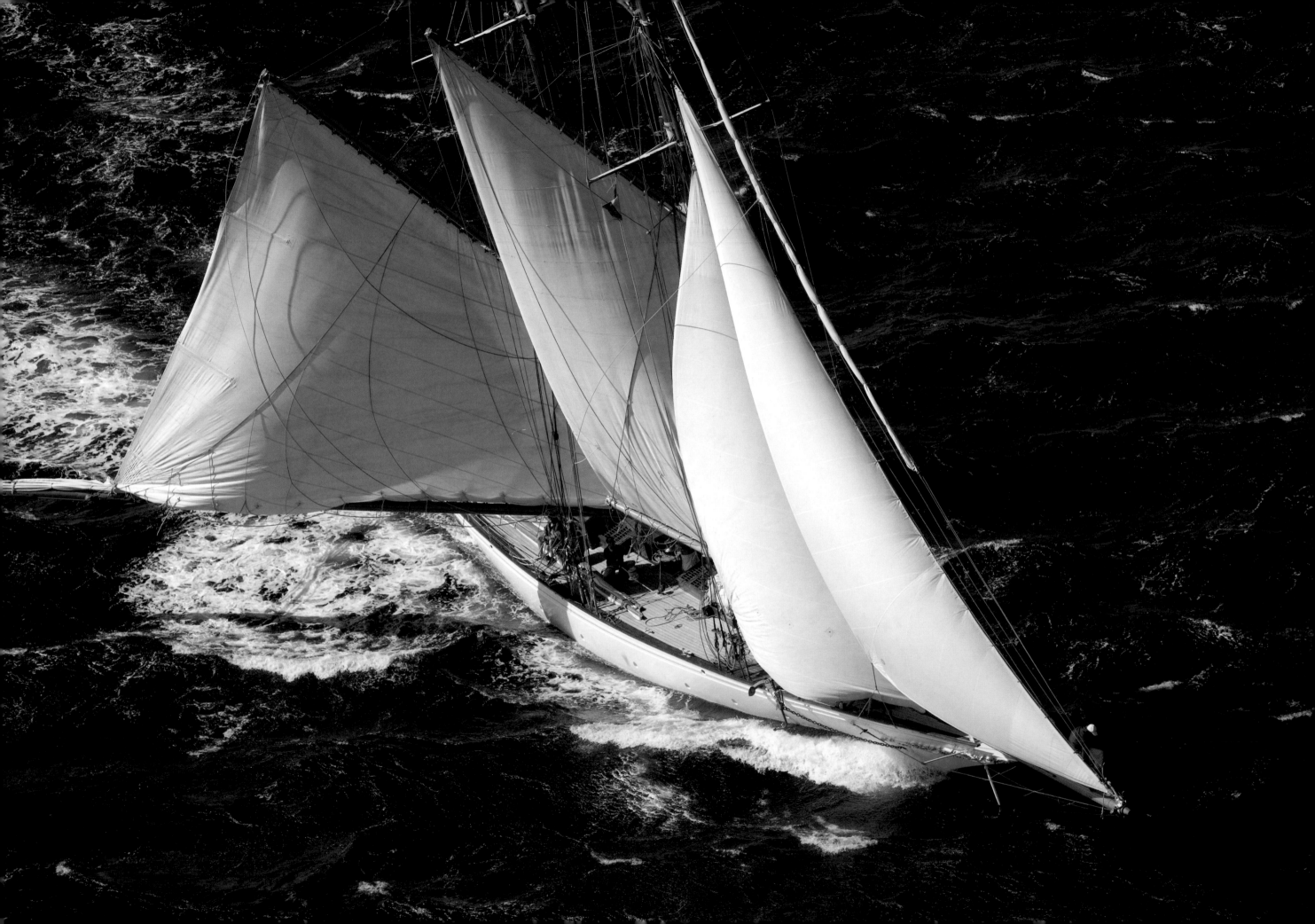

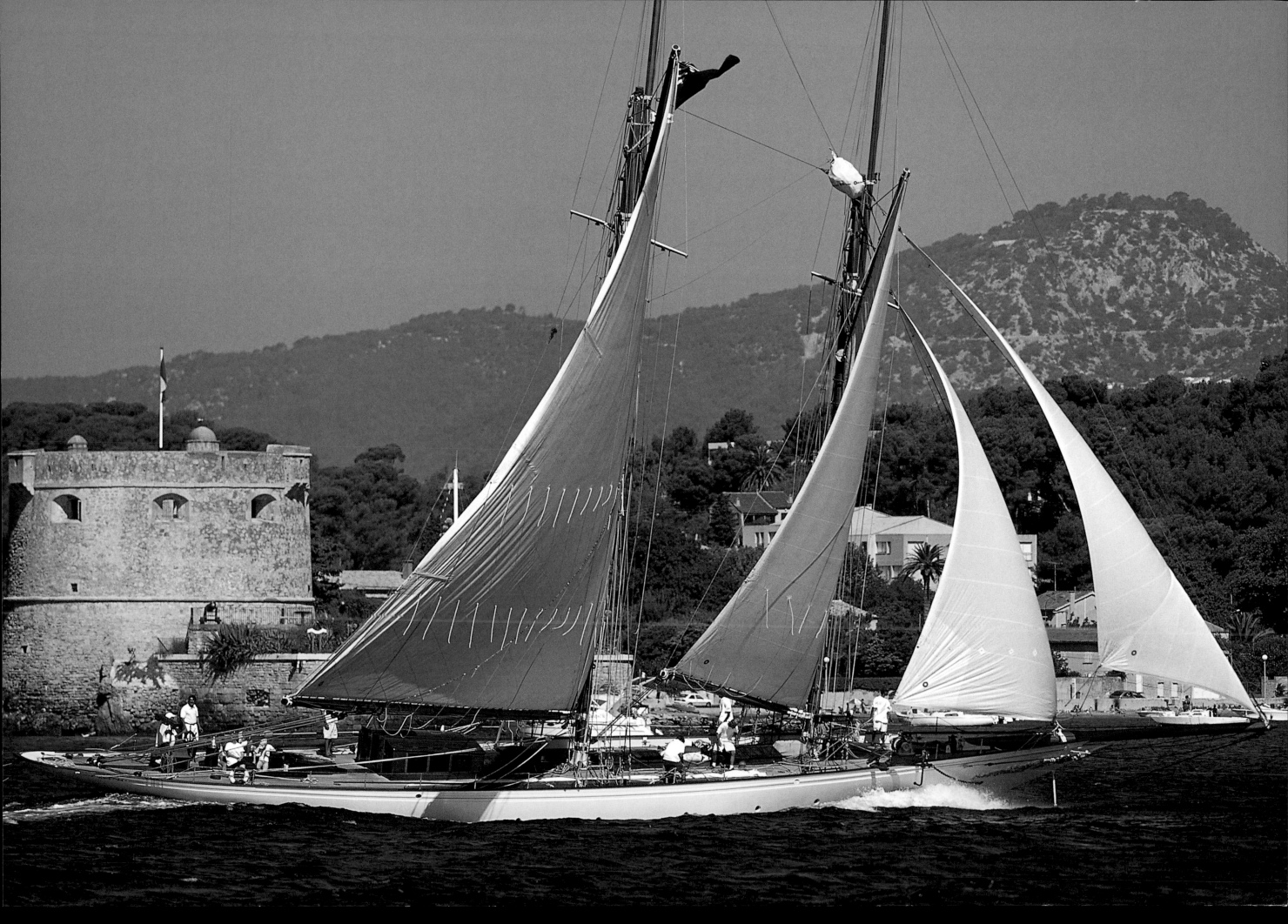

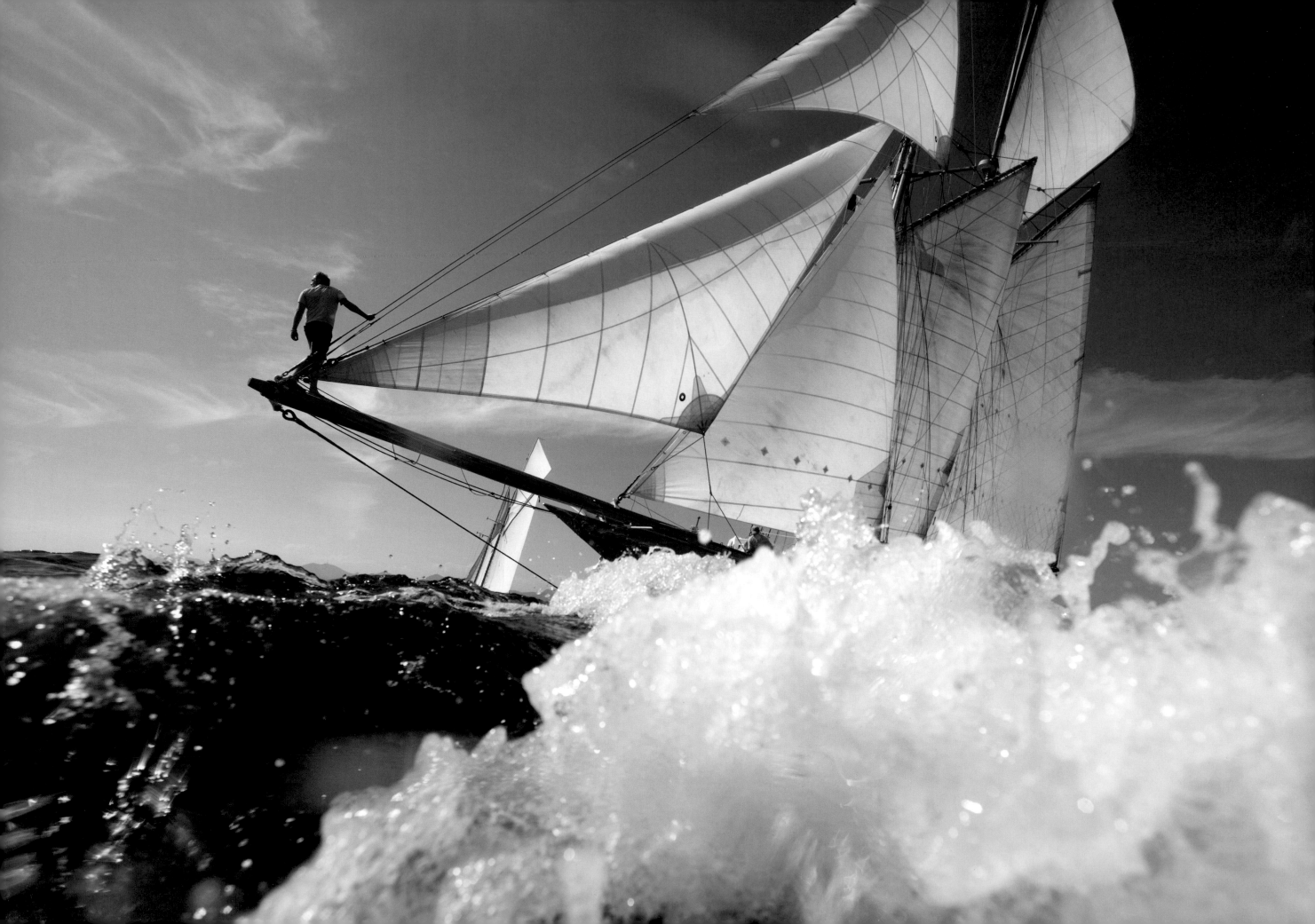

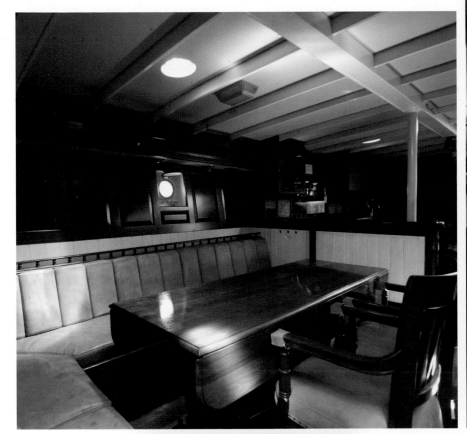

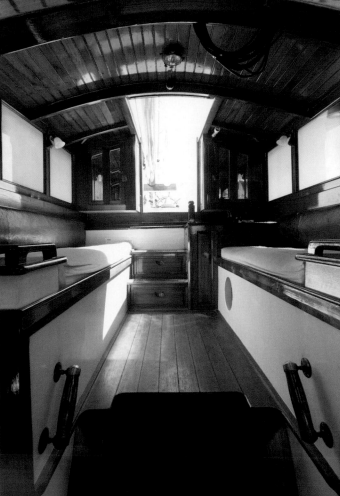

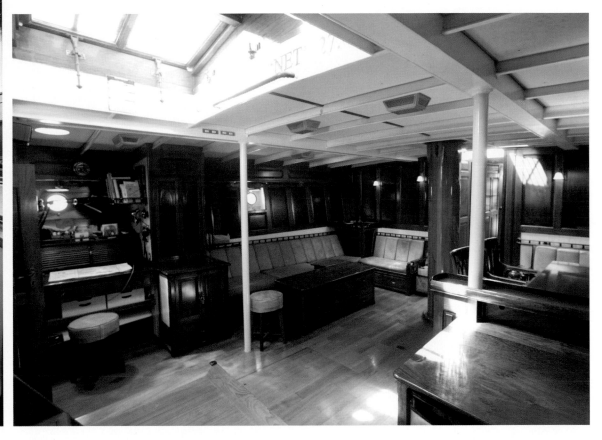

Opposite
The bowman keeps a watchful eye on the competition as *Sunshine* works to windward. Communication from this position has to be through hand signals.

Above
The saloon is huge, understated, and elegant. The wheelhouse is inspired by the schooner *Altaïr* designed by William Fife.

Made to Last

In early 2000, it was time to turn the hull right side up. Two cranes were used to place the yacht in her correct position. They then moved the hull to a sheltered hangar where twenty or so craftsmen set to work on the interiors, deck, and machine room. When Burma gained independence in 1947, the young republic needed a lot of ingenuity to keep machinery in working order, and as a result, today there are many people there who know how to remake stainless steel, galvanized iron, and bronze parts.

Sunshine's interior was adapted for use as a charter vessel. Two double staterooms with a head were forward of a huge saloon opening onto the galley and chart table. Aft were a large owner's stateroom and the captain's stateroom with its own head. Forward of the guest staterooms and separated by a waterproof bulkhead, there was a cabin containing two rows of bunks, and crew quarters containing four berths and a head.

The teak chosen for the woodwork and the rosewood panels, in a restrained and elegant style, was naturally carved by hand on the spot. The leather upholstery complemented these in fairly pale colors. They covered the deck in teak laths two inches (5 cm) thick, fixed on the underside to the metal structure, the joints caulked in cotton in the traditional way. In most of the current restoration, the teak laths covering the deck are less than 2¼ inches (3 cm) thick and are laid on marine hardboard. The skylights had to be slightly raised to comply with modern regulations, but in view of the size of the boat, this was an insignificant change. The wheelhouse—which slightly breaks up the silhouette in comparison to her look in 1901—remained very elegant and provides shelter, and even rest, on two banquettes.

Sunshine relaunched in 2003. A number of finishing touches still remained to be put in place, though. Her rigging was made of galvanized iron at the boatyard. Finally, in a memorable ceremony in October 2004, the schooner officially launched. With her Dacron sails from Japan, cut by Lee Sails in Hong Kong, *Sunshine* took to the waves. Her first destination was Phuket, Thailand. After cruising the seas of Thailand and Malaysia, the yacht finally reached the south of France in early June 2005, having made thirteen stopovers.

Replica or Reconstruction?

Is Eric Tabarly's *Pen Duick*, a Fife design dating from 1898, whose hull was laminated in 1958, a replica or a restoration? The classification as replica, reconstruction, or restoration is determined by specialists and is subject to opinion. For historical accuracy, as well as economy, Wood had considered rebuilding two vessels, *Sunshine* and *Asthore*, as the William Fife & Son boatyard had done in 1901 and 1902. In any event, the CIM, the organization that runs the classic yacht regattas in the Mediterranean, has definitively classified *Sunshine* in the "vintage" category.

· FEATURES ·

Name: SUNSHINE
Architect: William Fife III
Rigging: gaff schooner
Type: replica of SUNSHINE (1901)
Launched: October 2004
First owner: Peter Wood
Reconstruction: 2004
Boatyards (reconstruction): Myanmar Shipyards, Yangon
Construction: steel

Overall length: 109 feet 7 inches [33.40 m]
Deck length: 103 feet 8 inches [31.60 m]
Length at waterline: 71 feet 8 inches [21.84 m]
Maximum beam: 18 feet 6 inches [5.64 m]
Draft: 11 feet 3 inches [3.43 m]
Ballast: 90 tons
Displacement: 188 tons
Approximate sail area: 1,578 square feet [474 m²]
Engine: Cummins 6CTA 300 CV
Generators: Onan 17.5 kVA

· DECK PLAN ·

PORT

FORWARD STAIR-
WAY

DOGHOUSE WINCH SKYLIGHT WINCH BOWSPRIT

STEERING WHEEL

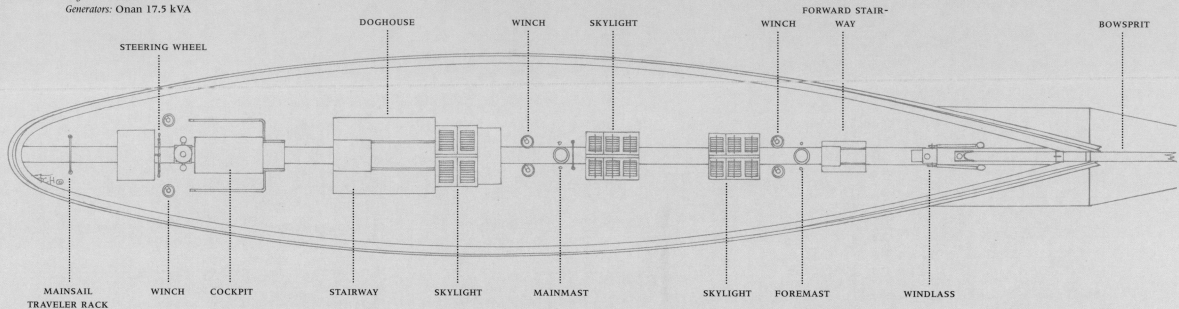

MAINSAIL
TRAVELER RACK WINCH COCKPIT STAIRWAY SKYLIGHT MAINMAST SKYLIGHT FOREMAST WINDLASS

STARBOARD

· LAYOUT ·

HEADS TECHNICAL CHART DOUBLE HEADS HEADS CREW QUAR-
ROOM TABLE STATEROOM TERS

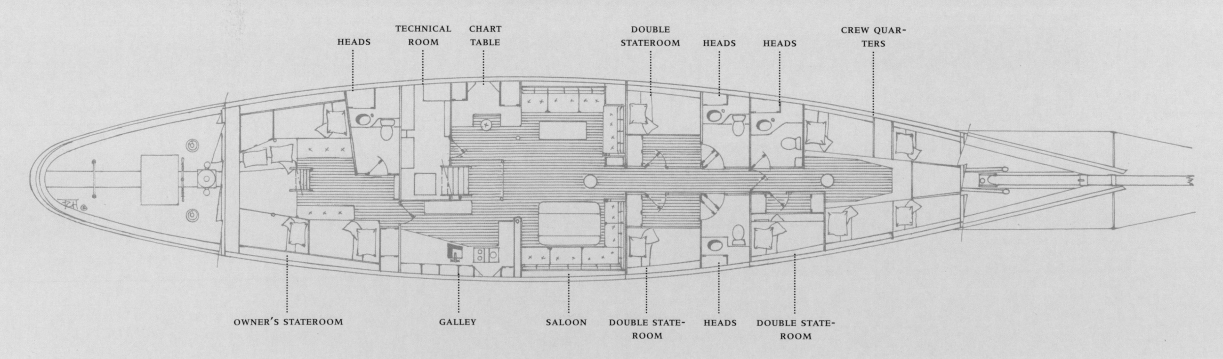

OWNER'S STATEROOM GALLEY SALOON DOUBLE STATE- HEADS DOUBLE STATE-
ROOM ROOM

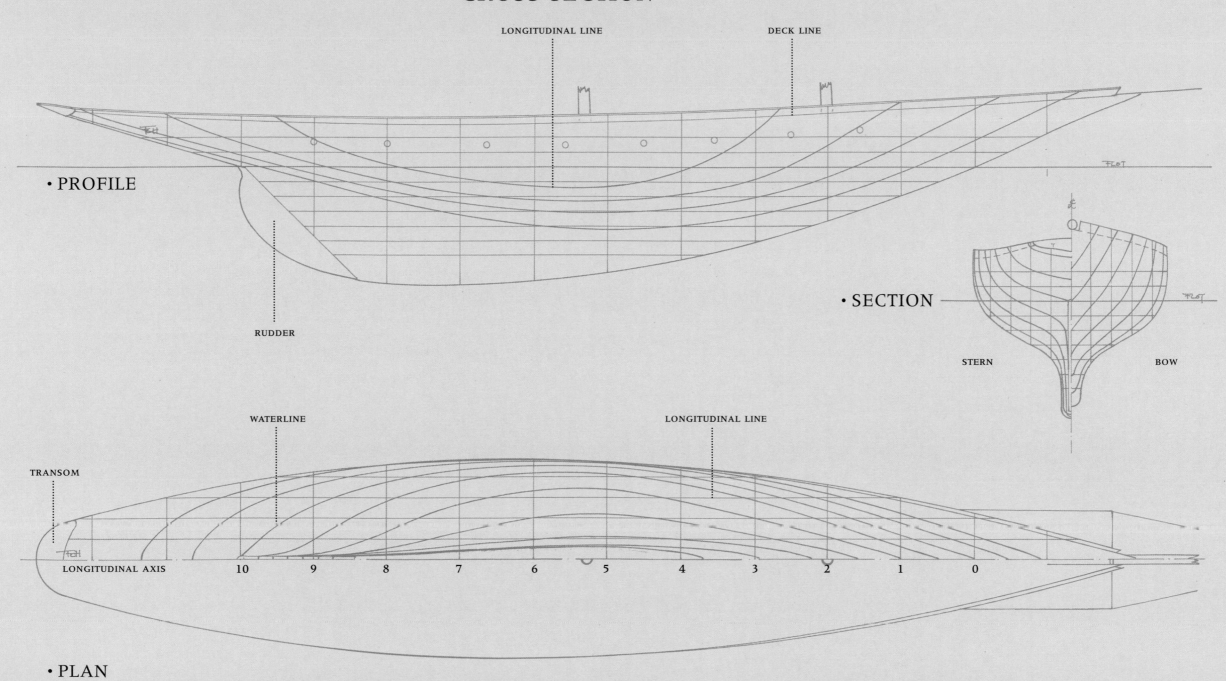

· CROSS SECTION

LONGITUDINAL LINE

DECK LINE

· PROFILE

RUDDER

· SECTION

STERN BOW

WATERLINE

LONGITUDINAL LINE

TRANSOM

LONGITUDINAL AXIS 10 9 8 7 6 5 4 3 2 1 0

· PLAN

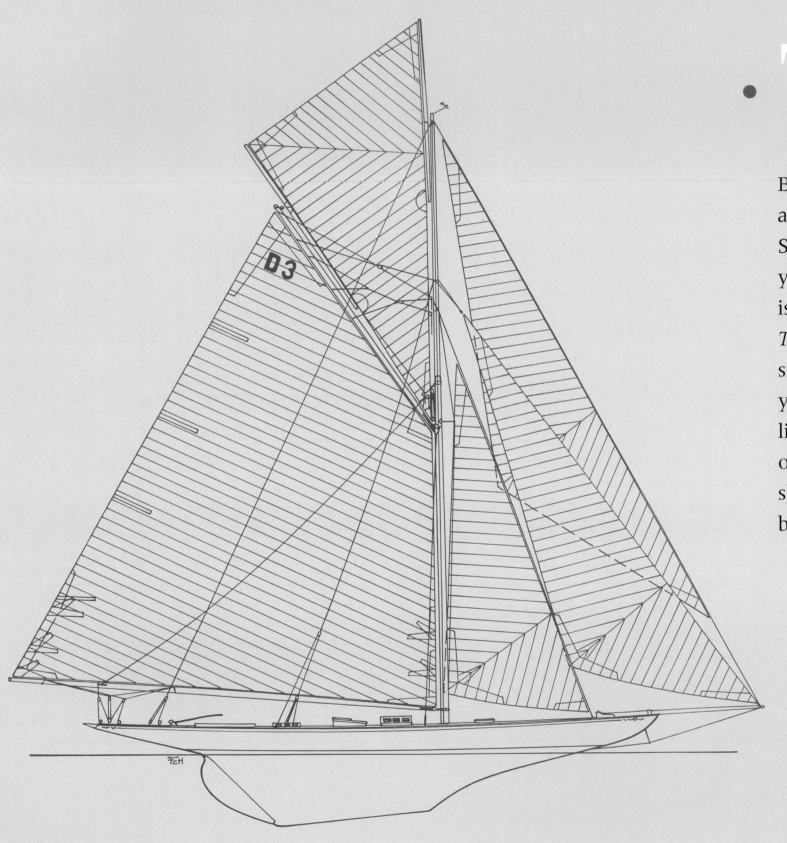

· Tuiga ·

Built in 1909 at Fairlie for the Duke of Medinaceli, a Spanish aristocrat and friend of the King of Spain Alfonso XIII, *Tuiga* is a fifteen-meter class yacht. Designed by the master, William Fife III, she is one of the handsomest yachts still afloat. Yet *Tuiga* is not an original design. Her shape is very similar to that of two other fifteen-meter class yachts designed by Fife, *Vanity* and *Hispania*. Their lines were based on the half-hull of *Cintra*, the second fifteen-meter designed by Fife, and her sister ship *Magda VIII*. *Cintra*'s model was used as the basic design for five other yachts.

Tuiga is the flagship of the Monaco Yacht Club, so she is always on show at important events. One of her most enthusiastic crew members is Prince Albert II of Monaco.

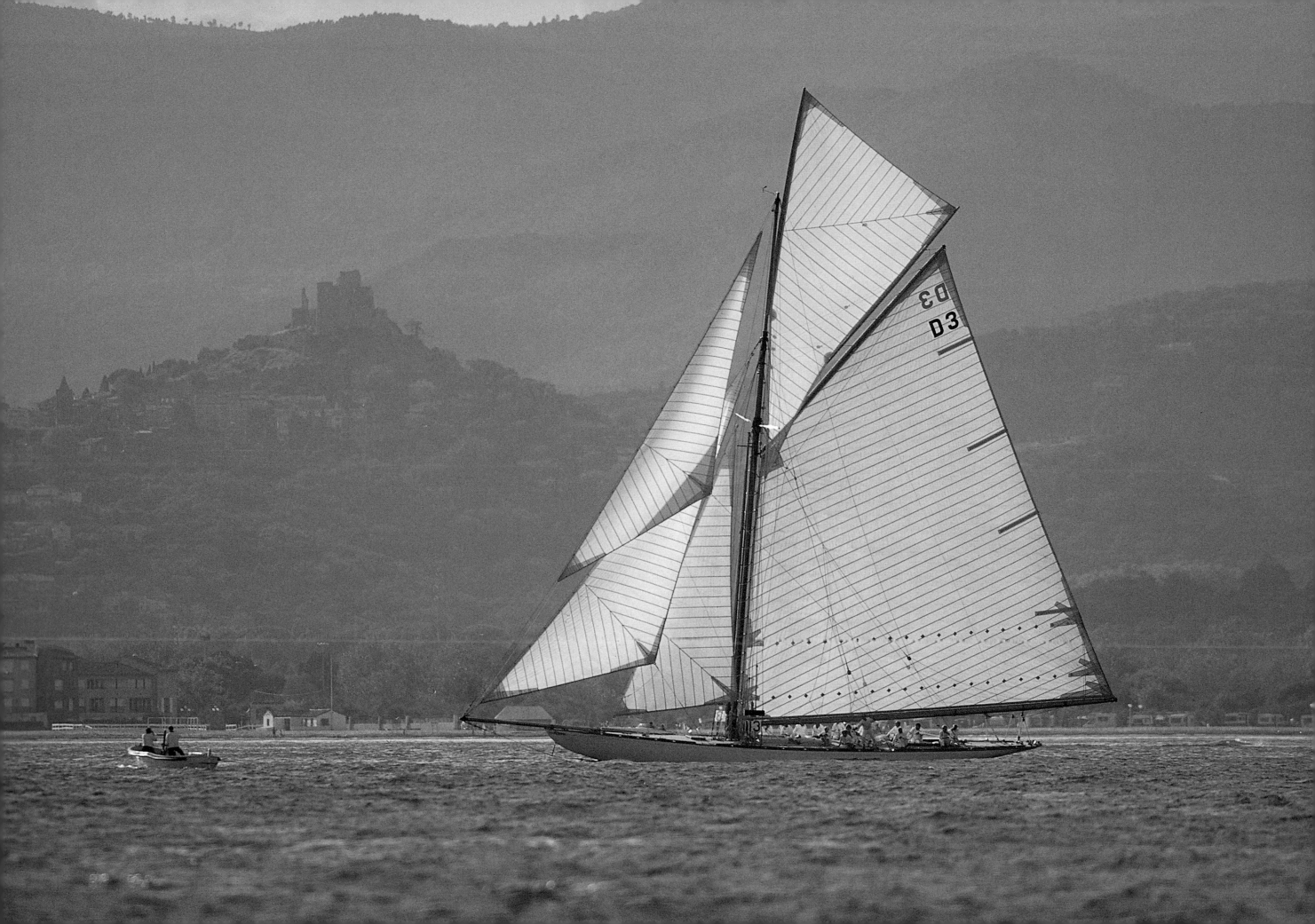

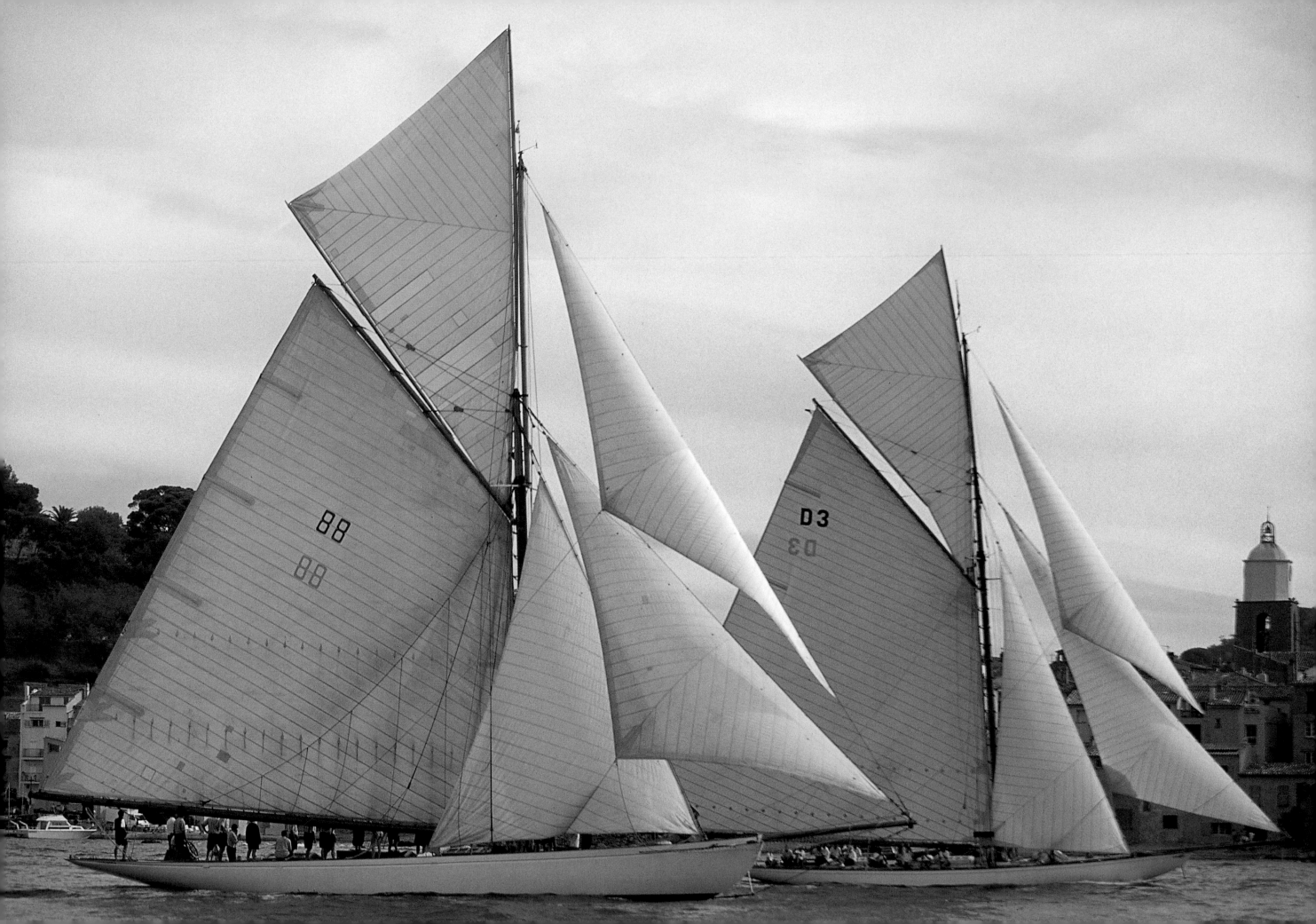

Nathanael Herreshoff is credited with the talent of building yachts on the basis of his talent for constructing half-hulls, whereas most of his contemporaries would first produce a half-hull and then carefully note the measurements for drawing a cross section of the vessel. Like his father and other architects of his generation, William Fife III did not draw the plans of his yachts in advance, but first made a model. What is surprising in his case is that the model was used to define the shapes of several yachts built to different scales.

Very few Fife half-hulls remain to help clarify his creative process. However, the differences between yacht plans created from the same model supply interesting comparisons. He traced the shape using a pantograph, then transferred the main measurements of the yacht to a cross section plan, whose characteristics might vary from one plan to the next. The measurements were then transferred again to a table of measurements and traced in life-size curves on the floor of the tracing room.

Something striking in the cross sections of Fife's vessels is that they often used the same family of curves. When I was looking for plans of yachts in Irvine for the book *American and British Yacht Design 1870–1887*, I saw on cross section plans created by William Fife II that the same plan was often drawn to several scales. When studying the history of the naval shipyards of Paimpol, which built fishing schooners in the second half of the nineteenth century, I also noticed that each plan consisted of several scale drawings with the name of the corresponding yacht. What is even more surprising is that the lines flow particularly well. On his plans, when drawing a curve, one or two leads are adequate for keeping the tracing batten following the line of the curve, whereas on the plans of some other architects, even six leads are not enough.

An International Rule

Whatever the method used by Fife to design *Tuiga*, she is a fifteen-meter vessel. The International Rule handicapping system came into force on January 1, 1907, and was an attempt to harmonize the various rules found all over Europe. This made it possible to develop ten or so classes of yachts ranging in length from 24 to 117 feet (7 to 35 m). These are further divided into the five-, six-, seven-, eight-, nine-, ten-, twelve-, fifteen-, nineteen-, and twenty-three–meter International Rule classes. An attempt has been made to add a fourteen-meter, but none is likely to be made.

International Rule, defining the rating of each series expressed in meters, is an addition to the characteristics of the yacht. To take account of the weight of the boat, a calculation element, a lowercase "d," is defined as the difference in the contour between a stretched rope and a rope following the lines of the hull, measured at its maximum width. One-third of the square root of the sail area is also taken into consideration.

To add up the speed and power, the weight, length, and sail are balanced logically. Obviously, the longer the boat, the larger she will be, and the faster she can travel. But she may have few sails for her size, and if the weight is

inadequate she will not be able to keep enough sail hoisted in a strong wind. It is up to each architect to find the right balance. Certainly, International Rule division, a device making it possible to bend the rules, is not easy to ascertain. International Rule, defended by the British and Nordic countries at the London Congress held from January 16 through 18, 1906, had the aim of developing habitable, seagoing, sturdy vessels. Their construction had to comply with the requirements of Lloyd's which would define its sampling depending on the rating.

When *Tuiga* was first built, the three existing fifteen-meter class boats, *Ma'oona*, *Shimna*, and *Mariska*, had to show what they were made of against 52-footers. Prior to 1907, the class that represented the fifteen-meter yachts was the 52-foot class. They were the result of the British Linear Rule of 1896, modified in 1901, at which date the lowercase "d" so beloved of Scandinavian yachtsmen was born. This same factor was repeated in the International Rule of 1906. Eighteen 52-foot yachts were built between the publication of the 1896 rule and 1906. *Penitent* (plan by Arthur Payne, 1896), the first on the list, revealed the talents of her skipper, William P. Burton. William Fife III designed seven 52-footers, Arthur Payne six, and Alfred Mylne three. Charles E. Nicholson could only trade a single one, and Herreshoff also designed one, *Sonya*, for Mrs. Turner Farley in 1905.

It was William Burton who laid down the law in this class. He was the successive owner of three 52-footers, *Gauntlet* (Payne design, 1901), which he got rid of very quickly as the yacht just did not move; *Lucida* (Fife design, 1902); and finally, *Britomart* (Mylne design, 1905) with which he dominated the series, winning a grand total of ninety-seven prizes. With a sail area almost as large as that of the fifteen-meter yachts, the 52-footers were slightly shorter by half a meter (20 inches) at the waterline; lighter, weighing two tons less in the keel; and their draft was slightly less. Their handling was more sensitive, making them more sporting, yet the construction price was a third less. Nevertheless the adoption of the International Rule resulted in their demise, with just one 52-footer being built after 1905.

Five Great Years

Although much research has been done on *Tuiga* and several publications have been dedicated solely to her, the date of her launch remains unknown. The reason for this is that the yacht was built purely as a pleasure boat for Alfonso XIII. The main event when her presence was noted was by the Duke of Medinaceli when *Tuiga* was at Pasejes, near Santander, for the launch of the fifteen-meter royal *Hispania* at the Astilleros Karrpard yard. The only date known is when *Tuiga* left the Clyde after taking six months to build, this being May 20, 1909, on the orders of Captain George Canning, under ferrying rigging, i.e., with a smaller mainsail with a free edge not attached to a boom.

While *Vanity* and *Tuiga* were built at Fairlie, *Hispania* had to be built on the Iberian Peninsula. William Fife visited Spain twice to supervise the progress

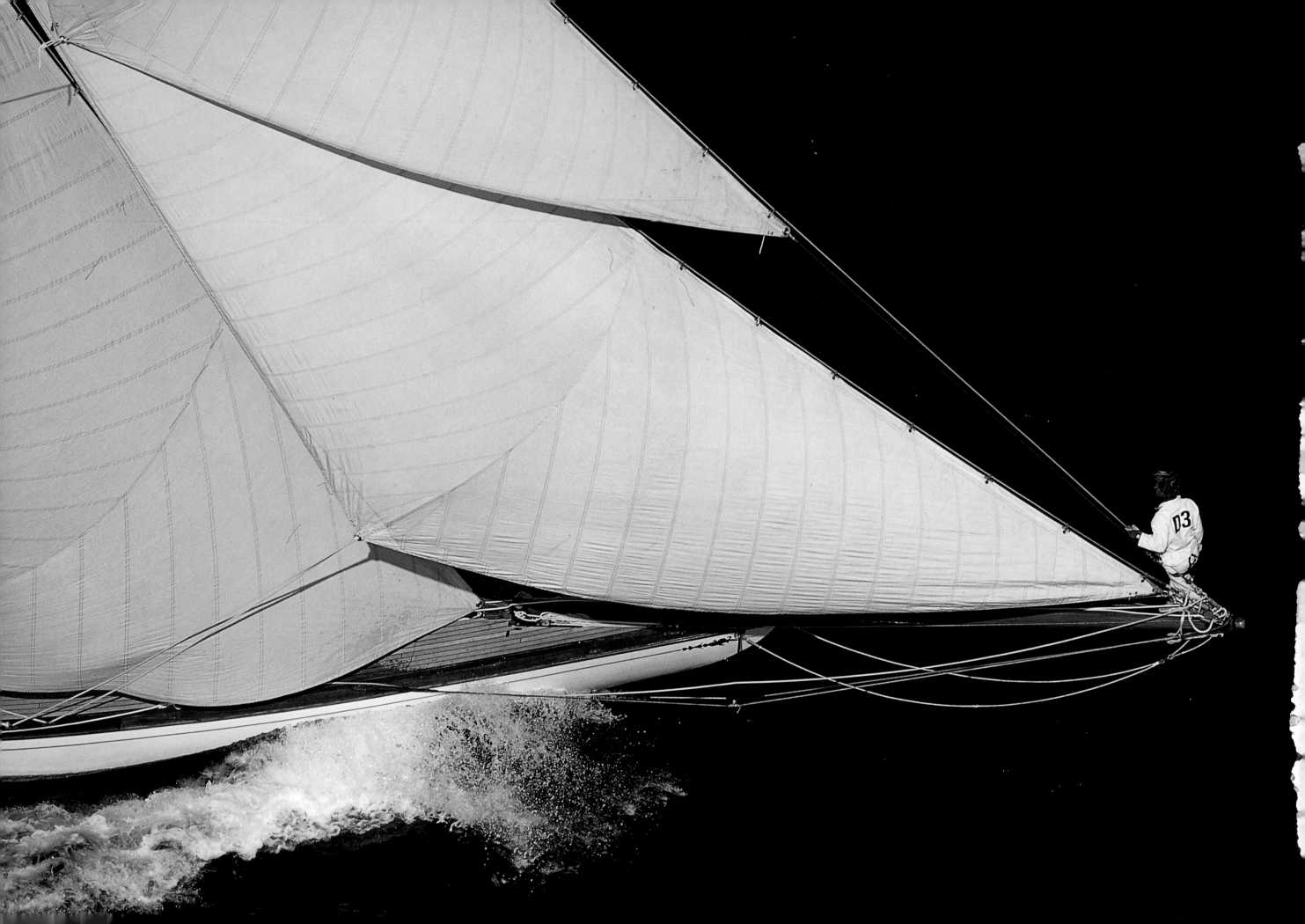

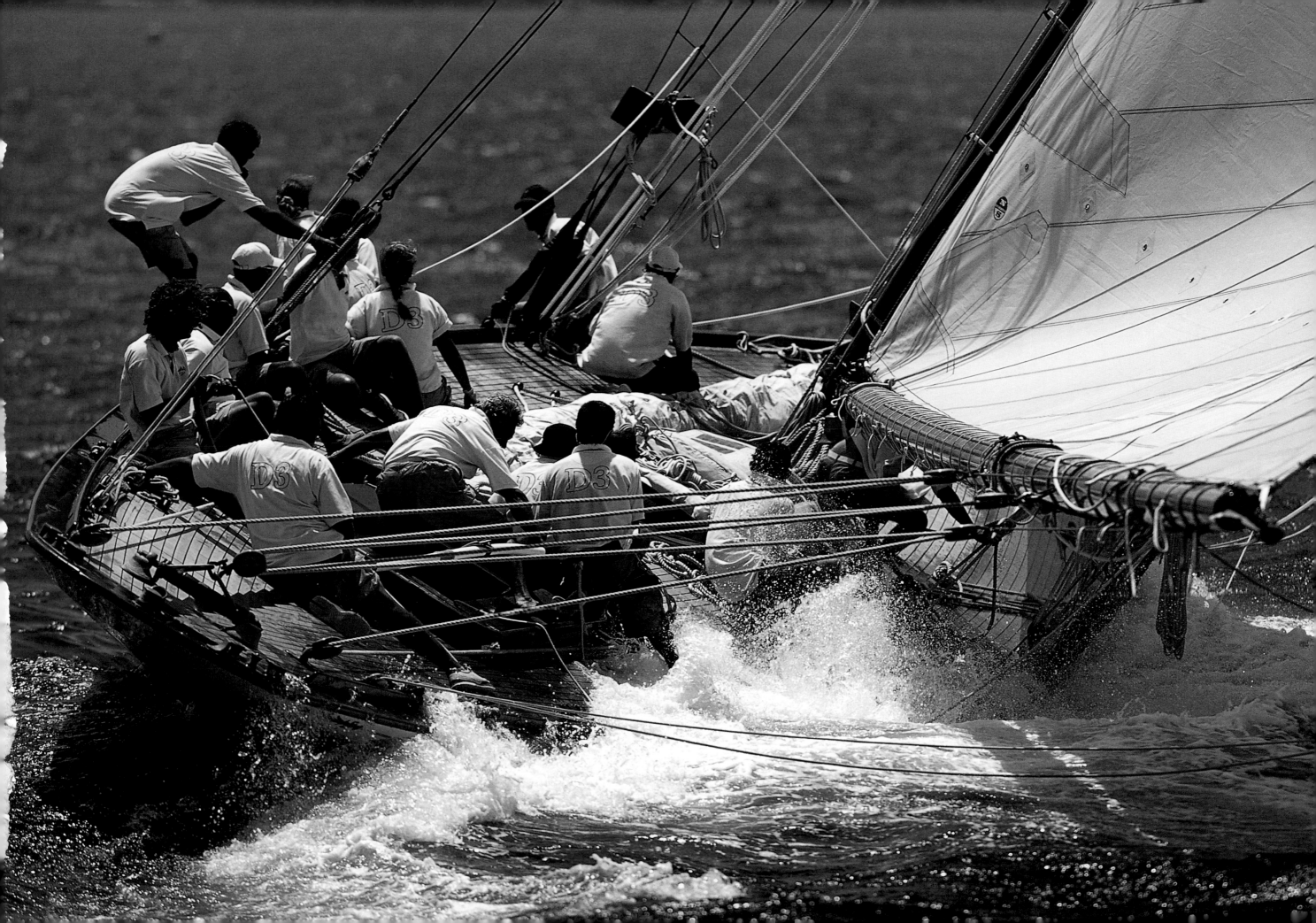

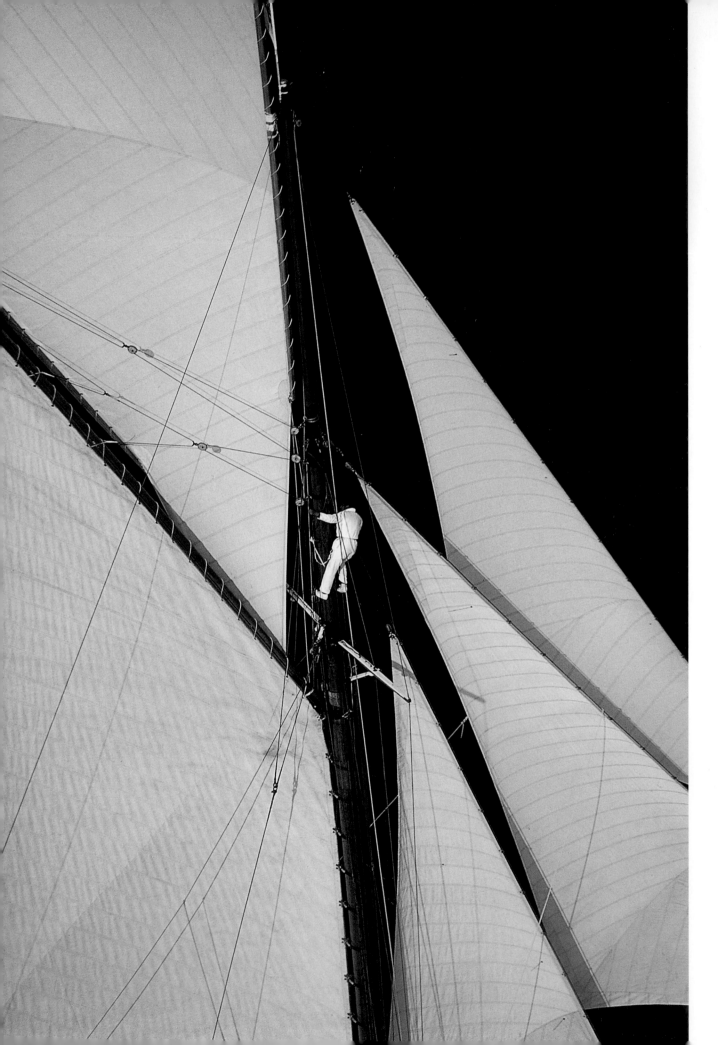

of the works. The Karrpard boatyard met the monarch's requirements best. This was the yard that had worked on the commission of the Marquis of Cubas, another Spanish grandee sensitive to the desires of his sovereign, who had his fifteen-meter *Encarnita* built using plans designed by the architect Joseph Guédon, and was famous for the yacht's success on the Basque Coast. There was definitely a fifteen-meter atmosphere for this royal baptism, and the king had expressed his wishes for this gathering. Another Spanish grandee, Don Claudio Lopez, became the owner of the fifteen-meter *Shimna* (a Fife 1907 design built for William Yates) that he had renamed *Slec*. For her first regatta, on July 3, 1909, in Santander, *Tuiga* beat *Slec* by seven minutes, a good start for a racing yacht. *Hispania* was finally ready for San Sebastian Week, from July 15 through 21. The fifteen-meter royal yacht, which out of deference to the sovereign was the sole boat on the starting line, won the first regatta. On the following day, *Hispania* suffered damage and left the victory to *Tuiga*. The third day was decisive for the Cuba Cup. The wind freshened in the middle of the course, and *Tuiga* allowed the king to get ahead, then abandoned the race. On the fifth day, between San Sebastian and Guetary, *Hispania* arrived smoothly four minutes ahead of her direct competitor. On the following day, in a strong southeasterly breeze, *Hispania* beat *Slec*. The last day was dedicated to the awards ceremony, held with much pomp, and presided over by the queen accompanied by Prince Henry of Prussia.

Four Great Seasons

The heyday of the fifteen-meter class was 1909. In addition to the three Spanish yachts, *Tuiga*, *Hispania*, and *Slec*, all of them skippered by British sailors, the president of the Cannes Regattas, Philippe de Vilmorin, had the fifteen-meter *Anémone II* designed for him by C. M. Chevreux and launched in January at the Le Marchand, Vincent & Co. in Cannes. But she was far from a success. The French yacht was beaten in Le Havre on July 28 and 29 by *Mariska* (1908, Fife plan) and *Vanity*, owned by John R. Payne, Arthur E. Watson, and Ian Hamilton. Although *Anémone II*'s sails had been made by Ratsey & Lapthorn like those of her competitors, the yacht seemed to suffer from a longitudinal imbalance and had trouble sailing into the wind. The flotilla was again expanded by the addition of William P. Burton's fifteen-meter *Ostara*, a Mylne design produced by R. McAlister & Son in Dumbarton, near Glasgow, which increased the number of yachts in the series built in that year to six.

Left
Following the tradition of professional sailors a century ago, this crew member tacks the topsail on every maneuver. He must feel small standing in the clouds of sail.

Opposite
Around the world racing champion Grant Dalton sailed aboard *Tuiga* and was astonished by the flexibility of the hull as it worked through the waves.

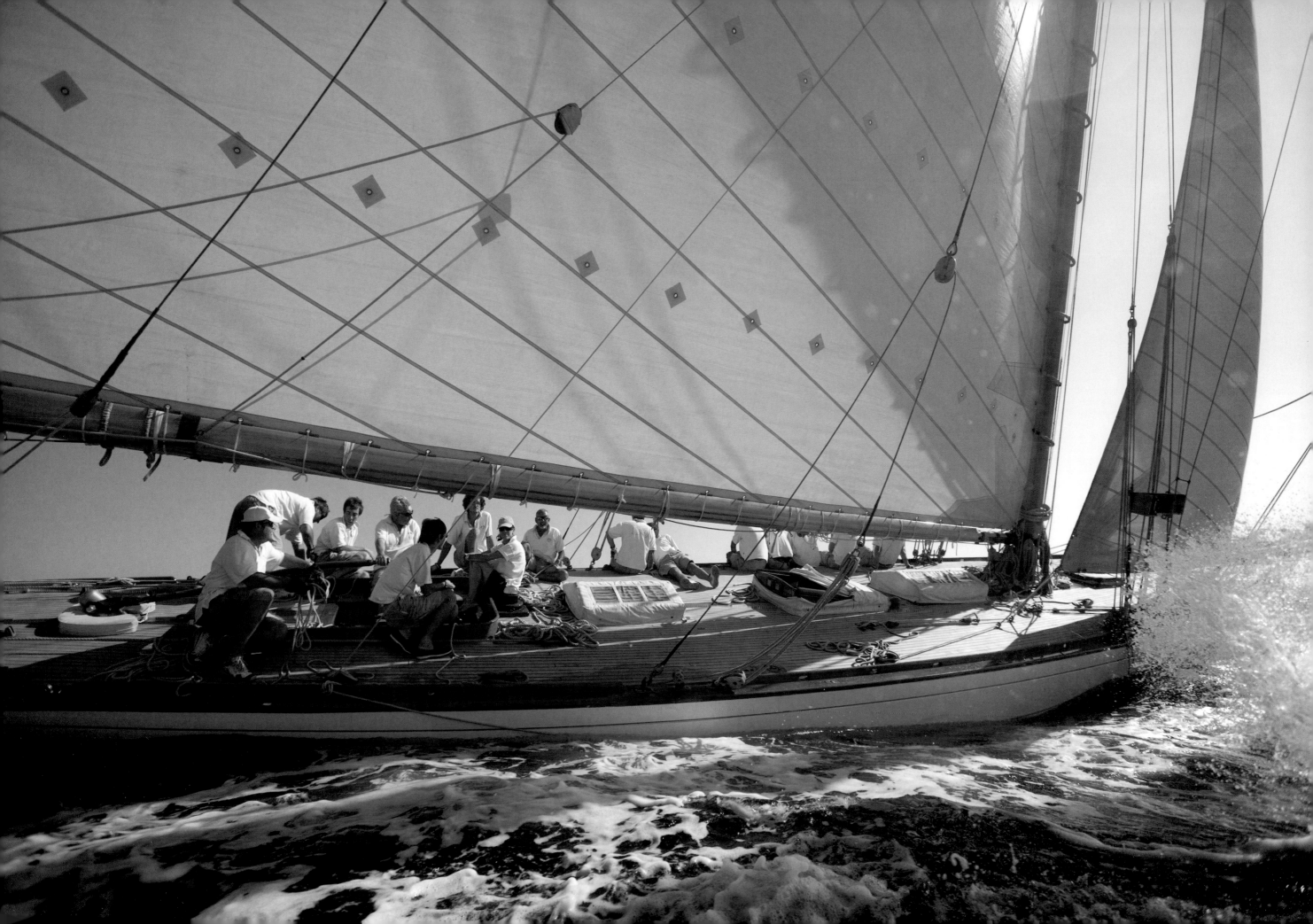

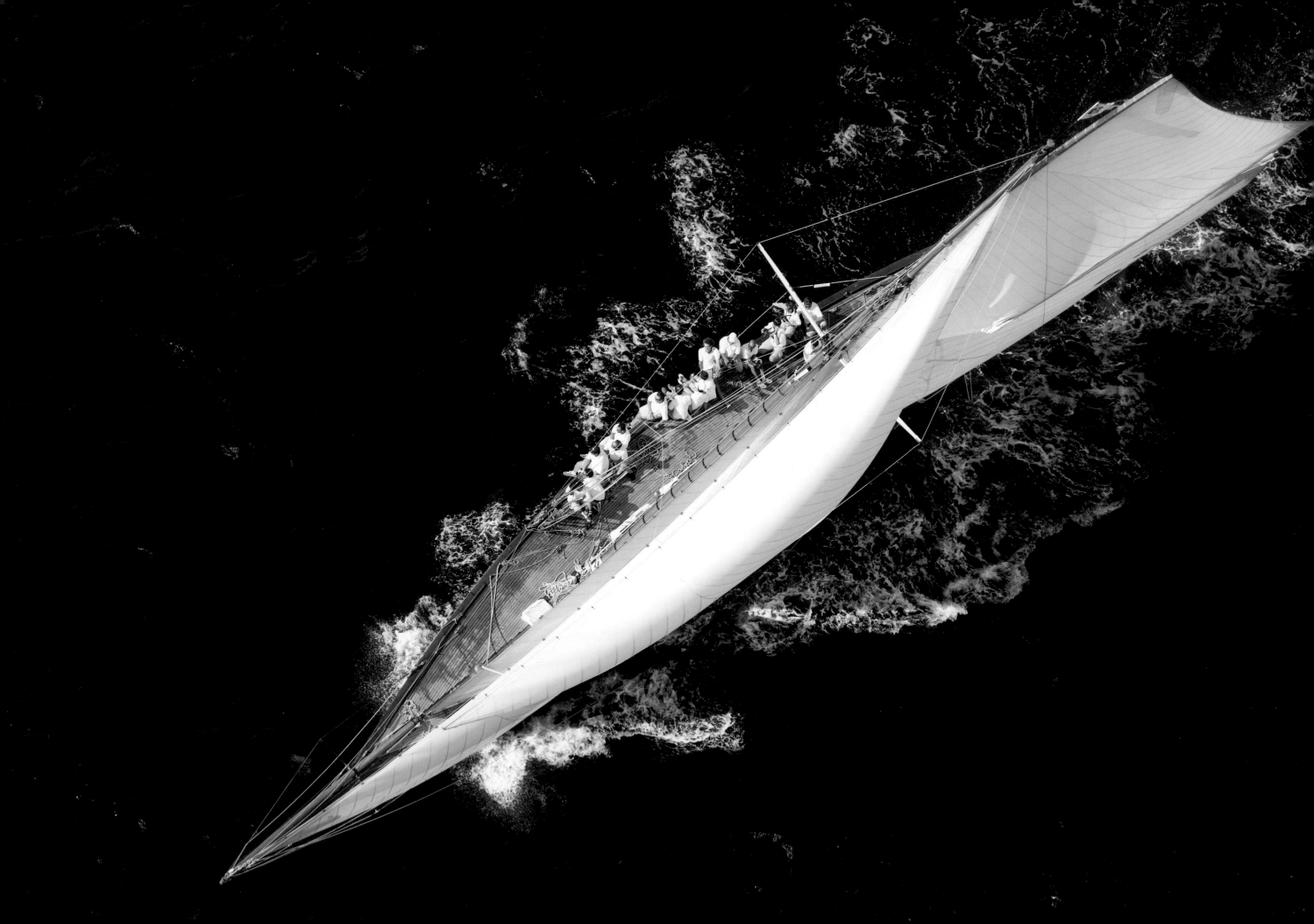

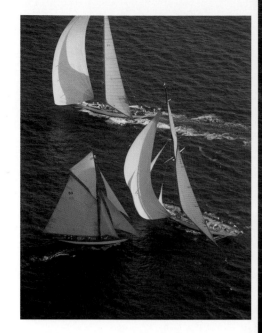

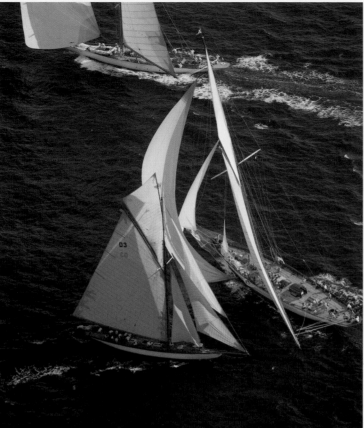

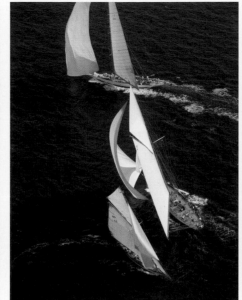

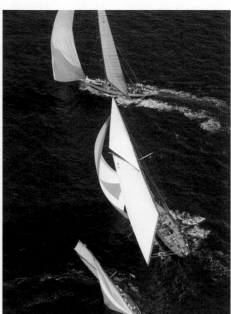

Above and Right
Lulworth, Cambria, and
Tuiga sail in close
proximity. *Tuiga*'s sails
are blanketed by *Cam-
bria*'s as she passes.
Helmsmen have to
anticipate maneuvers
well in advance of
any encounter.

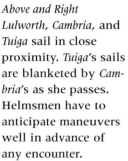

Opposite
Tuiga shows how
narrow her beam
is from this over-
head perspective.
There's not much
conversation
aboard the boat at
this moment.

For Cowes Week and the Clyde Regattas, *Tuiga* and *Hispania* sailed up the Solent. The three veterans, *Ma'oona*, the first fifteen-meter launched in 1907 by R. McAlister & Son for J. Talbot Clifton based on plans by Alfred Mylne; *Slec*; and *Mariska* confronted the four newcomers. *Ostara* beat her rivals with forty-nine first places, twenty-two seconds, and thirteen thirds. She was followed by *Vanity* and *Mariska*. *Tuiga* only had eight victories, the same number as her compatriot, *Hispania*.

The season ended with the Bilbao Nautical Week at which *Tuiga* won the trial, since *Hispania* had been detained in Madrid. *Encarnita*, only recently launched, did not measure up to the others and her mast broke. The results for the season proved the superiority of the two Scottish architects, Fife and Mylne.

The 1910 season saw the construction of three new fifteen-meter yachts. Mylne designed two, *Tritonia* for Graham C. Lomer and *Paula II* for German Ludwig Sanders, both built at R. McAlister & Son. The Fife boatyards produced *Sophie-Elizabeth* for Leopold Biermann, another German. In the English Channel and in Scotland, *Ostara* and *Vanity* were the victors once again, while the Spaniards stayed home, though not for good, because at the Bayonne-Biarritz Regattas held on July 30 and 31, they were greeted by a host of French supporters who welcomed King Alfonso XIII on board his *Hispania*, with Fife on board *Tuiga*. When the regattas were over, the monarch generously handed over the entirety of the prize money "to the poor of Biarritz," as reported by the French magazine *Le Yachtman* at the time.

In 1911, German architect Max Oertz designed the fifteen-meter *Senta* for the Duke of Saxe-Altenburg. The dominant proof for the class was the Commodore's International Challenge Cup, won by *Paula II*. So the cup left for Germany where it was up for grabs the following year. *Tuiga* did well, coming in second behind *Hispania* at the Ryde Festival on the Isle of Wight.

The 1912 season was enlivened by a small revolution. Two newcomers, both specially built in Great Britain to win back the Commodore Cup, would dominate the scene. These were *Lady Anne*, an entirely original Fife design, built for George Coast, and *Istria*, designed by Charles E. Nicholson for Charles C. Allom. *Istria*, which was meant to be the season's overall winner and would accomplish her mission, used new Marconi rigging. Her topmast was extended to the top of the sails. The gaff-topsail, the topmost sail, was laced to the mast rather than to a separate yard. Thus there were no longer two spars aloft, and the sail was better secured, especially when sailing into the wind. *Tuiga* ended the season in third place, in front of *Hispania*. Faced with the success of *Istria*, Nicholson was given command of two sailboats, *Pamela*, for S. Glen L. Bradley, and *Paula III*, for Ludwig Sanders. Fife completed his last fifteen-meter *Maudrey*, for W. Blatspiel Stamp using the same Marconi rigging as for *Istria*. Johan Anker, who had had a distinguished career with his twelve-meter class boats in Scandinavia, designed *Isabel-Alexandra* for German E. Luttrop. The three Mylne boats won victories on the Clyde, at Le Havre, and at Cowes, and *Paula III* won the cup in Germany.

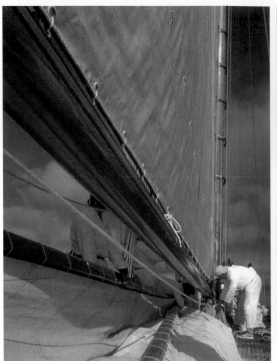

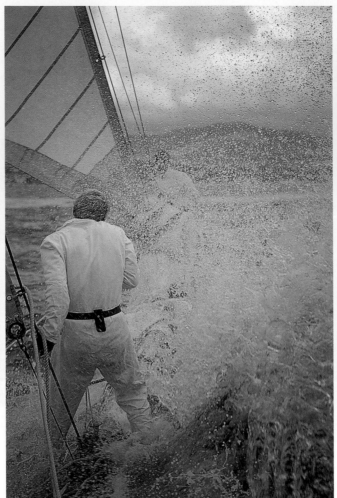
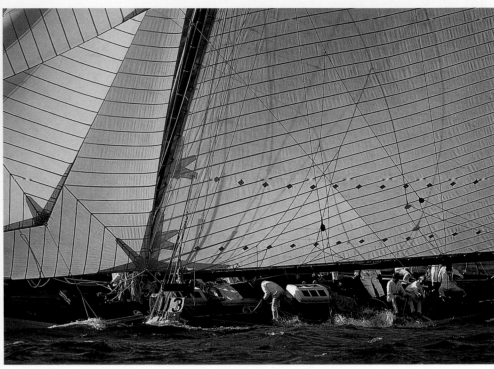

The End of the Fifteen-Meter Class

In 1914, only hours before the declaration of war, the British Admiralty confiscated every craft afloat in British territorial waters. *Isabel-Alexandra*, which had remained in Scandinavia, was bought by Norwegian O. Ditlev Simonsen. In the following year, *Paula III* was also sold to a Norwegian. Sweden and Norway, remaining neutral during World War I, developed their sailing skills by acquiring European racing yachts. *Hispania* was bought by a Norwegian in 1916, and *Tuiga* became the property of a Swede, J. Estlander. In 1917, about ten fifteen-meter boats were in Norwegian waters, and the twelve-meter regattas involved twenty or so boats. Anker designed the last fifteen-meter, *Neptune*, for a German.

In the following year, *Tuiga* was acquired by Norwegian Jac M. H. Linvig, who renamed her *Betty IV*. The last year in which the fifteen-meter class competed in regattas was 1920, at Tonsberg, near Oslo, from July 22 through 25. *Betty IV* came in third, behind *Magda X*, the former *Sophie-Elizabeth*, and *Isabel-Alexandra*. In 1923, three fifteen-meter boats took part in the Cowes regattas. During the regattas themselves, Linvig sold *Betty IV* to a fellow Norwegian, Henry Johansen, who only kept her for a season. John Sommerville Highfield, a member of the Royal Thames Yacht Club, became the new owner. He based his new sailboat in Cowes and named her *Dorina*. He fitted her with a Marconi mast and reduced her sail area. He invented his own system of runner tackle levers to replace the existing tackle and had electric lighting installed. Highfield sold *Dorina* in 1934 to J. Colin Newman. *Dorina* then became *Kismet III* and was given a 35 hp engine as well as new Bermuda rigging. In the following

year, Newman entered the yacht for the Fastnet race, a round-trip Plymouth-Fastnet course. Arriving first in Plymouth, *Kismet III* was handicapped by sixteen hours in favor of *Stormy Weather* as a smaller vessel, and found herself classed fourth due to compensation time. *Kismet III* spent each summer for thirty-four years moored beside one of the handsomest of stately Scottish homes, the Eilean Donan Castle, on the Kyle of Lochalsh, facing the Isle of Skye.

The former *Tuiga* never raced again. She was acquired by James B. Douglas in 1938 and returned to the Clyde. The Robertson & Sons boatyard added a roof to the yacht's deck and took care of her winter maintenance. In 1970, Ian Rose acquired *Tuiga* and gave her the aluminium mast from the twelve-meter *Sceptre*, renaming her *Nevada*. Rose had her ferried to the Mediterranean where he started a career as a charter yachtsman. She was then bought by a Greek based in Piraeus and subsequently sold to a young couple who planned to sail on a round-the-world trip. In 1989, Duncan Walker, the current manager of Fairlie Restorations, saw an advertisement in the sailing press and offered *Nevada* to Albert Obrist, the collector who had restored *Altaïr*, another legendary Fife design.

Tuiga was given back her original name and splendor after spending four years in the restoration yard. Like *Altaïr*, she was a pioneer of the revival of classic yachting. The Yacht Club de Monaco purchased the yacht in August 1995, and since then, *Tuiga* has been their pride and joy.

World champion sailor Paul Cayard lends a hand to Prince Albert aboard *Tuiga*. Cayard seems to relish the moment. The foredeck crew absorbs a lot of spray as they work to set their new sail.

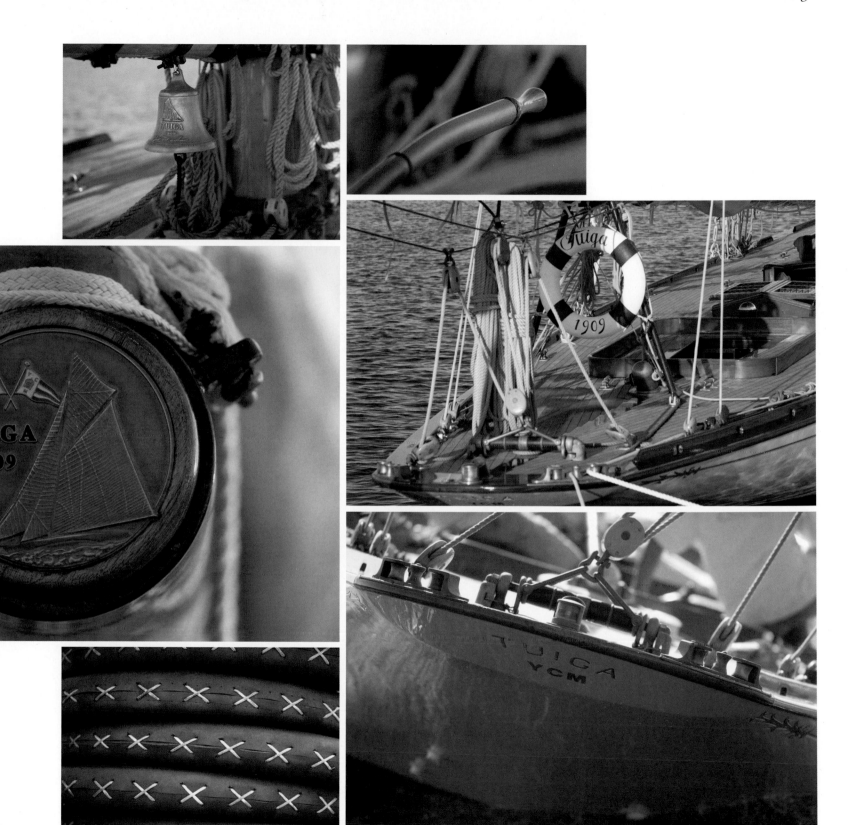

Details give class: the
ship's bell bearing her
name, the decorative
boom tip, the cross
stitches on the seams
of the spider hoops,
the coiled sheets, and
elegant fittings.

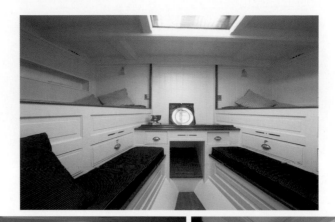

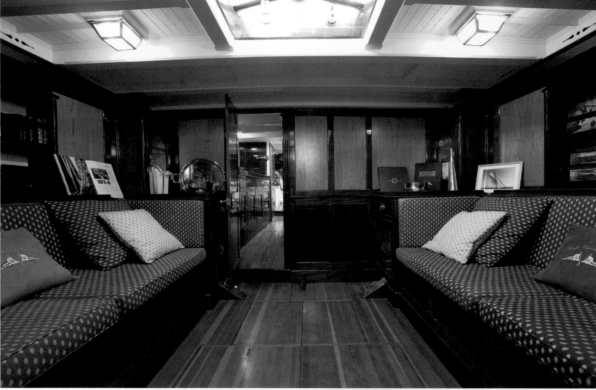

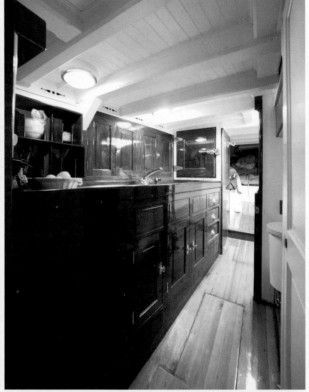

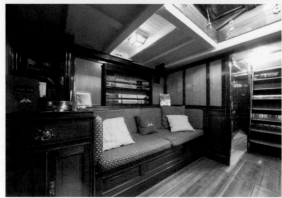

Above and Right
Woodwork in different shades, muted but *recherché*, and the detailing in expensive bronze are all inspired by other Fife designs of the same era.

Opposite
Like all yachts of the pre-World War I International Gauge, the *Tuiga* sits low in the water and has a variety of sails.

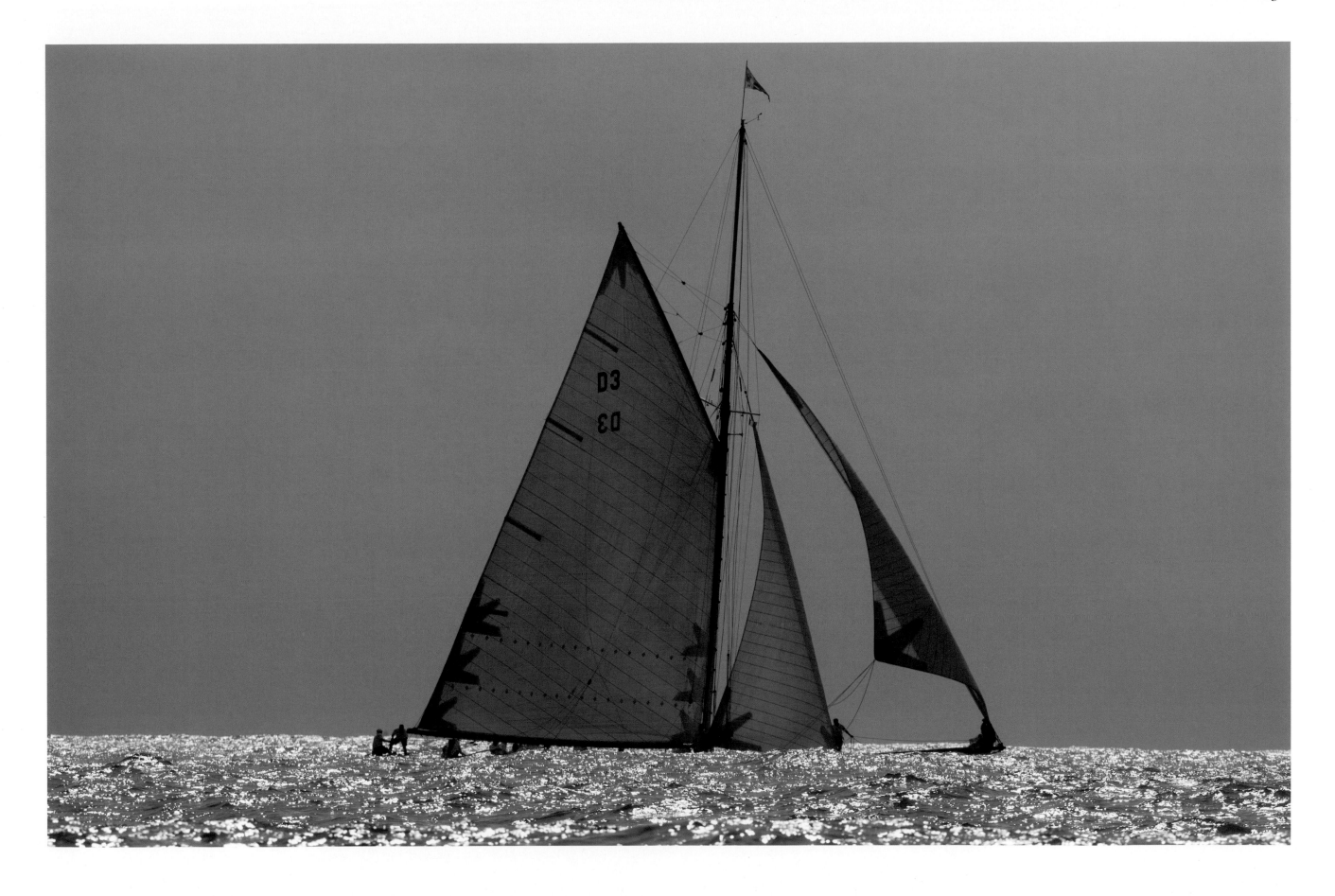

· FEATURES ·

Name: TUIGA
Architect: William Fife III
Builder: William Fife & Son, Fairlie
Rigging: gaff cutter
Type: fifteen-meter International Rule
Launched: 1909
First owner: Duke of Medinaceli
Other names: BETTY IV, DORINA, KISMET III, NEVADA
Restoration: 1993
Boatyards (restoration): Fairlie Restorations, Hamble
Construction: composite, elm planking on steel ribs

Overall length: 91 feet 10 inches [28 m]
Deck length: 76 feet 1 inch [23.18 m]
Length at waterline: 49 feet 2 inches [14.98 m]
Maximum beam: 13 feet 7 inches [4.15 m]
Draft: 9 feet 5 inches [2.87 m]
Ballast: 20 tons
Displacement: 39 tons
Approximate sail area: 1,379 square feet [414 m²]

· DECK PLAN ·

PORT

TILLER COCKPIT STAIRWAY SKYLIGHT PIN RAIL FORWARD STAIRWAY BOWSPRIT

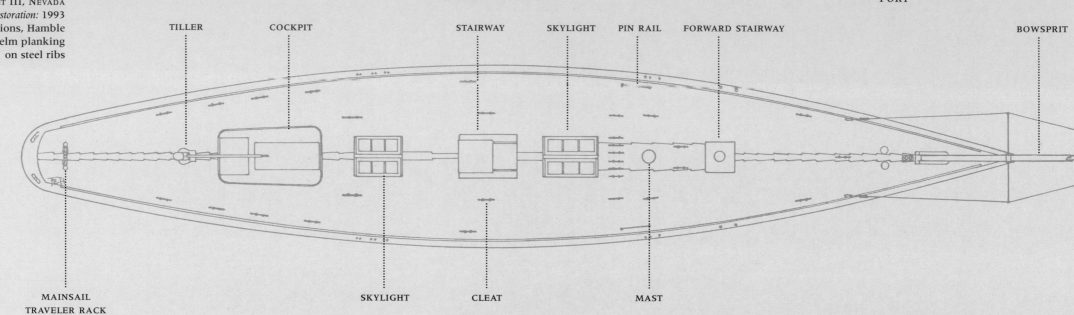

MAINSAIL TRAVELER RACK SKYLIGHT CLEAT MAST

STARBOARD

· LAYOUT ·

CHART TABLE HEAD SALOON GALLEY

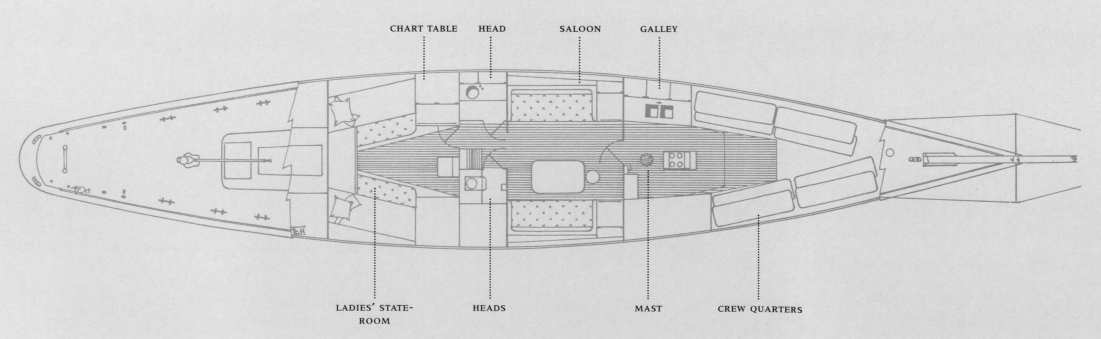

LADIES' STATE-ROOM HEADS MAST CREW QUARTERS

·CROSS SECTION

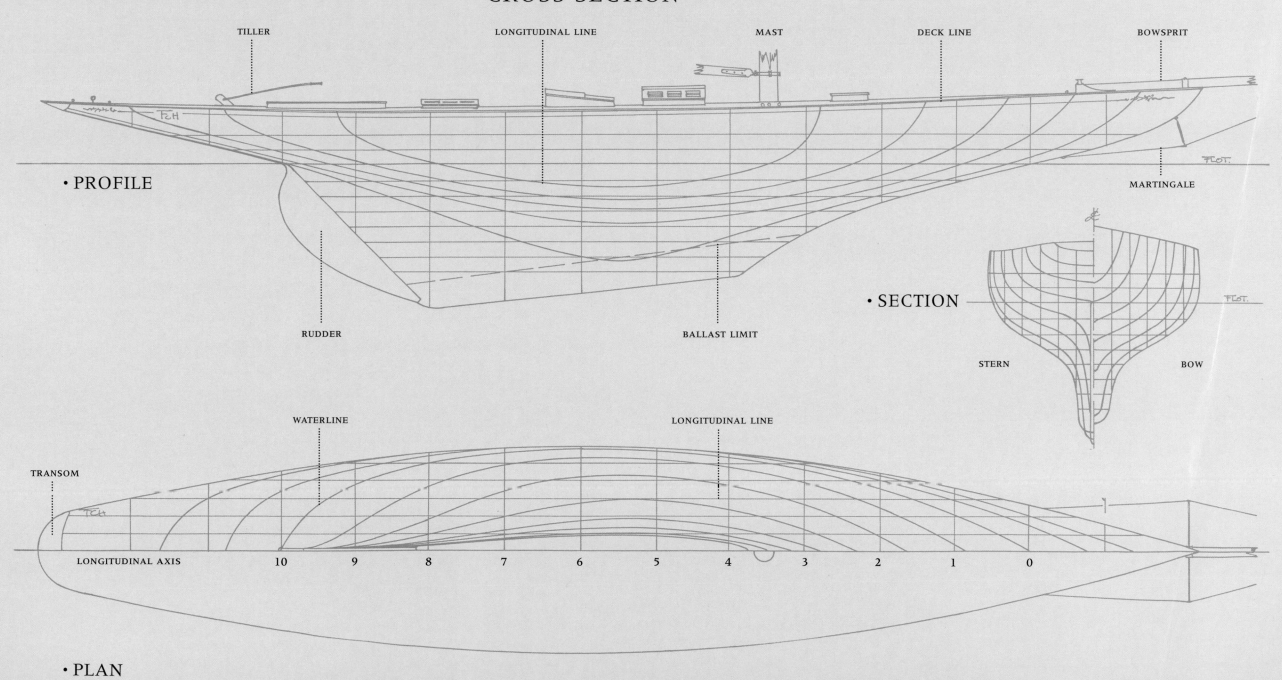

·PROFILE

TILLER

LONGITUDINAL LINE

MAST

DECK LINE

BOWSPRIT

MARTINGALE

·SECTION

RUDDER

BALLAST LIMIT

STERN

BOW

TRANSOM

WATERLINE

LONGITUDINAL LINE

LONGITUDINAL AXIS 10 9 8 7 6 5 4 3 2 1 0

·PLAN

• Zaca •

It's impossible to discuss the schooner *Zaca* without mentioning Errol Flynn, who owned her for thirteen years. In his memoirs *My Wicked, Wicked Ways*, the movie star describes how he sailed through a tropical storm in the Caribbean: "I never heard the wind blow so violently. *Zaca*'s prow dipped, plunging into the green water, and, I don't know how, we plowed through the next breaker, as high as a mountain. We were sailing on the edge of a tropical storm, the sky was as black as the sea." Flynn was no novice. He had been sailing since childhood and had covered thousands of miles in *Zaca*, his magnificent 120-foot (36-m) schooner. Made famous for having been the scene of Flynn's escapades in the 1950s, the yacht had a whole other life before it was fodder for gossip columnists.

Zaca was inspired by the schooners of Nova Scotia, especially *Bluenose*, rebuilt in 1963 in the same boatyard at Lunenburg.

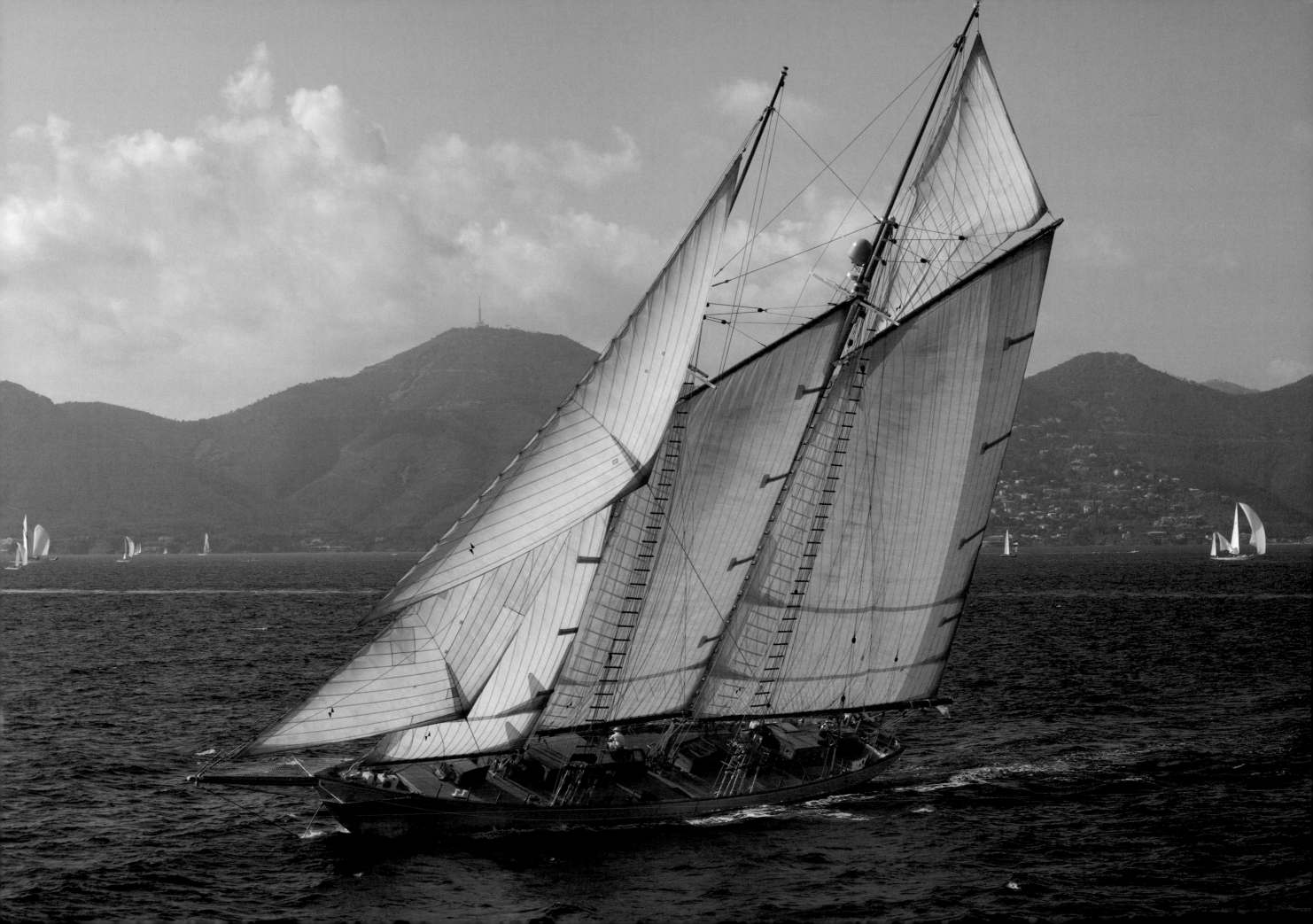

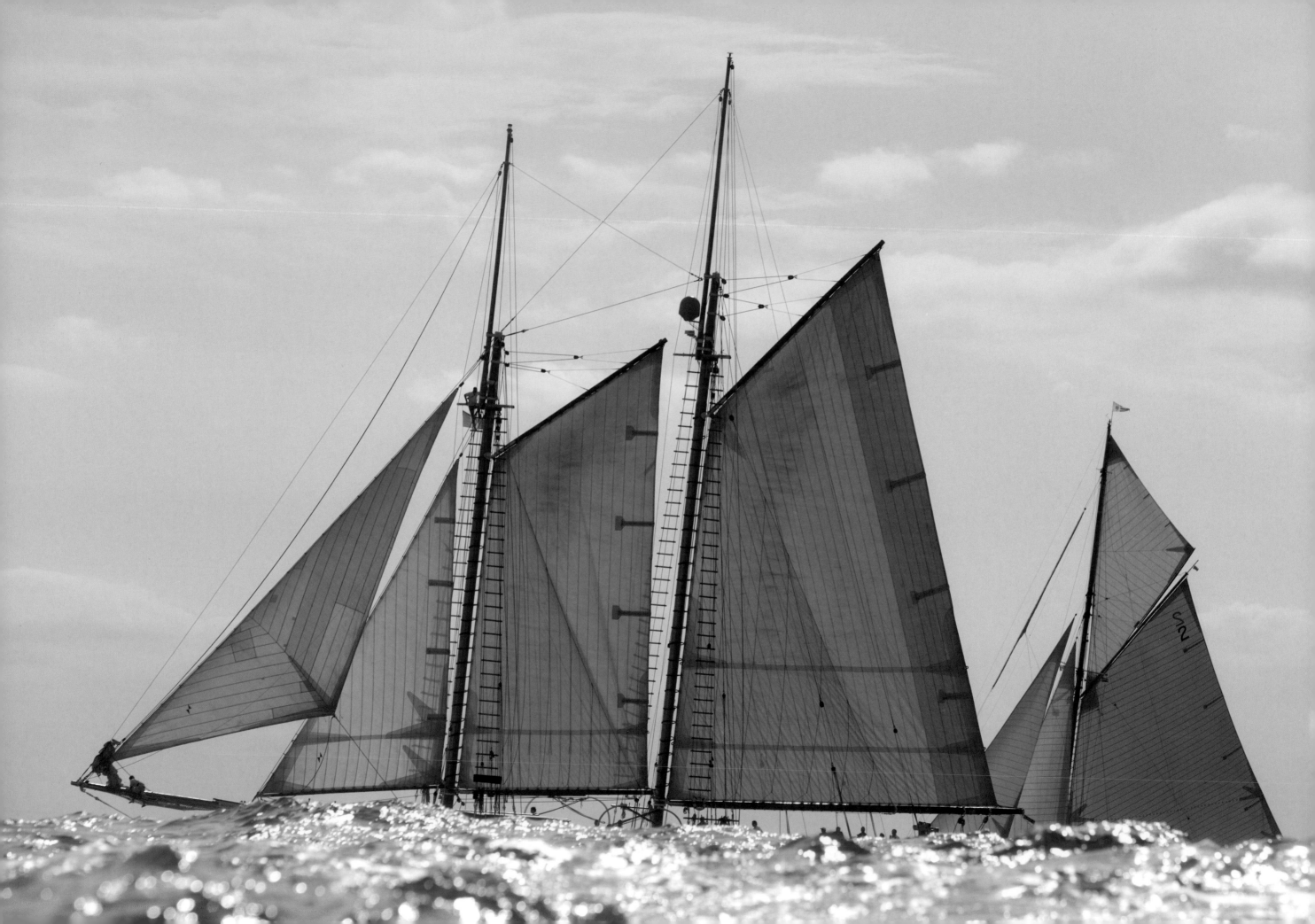

It happened in 1929, the worst year for the world of finance. While in Wall Street bankers were throwing themselves out of windows, in San Francisco, millionaire Charles Templeton Crocker (1884–1948) seemed to have been not the slightest bit affected by the catastrophe that had shaken his fellow Americans. In August, he ordered a big schooner in which to comfortably sail the seven seas.

Zaca, which means "peace" in the Native American Chumash dialect, designed by the architect Garland Rotch, was built in a boatyard in Sausalito on the San Francisco Bay, at the Nuñes Brothers boatyard. The yacht was very much inspired by the 146-foot (43.60-m) fishing schooner *Bluenose* designed by W. J. Roue and launched at Lunenburg, Nova Scotia in 1921, though she was far more luxuriously fitted out. The finest woods were used in her construction, oak for the double ribs, Oregon pine for the planking and deck beams, and teak for the decking. The deck fixtures and fittings were the finest and most modern then available. Nichrome, a rustproof metal alloy, was employed for all the metal fittings. Frigidaire specially made the refrigerator, freezer, and ice machine. The hot and cold running water was pressurized. At Crocker's special request, since he did not want to hear any noise in his stateroom, the two Diesel Hill six-cylinder, 120 hp engines, turning at 800 rpm, were installed forward of the saloon, beneath the dining room. The 50-foot (15-m) transmission shafts were made to measure. Ignition was provided by electrically operated compressed air pumps. The electricity supply came from four five-kW generators. High-pressure pumps on deck were used as fire extinguishers, while the staterooms, saloon, dining room, and machine rooms were equipped with automatic carbon monoxide extinguishers. The saloon and dining room were paneled in Moroccan leather, and the chart table included a shortwave transmission apparatus with a range of 11,400 miles, the antennae being attached to each masthead.

On deck, the windlass, capstan, and double winches for the halyards were controlled by separate motors, so that only three men were needed to hoist the sails. All of the sails—those for everyday use, those for high winds, and those for when there was little wind—covered an area of more than 17,222 square feet (1,600 m²) and were cut from genuine Egyptian cotton. The tenders were fitted with a 20-foot (6-m) motorized punt, a skiff, a rowboat, a small canoe, and Chris-Craft outboard motors that could reach a speed of more than 30 knots. To build *Zaca*, Manuel Nuñes, a Portuguese native of the Azores, used the finest ships' carpenters and craftsmen in California. The total cost of the yacht was $350,000, a huge sum for those days, especially in that year of financial crisis.

The Inaugural Voyage

On April 12, 1930, *Zaca* was named by the actress Marie Dressler and described as, "Best Yacht on the Pacific Coast" by *Pacific Sportsman* magazine. On June 7, the schooner sailed beneath the Golden Gate Bridge bound for the Marquesas, her first stop on a world tour. In addition to the owner, his valet,

The idea of reconstructing *Bluenose* was born when a replica of the *HMS Bounty* was built in Lunenburg for the film *Mutiny on the Bounty*. In his first major movie role, Errol Flynn played Fletcher Christian, an ancestor of his aunt Ethel Christian, the man who fomented the famous mutiny.

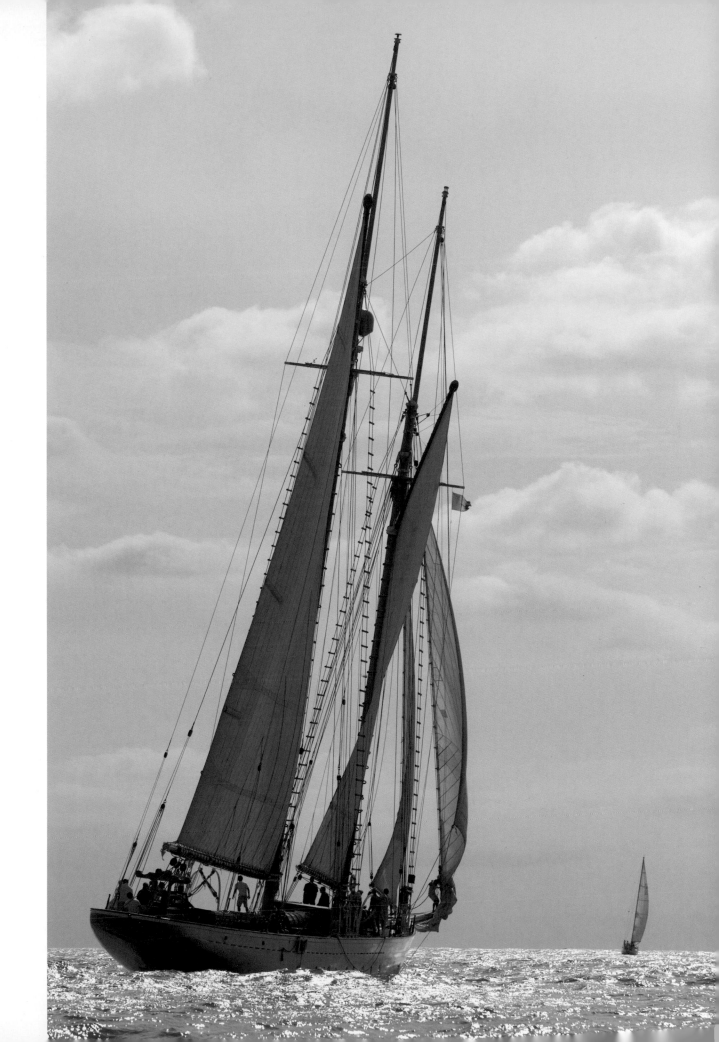

his personal physician, a friend, and the architect, there was a crew of ten sailors on board. A library containing three hundred titles and 150 phonograph records was also taken on board. As soon as the speed under sail dropped to below five knots, the engines were brought into play, and this initial, 3,000-mile crossing was completed in less than twenty days. From Nuku-Hiva, *Zaca* visited French Polynesia, then the Cook Islands, Fiji, Vanuatu, and Papua-New Guinea. Crocker, a graduate of Yale, was deeply interested in the way of life of the peoples of these islands and, delighted with his discoveries, began a collection of objects that he sent to the San Francisco museum. After passing through the Torres Straits, the schooner made a series of stops in Indonesia before reaching Singapore. They celebrated the New Year in the Malacca Straits, en route to Sri Lanka. After a brief stopover in Aden and Port Sudan, the yacht entered the Suez Canal. A sudden Meltemi wind arose south of Crete. *Zaca* was making thirteen knots in full sail, when the motorized whaler went overboard with its davits. The crew managed to haul down some of the sail, getting extremely wet in the process. Once they reached Malta, where the whole of the British Mediterranean fleet had assembled to greet the yacht, *Zaca* was put into dry dock, and all of the black paint on the hull was renewed. Crocker and his friends were invited aboard *Queen Elizabeth* for a reception, and attended another on board the aircraft carrier, *HMS Glorious*. *Zaca* reached Cannes on March 7, 1931, overtaking the schooner *Ailée* owned by Virginie Hériot, and was awarded a commemorative plaque by the Cannes Yacht Club. Leaving port with her flag flying from the masthead, extended along her whole 100 feet (30 m), the boat passed through the Straits of Gibraltar and out into the Atlantic Ocean. Crocker was less pleased with the next stage of his voyage, because he suffered from seasickness and had to spend quite a lot of time in his bunk.

Between Tenerife and Puerto Rico, a distance of some 3,000 miles, *Zaca* was engine-powered for more than fourteen of the seventeen-day journey. The schooner finally returned to San Francisco on the morning of May 27, 1931, having covered 27,490 miles at an average speed of 6.5 knots. Of the 351 days of the trip, half had been spent in dock and the yacht had been engine-powered for three-quarters of her time at sea.

From Zoology to the Navy

During the trip, Crocker discovered a passion for the study of marine life. He converted *Zaca* into an oceanic research vessel, building a laboratory, aquariums, and a 33-foot (10-m) movable footbridge suspended from the masts, which could be stowed vertically to the bulwarks, as well as a crane that could be lowered from the tip of the bowsprit. Surrounded by the finest scientific minds, Crocker organized expeditions to find rare specimens in the silent world. From the Galapagos, one of whose peaks has since been named for him, he brought back 311 species of fish, an albatross with a wingspan of more than thirteen feet (4 m), and about four thousand plants for the California Academy of Sciences. *Zaca* continued to sail through the Pacific, from

Left
Apparently, Flynn's mother was a descendant of another of *Bounty*'s mutineers, Edward Young, a cadet, who found refuge on Pitcairn Island.

Opposite
Fletcher Christian's sword had always remained in Flynn's family as a trophy.

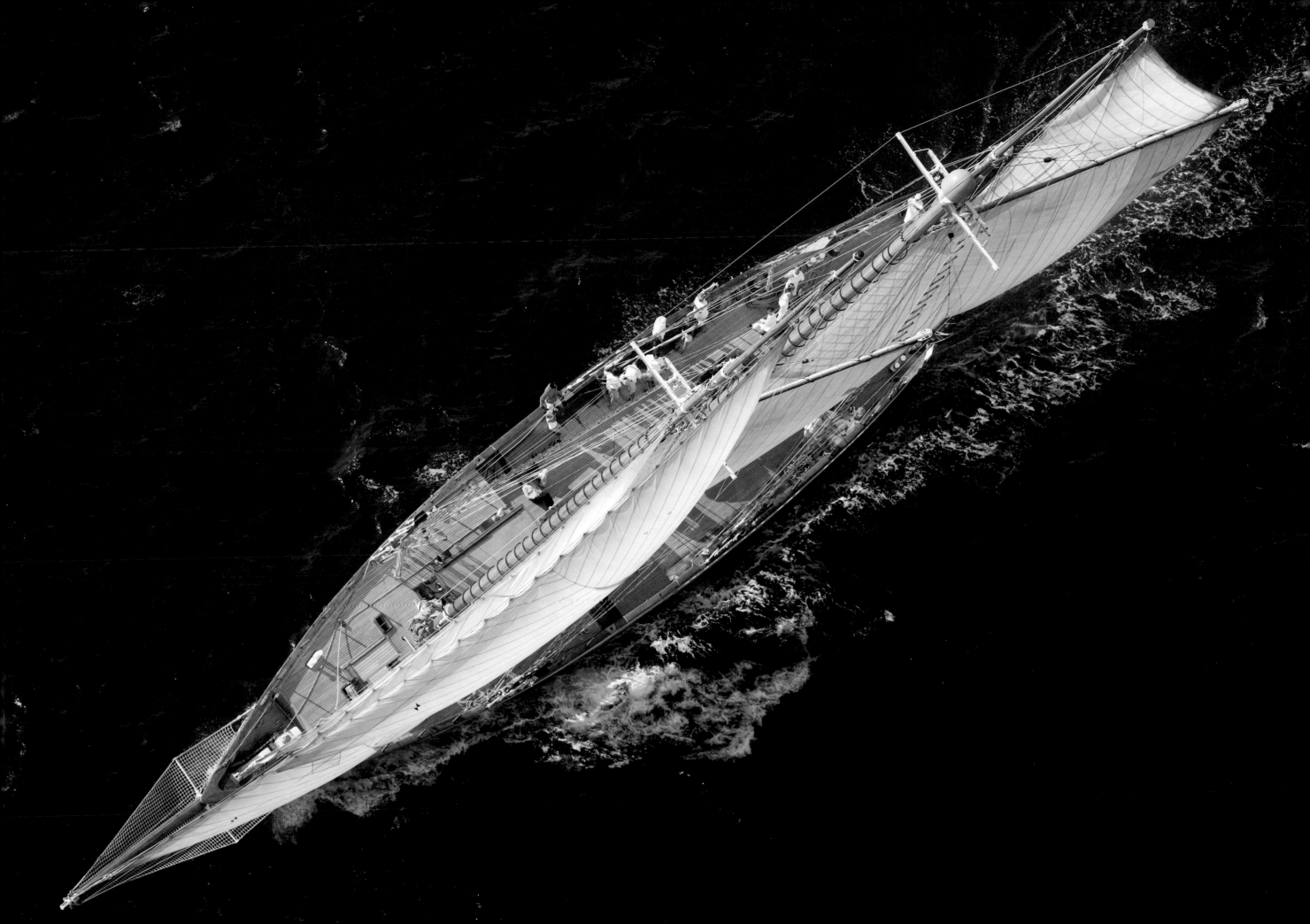

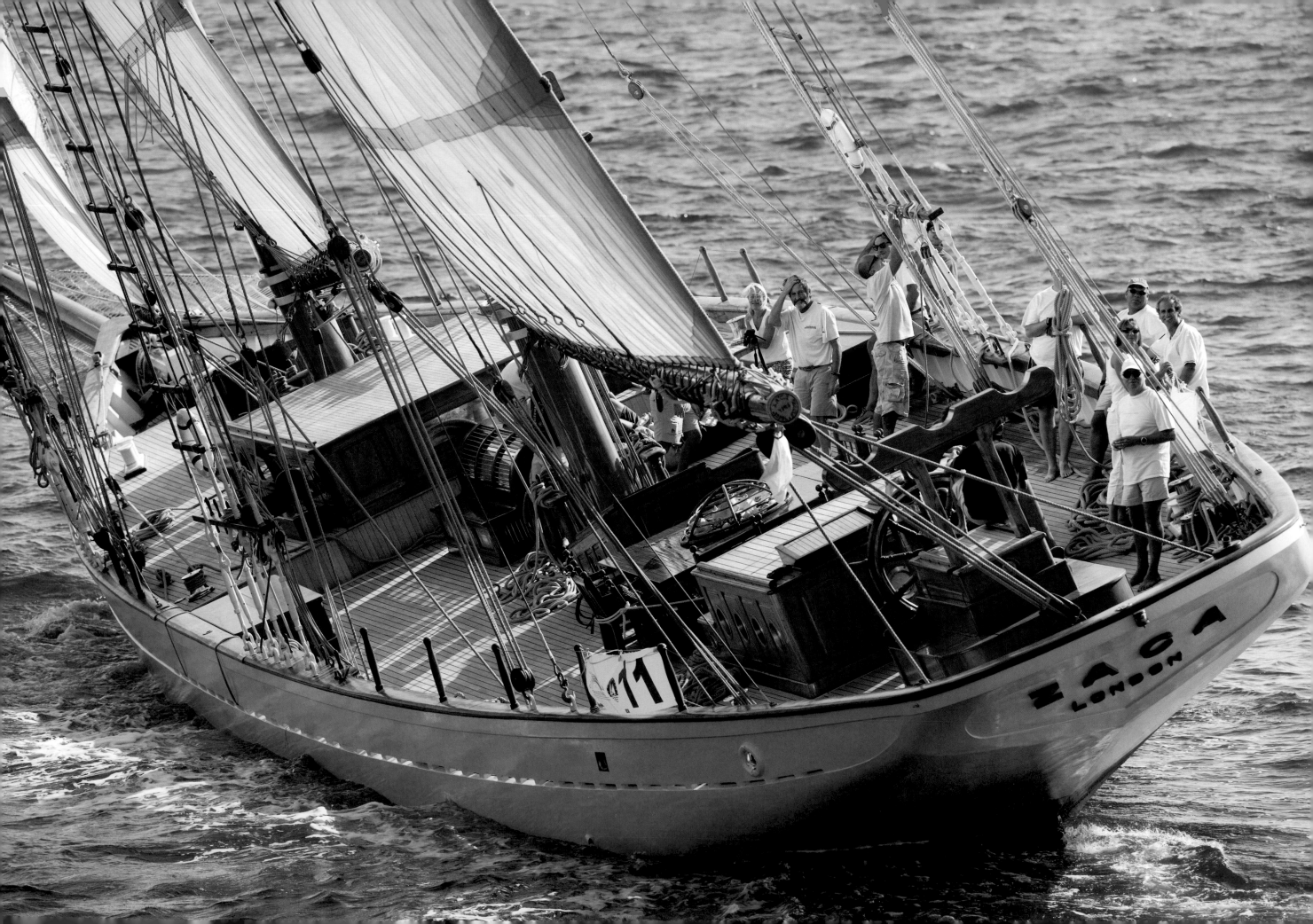

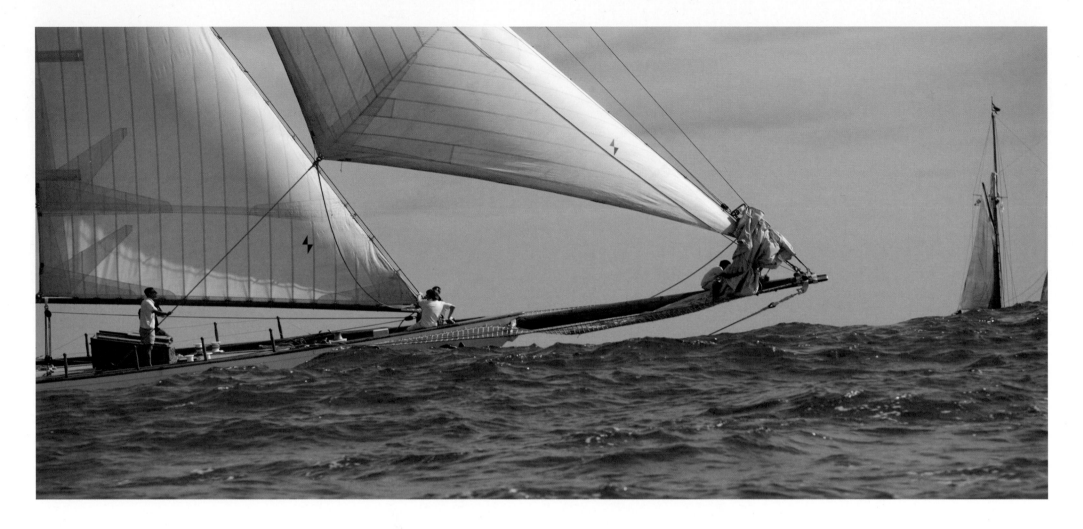

Above
Flynn used his charm to
break into Hollywood
films where he took over
for another actor in the
pirate movie *Captain Blood*.
"A real bombshell!" is how
producer Jack Warner
described him.

Opposite
Flynn's first movie part
was *In the Wake of the Bounty*,
shot in Sydney, and edited
with documentary images
filmed in Tahiti and on Pit-
cairn Island.

Easter Island to the Solomon Islands, contributing richly to the collection of
the Academy of Sciences in San Francisco until 1940. Like seventeenth-
century explorers, Crocker had a painter and illustrator on board for whom
he provided photographic materials and an underwater camera, making him
a precursor of the French marine biologist, Jacques Cousteau. One of his
expeditions was the subject of a work by the biologist William Beebe, director
of the Tropical Research Department and published under the auspices of the
New York Zoological Society in 1938. The schooner spent two months in the
Gulf of California at the end of which Beebe and his team produced no fewer
than sixteen papers in zoological society journals.

World War II ended the schooner's charitable activities. The U.S. Navy was
looking for boats for local patrols and rescues at sea, and Crocker handed over
Zaca on June 12, 1942 for the sum of $40,000. Eight days later, the schooner,
painted gray and marked with the number IX-73, was assigned to the West-
ern Sea Frontier as a plane-guard ship for rescuing aircrews who had bailed
out into the sea. The yacht patroled San Francisco Bay, equipped with 20-mm
machine guns and a crew of thirty-five sailors. She was relieved from duty on
October 6, 1944, and moored at Treasure Island, the naval base facing Alca-
traz between San Francisco and Oakland, and was put up for sale by the U.S.
military administration in May 1945 for $30,000.

Zaca *and the Star*

A whole different life began for the vessel in 1946 when movie actor Errol
Flynn (1909–1959) discovered the yacht for sale in a sailing magazine. The
Hollywood star was a keen yachtsman with former careers as an explorer,
gold prospector, tobacco grower, and a seller of labor in Papua New Guinea.
He was an Australian, a sportsman, and an amateur boxer, whose acting career
began in 1932 when he played the chief mutineer in the film *In the Wake of
the Bounty*, an Australian documentary about the famous mutiny on the *HMS
Bounty*. Two years later, he was an instant hit in the starring role of the pirate
film *Captain Blood*. Over a twelve-year period, Flynn made thirty or so movies
in which he always played romantic, heroic swashbucklers. He excelled in
pirate and cloak-and-dagger parts, such as Captain Blood and Robin Hood.

At the age of twenty, Flynn became the owner of an Australian cutter and
then a ketch. He acquired *Zaca* in 1946, investing $80,000 in her restoration.
At the time he claimed, "I want *Zaca* to be the symbol of everything I stand
for." He installed new masts, overhauled the structure, and changed her inte-
rior, adding a projection room, comfortable sofas, and a huge bed with a mir-
ror on the ceiling.

On her first excursion, the schooner hugged the Mexican coastline and
resumed her earlier vocation as an oceanographic research vessel. Flynn's fa-
ther, Theodore Flynn, was an eminent professor of marine biology, and, with

Page 196–197
At twenty, Flynn
acquired his first yacht,
Sirocco, an Australian
cutter from 1881. In
1936, Flynn bought
the ketch from John
Alden, which had had
many names: *Kerenita*,
Simoon, *Watchuett II*, and
Avenir. She kept the
name *Sirocco* until 1942.

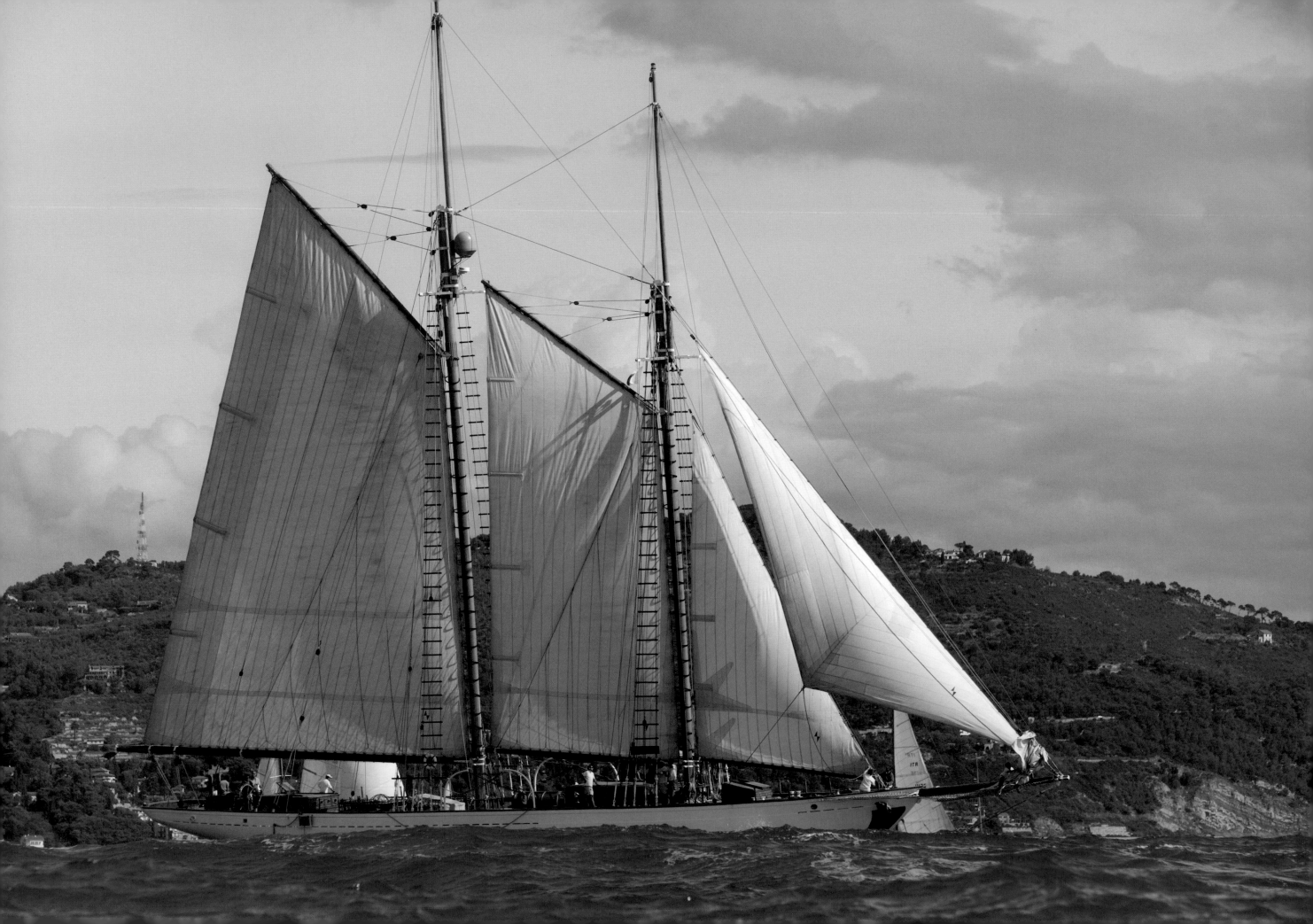

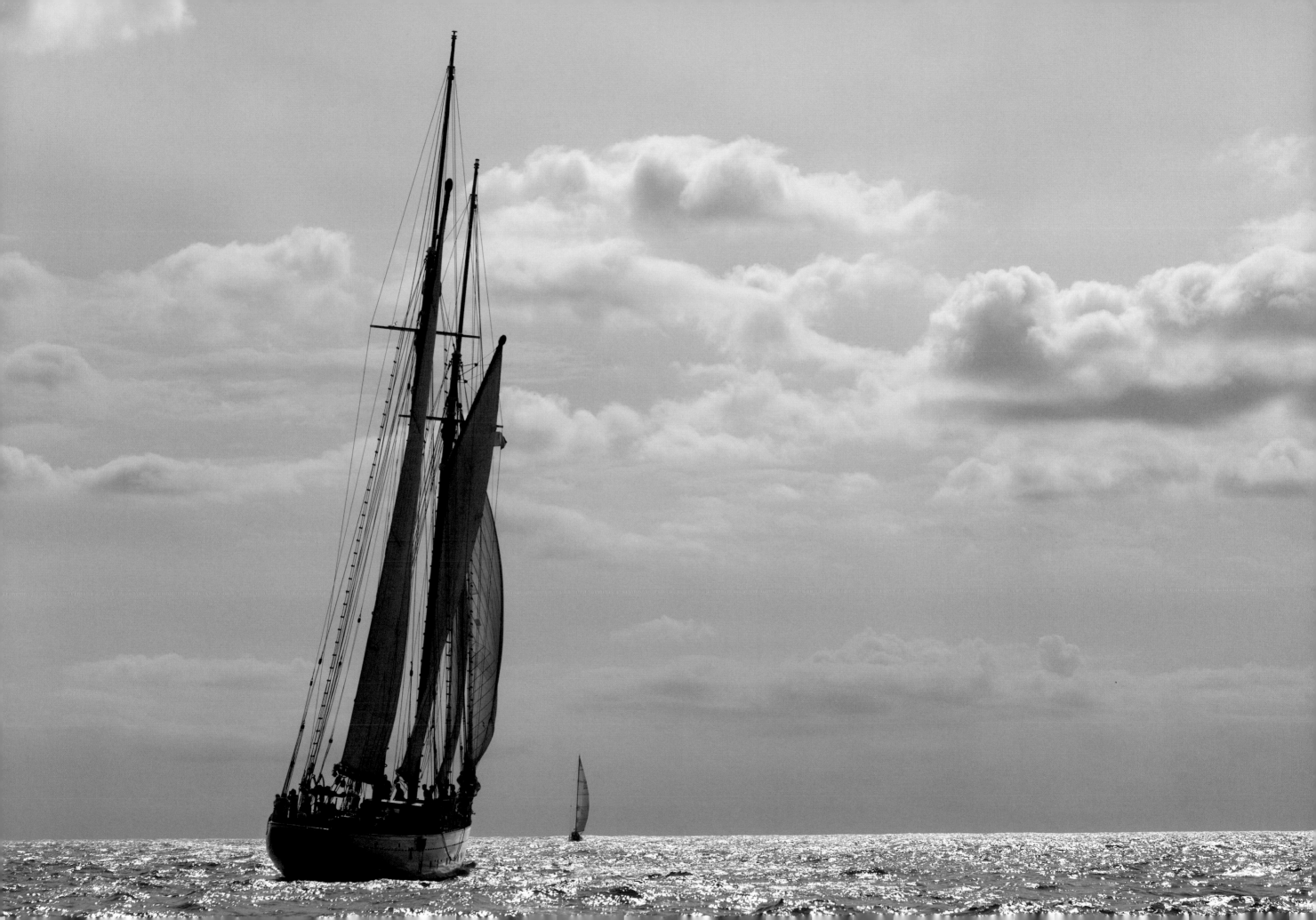

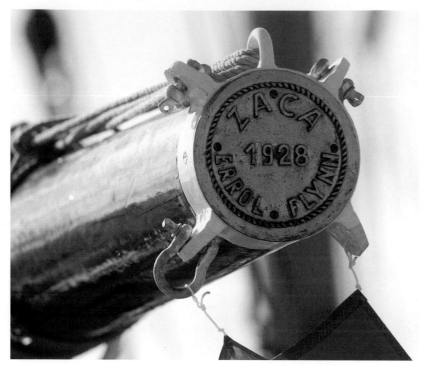

Above
On the first day's filming of Orson Welles's *The Lady from Shanghai*, starring Rita Hayworth, a cameraman died of a heart attack on board. Flynn demanded that the body be buried at sea, according to tradition.

his son, discovered two new species of fish, including *Gibbonsia norea* named for Flynn's second wife, Nora Eddington (1924–2001).

From then on, the fate of *Zaca* was linked to the movies and the excesses of her new owner. There are rumors that Flynn used the boat for smuggling gold and arms in South America and that Eva Perón almost abandoned politics for his charms. One thing is certain: in 1947 the yacht was the location for filming *The Lady from Shanghai*, with Rita Hayworth and her husband Orson Welles. Flynn insisted on skippering the boat during filming, and he can even be seen in the background in one scene. The yacht was also used in the movie *The Treasure of Yucatan* and in a short entitled *Cruise of the Zaca*.

Flynn's honeymoon with his third wife, Patrice Wymore, was particularly eventful. Flynn was accused of the statutory rape of a seventeen-year-old in the shower of his stateroom. The whole courtroom visited the site of the alleged attack and noticed how small the shower was. The star was acquitted. When Flynn sailed to Monaco in 1951 to make *The Adventures of Captain Fabian*, the Voisin boatyard in Villefranche-sur-Mer did some minor work on *Zaca*. Bernard Voisin, owner of the boatyard, recalls: "We were never paid, he just offered us rum. For the last scene, Errol Flynn was too drunk to play the part and I acted as his double."

Shipwreck and Rebirth

In 1952, Flynn decided to live on board his schooner in Palma de Majorca, leading a busy and luxurious lifestyle visiting casinos and palaces. Worn out by alcohol, drugs, and sickness, the actor continued to make the movies for which he became famous, such as Henry King's *The Sun Also Rises* and *The*

Roots of Heaven directed by John Huston. But in 1959, Flynn's financial situation was dire. In October, he traveled to Vancouver, to arrange the sale of *Zaca* to Canadian millionaire George Caldough, who was offering him $150,000 for vessel. Flynn died of a heart attack before he had signed the deal, and thus *Zaca* was abandoned in Palma until 1965. An Englishman bought her for $40,000 and had her sent to the south of France.

The yacht was in a pitiful condition when she was finally towed to Villefranche-sur-Mer. The owner cancelled the sale and the vessel was handed over to Voisin. Two years later, Voisin bought her from Flynn's widow, Patrice Wymore, for the symbolic sum of $5,000. He was so fond of the yacht and so obsessed with her that he requested an exorcism ceremony, which was held at the Monaco Cathedral in 1979. But Voisin never had the means to maintain or restore the yacht. Philippe Coussins bought the Voisin boatyard in December 1988, and *Zaca* was abandoned and left to rot in the port of Beaulieu.

In 1990, businessman Roberto Memmo fell in love with the sunken schooner and fought to acquire her. The vogue for restoring classic yachts had begun and prices were rising. He purchased the wreck for the sum of 100,000 euros, and sent her to a boatyard at Saint-Mandrier-sur-Mer, close to the southern French city of Toulon. For two years, fifty carpenters and specialist craftsmen worked on restoring the hull, deck, and rigging. Plans of the interior were assigned to the same firm of architects who had restored *Zaca* in 1946.

To celebrate her rebirth, *Zaca* was renamed on September 22, 1994, and her home port became Monaco. Since 1999, her skipper, Bruno Diaz Piaz, has ensured that the schooner, today considered a gem of American history, is kept in tip-top condition and does not acquire so much as a wrinkle.

Opposite
Kneeling on the boom, the crewman folds the mizzen as it is hauled down.

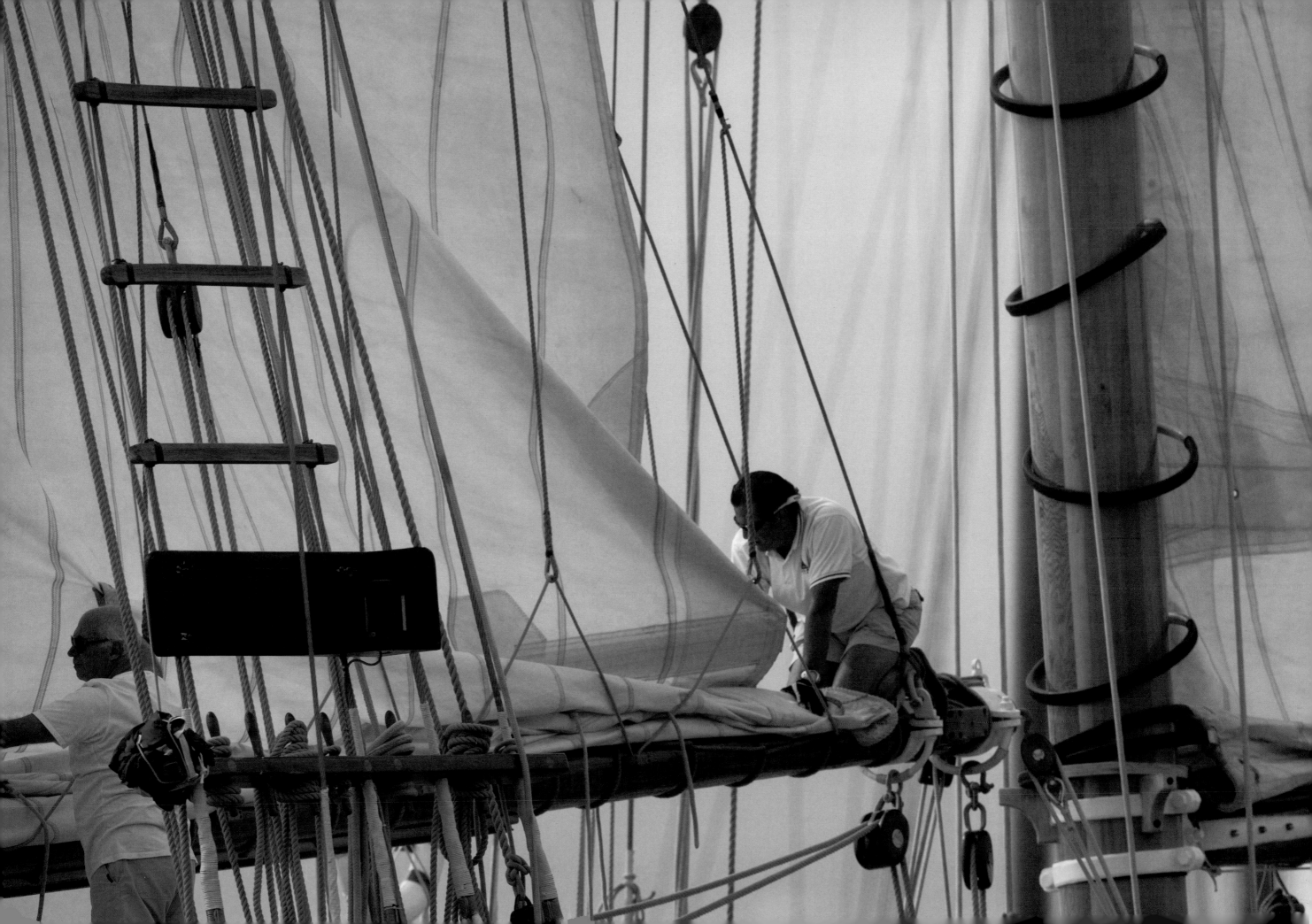

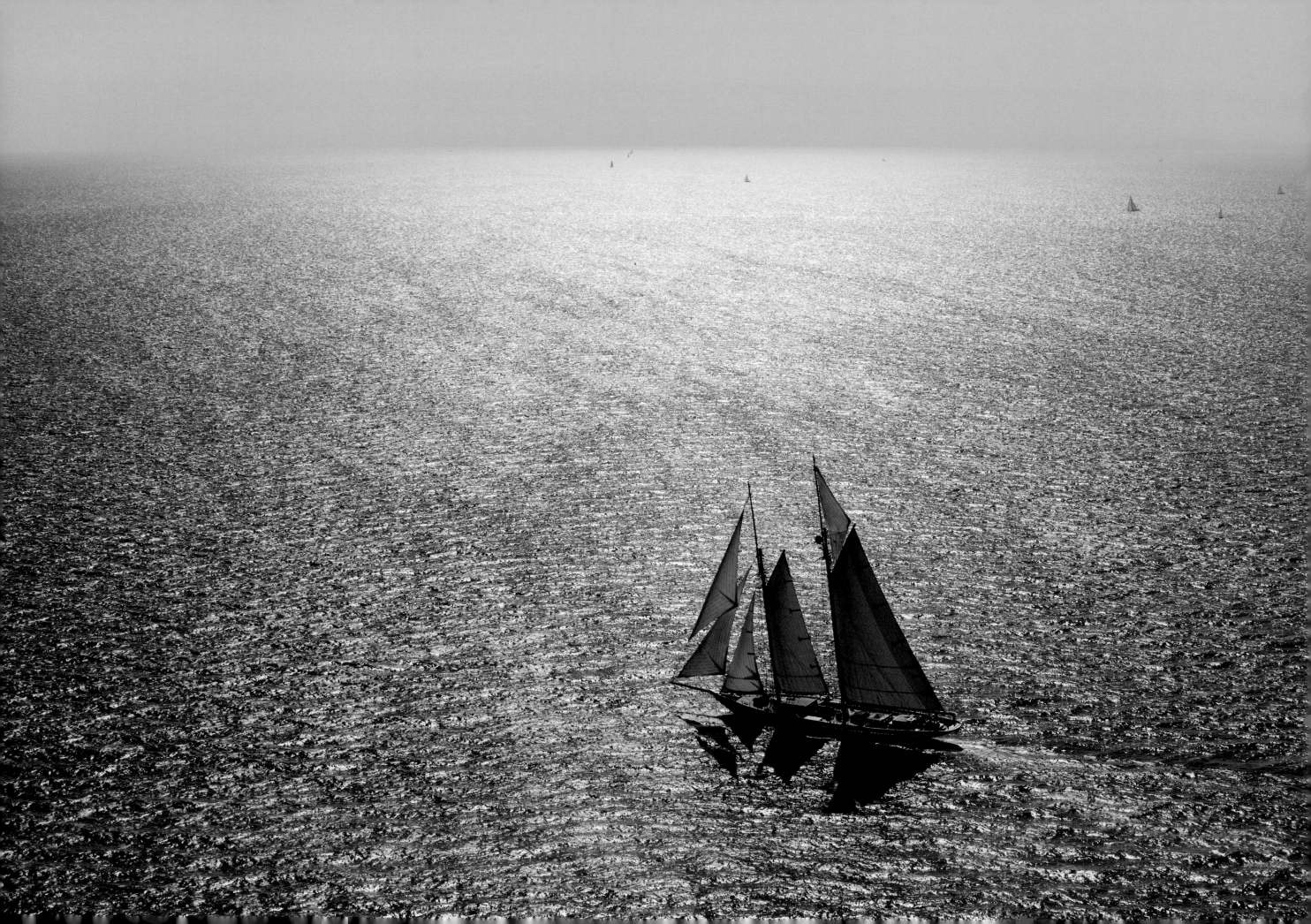

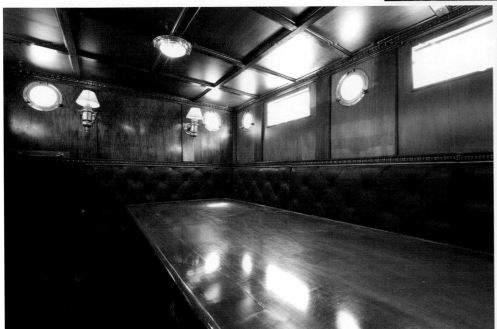

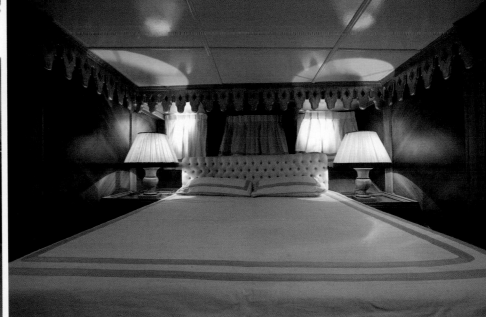

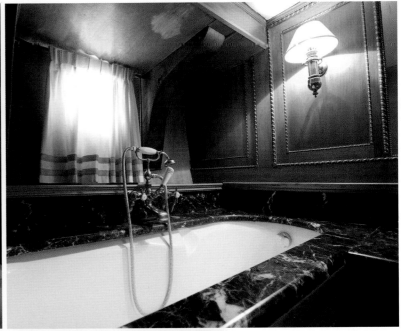

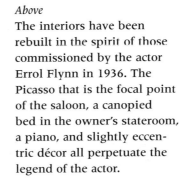

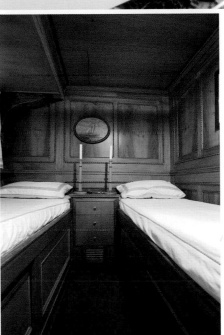

Opposite
The best thing about sailing is the freedom gained by moving away from land. *Zaca* looks alive and graceful sailing to windward on the open sea. The shadows provide a magnificent backdrop to the sails trimmed to perfection. *Zaca* is one of the few surviving great yachts built on the Pacific coast in the early twentieth century.

Above
The interiors have been rebuilt in the spirit of those commissioned by the actor Errol Flynn in 1936. The Picasso that is the focal point of the saloon, a canopied bed in the owner's stateroom, a piano, and slightly eccentric décor all perpetuate the legend of the actor.

· FEATURES ·

Name: ZACA
Architect: Garland Rotch
Builder: Nuñes Brothers, Sausalito
Rigging: gaff schooner
Type: ocean racer
Launched: April 12, 1930
First owner: Charles Templeton Crocker
Restoration: 1994
Boatyard (restoration): International Marine Services,
Saint-Mandrier-sur-Mer
Construction: teak planking on oak ribs

Overall length: 147 feet [44.80 m]
Deck length: 118 feet [35.96 m]
Length at waterline: 96 feet [29.26 m]
Maximum beam: 23 feet 8 inches [7.23 m]
Draft: 13 feet 10 inches [4.20 m]
Displacement: 220 tons
Approximate sail area: 2,098 square feet [630 m²]

· DECK PLAN ·

STEERING WHEEL STAIRWAY MAST SKYLIGHT WINCH MIZZENMAST FORWARD STAIR-WAY *PORT* BOWSPRIT

MAINSAIL TRAVELER RACK AFT STATEROOM STAIRWAY FOOT OF THE MAST PIN RAIL WELL DECK DECKHOUSE FOOT OF THE MAST PIN RAIL CLEAT WINDLASS

STARBOARD

· LAYOUT ·

AFT STATEROOM HEADS DOUBLE STATEROOM SALOON DINING ROOM SKIPPER'S STATE-ROOM CREW SALOON

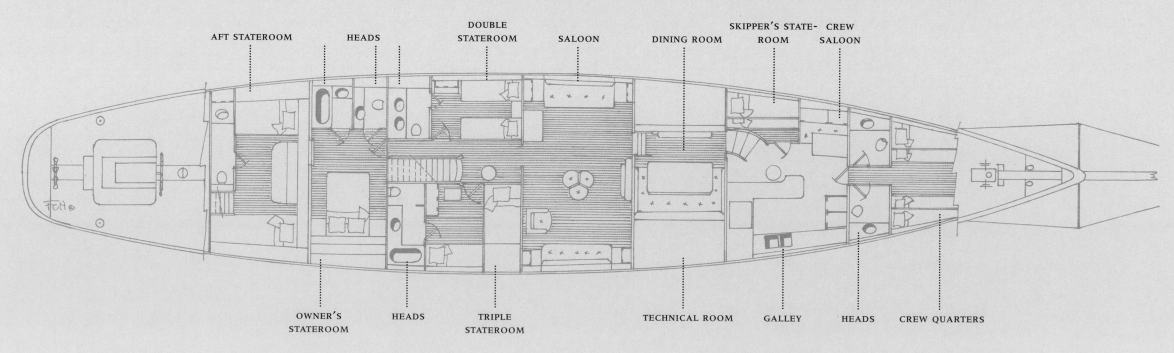

OWNER'S STATEROOM HEADS TRIPLE STATEROOM TECHNICAL ROOM GALLEY HEADS CREW QUARTERS

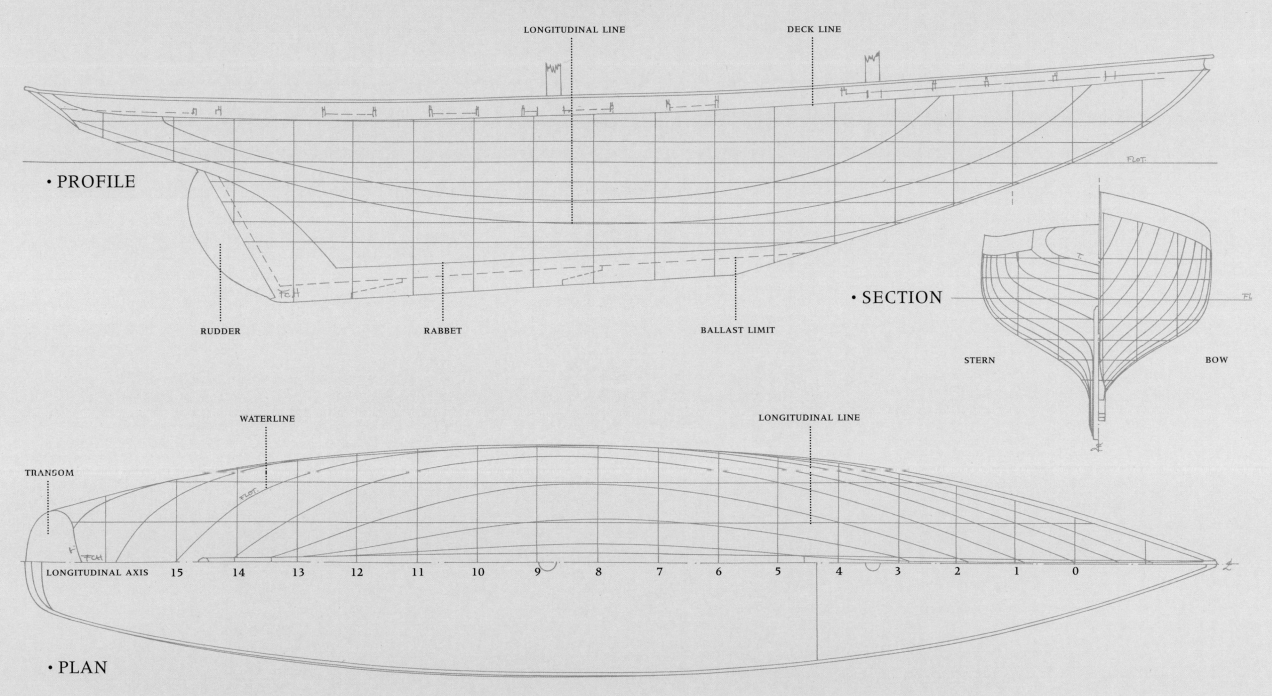

·CROSS SECTION

LONGITUDINAL LINE

DECK LINE

·PROFILE

FLOT.

·SECTION

FL

RUDDER

RABBET

BALLAST LIMIT

STERN

BOW

WATERLINE

LONGITUDINAL LINE

TRANSOM

FLOT.

LONGITUDINAL AXIS 15 14 13 12 11 10 9 8 7 6 5 4 3 2 1 0

·PLAN

SELECTED BIBLIOGRAPHY

Beebe, William. Zaca *Venture*. New York: Harcourt, Brace and Co., 1938.

Bell, Helen G. *Winning The King's Cup. An Account of the Elena's Race to Spain 1928*. New York: G.P. Putman's Sons, 1928.

Bobrow, Jill. *In the Spirit of Tradition: Old and New Classic Yachts*. Waistfield, Vt.: Concepts Publishing, 1997.

Bobrow, Jill, and Dana Jinkins. *Classic Yacht Interiors*. New York: W.W. Norton & Company, 1982.

Bowman, W. Dodgson. *Yachting and Yachtsmen*. London: Geoffrey Bles, 1926.

Bray, Maynard, and Carlton Pinheiro. *Herreshoff of Bristol, A Photographic History of America's Greatest Yacht and Boat Builders*. Brooklin, Maine: Woodenboat Publications, 1989.

Burnet, Constance Buel. *Let the Best Boat Win, The Story of American's Greatest Yacht Designer*. Boston: Houghton Mifflin Company, 1957.

Carter III, Samuel. *The Boatbuilders of Bristol*. New York: Doubleday & Company, 1970.

Chapelle, Howard I. *The American Fishing Schooners, 1825–1935*. New York: W. W. Norton & Co., 1973.

Charles, Daniel. *Le Yachting, Une histoire d'hommes and de techniques*. Paris: E.M.O.M., 1980.

Charles, Daniel, Ian Nicholson, William Collier, John Leather, and Duncan Walker. Tuiga, *1909*. London: Yachting Heritage, 2005.

Chevalier, François, and Jacques Taglang. *American and British Yacht Designs, 1870–1887*. 1st ed. Paris: F. Chevalier and J. Taglang; Vol. I, 1991; Vol. II, 1992.

———. *America's Cup Yacht Designs, 1851–1986*. 1st ed. Paris: F. Chevalier and J. Taglang, 1987.

———. *J-class*. London: Yachting Heritage, 2002.

Crane, Clinton, D. *Clinton Crane's Yachting Memories*. New York: Van Nostrand Company, 1952.

Crocker, Templeton, *The Cruise of the* Zaca. New York: Harper & Brothers, 1933.

Dear, Ian. *Fastnet: The Story of a Great Ocean Race*. London: B.T. Batsford Ltd, 1981.

Diaper, Captain Tom. *Tom Diaper's Log, Memoirs of a Racing Skipper*, London: Robert Ross & Co., 1950.

Dixon, Douglas. *The King's Sailing Master*. London: George G. Harrap & Co., 1948.

Duck, Noëlle. *Guide to Classic Yachts*. Paris: Collection Guide Thématiques de France, Gallimard, June, 2004 (in English and French).

———. *La Passion bleue, A Tribute to Owners*. Monaco: Yacht Club de Monaco, 2002.

Eastland, Jonathan. *Great Yachts and their Designers*. 1st ed. New York: Rizzoli International Publications, Inc., 1987.

Fife McCallum, May. *Fast and Bonnie, A History of William Fife and Son Yachtbuilders*. Edinburgh: John Donald Publishers, 1988.

Finlayson, W. J. *Yacht Racing on the Clyde from 1883 to 1890 (and next)*. Glasgow and London: MacLure, MacDonald & Co., 1890.

Fox, Uffa. *Sail and Power*. First ed., London: Peter Davies Ltd., 1936.

———. *Uffa Fox's Second Book*. First ed. London: Peter Davies Ltd., 1935.

Garland, Joseph E. *The Eastern Yacht Club. A History from 1870 to 1985*. Boston: The Eastern Yacht Club, 1989.

Haglind, Henning, and Erik Pallin. *Kungl-Svenska Segel Sällskapet—1830–1930*. Stockholm: Ahlén & Akerlunds Förlag, 1930.

Hamilton-Adams, C. P., *The Racing Schooner* Westward. London: Stanford Maritime Ltd., 1976.

Heckstall-Smith, Anthony. *Sacred Cowes, or The Cream of Yachting Society*. London: Allan Wingate, 1955.

Heckstall-Smith, Brooke. *The Britannia and Her Contemporaries*. London: Methuen & Co., 1929.

Herreshoff, L. Francis. *Capt. Nat Herreshoff, The Wizard of Bristol*. White Plains, N.Y.: Sheridan House, 1953.

———. *The Common Sense of Yacht Design*. New York: Caravan-Maritime Books, 1974.

———. *The Golden Age of Yachting*. New York: Sheridan House, 2007.

Hickey, Captain John J., Officer "787." *The Life and Times of the Late Sir Thomas J. Lipton, From the Cradle to the Grave, International Sportsman and Dean of the Yachting World*. New York: The Hickey Publishing Company, 1932.

Hunt's Universal Yacht List for 1869 (and next). London: Hunt & Co, 1869.

Irving, John. *The King's* Britannia, *The Story of a Great Ship*. London: Seeley Service & Co., 1937.

Johnson, Peter. *Yacht Rating, 170 Years of Speed, Success and Failure Against Competitors, and the Clock*. Lymington, Hampshire: Bucksea Guides, 1997.

Kemp, Dixon, and Horace Cox. *The Yacht Racing Calendar and Review for 1890 (and next)*. London: "The Field" Office, 1890.

Knight, Lucia del Sol, and Daniel Bruce MacNaughton. *The Encyclopedia of Yacht Designers*. New York: W. W. Norton & Company, 2006.

Kramer, Klaus. *Max Oertz*. Schramberg, Germany: Klaus Kramer Verlag, 2001.

Leather, John. *The Big Class Racing Yachts*. London: Stamford Maritime, 1982.

Lipton, Sir Thomas J. *Leaves from the Lipton Logs*. London: Hutchinson & Co., 1932.

———. *Lipton's Autobiography*. New York: Duffield and Green, 1932.

Nicholson, John. *Great Years in Yachting*. Lymington, Hampshire: Nautical Publishing Company, 1970.

Pace, Franco. *William Fife*. Paris: Voiles Gallimard, 1998.

Parkinson, John, Jr. *The History of the New York Yacht Club. From its Founding Through 1973*. New York: The New York Yacht Club, 1975.

Pastore, Christopher. *Temple of the Wind, The Story of America's Greatest Naval Architect and His Masterpiece*, Reliance. Guilford, Conn.: The Lyons Press, 2005.

Poor, Charles Lane. *Men Against the Rule, A Century of Progress in Yacht Design*. New York: The Derrydale Press, 1937.

Robinson, Bill. *The Great American Yacht Designers*. New York: Alfred A. Knopf, 1974.

Rogers, Andrew. Iduna. *The Restoration of a Classic Dutch Yacht*. Naarden, the Netherlands: Van Klaveren Maritime, 2004.

Scott Hughes, John. *Sailing Through Life*. London: Methuen, 1947.

Shoettle, Edwin J. *Sailing Craft. Mostly Descriptive of Smaller Pleasure Sail Boats of the Day*. New York: The MacMillan Company, 1928.

Stone, Herbert L. *The America's Cup Races*. New York: The Macmillan Company, 1930.

Summers, Captain James C. *"Who Won?": The Official American Yacht Record and Pocket Register for 1890 (and next)*. New York: James C. Summers, 1890.

Tabarly, Eric. *Pen Duick*. Paris: Editions Ouest-France, 1989.

Vanderbilt, Harold S. Enterprise, *The Story of the Defense of the America's Cup in 1930*. New York: Charles Scribner's Sons, 1931.

Ward, Captain A. R. *The Chronicles of The Royal Thames Yacht Club*. Arundel, West Sussex: Fernhurst Books, 1999.

Waugh, Alec. *The Lipton Story, A Centennial Biography*. London: Cassell and Company, 1951.

INDEX

GLOSSARY

15-meter class. Yachts of the fifteen-meter class, *International Rule*. Twenty were built between 1907 and 1917, two in Spain, one in Germany, one in France, two in Norway, and the other fourteen in Great Britain. They were *Ma'oona* (A. Mylne, 1907), *Shimna* (W. Fife, 1907), *Mariska* (W. Fife, 1908), *Anémone II* (C. M. Chevreux, 1909), *Ostara* (A. Mylne, 1909), *Tuiga* (W. Fife, 1909), *Vanity* (W. Fife, 1909), *Hispania* (W. Fife, 1909), *Encarnita* (J. Guédon, 1909), *Paula II* (A. Mylne, 1910), *Sophie-Elizabeth* (W. Fife, 1910), *Tritonia* (A. Mylne, 1910), *Senta* (M. Oertz, 1911), *Istria* (C. & N., 1912), *Lady Anne* (W. Fife, 1912), *Isabel-Alexandra* (J. Anker, 1913), *Maudrey* (W. Fife, 1913), *Pamela* (C. & N., 1913), *Paula II* (C. & N., 1913), and *Neptune* (J. Anker, 1917).

19-meter class. Yachts of the nineteen-meter class, *International Rule*. A large cutter, intermediate in size between the fifteen-meter class and the 23-meter class. Four were built in Great Britain in 1911 and two in Germany in 1913. They were *Corona* (W. Fife, 1911), *Mariquita* (W. Fife, 1911), *Octavia* (A. Mylne, 1911), *Norada* (C. & N., 1911), *Cecilie* (M. Oertz, 1913), and *Ellinor* (G. Borg, 1913).

23-meter class. Yachts of 23-meter class, *International Rule*. A large cutter corresponding to the J-class of the *Universal Rule*. Six were built in Great Britain between 1907 and 1929: *Brynhild* (C. & N., 1907), sank in 1910; *White Heather II* (W. Fife, 1907), classed as J in 1930; *Astra* (C. & N., 1928), classed as J in 1931; *Candida* (C. & N., 1929), classed as J in 1931; *Shamrock* (W. Fife, 1908), demolished in 1933; *Cambria* (W. Fife, 1928), classed as J in 2003.

Aft. At or towards the stern, at the back of a boat or ship.

Alter course, to. To move away from *windward*.

America's Cup. International yacht race first held in 1851, the oldest race of its kind.

Backstay. Wire support for masts leading from the masthead to the *stern* (*standing rigging*).

Ballast. Weighted part of the keel that keeps a sailboat stable in the water in order to balance the force of the sails. Extra bulk carried in the bottom of the hull.

Bank. Raised seabed, sometimes revealed by the tide.

Beach, to. For a ship, to allow the ship to run aground, the hull resting on the ground.

Beam. The widest part of the boat, a horizontal structure supporting the deck or the roof.

Beat. To sail to windward in a sailboat by frequently changing *tack* or direction.

Beaufort scale. Created in 1806 by Englishman Admiral Francis Beaufort (1774–1857) and used to measure wind speed on a scale of 0 to 12. Each point represents a state of the sea. Force eight, between 34 and 40 *knots* is a gale-force wind, force ten is storm, and force twelve above 64 knots is a hurricane.

Belaying. Making the ship fast in port or at her *mooring*.

Bending strake. Vertical planking on the side of the roof or its extension.

Bermuda rigging. *Rigging* originally used in Bermuda, in which the mainsail is triangular.

Berth. Permanent or semipermanent *mooring*; a place at a dock or wharf.

Boom. *Spar* at right angles to the mast that grips the foot of the sail.

Boomkin. Spar projecting from stern to secure backstay.

Bosun's chair. Small seat used to hoist a crew member aloft.

Bow, stem. The front of a boat or ship.

Bow wave. Waves produced on each side of the *bow* or *stem* of a ship as she moves forward.

Bowline. Knot used to make a loop at the end of a rope or tie the boat to a mooring ring or post.

Bowsprit. *Spar* that extends the *stem* of a sailboat forward.

Bulb keel. *Keel* whose *ballast* is concentrated in a bulb below a keel sail.

Bulkhead. Below-deck, waterproof partition, sealing off one part of the boat or ship from another.

Bulwark. Raised part of the hull rising above the deck to form a protection.

Cap shroud. The outermost shroud.

Capstan. Vertical *winch*.

Centerboard. Movable *keel* that pivots out of a slot or slides down in the hull of a sailboat, known as a centerboard trunk or case. Provides lateral resistance counteracting the force of sails.

Chain plates. Strengthened metal deck fittings on each side of a boat that hold the cables that keep the mast in place (*standing rigging*).

Cleat. Fitting for securing a rope line; to secure a rope line to a cleat.

Clew. Lower aft corner of a sail.

Clipper. Fast sailing ship with three or four masts, once used mainly for transporting tea to England from Asia.

Close-hauled. Sailing as close to the wind as possible, with the sails pulled in tightly.

Cockpit. Cabin in the center of a yacht deck from which the boat is steered.

Cringle. Metal or plastic eye sewn into a sail.

Cutter. Sailing ship with at least two foresails and a *jib*. Mast is often in the middle (fore end aft) of boat.

Daggerboard. Movable *keel* that slides vertically inside its trunk or case, for lowering below the *hull*.

Deck. Flat part of the ship covering the *hull*.

Deck fittings. All of the equipment on deck used for maneuvers, navigation, and safety, such as *winches, cleats,* pulleys, shackles, compass, *stanchions,* and hatches.

Deck line. The line between the *deck* and the *hull* of a boat.

Dinghy, sailing. Small sailboat equipped with a *centerboard* that helps her sail better into the wind. The term *dinghy* is also used to refer to a rowboat.

Displacement. The volume of water displaced by a vessel. See also *draft*.

Doghouse, wheelhouse. Cabin or shelter on the deck of a boat containing the *helm*. See also *cockpit*.

Draft. Maximum depth of water displaced by *hull*. See also *displacement*.

Dry dock. Small basin in a boatyard that can be flooded to allow a boat to be floated in and then drained to allow the craft to rest on a dry platform.

Fag end. Small piece of loose rope.

Fairlead. Ring or loop for guiding a rope.

Fender. Sheathed protective pad, hung over the sides, between the boat and the quay, pontoon, or other vessel.

Floating dock. Small space filled with water used to overhaul boats and containing *ballast* that enables the craft to be partially submerged.

Foils. Collective term for the *keel, centerboard, skeg,* and *rudder*. Sometimes used to refer to sails when describing the aerodynamic force of the wind.

Foot. Bottom of a sail or mast.

Forestay. Stay leading from the mast to the *bow*.

Freeboard. Height between the deck and the waterline.

French Rule. The so-called Godinet Rule, of 1992, that includes the flotation length, sail area, and circumference of the *hull* at its widest point.

Frigate. Three-masted warship, square-rigged when a sailing vessel, with a row of canons.

Furl. Fold a *stay* over a *spar* or over itself.

Gaff rigging. *Rigging* consisting of one or more mainsails in the shape of a trapezium of which the front part is fixed to the mast and the upper part attached to a *spar*.

Galley. The boat's kitchen.

Gennaker. An asymmetrical foresail that helps capture as much of a following wind as possible.

Genoa. Triangular headsail usually used in Bermuda-rigged sloops, also larger than the *jib*.

Gunwhale. Pronounced "gunnel," top edge of the side of the *hull*.

Half-hull. Reduced-size model showing the *starboard* side of a ship's *hull*.

Halyard. Rope used to hoist a sail.

Haul in. Pulling down a sail by dragging at a *sheet* or rope.

Heads. The bathrooms.

Heel. To lean heavily to one side; also a fitting at the foot of the mast.

Helm. Tiller or wheel, and by implication the *rudder* used to steer the boat.

Hoist home. To extend a *halyard* or rope.

Hull. The main body of a boat.

International Rule. Adopted in London in 1906 by European yachtsmen and brought into force in 1907. The formula consists of adding the flotation length, width, area of sail, and the difference in the circumference of the hull.

It was modified in 1917, and then again in 1933. The *rating* is expressed in meters.

J-class. A *Universal Rule* class, the America's Cup yachts between 1930 and 1937, including *Shamrock V, Velsheda, Endeavour, Cambria, Astra,* and *Candida.*

Jib. Triangular sail before the mast. Big sailboats may be equipped with a small *jib,* a large *jib,* a *jib topsail* or flying *jib,* and a storm *jib.*

Jibe ho, gybe. To change direction when sailing in a manner such that the *stern* of the boat passes through the eye of the wind and the *boom* changes sides.

Keel. Ballasted plate fixed below the *hull* of a sailboat to resist *leeway* and keep the craft balanced in the water.

Ketch. Two-masted sailboat, the smaller mast being *aft* in front of the *helm.*

Knot. A unit of speed, representing one *nautical mile* (6,076 feet [1,852 m]) per hour.

Lateen sail. Triangular sail of which the widest side is fixed to a *yard* known as the antenna.

Leeward. Away from the wind.

Leeway. Sideways drift of a boat to *leeward* caused by the effect of the wind.

List. Sideways lean of a boat, the list of a *monohull* into the wind is quite considerable.

Long stern timbers. Extension of the *keel* in the *aft* of the *hull.*

Luff. Forward edge of a triangular sail; to turn inward toward the wind; to make the forward edge of the sail shake and lose wind by sailing too close to the wind or with the sail insufficiently sheeted in. An alteration of course toward the wind.

Marconi rigging. *Gaff rigging* in which the large *topsail* extends right up to the *topmast* and is bent around it.

Mizzenmast. Small mast *aft* on a *ketch.*

Monohull. Single-hulled boat.

Mooring. Permanent arrangement of anchors and cables by which a boat can be secured; the process of securing a boat to a *berth* or mooring buoy.

Multihull. Ship with two or three *hulls.*

Nautical mile. Unit of distance in the sea, equal to one minute of latitude, or the twenty-one thousandth and six hundredth (60 x 360) of the circumference of the earth, or 6,076 feet (1,852 m).

Pearl, to. When the ship's *bow* dips into the wave, and water covers the foredeck.

Pitching. Lengthwise rocking movement of the boat.

Planking. Wooden planks or metal sheets covering the *deck.*

Port. The left side of the ship.

Rake. The angle at which a mast leans forward or *aft.* Also the part of a ship above the water, fore or aft, above the waterline.

Rating. Result of the calculation of *tonnage,* making it possible to create a class of yachts or calculate compensated

time so as to equalize the chances of different yachts in a race.

Reach. To sail with the wind blowing from the side.

Reef. To lower a sail so it is smaller in area. See also *bank.*

Reefing lines. Lines used to pull the *reef* in the sail.

Rib. Part of the transverse structure of the *hull* to which the *planking* is fixed.

Rigging. The rigging characterizes the type of yacht, such as the *ketch,* the *schooner,* or the *three-masted barque.* It consists of the set of masts, their supports, and sails.

Rudder. Movable underwater blade used to steer the boat and controlled by the tiller or wheel.

Runner and tackle lever. Replaces the *runner tackle* keeping it taut while retaining the same tension. The system was perfected by John S. Highfield, owner of *Dorina,* formerly *Tuiga.*

Runner tackle. Movable cable keeping the mast held back on each side of a yacht.

Running rigging. The moving lines such as the *sheets* and *halyards* used for setting and *trimming* the sails.

Saloon. Wardroom, meeting room, and dining room on board.

Schooner. Two-masted sailboat, the mainmast being behind the *mizzenmast.* Forward mast is shorter than aft mast.

Sheets. Ropes or lines used to adjust the sails, attached to the *clew* of a sail or to the *boom.*

Shrouds. Cables that hold the mast in position (*standing rigging*).

Sister ship. Used to describe a boat or ship designed using the same plan and cross section as another boat.

Skeg. Downward projecting foil at the *aft* of a boat, smaller than the *keel* to support the *rudder.*

Skiff. Long, narrow rowboat, used for racing.

Sloop. Sailboat *rigging* consisting of a mainsail, foresail, and a *jib.*

Spar. Any fitting that makes it possible to raise or lower a sail, such as the mast, *boom,* whisker pole, or *boomkin.*

Spinnaker. Large, light downwind sail, rounded when filled with wind and forward of the *forestay.*

Spreaders. Crosspieces on the mast to spread out the cables (*shrouds*) that keep them horizontal.

Stanchion. Upright post supporting the guardrails.

Standing rigging. The fixed shrouds and stays that support the mast.

Starboard. Right-hand side of a boat.

Stay. Cable supporting the mast from the front (*standing rigging*).

Stem. Front part of the *hull.*

Step (mast). Recess or fitting into which the base of the mast is secured.

Stern. Rear part of the *hull.*

Tacking. Course of a boat sailing to *windward,* known as *starboard* tack when the wind is from the starboard (right) side, and *port* tack when it comes from the port (left) side.

Tackle. Set of ropes and pulleys making it easier to spread the effort of hauling sails up and down.

Three-masted barque. Three-masted sailboat, of which the first three sails are square.

Tiller ropes. Cables linking the *rudder* to the *helm* or tiller.

Tonnage. The rules and calculation used to define a class of yachts or to establish a handicap in order to enable different sizes of yachts to race against each other so as to even out the chances of winning. The result of the calculation defines the yacht's *rating.*

Topmast. In *gaff* or *Marconi rigging,* a *spar* above the mast supporting the *topsail.*

Topsail. In *gaff rigging,* a triangular sail above the mainmast above the mainsail.

Traveler. Sliding device that travels along a track, used for altering the *sheet* angles.

Trim. The longitudinal position of the boat in relation to the draft; also to let out or pull in sails.

Trim sheet. Calculation of the total weight of all the elements of which a boat or ship consists in order to find out her submerged volume.

Trip. To release the anchor or rope too quickly.

Turnbuckle. Metal fitting used to tighten or loosen the tension for *standing rigging.*

Universal Rule. Devised in 1903 by the American naval architect, Nathanael Herreshoff, classifying yachts using letters, *schooners* from A through F and *sloops* from G through R. *J-class* has a *rating* of 65 to 76 feet. The draft of the yacht is also part of the calculation of the *tonnage.*

Vang. Metal strut between the *boom* and the mast, for holding the boom down.

Whaler. Light, narrow boat, pointed at each end. Consisting of sand, rocks, mud, or coral. Also known as a *reef.*

Winch. Vertical cylindrical mechanical jack for hauling ropes.

Windlass. Horizontal *winch,* now mechanical, used to pull in a heavy cable or chain, such as the anchor chain.

Windward. Into the wind.

Yard. *Spar* attached to the mast and used to haul square or triangular sails.

Yawl. Two-masted sailboat, the smallest mast being behind the *helm.*

Yoke. Y-shape topmast fittings. Part that links the lower and upper part (*topmast*) on *gaff rigging.*

ACKNOWLEDGMENTS

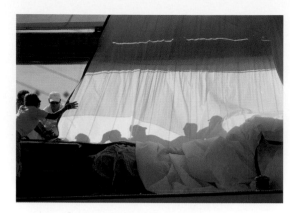

The authors would like to thank all those without whom this book would not have been possible, the naval architects, boatyards, owners, skippers, sailing clubs, museum, historians, journalists, photographers, writers, and friends, especially the following: Jacques Taglang, Gabrielle Abraham, Bernard d'Alessandri, Daniel Allisy, Jacques Anderruthy, Isabelle Andrieux, Françoise Aubert, Nathalie Bailleux, Chris Barkham, Stefan Benfield, Jenny Bennett, Marc P. G. Berthier, Jill Bobrow, Carlo Borlenghi, Pierre-Marie Bourguinat, Jérôme Boyer, Maynard Bray, Elaine Bunting, Nic Campton, François Carn, Amandine Cau, Françoise Chabert, Daniel Charles, Laurent Charpentier, Brigitte Chevalier-Brest, Dominique Chalot, William Collier, Tom Cunliffe, François-Jean Dahen, Butch Dalrymple-Smith, Ian Dear, Gerard Dijkstra, Noëlle Duck, Stephano Faggioni, Christian Fevrier, May Fife McCallum, Delphine Fleury, Martin Francis, Daniel Funk, Dominique Gabirault, Yves Gagnet, Bugsy Gedlek, Isabelle Geffroy, David Glenn, Renaud Godard, Jim Grant, Guilain Grenier, C. P. Hamilton Adams, Hervé Hillard, Malcom J. Horsley, Michelle Icard, Thom James, Isabelle Jendron, Dana Jinkins, Atlan G. Kastelein, Ed Kastelein, Lewis Kleinhans, Eric Knight, Alex Laird, Luigi Lang, Patrick Langley, Roger Lean-Vercoe, John Leather, Philippe Lechevalier, Thierry Leret, Robin Lloyd, Guiseppe Longo, Chris Madsen, Michel Maeder, Philippe Menhinick, Laurent Miagkoff, Mille and Une Vagues, Ian Murray, John and Françoise Murray, Gérard Naigeon, Federico Nardi, Albert Obrist, Franco Pace, Marc Pageot, Gilbert Pasqui, Thomas J. Perkins, Thom Perry, Nigel Pert, Doug Peterson, Bruno Petitcollot, Bruno dal Piaz, Harriet Anne Pierson, Fabienne Ploquin, Myriam Poisson, Mike Porter, Philippe Quentin, Didier Ravon, Florence Renault, Florence Richin, Éric Robert Peillard, Michel de Rohozinski, Martin A. Romein, Dominique Romet, Andrew Rogers, Gilles Rosfelder, Jean-Marc Salis, Peter Saxby, Flavio Serafini, Antoine Sezerat, Anne-Marie Schuitenmaker, Harry R. Spencer, Paul Spooner, Olin J. Stephens, Jim Thom, Emmanuel de Toma, Bill Trenkle, Sophie Tricon, Maguelonne Turcat, Johan van den Bruele, Francis van de Velde, Christophe Varène, Mireille Vatine, Dafne Vecchi, Éric Vibart, Duncan Walker, Peter Ward, Peter Wood, Tommy Workman, Patrice Wymore Flynn, Beppe Zaoli, and Zbynek Zak.

Abbeville Press would like to thank Gary Jobson for his invaluable guidance and assistance.

First published in France in 2007 by Editions du Chêne-Hachette Livre, 43, Quai de Grenelle, 75905 Paris Cedex 15.
Editor: Nathalie Bailleux
Art direction and graphic design: Nancy Dorking

First published in the United States of America in 2008 by Abbeville Press, 137 Varick Street, New York, NY 10013

For the English Language Edition
Editor: Michaelann Millrood
Production manager: Louise Kurtz
Copyeditor: Ashley Benning
Jacket design and interior typography: Misha Beletsky
Composition: Julia Sedykh
Translator: Josephine Bacon, American Pie

The photographs in this book are by Gilles Martin-Raget and can be ordered from his website at www.martin-raget.com. The photographs on page 201 are by Guilain Grenier.

First edition
10 9 8 7 6 5 4 3 2 1

ISBN 978-0-7892-0995-5

Library of Congress Cataloging-in-Publication Data
Chevalier, François, 1944-
 [Mythiques yachts classiques. English]
 Classic yachts / text and drawings by François Chevalier ; photography by Gilles Martin-Raget ; foreword by Gary Jobson ; [translator, Josephine Bacon]. — 1st ed.
 p. cm.
 ISBN 978-0-7892-0995-5 (hardcover : alk. paper) 1. Yachts—History.
2. Sailing ships—History. I. Title.

VM331.C5813 2008
623.822′3—dc22
 2008014248

For bulk and premium sales and for text adoption procedures, write to Customer Service Manager, Abbeville Press, 137 Varick Street, New York, NY 10013, or call 1-800-ARTBOOK.

Visit Abbeville Press online at www.abbeville.com.